Writing Design

Writing Design

Words and Objects

Edited by

Grace Lees-Maffei

London • New York

English edition
First published in 2012 by
Berg
Editorial offices:
49–51 Bedford Square, London WC1B 3DP, UK
175 Fifth Avenue, New York, NY 10010, USA

Berg is an imprint of Bloomsbury Publishing Plc.

Library of Congress Cataloging-in-Publication Data

A catalogue record for this book is available from the Library of Congress.

British Library Cataloguing-in-Publication Data

A catalogue record for this book is available from the British Library.

ISBN 978 1 84788 956 0 (Cloth)
 978 1 84788 955 3 (Paper)
e-ISBN 978 1 84788 957 7 (individual)

Typeset by Apex Covantage, LLC, Madison, WI, USA
Printed in the UK by the MPG Books Group

www.bergpublishers.com

CONTENTS

ILLUSTRATIONS

110

CONTRIBUTORS

Professor Michael Biggs holds a personal chair in Aesthetics, and was Associate Dean and led faculty research at the University of Hertfordshire, UK, and Visiting Professor in Arts-based Research in Architecture at the University of Lund, Sweden. He coordinates a network of excellence in arts research and has published widely on research theory in the creative and performing arts. He recently edited *The Routledge Companion to Research in the Arts*.

Barbara Brownie is a lecturer in visual communication and online learning. After working as a multimedia designer and experimental photographer, she returned to education to lead the Distance Learning MAs in Graphic Design and Illustration at the University of Hertfordshire. She has submitted her PhD on the behaviour of fluid character forms in temporal typography, concentrating on linguistic forms which undergo transformations into shapes and images.

Dr Daniela Büchler is Senior Research Fellow and project leader at the School of Creative Arts at the University of Hertfordshire, UK; Visiting Research Fellow at Mackenzie University, Brazil; and Guest Scholar at Lund University, Sweden. She has degrees and experience as practitioner and researcher in architecture, urban planning and industrial design.

Polly Cantlon, a foundation lecturer for the Bachelor of Computer Graphic Design at the University of Waikato, NZ, is a generalist studio design teacher, and a specialist in the history of graphic design. She has presented papers internationally on topics of New Zealand graphic design, and her research interests are popular graphics and typography. She is currently working on a PhD dissertation examining the history of graphic design in New Zealand.

Dr Kjetil Fallan is Associate Professor of Design History in the Department of Philosophy, Classics, History of Art and Ideas at the University of Oslo. He is the author of *Design History: Understanding Theory and Method* (Berg, 2010) as well as numerous journal articles including *The Journal of Design History*, *Design Issues*, *Enterprise and Society* and *History and Technology*. His edited volume *Scandinavian Design: Alternative Histories* is forthcoming with Berg (2012). Fallan also serves on the editorial board of *The Journal of Design History*.

Dr Fredie Floré is Assistant Professor in Architectural History at VU University Amsterdam and post-doctoral researcher at the Department of Architecture and Urban Planning, Ghent University. Her research focuses on the history of (educational) discourses on domestic architecture, home culture, interiors and design in Belgium and the Netherlands in the second half of the twentieth century. She is co-editor of two books and has published in national and international books and journals, including *Architectural History*, *The Journal of Architecture*, *The Journal of Design History* and *De Witte Raaf*. Recently, her book *Lessen in Goed Wonen. Woonvoorlichting in België 1945–1958* was published by Leuven University Press (2010).

Dr Stephen Hayward is an Associate Lecturer with responsibility for Critical Contexts on the MA programmes at Central Saint Martins, University of the Arts, London. His current research reconsiders the history of modern design from a phenomenological perspective.

Anne Hultzsch teaches Architectural History at the Bartlett (UCL) where she has submitted her PhD, funded by RIBA and AHRC. Trained as an architect in Munich and Rome, she has practiced in Vienna, Rotterdam and London and holds an MSc in Architectural History (UCL). Her PhD 'An Archaeology of Perception: Verbal Descriptions of Architecture in Travel Writings' links the history of perception to that of language, arguing that the experience of any built space is, and has been, shaped by the ways found to express and communicate it.

Chae Ho Lee is an Assistant Professor of Design at the University of Hawai'i at Mānoa. His work spans advertising, exhibition, identity, publication, and web design. He has worked for a number of prestigious advertising agencies and design studios in the Pacific Rim, New York and Dubai. He has exhibited his design work nationally and internationally and has presented his research at international conferences in England, Japan, and Egypt. His current research has been published by the journals *Creative Quarterly* and *Visible Language*, among others. He received his MFA with honours from the Rhode Island School of Design in 1999.

Dr Grace Lees-Maffei is a Reader in Design History and Coordinator of the TVAD Research Group, working on text, narrative and image, at the University of Hertfordshire, UK. She researches the mediation of design through channels including domestic advice literature, corporate literature and advertising. Publications include *The Design History Reader* co-edited with Rebecca Houze, chapters in *Performance, Fashion and the Modern Interior* and *Autopia,* and articles in *The Journal of Design History*, *Modern Italy*, and *Women's History Review*. Lees-Maffei is Managing Editor of *The Journal of Design History*, and on the advisory board for *The Poster*.

Alice Lo completed her bachelor's in Computer Graphic Design at The University of Waikato/Te Whare Wananga o Waikato, NZ, and her master's in Communication De-

sign, at Central Saint Martins School of Art and Design in London. On returning to New Zealand, Alice took a teaching position for the Computer Graphic Design course at The University of Waikato. She is now a freelance graphic designer and focuses on designing experimental typefaces.

Mhairi McVicar is a Lecturer at the Welsh School of Architecture, Cardiff University, and, following practice as an architect in Chicago, US, is now a principal of Collaborative Design Studio (www.cdstudio.co.uk). Her publications on precision in architectural practice include 'Contested Fields: Perfection and Compromise at Caruso St John's Museum of Childhood' in *Architecture and Field/Work,* ed. Ewing et al. (Abingdon, Oxon: Routledge, 2010); 'Passion and Control: Lewerentz and a mortar joint' in *Quality Out of Control*, ed. Dutoit et al. (Abingdon, Oxon: Routledge, 2010); and 'Memory and Progress: confessions in a flagstone wall' in *Architectural Research Quarterly* 11, nos. 3–4 (2007).

Jeffrey L. Meikle is Stiles Professor in American Studies and Professor of Art History at the University of Texas at Austin. His books include *Design in the USA*; *American Plastic: A Cultural History* (winner of the Society for the History of Technology's Dexter Prize), and *Twentieth Century Limited: Industrial Design in America, 1925–1939*. Current research explores landscape-view postcards as representations of the American scene during the 1930s and 1940s, and the reception and appropriation of the works of Beat generation writers by artists in various fields from the 1960s through the 1990s.

Gabriele Oropallo teaches design history at University College London, where he is completing a PhD on political and social commitment and design in the second half of the twentieth century. In 2006, the European Commission awarded him a Marie Curie research fellowship. In parallel with his academic activities, he has been involved in curating, photography and film-making as means of undertaking and presenting research in design and architecture.

Dr John Stanislav Sadar was born in Canada and earned a BArch from McGill University in Montreal, a MArch from the Teknillinen Korkeakoulu in Helsinki, and a PhD from the University of Pennsylvania. Having worked in private practice with various firms in Finland, Slovenia, Canada and the United States, he is currently teaching in the Department of Architecture at Monash University's Faculty of Art and Design in Melbourne.

Ann Sobiech Munson, RA CCS, is an architect and specifications writer at Substance Architecture, Des Moines, Iowa, US. From 2004–2011 she taught at Iowa State University, US, where she directed the required first-year curriculum in the College of Design. With degrees in both Architecture and English, she has design experience that ranges from working on projects at historically significant sites to teaching introductory-level lectures that present case studies in design and contemporary culture. Her research addresses the

intersection of architecture and culture through writing practices in the varied contexts of teaching and learning, architectural practice and popular media.

Léa-Catherine Szacka studied architecture in Canada and Italy before joining the PhD program at the Bartlett School of Architecture in London. Her research concerns the paradox of exhibiting architecture, specifically within a postmodern context. Currently researching the history of exhibitions at the Centre Pompidou in Paris, Szacka has previously collaborated with the Barbican Arts Centre in London and Actar publisher in Barcelona in addition to teaching architecture at Nottingham Trent University.

Dr Stina Teilmann-Lock is Postdoctoral Fellow at the Centre for Information and Innovation Law at the University of Copenhagen and holds a PhD in comparative literature from the University of Southern Denmark. She is the author of *British and French Copyright: a Historical Account of Aesthetic Implications* (Copenhagen: Djoef, 2009), co-editor of *Art and Law: the Copyright Debate* (Copenhagen: Djoef, 2005) and has published numerous articles on art, design and copyright. She has worked as a patent administrator and has been a Carlsberg Research Fellow at the Danish Design School.

Dr Jane Tynan is a Senior Lecturer at Central Saint Martins College of Art and Design, London. Her research explores the history and politics of design, and currently focuses on the design, production and consumption of clothing for European civil and military organizations in the early twentieth century. Recent publications consider the emergence of the trench coat in First World War Britain, the use of khaki as camouflage device, and military aesthetics in wartime press photographs. She is currently working on a single authored book about First World War British army clothing worn by combatants on the western front.

ACKNOWLEDGEMENTS

My primary thanks, as editor, are to the contributors to this volume: they have met a series of deadlines with consummate professionalism. I also want to acknowledge all the contributors to the conference *Writing Design: Object, Process, Discourse, Translation*, hosted by the TVAD Research Group at the University of Hertfordshire, from which this volume was developed: thank you to the peer reviewers, speakers, panel chairs and respondents, administrators and co-convenor Jessica Kelly. The conference was the Design History Society's 2009 annual meeting, and I thank the Society for its continued support for the Writing Design research project and specifically for the award in 2011 of the Society's Research Grant for production costs associated with the book. I am grateful to the staff at Berg, including Agnes Upshall, Tristan Palmer and the book's reviewers, for their support of the project, and to the School of Creative Arts at the University of Hertfordshire, particularly Steven Adams. Alice Twemlow, Maddalena Dalla Mura, Dipti Bhagat, Javier Gimeno-Martínez, Haruhiko Fujita and Akira Hirano at the Lisa Sainsbury Library very kindly helped me track down sources. My work on projects such as this one impacts upon the daily life of my husband, Nic Maffei, and that of our children, Jay and Laurel—thank you, all three. Finally, for bringing me up to appreciate the importance of design, I thank Sylvia and Peter Lees: designers, teachers, parents.

INTRODUCTION: WRITING DESIGN

GRACE LEES-MAFFEI

'[T]he first one-piece plastic chair to feature the natural surface of its material, varie-gated and satiny.'

'The molders used a matted preform of short strands of fiberglass and polyester resin formed by suction against a wire screen. Using the match-die method, they molded each perform for three minutes at a temperature of 130°C and pressures ranging from 100 to 150 psi.'

'The chair's iconic status derives not only from the confidence of its design and its great commercial success, but also from the countless imitative plastic chairs it gener-ated in the next half century, each in its own way indebted to this now seemingly simple design.'

'This chair is just so versatile and this is one of the reasons for its notoriety!'[1]

These different descriptions of the DAR plastic armchair, designed by Charles and Ray Eames for the Herman Miller Furniture Company (1948–50), reveal as much about the authors, their aims and the contexts within which they were written as they do about the chair. The DAR chair won the Museum of Modern Art's (MoMA) 'Low Cost' competition in 1950; in praising it, the MoMA curator Edgar Kaufmann Jr. emphasized its technical innovation in terms that would be accessible, and attractive, to an audience of potential purchasers. In 1995, when Professor of American Studies Jeffrey L. Meikle included the chair among hundreds of examples in his *American Plastic: A Cultural History*, he could assume that his readers possessed both the interest and understanding necessary to appreci-ate technical details about the chair's production. In 2006, art historian Martin Eidelberg described the DAR's 'iconic status' as a way of contextualizing another Eames icon, the lounge chair. In so doing, he underlined the influence, aesthetic as much as technical, exerted by the DAR. In 2011, Vertigo Interiors was one of many sellers to list reproduc-tion Eames chairs (in this case the RAR, or rocking armchair) on the online auction site eBay, where concise, simple and appealing descriptions are intended to produce sales. The provocation implied by the misuse of the word 'notoriety', as opposed to 'celebrated status', or some other more positive term, is largely irrelevant on Ebay, but to someone interested in design, and what people say about it, it is a telling detail.

This introduction establishes 'writing design' as a polyvalent and useful term for think-ing about how text is used in design criticism, design history and design practice; in so doing, it provides bibliographic pointers to a wide range of related publications. Core

senses for the term 'writing design' have informed the organization of the book; this introduction situates the chapters within that organization and considers alternative reading routes before closing with a summary of the book's contribution.

As the chapters in this book make clear, design can take many forms, whether plan, model, or other schema, object or building, craft or design/art, or practice, process or service. We can encounter design through examination of designed objects or through images of the same, but we also encounter much design through words, written or spoken. From students attending lectures and seminars and researching and writing essays, to designers keeping up with current practice in professional magazines and on the websites and blogs; from shoppers browsing product specifications online, in catalogues and magazines, and in retail environments, to museum and gallery visitors reading labels and design historians scrutinizing letters and probate inventories in archives, words are crucial in learning about design past, present and future, as well as in communicating what we know. Becoming informed about design, and sharing what we have learned, requires a process of translating lines, shapes, colours, objects, materials, textures, surfaces, techniques, knacks, haptic, habitual and sensory processes, and feelings, fleeting impressions, emotions and memories, into words. Cultural historian Marius Kwint suggests that objects 'furnish recollection; they constitute our picture of the past'; they also 'stimulate remembering' both intended (for example, public sculpture and souvenirs) and unintended (in serendipitous encounters with objects rich in associations); finally, objects form a record. Yet, Kwint concludes, objects are silent and 'ultimately defy all attempts to represent them in language. Poetry can at least respect this integrity by its economical use of words, and the mimetic, crafted nature of verse.' But prose, Kwint implies, cannot.[2]

Certainly, translating the non-verbal attributes of the production, mediation and consumption of design into words can be difficult; after all, idiomatically at least, a picture is worth a thousand words. When it is difficult, this process is easily visible: many readers of this book will have struggled, as have I, to describe design in ways which do justice to the design itself and/or the intended point to be made.[3] We are not alone, which is why support for writing in art and design has grown in recent years, ranging from how-to books aimed at design students[4] to initiatives intended to help staff deliver teaching which effectively engages design students in the writing process.[5] Wrestling with writing extends beyond art and design, of course. In introducing his book *Writing and Revising the Disciplines*, comparative literature professor Jonathan Monroe argues that 'careful attention to the relationship between writing and learning is not the responsibility of any one discipline, but of all disciplines.' Monroe distinguishes between 'the physical sciences, where writing is often thought to be an ancillary activity of incidental importance; the social sciences, where writing's role is commonly understood as perhaps integral, but primarily instrumental; and the humanities, where writing is more readily perceived as defining if not constitutive of each discipline's particularity.'[6] And, influentially, cultural theorist Mieke Bal and fellow editor Bryan Gonzales have made the case for interdisciplinary cultural analysis based on close reading and authorial self-reflexivity.[7]

Notwithstanding the difficulty of translating design into words, the disciplines of design history, design studies and design criticism have burgeoned in the past three decades and especially in the past five years or so. In 'Design Books: Not Just Eye Candy', his foreword to Jason Godfrey's *Bibliographic: 100 Classic Graphic Design Books* (2009), prolific design critic Steven Heller notes that:

> Currently, an increasing number of publishers worldwide are issuing many more titles per year, everything from conventional 'how-to' and process books, to esoteric monographs on design 'culture'. I am convinced that the number of volumes devoted to design and related themes over the course of the past couple of years is near or equal to the number of books published throughout the entire 1930s, or even the 1980s.[8]

It seems as though there are more words about design generated in the media than ever before.[9] In addition to the books produced by publishers, to which Heller refers, we should recognize the design press and little magazines, fanzines and other informal, amateur publications, in shaping design thinking.[10] In 2011, Alice Twemlow reported that while several established graphic design titles have folded and others have sought ballast in cultivating their online presence and community, there is a 'profusion of new graphic design books, journals and zines published in small offset print runs or one at a time using print-on-demand services and edited, designed, published, and distributed by designers'.[11] Twemlow should know: she is chair of one of a handful of new master's degrees in design criticism recently established in London and New York, in response to a mushrooming interest in design criticism, discussed further in the introduction to Part One. And the burgeoning of design discourse online has provided a forum not only for words about design but also for critiques of writing about design. An example is Stephen J. Eskilson's *Graphic Design: a New History* (2007), which prompted a series of exceptionally critical reviews, comments and blogs, including complaints about his neglect of 'designer-writers'.[12]

While various pedagogical support structures make the practice of writing visible, in general, the ubiquity of the process of translation from design into words and back again means that it is largely taken for granted, and the *methodology* of writing design remains under-explored. Exceptions include Tony Fry's *Design History Australia* (1988) which, although ostensibly about writing design history from an Australian perspective, remains relevant to design historians everywhere for its prescience in anticipating the mediation emphasis of twenty-first-century design history.[13] Published the following year, Victor Margolin's *Design Discourse: History, Theory, Criticism* was the first of a series of anthologies from *Design Issues*, in which the essays demonstrate the variety and quality of design discourse.[14] Additional recently published anthologies include Fiona Candlin and Raiford Guins's *The Object Reader* (2009), which considers the nature of objecthood and the narrative potential of the artefact, and a book I edited with Rebecca Houze, *The Design History Reader* (2010), which reviews the development of design history through a selection of recommended texts.[15] Kjetil Fallan's *Design History: Understanding Theory and Method* (also 2010) emphasises the design historical application of methods drawn from science and

technology studies, and especially the history of technology.[16] Notwithstanding valuable excursions into relevant methodology, and the ubiquity of writing on design, the process of writing design has received relatively little academic attention from design historians; hence the need for this focussed book.

DEFINITIONS AND STRUCTURE

This book uses the term 'writing design' to describe a number of related processes. Firstly, it denotes the broad conjunction between design and language (writing + design), which is the topic of this book as a whole and of the wider project from which it derives.[17] The chapters explore this relationship principally over the past hundred years, with case studies outside that period. The book's subtitle, *Words and Objects*, summarizes the complex relationships between language and design, as both process and product, examined in the chapters. But, while words are a constant presence throughout the book, objects are not. Design is not reducible to objects, for two reasons: some design outputs exist outside the category of objects due to their scale, such as buildings and cities, or immateriality, such as screen-based media, fragrances, behaviours and logistics; and design is, as design historian Professor Penny Sparke has noted, 'Both a verb and a noun, it is not just a feature of our surroundings, it is also the creative process that makes them possible.'[18] The Words for Design project, led by Haruhiko Fujita of Osaka University in Japan, has delivered a compelling internationally comparative analysis of the word 'design'.[19] In *Writing Design: Words and Objects*, the four parts of the book explore different senses of the term to show how writing contributes to the creative process of design, and the processes of researching, understanding, criticizing and communicating about design.

Poet and literary critic Susan Stewart has asked: 'In *talking of* an object's qualities, do we *form* an object's qualities?'[20] In the opening chapter of this book, 'Writing about Stuff: The Peril and Promise of Design History and Criticism', Jeffrey L. Meikle answers, yes; by writing *about* design, we *bring it into being*. This is a second sense of 'writing design'. Specifically, writing on design conjures images in the mind's eye, whether of products or processes, so that by describing a design we are, at least linguistically and intellectually, reproducing it, or creating it, in a form which allows others to experience it. This is the case whether the design exists in material form or remains at the ideas stage. This process is called 'ekphrasis'; Anne Hultzsch's chapter in Part Two provides a clear analysis, using different terminology, of ekphrasis.

But there is another way in which 'writing design' brings design into being, and that is through criticism and reform. Although writing on design often analyses design *after the fact*, or after the processes of briefing, conception, design and manufacture have occurred, design criticism and design reform discourses critique what exists with the aim of improving what will follow. Design criticism is a particularly engaged form of writing design: it privileges the critic's personal interpretation. Conversely, academic writing on design, whether produced under the banner of design history, design studies, material culture studies, popular culture studies, American studies, architectural history or literary studies

(and all those other fields of study with expertise in design), tends to aspire to neutrality, even though neutrality is recognized to be an unobtainable ideal. Part One of this book, 'Righting Design—*On the Reforming Role of Design Criticism*' opens with Meikle's survey before moving on to two detailed case studies, Fredie Floré's 'Design Criticism and Social Responsibility: The Flemish Design Critic K.-N. Elno (1920–1993),' and 'The Metamorphosis of a Norwegian Design Magazine: *nye bonytt*, 1968–1971' by Kjetil Fallan. Stephen Hayward brings the discussion of design criticism up to the present in 'Writing Contemporary Design into History.'

Thirdly, writing design denotes the practice of finding out about design through reading the panoply of textual materials related, variously, to design as practice and product and communicating what we know through books, articles and presentations.[21] Objects have routinely been codified into textual descriptions, such as catalogues, and numerical data, including probate inventories, which have later been decoded by design historians and others, and written about further.[22] This process can produce what editors David Raizman and Carma R. Gorman have called 'alternative narratives in the history of design' in the subtitle of their book *Objects, Audiences and Literatures* (2007).[23] For example, historian Amanda Vickery's 'Women and the World of Goods: A Lancashire Consumer and Her Possessions, 1751–81' draws on 'family and estate papers, social correspondence and personal manuscripts' and 'Elizabeth Shackleton's thirty-nine diaries . . .' to examine 'the way domestic goods were used and the multitude of meanings invested in possessions over time.'[24] In the same volume, and for the same period, historian John Styles expresses surprise at 'the extent to which manufacturers [have] secured information by means of the written or spoken word.' As well as apprising themselves of design innovations through verbal means, manufacturers used language to engage their employees in the adaptation of designs. While 'in the course of the eighteenth century the use of two-dimensional designs probably increased, . . . a specialized and sophisticated verbal language of visual description remained crucial.'[25] In addition, ephemeral objects and images as well as documentary sources have not always survived intact, so what is known about design in the eighteenth century, and other periods up to the present, has been surmised from the visual and textual records.

While design history has taken the object as its starting point and looked to textual sources to find out about objects and communicate their social and historical significance, beyond design history, recognition of the value of objects as an historical resource has occurred relatively recently. British Museum Director Neil MacGregor has pointed out that 'the study of things can lead to a truer understanding of the world' because it gives non-literate societies a voice and 'should therefore, with sufficient imagination, be more equitable than one based solely on texts.' MacGregor's history recognizes the connection between language and making from the micro-level of the individual brain, as similar areas of the brain are employed in shaping stones and sentences, to the macro-level of societies, as writing leads to the development of systems such as money and government.[26] A history attentive to relationships between design and words, such as *Writing Design*, is particularly well-positioned, methodologically, to illuminate such developments.

Reading, like writing, is an active process and can be seen as another way of writing design. American poet Walt Whitman recognized that 'reading is not a half-sleep, but, in the highest sense, a gymnast's struggle. . . . the reader must be on the alert, must himself or herself construct indeed the poem, argument, history, metaphysical essay—the texts furnishing the hints, the clue, the start of the framework.'[27] Here, Whitman anticipates the work of Roland Barthes on the shift 'from work to text', and 'the death of the author', which require us to cease to privilege the authorial intention in the creation of cultural artefacts—whether poetry or product design. Barthes distinguished between *lisable* (readerly) and *scriptable* (writerly) texts, which invite, respectively, a passive or active response from the reader in the production of meaning.[28] Barthes's 'text' leads the way for Richard Dawkins's 'meme', although Dawkins does not mention Barthes. Dawkins coined the term 'meme', in deliberate assonance with 'gene', to suggest that ideas have a life of their own, in that they replicate throughout a population. Dawkins later noted that 'the word meme seems to be turning out to be a good meme.'[29] This idea of the agency of cultural motifs has been developed in relation to images by the art historian W.J.T. Mitchell, within the context of his continuing analysis of relationships between text and image.[30]

As well as demonstrating the design historical project of mining the written record to find out about design, and then communicating what has been learned primarily through textual means, the chapters in Part Two of this book, 'Mediations—*Between Design and Consumption*' explore the role of discourse in mediating between design and its consumers, from architectural criticism to government regulation.[31] Anne Hultzsch's 'Thinking in Metaphor: Figurative Conceptualizing in John Evelyn's *Diary* and John Ruskin's *Stones of Venice*,' contains no figures, and yet it is full of imagery wrought in words, as she explicates the techniques used by two influential thinkers to express place and space on the page and thereby create powerful images in the mind's eye. Jane Tynan's 'Regulating the Body in Army Manuals and Trade Guides: The Design of the First World War Khaki Service Dress' uses instructional manuals to reveal the underlying messages of class and status communicated through service uniforms, while John Stanislav Sadar's ' "Vita" Glass and the Discourse of Modern Culture', provides a compelling case study of a mismatch between design and rhetoric which led to the ironic demise of 'Vita' Glass. Finally, in 'Lewis Mumford's Lever House: Writing a "House of Glass" ', Ann Sobiech Munson combines the close reading of mediating discourses which characterizes Part Two with the analysis of design criticism begun in Part One.

Part Three, 'Designing *With* and *Through* Language' illuminates a fourth sense of writing design: words are part of the design process and can form the very medium of design. As Gabriele Oropallo notes in the following part of the book, 'Practice and the verbalization of design are intimately connected. Designers write to present and pitch their work, quote their influences, describe their methods and formulate their views on design history and theory.' Ellen Lupton and J. Abbott Miller's book *Design Writing Research: Writing on Graphic Design* is a case in point: in introducing their writings, design journalist Rick Poynor concludes that Lupton and Miller have 'turned critical reflection into a viable form

of practice.' In this now-classic book, the authors communicate the importance of writing through both their texts and the book's design; it shows how practitioners can think about, and write about, graphic design and the theoretical positions intended to explain it, such as deconstruction. In introducing his *Bibliographic,* Jason Godfrey concludes that the books he showcases 'are important assets in the understanding of graphic design and valuable tools in the shaping of its future'.[32] In their chapter for Part Three, Polly Cantlon and Alice Lo amplify Godfrey's dual-focus approach to understanding the significance of design books through scrutinizing the relationship between form and content. In the case of graphic design books especially, it is not unreasonable to expect the book design and production team to practice what the author preaches. In contrast to Godfrey's bibliophilism, Margolin has provided a sobering analysis of 'Narrative Problems in Graphic Design History'; how might his essay have been different if he had considered the form of the design of the books he examines, as well as the content?[33]

Although graphic designers have a particularly intense interaction with words—for example through the composition of page layouts—the importance of writing within design practice extends far beyond graphic design. Writing has both pragmatic and poetic roles in design practice, as Mhairi McVicar makes clear in her chapter, 'Reading Details: Caruso St John and the Poetic Intent of Construction Documents'. She cites David Leatherbarrow, who has emphasized the fact that architects spend most of their time making drawings and models rather than buildings.[34] Research fellow Peter Medway has studied the relationship between architecture, language and semiotics, noting that while the 'builders build a building with steel and concrete', the architect, 'with words and drawings, creates two other structures, one ideational, one interpersonal: a virtual building and a social network, a web of intertwined understandings, agreements and consents. Without both in place and constantly maintained, no building would happen; and both depend critically on language.'[35] McVicar goes further to demonstrate the importance of apparently mundane and pragmatic written communications between architect and contractors for realizing the poetics of architecture and design.[36] In the next chapter, 'Applying Oral Sources: Design Historian, Practitioner and Participant', Chae Ho Lee explains the benefits of participant action research for design students and, by extension, designers and design historians, and, as Twemlow points out, 'to a designer unused to writing and editing, the transcribed interview appears to be the most straightforward and approachable editorial format.'[37] The term 'writing design' privileges words on paper, but it is not intended to exclude the spoken word, hence the importance of Lee's chapter. Of course, some books begin as talks,[38] and speech in design has been the subject of useful research, notably by Arlene Oak and Linda Sandino.[39]

In the closing of Part Three, Barbara Brownie's 'Fluid Typography: Construction, Metamorphosis and Revelation' presents a two-fold contribution to understanding the intersections of design and words as she examines kinetic artefacts which take letterforms as both their subject matter and their medium, and provides a coherent set of critical terms for describing such artefacts. Brownie's chapter anticipates Oropallo's 'Design as a Language

without Words: A G Fronzoni' in Part Four. Fronzoni used words as a visual medium: he rejected, and subverted, text by making arresting multi-layered visual statements in print design and architecture.

The final part of the book, 'Showing as Telling—*On Design Beyond Text*', is a counterpoint: instead of making the case for the richness and relevance of 'writing design' as an analytical perspective, the four final chapters question, in turn, the necessity, desirability, efficacy and utility of words within design practice. In 'Showing Architecture through Exhibitions: A Taxonomical Analysis of the First Venice Architecture Biennale (1980)' Léa-Catherine Szacka reveals the narrative qualities embedded in the visual and material attributes of exhibitions, from exhibits to venues. Szacka's decision not to extend her analysis to the textual elements which typically accompany exhibitions, such as labels and catalogues, suggests that these are a subordinate, and even dispensable, layer of communication. Following Oropallo's analysis of Fronzoni, a graphic designer who rejected text, Stina Teilmann-Lock's chapter, 'On the Legal Protection of Design: Things and Words about Them', examines situations in which words fail design, by compromising its legal protection through inadequate description. Finally, Michael Biggs and Daniela Büchler argue, in 'Text-led and Object-led Research Paradigms: Doing Without Words', that the titular research paradigms derive from distinctly different worldviews and that one should not emulate the other, as happens when a textual explication of design work is required in the assessment of 'practice-based research'. Writing design thereby encompasses the sense that design is not equivalent to text. The chapters in Part Four intersect variously with the position that design itself is eloquent and communicates narrative.[40] The non-equivalency proposed in Part Four is complicated by its delivery primarily through the written word, notwithstanding the valuable images which accompany the texts. *Writing Design* shows, therefore, not only that words are a useful and illuminating medium through which design can be communicated, analysed and contested but also that words about design can incorporate critiques of their own validity in that activity.

This introduction has discussed various relationships between words and design, but there are rhetorical strategies which have not been mentioned. One of these is, aptly, omission. What is not written about is as revealing as what *is*. Omissions are eloquent: they form our norms as much as presence does, and they can imply disregard. For example, the fact that this book does not provide an analysis of treatments of design as a language, which range from fully developed grammatical metaphors to those which loosely recognize that design is a medium of communication,[41] does not preclude the emergence of a convincing analysis of design as a language in future. Following on from the discussion of active reading, above, suffice it here to note that identifying omissions requires 'reading against the grain'; it is easier to identify what is there than to discern what has been excluded.

CONNECTIONS

The organization of this book into four definitional parts is not intended to preclude a range of thematic connections which remain available as reading routes through the

material. For example, several chapters adopt a typological approach and analyse culture according to categories, such as Meikle's chapter on design criticism, Hayward's account of contemporary design, Tynan's approach to army and trade manuals, Cantlon and Lo on modernist books, Teilmann-Lock's chapter on the documentation of copyright, Lee on oral methods in design education, Brownie on fluid typography, and Biggs and Büchler on object-led research paradigms. Other chapters demonstrate the benefits of close reading, from a focus on the work of an individual practitioner (Floré on Elno; Oropallo on Fronzoni) to an analysis of a magazine (Fallan on *nye bonytt*), an article (Sobiech-Munson), a marketing campaign (Sadar), an exhibition (Szacka) and even memoranda about a mastic joint (McVicar). Chapters one to nine are concerned, to varying degrees, with design publishing, although Tynan's chapter extends conventional definitions of that category. Cantlon and Lo, Brownie and Oropallo all deal with graphic design, arguably the epitome of the interaction of word and image, while Hultzsch, Sadar, Munson and McVicar, Szacka and, to some extent, Oropallo discuss architecture and its representation and probe the relationship between architecture and design. Several chapters demonstrate the value of pedagogical reflection (Cantlon and Lo; Lee; Biggs and Büchler). Any attempt to group the chapters according to those which focus on texts and those which focus on objects quickly shows that they all engage with what Teilmann-Lock terms 'things and words about them'. For example, Fallan and Cantlon and Lo scrutinize magazines and books, respectively, as both texts and objects, while McVicar, Teilmann-Lock and Biggs and Büchler show, in different ways, that words do not stand in for objects: indeed, Biggs and Büchler close the book by 'doing without words'.

Another layer of linkage and diversity is provided by the book's authorship. Several of the authors are practitioners in addition to being design historians and commentators, thus the book addresses the relationship between theory and practice in several ways. *Writing Design* showcases leading and emergent authors alike, who work in graphic design, architecture, aesthetics, design history, architectural history and American studies. The book will interest readers in those fields, plus material culture studies, museum studies, the design disciplines—including exhibition design and interaction design—as well as literary, media and communication studies, word/image studies and popular culture studies. Similarly diverse is the international range of the authors and their topics; the authors are working in the United Kingdom, the United States, Brazil, New Zealand, Belgium, Denmark and Norway and the chapters consider examples from all of these countries plus Italy and Dubai, UAE. This geographical spread carries the important benefit of including material translated into English for the first time, from the writings of Belgian K.-N. Elno to the Norwegian magazines *Bonytt* and *nye bonytt*.

CONTRIBUTIONS

The term 'writing design' might be seen to characterize the general project of design history, design studies and design criticism; indeed, the chapters in this book mine a variety of source material to understand design, as does much work in those fields, and this

introductory essay has signposted some relevant examples of related literature. But *Writing Design: Words and Objects* contributes, in particular, a keen understanding of what is at stake in related processes that we all take for granted: writing about design, learning about design through writing, and designing through writing. Here, authors look *at* words as well as *through* them by, for example, critiquing documentary sources, using techniques from literary analysis, and linguistics, among other fields. As well as sharing a concern for the relationship between words and objects, the book's chapters demonstrate a self-reflexive approach to 'doing' design criticism, design history or design pedagogy, just as Stuart Hall and his contemporaries were concerned with 'doing' cultural studies.[42] The chapters function, therefore, as not only as exemplars in the practice of writing design but also as instructive reflections on that process.

This book explores the relationship between words and objects from a variety of standpoints. In the first half of the book, the focus is on the interplay of, or relationship between, words and design as in the case of texts which intend to change the nature of designed goods (Part One) and words written about design after production, as a way of mediating the meanings it apparently communicates (Part Two). In the book's second half, the word-design relationship is collapsed, as words cease to change, or explain, design: rather, words *become* design. Part Three focuses on words as a medium for design and Part Four replaces the idea of a relationship between two interrelated phenomena with their non-equivalency. Part Four makes the case, cogently and persuasively, for design *beyond* text.[43] But, the collective achievement of *Writing Design: Words and Objects* is as an examination of the vitality and variety of ways in which design and text intersect. Every design professional, whether designer, maker, critic or historian, needs to reflect on her or his use of language in designing, describing design and analysing it. This book is intended to assist in that process: as a set of mediations on the relationships between words and design practices and products, it forms a tool with which to think, and argue.

NOTES

1. Edgar Kaufmann Jr., *What is Modern Design?* (New York: Museum of Modern Art, 1950), 11; Jeffrey L. Meikle, *American Plastic: A Cultural History* (New Brunswick, NJ: Rutgers University Press, 1995), 202; Martin Eidelberg, 'Charting the Iconic Chair,' in Martin Eidelberg, Thomas Hine, Pat Kirkham, David A. Hanks and C. Ford Peatross, *The Eames Lounge Chair: An Icon of Modern Design* (London and New York: Merrell Publishers in association with Grand Rapids Art Museum, Grand Rapids, MI, 2006), 25; Vertigo Interiors, auction listing for 'Eames Rocking Rocker RAR Lounge Chair Retro White Retro,' accessed February 7, 2011, http://cgi.ebay.co.uk/Eames-Rocking-Rocker-RAR-Lounge-Chair-Retro-White-Retro-/150526410280?pt=UK_Collectables_Vintage_RL&hash=item230c12be28.

2. Marius Kwint, 'Introduction: The Physical Past,' in *Material Memories: Design and Evocation,* ed. Marius Kwint, Christopher Breward and Jeremy Aynsley (Oxford: Berg, 1999), 2, 16.

3. For a candid account of the difficulties of writing about design, see Jeffrey L. Meikle 'Material Virtues: On the Ideal and the Real in Design History,' *Journal of Design History* 11, no. 3 (1998): 191–99. Meikle titled one of his book reviews 'Ghosts in the Machine: Why it's Hard to Write about Design,' *Technology and Culture* 46, no. 2 (April 2005): 385–92.

4. For example, Pat Francis, *Inspiring Writing in Art and Design: Taking a Line for a Write* (Bristol: Intellect, 2009); Michael Clarke, *Verbalizing the Visual: Translating Art and Design into Words* (Lausanne: AVA Publishing, 2007); Patricia Eakins, *Writing for Interior Design* (Oxford: Berg, 2005).

5. Writing Purposefully in Art and Design (WritingPAD), a project supported by the Higher Education Funding Council for England (HEFCE), and the UK Government Department for Employment and Learning (DEL), through their Funding for the Development of Teaching and Learning, http://www.writing-pad.ac.uk; Dipti Bhagat and Peter O'Neill, 'Writing Design' in *Writing in the Disciplines*, ed. Mary Deane and Peter O'Neill (Basingstoke: Palgrave Macmillan, 2011); Nancy Roth, 'Writing as Pretext: On the Way to an Image,' *Arts and Humanities in Higher Education* 9, no. 2 (2010): 256–64; Peter Medway, 'Writing and Design in Architectural Education,' *Transitions: Writing in Academic and Workplace Settings*, ed. Patrick Dias and Anthony Paré (Cresskill, NH: Hampton Press, 2000), 89–128; and Steve Garner, ed., *Writing on Drawing: Essays on Drawing Practice and Drawing Research* (Bristol: Intellect Books, 2008), which is aimed at 'artists, scientists, designers, and engineers'.

6. See Jonathan Monroe, ed., *Writing and Revising the Disciplines* (Ithaca, NY, and London: Cornell University Press, 2002), viii, vii. This book derives from the Knight Institute for Writing in the Disciplines at Cornell University; see Katherine K. Gottschalk, 'Putting—and Keeping—the Cornell Writing Program in its Place: Writing in the Disciplines,' *Language and Learning Across the Disciplines* 2, no. 1 (April 1997): 22–45; Jan Parker, 'Writing, Revising and Practising the Disciplines: Carnegie, Cornell and the scholarship of teaching,' *Arts & Humanities in Higher Education* 2, no. 2 (2003): 139–53, and http://www.arts.cornell.edu/knight_institute/.

7. Mieke Bal and Bryan Gonzales, eds., *The Practice of Cultural Analysis: Exposing Interdisciplinary Interpretation* (Palo Alto, CA: Stanford University Press, 1999).

8. Steven Heller, 'Design Books: Not Just Eye Candy,' in *Bibliographic: 100 Classic Graphic Design Books* by Jason Godfrey (London: Laurence King, 2009), 5.

9. This proliferation can be seen as a catalyst to the development of selection tools, such as http://www.designersandbooks.com/, in which designers, and a handful of design commentators, provide lists of their favourite books, thereby revealing something of their inspirations and influences, as well as potentially guiding the reading of visitors to the site.

10. The ephemeral nature of little magazines leads to efforts to catalogue and preserve them. These impulses have informed the presentation of the dossier of interviews and reproductions found in Beatriz Colomina and Craig Buckley, eds., *Clip, Stamp, Fold: The Radical Architecture of Little Magazines, 196x–197x* (Barcelona and New York: Actar, 2010). See also Teal Triggs, *Fanzines* (London: Thames and Hudson, 2010).

11. Alice Twemlow, 'On Demand: The Rise of Micro Design Publishing,' in *Graphic Design Worlds / Words*, ed. Giorgio Camuffo and Maddalena Dalla Mura (Milan: Electa, 2011): 64–9, 64.

12. Stephen J. Eskilson, *Graphic Design: A New History* (London: Laurence King, 2007). The book has a companion website with interactive materials for students: http://yalepress.yale.edu/yupbooks/eskilson/index.asp. In reviewing the book for *Eye* 66 (Autumn 2007), Mary-Ann Bolger noted a couple of errors, but Paul Shaw found many more and wrote a letter to *Eye* entitled 'Trainspotter,' *Eye* 67 (Spring 2008), to which Bolger replied: http://www.eyemagazine.com/opinion.php?id=157&oid=418. The book also received a lengthy critique from Alice Twemlow and Lorraine Wild on the *Design Observer* website, December 6, 2007, http://observatory.designobserver.com/entry.html?entry=7017, which prompted many comments, including one from the book's publisher, Laurence King, to which Lorraine Wild replied. On December 1, 2008, Shaw posted a list of all the errors he discerned in Eskilson's book to his blog, *Blue Pencil*, http://paulshawletterdesign.blogspot.com/2008/12/blue-pencil-no-2.html.

13. Tony Fry, *Design History Australia* (Sydney: Hale and Iremonger and the Power Institute of Fine Arts, 1988).

14. Victor Margolin, ed., *Design Discourse: History, Theory, Criticism* (Chicago: University of Chicago Press, 1989), including Richard Buchanan, 'Declaration by Design: Rhetoric, Argument, and Demonstration in Design Practice,' *Design Issues* 2, no. 1 (Spring 1985): 4–22.

15. Fiona Candlin and Raiford Guins, eds., *The Object Reader* (London: Routledge, 2009); Grace Lees-Maffei and Rebecca Houze, eds., *The Design History Reader* (Oxford: Berg, 2010). See also the readers mentioned below.

16. Kjetil Fallan, *Design History: Understanding Theory and Method* (Oxford: Berg, 2010).

17. The Writing Design project, led by Grace Lees-Maffei, is based within the TVAD Research Group at the University of Hertfordshire, which researches relationships between text, narrative and image. TVAD hosted the Design History Society Annual Conference 'Writing Design: Object, Process, Discourse, Translation', 3–5 September 2009, convened by Grace Lees-Maffei with Jessica Kelly; additionally, TVAD is home to the double-blind peer-reviewed open-access journal *Writing Visual Culture* (previously titled *Working Papers on Design*), which published a volume developed from the conference: 'Writing Design: Words, Myths, Practices,' ed. Grace Lees-Maffei, *Working Papers on Design* 4 (Dec. 2010), http://sitem.herts.ac.uk/artdes_research/papers/wpdesign/wpdvol4/vol4.html.

18. Penny Sparke, *The Genius of Design* (London: Quadrille Publishing, 2009), 10.

19. Haruhiko Fujita, ed., *Words for Design: Comparative Etymology and Terminology of Design and Its Equivalents*, vols. 1–3 (Osaka: Japan Society for the Promotion of Science, 2007–9), and Haruhiko Fujita, ed., *Another Name for Design: Words for Creation. International Conference of Design History and Design Studies* (Osaka: Osaka University, 2008). See also Raymond Quek, 'Excellence in Execution: Disegno and the Parallel of Eloquence,' and Eduardo Côrte-Real, 'The Word "Design": Early Modern English Dictionaries and Literature on Design, 1604–1837,' both in Lees-Maffei, ed., 'Writing Design: Words, Myths and Practices,' *Working Papers on Design* 4 (Dec. 2010). http://sitem.herts.ac.uk/artdes_research/papers/wpdesign/wpdvol4/

vol4.html.; Adrian Forty, 'Design,' in *Words and Buildings: a Vocabulary of Modern Architecture* by Adrian Forty (London: Thames and Hudson, 2000), 136–41. Work focussed on elucidating the cultural and historical significance of individual words follows in the footsteps of cultural materialist Raymond Williams's influential *Keywords: a Vocabulary of Culture and Society* (London: Fontana, 1976), which has been updated by Tony Bennett, Lawrence Grossberg and Meaghan Morris, eds., as *New Keywords: a Revised Vocabulary of Culture and Society* (Oxford: Blackwell, 2005).

20. Susan Stewart, 'Prologue: From the Museum of Touch,' in *Material Memories*, ed. Marius Kwint, Christopher Breward and Jeremy Aynsley (Oxford: Berg), 18.

21. Few attempts have been made to catalogue this work. Anthony J. Coulson's *A Bibliography of Design in Britain, 1851–1970* (London: Design Council, 1979) remains useful as a record of historical design writing up to 1970, while *Design Abstracts Retrospective* (*DAR*), http://design-research.co.uk/design_abstracts_retrospective.htm, and the *Design and Applied Arts Index* (*DAAI*) index design periodicals, 1900–87 and 1987–present, respectively, http://www.csa.com/factsheets/daai-set-c.php.

22. Readers, or anthologies, function as aggregators of this textual material. In addition to those mentioned above, see, for example, Paul Greenhalgh, ed., *Quotations and Sources on Design and the Decorative Arts* (Manchester: Manchester University Press, 1993); Jon Bird, Barry Curtis, Melinda Mash, Tim Putnam, George Robertson, Sally Stafford and Lisa Tickner, eds., *The BLOCK Reader in Visual Culture* (London: Routledge, 1996); Harry Palmer and Mo Dodson, eds., *Design and Aesthetics: a Reader* (London: Routledge, 1996); Isabelle Frank, ed., *The Theory of Decorative Art: an Anthology of European and American Writings, 1750–1940* (New York: The Bard Graduate Centre for Studies in the Decorative Arts, and New Haven and London: Yale University Press, 2000); Mark Taylor and Julieanna Preston, eds., *Intimus: Interior Design Theory Reader* (Chichester: Wiley-Academy, 2006); Carma Gorman, ed., *The Industrial Design Reader* (New York: Allworth, 2003); Linda Welters and Abby Lillethun, eds., *The Fashion Reader* (Oxford: Berg, 2007); Ben Highmore, ed., *The Design Culture Reader* (London: Routledge, 2009); Hazel Clark and David Brody, eds., *Design Studies: A Reader* (Oxford: Berg, 2009); Glenn Adamson, ed., *The Craft Reader* (Oxford: Berg, 2010).

23. David R. Raizman and Carma R. Gorman, eds., *Objects, Audiences and Literatures: Alternative Narratives in the History of Design* (Newcastle: Cambridge Scholars Publishing, 2007). See also three articles which interrogate the construction of 'myths' surrounding designed objects in Lees-Maffei, ed., *Working Papers on Design*: Ciara Murray, 'Brother Armstrong and the Freemasons: Belleek's Masonic Tableware'; Juliet Ash, 'The Untruthful Source: Prisoners' writings, official and reform documentation, 1900–1930'; and Monica Penick, 'Marketing Modernism: House Beautiful and the Station Wagon Way of Life'.

24. Amanda Vickery, 'Women and the World of Goods: A Lancashire Consumer and Her Possessions, 1751–1781,' in *Consumption and the World of Goods,* ed. John Brewer and Roy Porter, (London: Routledge, 1993): 274–301, 279, 281–2.

25. John Styles, in Brewer and Porter, eds., *Consumption and the World of Goods*: 527–54, 545, 547.

26. Neil MacGregor, *A History of the World in 100 Objects* (London: Allen Lane, 2010), xxv, xvii, xix, 17, 94. See also Sarah Barber and Corinna M. Penistone-Bird, eds., *History Beyond the Text: A Student's Guide to Approaching Alternative Sources* (London: Routledge, 2009), which examines the historical utility of cultural artefacts, broadly categorized to include music, fine art and landscape and material cultural typologies; Karen Harvey, ed., *History and Material Culture: A Student's Guide to Approaching Alternative Sources* (London: Routledge, 2009) is useful for showing how objects speak historically, which is—arguably—the task of the design historian. The same treatment is extended to various types of textual source material in Miriam Dobson and Benjamin Ziemann, eds., *Reading Primary Sources: The Interpretation of Texts from 19th and 20th Century History* (London: Routledge, 2008) from the same book series, in which a methodological survey is followed by chapters each devoted to a single type of textual primary source.

27. Walt Whitman, *Democratic Vistas: With an Introduction by John Valente, Library of Liberal Arts 9*, ed. Oskar Piest (New York: Liberal Arts Press, 1949), 67–8 cited in Hunter R. Rawlings, 'Writing the Humanities in the Twenty-First Century,' in Monroe, ed., *Writing and Revising the Disciplines*, 192.

28. Roland Barthes, 'From Work to Text' and 'The Death of the Author' in *Image Music Text*, trans. Stephen Heath (London: Fontana, 1977); Roland Barthes, *S/Z*, trans. Richard Miller (New York: Hill and Wang, 1974), 4. Barthes is a towering figure in the analysis of culture, and his work is perennially applicable to the understanding of design. See, for example, *Mythologies*, trans. Annette Lavers (London: Jonathan Cape, 1972, and Paris: Editions du Seuil, 1957); 'The Photographic Message' (1961) and 'Rhetoric of the Image' (1964) in *Image Music Text*; *The Fashion System*, ed. Heath, trans. Matthew Ward and Richard Howard (Berkeley and Los Angeles, CA: The University of California Press, 1983) and originally published as *Systeme de la Mode* (Paris: Editions du Seuil, 1967); *Camera Lucida*, trans. Richard Howard (London: Jonathan Cape, 1982) and originally published as *La Chambre Claire* (Paris: Editions du Seuil, 1980); and *The Language of Fashion*, ed. Andy Stafford and Michael Carter, trans. Andy Stafford (Oxford: Berg, 2006).

29. Richard Dawkins, *The Selfish Gene*, 3rd ed. (Oxford: Oxford University Press, 2006 (1976)), 322. Here, material added in the second edition of 1989, and replicated in the third edition of 2006, has Dawkins providing reflective notes on chapter 11, 'Memes: the new replicators'.

30. W.J.T. Mitchell, *What Do Pictures Want?* (Chicago: University of Chicago Press, 2004); *Picture Theory: Essays on Verbal and Visual Representation* (Chicago: University of Chicago Press, 1994); *Iconology: Image, Text, Ideology* (Chicago: University of Chicago Press, 1986); W.J.T. Mitchell, ed., *The Language of Images* (Chicago: University of Chicago Press, 1980).

31. On the utility of mediation as a focus within design history, see Lees-Maffei, 'The Production-Consumption-Mediation Paradigm,' *Journal of Design History* 22, no. 4 (2009): 351–76, and Lees-Maffei, 'Mediation, section 11 in *The Design History Reader*,' ed. Grace Lees-Maffei and Rebecca Houze (Oxford: Berg, 2010), 427 ff.

32. Jason Godfrey, 'Introduction,' *Bibliographic* by Godfrey, 7. For further examples of bibliophilism, see the catalogues produced by auctioneers of twentieth-century design, such as *Books of Art + Design* and *Books on Modernism* (both Chicago: Wright, 2006). The contents being sold through these catalogues cater to bibliophilism, and the availability of the catalogue on a subscription basis reminds us that design can be enjoyed simply as a series of representations. Thanks to Gerald L. Maffei for his gift of Wright catalogues.

33. Victor Margolin, 'Narrative Problems in Graphic Design History,' *Visible Language* 28, no. 3 (Fall 1994): 233–43 reproduced in Victor Margolin, *The Politics of the Artificial: Essays on Design and Design Studies* (Chicago: University of Chicago Press, 2002), 188–201.

34. David Leatherbarrow, *Uncommon Ground: Architecture, Technology, and Topography* (Cambridge, MA: MIT Press, 2000), 25.

35. Peter Medway, 'Constructing the virtual building: Language on a building site,' *Using English: From Conversation to Canon*, ed. Janet Maybin and Neil Mercer (London: Routledge, 1996), 108–12, 111. By the same author, see 'Rhetoric and architecture,' *Learning to Argue in Higher Education*, ed. Sally Mitchell and Richard Andrews (Portsmouth, NH: Heinemann, 2000), 26–39; 'Writing, speaking, drawing: The distribution of meaning in architects' communication,' *The New Writing Environment: Writers at Work in a World of Technology*, ed. Mike Sharples and Thea van der Geest (London: Springer Verlag, 1996), 25–42; and Peter Medway and B. Clark, 'Imagining the Building: Architectural Design as Semiotic Construction,' *Design Studies* 24, no. 3 (2003): 255–73.

36. See also, Tomás Maldonado, 'Is Architecture a Text?,' *Casabella* 560 (September 1989): 35–7 (English digest, 60–1) and 'Intersections: Architecture and Poetry,' a conference at the Courtauld Institute of Art, London, June 3–4, 2011, organized by Caroline Levitt and Ayla Lepine. Maldonado's exploration of the relevance of Derridean deconstruction to architecture is discussed by Gabriele Oropallo in chapter 14.

37. Twemlow, 'On Demand,' 65.

38. For example, Jeremy Aynsley and Harriet Atkinson, eds., *The Banham Lectures: Essays on Designing the Future* (Oxford: Berg, 2009).

39. Arlene Oak, 'What Can Talk Tell Us About Design? Considering Practice through Symbolic Interactionism and Conversation Analysis,' in 'Undisciplined!' Design Research Society Conference 2008, Sheffield Hallam University, 16–19 July 2008, Sheffield Hallam University Research Archive, http://shura.shu.ac.uk/506/; Oak, 'Particularizing the Past: Persuasion and Value in Oral History Interviews and Design Critiques,' *Journal of Design History* 19, no. 4 (2006): 345–56; Linda Sandino, 'Oral Histories and Design: Objects and Subjects,' *Journal of Design History* 19, no. 4 (2006): 275–82; and Voices in the Visual Arts (VIVA), http://www.vivavoices.org/website.asp?page=viva

40. See, for example, Nathan Crilly, James Moultrie and P. John Clarkson, 'Seeing things: consumer response to the visual domain in product design,' *Design Studies* 25 (2004) 547–77; Lees-Maffei, 'Balancing the Object; the reinvention of Alessi,' *things* 6 (Summer 1997): 74–91;

and Lees-Maffei, '*Italianita* and Internationalism: the Design, Production and Marketing of Alessi, s.p.a.,' *Modern Italy* 7, no.1 (2002): 37–57.

41. See, for example Owen Jones, *The Grammar of Ornament* (London: Messrs Day and Son, 1856); Barthes, *The Fashion System*; Barthes, *The Language of Fashion*; Alison Lurie, *The Language of Clothes* (London: Heinemann, 1981); Gunther Kress and Theo van Leeuwen, *Reading Images: the Grammar of Visual Design,* 2nd ed. (London: Routledge, 2006 (1996)); and Deyan Sudjic, *The Language of Things* (London: Allen Lane, 2008).

42. Paul du Gay, Stuart Hall, Linda Janes, Hugh Mackay and Keith Negus, *Doing Cultural Studies: the Story of the Sony Walkman* (London: Sage and The Open University Press, 1997).

43. Some recent work which has attempted to move beyond text, or beyond the logo-centrism of academic research, has been supported by the United Kingdom's Arts and Humanities Research Council major project 'Beyond Text', http://www.beyondtext.ac.uk/.

PART I RIGHTING DESIGN—ON THE REFORMING ROLE OF DESIGN CRITICISM

INTRODUCTION

GRACE LEES-MAFFEI

Just as the processes termed 'Web 2.0' enable professionals and amateurs alike to publish writing about design (and everything else) with unprecedented ease and reach, design criticism is currently undergoing a process of professionalization with a group of new master's degrees having been recently launched in London and New York.[1] These parallel trends are not coincidental, nor are they contradictory. The greater accessibility of design criticism, for readers, authors, editors and publishers, facilitated by electronic delivery, has stimulated interest in design commentary and provided a practical outlet, beyond the purview of the editorial gatekeepers of the print publishing industry. The freedom from commercial constraints offered by self-publication on the Web should liberate design criticism from serving as little more than an extension of manufacturers' public relations and marketing departments. However, tutors in design writing Anne Gerber and Teal Triggs have lamented the fact that 'these virtual spaces, while increasing the number of outlets available for writers, have fostered yet more descriptive commentary rather than developing an agenda for any sustained critical discourse. The technology, while encouraging immediacy, is lacking a rigorous and disciplined approach to written (and visual) communication.'[2] Moves to professionalize design criticism may be regarded as consistent with a shift towards 'Web 3.0' whereby experts reclaim authorial control, rather than the variant meaning in which computers independently generate content.

As design criticism proliferates, so the need for a reflexive literature on its nature and practice is felt. *Writing Design* contributes to that literature an ontological meditation on the relationship between words and objects, and in designing, reading, knowing and communicating. Part One, specifically, approaches the theme of writing design through the homonym 'righting design'; it considers the ways in which writing about design has tried to improve, or reform, design practice and designed products. In the first chapter, 'Writing about Stuff: The Peril and Promise of Design History and Criticism', Jeffrey L. Meikle provides a long view of the history and historiography of design criticism of the last 150 years, while the three following chapters provide case studies of twentieth- and twenty-first-century design criticism. Meikle reprises his self-reflexive consideration of the part words, images and objects have played in his own research and writing[3] before turning to the design reformers of the nineteenth century, such as Owen Jones and William Morris. Design historians have privileged Morris's work as a designer, design reformer and maker, but he is at least as well-known for his literary output as a poet, novelist and socialist.

For Morris, words were one medium among many through which he spread his message. Meikle brings his discussion up to the present with a consideration of *Design and the Elastic Mind*, a recent exhibition on design and science, thereby prefiguring the treatment of exhibitions (including *Design and the Elastic Mind*) and the link between technology and the body presented in the final chapter of Part One.

In our second chapter, 'Design Criticism and Social Responsibility: The Flemish Design Critic K.-N. Elno (1920–1993)', Fredie Floré shifts the focus from the genre-level account provided by Meikle, to the *oeuvre* of a twentieth-century individual.[4] Elno campaigned against the creeping dominance of consumer culture and design's role in its reification through his writing and editorial activity, but his ultimate sanction was a self-imposed and gradual cessation of design criticism. While Floré's chapter examines the work of one design critic, Kjetil Fallan's case study 'The Metamorphosis of a Norwegian Design Magazine: *nye bonytt*, 1968–1971' takes a single magazine title as its focus. Both Floré and Fallan show how magazines have been the vehicle for design reform criticism harnessed to an anti-consumerist cause, with an initial burst of energy and enthusiasm ceding to an alternative approach. While Floré notes that Elno's withdrawal from the debate left a vacuum of design criticism in Belgium which has yet to be satisfactorily filled, Fallan charts the way in which Norway's premiere channel of professional design discourse ceded to the commercial impulse, as *Bonytt* reinvented itself as interior design magazine *nye bonytt*. Fallan does not seek to privilege a discourse aimed at professionals, or producers, over a discourse aimed at consumers, nor does he prefer a discourse aimed at the (male) designer over the (female) householder and reader of consumer magazines. Rather, like Floré, he laments the dearth of design criticism which followed *Bonytt*'s reinvention.

The history of design criticism collectively provided by the chapters in Part One is brought up to present with Stephen Hayward's 'Writing Contemporary Design into History'. Hayward's analysis considers a rarefied group of objects which challenge definitions of 'design' and the affordances offered by utilitarian objects, to the extent that they are perhaps best described as 'design/art'.[5] Like Meikle, and the treatment of exhibitions provided by Léa-Catharine Szacka in Part Three, Hayward shows how exhibitions of design can be instrumental focal points for design debates. The exhibitions discussed in *Writing Design* demonstrate a range of techniques for combining word, object and image to tell a story, educate and persuade.

The chapters in this section address the development of design criticism across Western Europe and the United States. While Meikle's and Hayward's chapters make transatlantic comparisons, Floré and Fallan provide case studies in which design criticism is bound up with the development of national identities in Belgium and Norway, respectively. Design criticism has displayed an enduring concern to reform design, but there remains a pressing need to reform the reforming discourse of design criticism itself, especially as a response to globalization, if greater recognition is to be paid to the diversity of design practice around the world. Some worthwhile work has been undertaken in this direction, more is ongoing[6] and—although online access is not equitably distributed throughout the developed and

developing worlds—the relatively easy digital dissemination of design discourse promises much potential in this task.

NOTES

1. Both an MA in Design Writing Criticism in the School of Graphic Design at London College of Communication, University of the Arts London, and an MFA in Design Criticism at the School of Visual Arts, New York, were launched in 2008. The Department of Critical Writing in Art & Design was launched at the Royal College of Art, London in October 2010 to provide MA and research degrees.
2. Anna Gerber and Teal Triggs, 'Comment,' *Blueprint* (October 2007): 80.
3. Jeffrey L. Meikle, 'Material Virtues: On the Ideal and the Real in Design History,' *Journal of Design History* 11, no. 3 (1998): 191–9.
4. In this book about words and objects, names play an important role. While Meikle's opening chapter touches on the work of Norman Bel Geddes, a man whose name incorporates that of his wife, the subject of the second chapter—K.-N. Elno—also adopted a contraction of spousal names.
5. See Barbara Bloemink and Joseph Cunningham, eds., *Design ≠ Art: Functional Objects from Donald Judd to Rachel Whiteread* (New York: Merrell and Cooper-Hewitt, National Design Museum, 2004).
6. For example, Glenn Adamson, Giorgio Riello and Sarah Teasley, eds., *Global Design History* (London: Routledge, 2011).

1 WRITING ABOUT STUFF: THE PERIL AND PROMISE OF DESIGN HISTORY AND CRITICISM

JEFFREY L. MEIKLE

To understand the concept of 'writing design' is a complex task because the phrase encompasses a multitude of motives and methods. One might interrogate how critics write about objects and environments, how designers write about work processes, how college instructors define design practice for students, how theorists contextualize material objects, or how these different verbalizations in turn shape the material world. Despite this diversity, all these discourses share a common reference point. Each engages with a fundamental gap, disjunction or transformation occurring at a single problematic meeting point—that of things and words. Once we talk or write about a specific object, it loses existential purity and becomes part of a verbal process at least two times removed from physical reality. To consider writing design requires grappling with the question of what's at stake in translating objects into words.

Thirty years ago I published a cultural history of the industrial design profession in the United States during the Great Depression. Only later did I realize I had not actually interrogated the objects I wrote about. In fact, while researching *Twentieth Century Limited*, I rarely saw, touched, used or otherwise physically interacted with the material objects and environments I purported to describe, analyze and interpret. Instead, my knowledge came from monotone photographs whose purpose was to publicize products in magazines, trade journals and advertisements. Standing alone, often spot-lit as if on stage, these images reflected a cool abstraction at odds with reality. More to the point, many of the photographs came with text pasted to the back or printed underneath. It was hardly surprising that I attended to such images and paid close attention to their definitional texts because, I later realized, I had *not* approached my task with the object-oriented expertise of an art historian or curator. Instead, I applied techniques from training as a literary historian to analyze forgotten writings of industrial designers, advertising agents, product engineers and business executives. Despite lacking direct experience of the objects themselves, I was able, by interpreting the *words* of in-house memos, publicity releases and magazine articles, to reconstruct cultural metaphors and a utopian agenda shared by designers, corporate patrons and ordinary consumers. My use of literary analysis both hindered and helped, reinforcing an ironic blindness to material artefacts but enabling me to situate an emerging commercial design profession within broader cultural contexts.[1]

Meditating on writing design, I realize the process of constructing verbal discourse, the placing of one word after another, differs markedly from the design process that yields material objects. The very thinking of things by a designer occurs, according to the historian Eugene Ferguson, in 'the mind's eye', which he believes perceives spatially and organizes associatively in a manner not open to rational explanation.[2] Designers rely on visual images—sketches, elevations, isometrics and computer-generated modelling—to manipulate potential characteristics of material objects at all scales of size and complexity. Consumers and users of objects and environments rely on non-rational visual and tactile cues to navigate the world of designed objects. Few people actually engage in the difficult process of translating objects into words. I recall struggling as a novice design historian to find precise phrases for verbally representing the photographic image of an Art Deco shop's stylized ornament. The description I came up with is forgettable, though the pain of constructing it remains vivid. A reader of my book manuscript, after confessing he could not visualize any of my descriptions of objects, complained that it would take a Zen master to penetrate them. The 'mind's-eye' consciousness of a designer—non-linear, multidimensional, spatial, associational—does seem similar to the popular concept of Zen consciousness.

Some design writers and historians shy away from translating objects into words. Instead, we become abstracted from artefacts, focusing on their presentation and reception in mass culture, their functional and expressive roles in everyday life or their shaping and channelling of the behaviour of those who interact with them. Sometimes, when my sense of a particular object will not resolve itself into words, I entertain the notion that it would be easier to write about literature or philosophy or the history of science than about design. After all, in those fields the major ideas seem inherent by definition in the object of study, already verbalized by novelists and poets, philosophers and scientists. One need only identify them, clarify them, trace their development, put them in conjunction or conflict with other ideas, and perhaps deconstruct them. A historian of design, by contrast, must independently devise ideas and inject them into otherwise mute objects. Or so it seems. How fine it would be if objects could talk as directly as *Pride and Prejudice, On the Origin of Species*, or even *Gravity's Rainbow*.

Objects do talk, however, or at least they can be read. Many excellent interpreters reveal the historical significance of objects without putting extraneous words in their mouths. I think of Adrian Forty tracing shifts in gender relations through office furniture from the late nineteenth century to the early twentieth. Or Regina Blaszczyk seeing in the concentric rings on the surface of a 1930s Fiesta dinner plate, not only a reflection of streamlined motion, but also an echo of traditional ceramics thrown on a wheel. Or Charles Goodsell comparing city council chambers over two centuries and finding evidence in their furnishings and ornament of a movement from elitist paternalism towards democratic citizen participation. Or the novelist Nicholson Baker, who, in *The Mezzanine* (required reading for design students more than two decades after its publication), meditates on such material minutiae as the shift from paper to plastic drinking straws and the resulting adjustments in human behaviour.[3]

Baker's novel, though obsessed with meticulous observation of minute detail, reminds us that translating objects into words accomplishes little without the social, cultural and historical significations that we regard as our stock in trade. Baker's narrator, an office worker musing on everyday things, discovers his credo when he opens a paperback edition of Marcus Aurelius's *Meditations* to a random page that displays this sentence: 'Manifestly, no condition of life could be so well adapted for the practice of philosophy as this in which chance finds you today!' Baker, a Proust of consumer culture, ponders the history revealed by the fall of shampoo brands from the top shelf in a pharmacy, where new brands are promoted, to the bottom shelf, where outmoded brands used only by the elderly reside, before vanishing forever. He concludes that 'the only way' to 'understand the proportion and range and effect of those changes, . . . the often undocumented daily texture of our lives . . . is to sample early images of the objects in whatever form they take in kid-memory' and then compare them with present images.[4] We all have private nostalgias for such forgotten brands as Prell shampoo, private histories of the demise of home delivery of milk or, more recently, the typewriter, the videotape or the road map. But most of us maintain greater distance than Baker from the material phenomena that engage us professionally as scholars and writers. Clearly there is more to what we do than translating objects into words. Without a larger agenda there would be little point to writing about objects.

RATIONALIZING DESIGN

One way of investigating how and why design writers interpret material artefacts is to ask, *when* did people first write about design, and *why*? I propose that writing design emerged soon after design's appearance as a distinct element in the production of goods. Although historians have proposed Wedgwood's eighteenth-century pottery as an early site of product design,[5] let's think generally about the shift from workshop to factory. Under the craft system, an artisan laboured by hand to produce an object whose general outline was traditional but whose form varied according to an artisan's personal inflections, imperfect materials, accidents in working the material and an individual customer's wishes. An artisan's intention moved intuitively from mind's eye through hand's motion to shaping a physical object. Rationalized factory production of nearly identical objects, on the other hand, involved separating the task of conceiving work from the task of doing it. A new worker, the designer, devised two-dimensional patterns or three-dimensional prototypes for mechanical reproduction by other workers. Because artisans learned by doing, there was little need to translate craft processes into verbal instructions by writing them down. Nor did anyone need to direct the hand of the artisan according to a plan or design committed to paper. Nor, finally, was anyone needed to explain or interpret the process to society in general because that was how things had always been done.

The first of a steady stream of design writers emerged during the industrial revolution after the division of labour yielded the designer as a separate pattern-maker. Although the earliest design writers passionately confronted the design process, they found it difficult to accept the material and social changes it entailed. Writing in the mid-nineteenth century,

they tended towards either of two general strategies. While some denied the severity of material and social change, others tried to turn back the clock to a time before mechanism came to regulate natural patterns of human labour. This is a familiar story, but I intend to shift the emphasis.

When I first thought about the concepts of writing design and translating objects into words, I wondered whether any interpreters of design had ever succeeded without relying on verbalization. Immediately Owen Jones's *The Grammar of Ornament* came to mind, a gorgeous book from 1856 filled with carefully rendered, vibrantly coloured lithographs of hundreds of examples of ornament from around the world. Though I had not looked at it for years, I recalled the book, despite its emphatically linguistic title, as a *visual* artefact. Its pages, I thought, might reveal non-verbal design commentary. But when I took another look, I discovered that although *The Grammar of Ornament* is indeed visually compelling, Jones devoted nearly as much space to textual explication as to visual illustration. More importantly, the *Grammar*'s verbal rhetoric contradicts its visual rhetoric. Within sections devoted to Egypt and Assyria, Greece and Rome, Persia and India, as well as the medieval period and the Renaissance, Jones combined dozens of ornamental patterns on a single page, not 'in context or in situ', according to a recent scholar, but 'isolated on the page within some form of organizing grid'.[6] With all the world's ornament collected from across place and time, categorized rationally and subordinated to geometrical arrangement, Jones seemed to be creating a grammar as artificial as the new systems of design and manufacture. He claimed, however, to find in these diverse ornamental traditions a common rhetoric grounded in nature, in the organic. Writing against the 'constant [mechanical] repetition' of 'ill-contrived form' and 'misapplied' ornament typical of factory production, he argued that society, to regain a 'healthy condition', must 'get rid of the acquired and artificial, and return to . . . natural instincts', becoming once again 'as little children or as savages'.[7] However contrived his classification might now appear, Jones sought, in devising it, to deny radical social transformations by submerging them in nature's timeless universal currents.

More familiar are the conservative reactions of John Ruskin and William Morris. Ruskin opposed the openness to global ornamental traditions of *The Grammar of Ornament*, in particular rejecting the artificial precision of classical Greek architecture in favour of the 'messy vitality' of work by medieval stonemasons.[8] He also dismissed the decorative traditions of India, so admired by Jones, as barbaric. Ruskin and his disciple Morris are well known for wanting to abandon the alienating division of labour of the factory and return to an idealized medieval system of artisans participating communally in all aspects of production. Morris, perhaps the first design writer to address both sides of the production-consumption equation, also argued for the redemptive quality of honest, well-made domestic furnishings. Good design of the Arts and Crafts persuasion thus would perform double duty, morally uplifting those who made its products and those who used them.

Although Morris and his associates designed, produced and sold a wealth of furniture, tiles and textiles, it is for his philosophy that he is most often cited. His verbal design rhetoric mostly skimmed over the surface of the material world. Rather than writing design

by directly translating objects into words, he wrote ideologically engaged social criticism. Other Arts and Crafts theorists, from C. R. Ashbee to Gustav Stickley, reinforced this commonly accepted way of writing about design. Their writings focused not so much on the design and manufacture of actual objects but instead on how the work of designers contributed to civilization's moral and social progress. Since then, many design writers, who perhaps ought to be more interested than other observers in specific forms, textures, colours, substances and assemblages of the material world, have tended to subordinate the very *stuff* of their discourse to more general abstract issues. I'd like to develop this theme through brief discussions of two subsequent moments in design writing—one historical, the other contemporary.

PROMOTING DESIGN

The modernist movement has provoked so many words that I hesitate to add more. Even Reyner Banham, a critic whose career in writing design embraced the glorious specificity of material things, devoted his first book, a history of early modernism, to '*theory* [that is to say, *words*] and *design* in the first machine age'.[9] More than other design writers before or since, modernists privileged the word over the object. However, their faith in the generative force of words, which initially yielded exhilarating utopian manifestos, eventually trapped designers in a rigid set of prescriptions that might be understood, borrowing from Nietzsche, as a 'prison-house of language'. Modernists, like Victorian-era progressives, imposed an artificial, intellectually determined ideology on the material world. Unlike the progressives, however, who emphasized design's closeness to nature, whether in the organic process of craft, the naturalism of rough-hewn furniture and botanical ornament, or the biological evolutionism of their social philosophy, modernists celebrated artificiality as the key to a rational machine civilization.

Le Corbusier was modernism's preeminent design writer. His *Towards a New Architecture*, found on the shelf of every Anglo-American designer and architect after its translation in 1927, seemed a Mosaic tablet full of resonant commandments ready for textual interpretation by enthusiastic disciples. While Jones had precipitated a 'grammar of ornament' from the decorative traditions of diverse cultures, Le Corbusier discovered a universal 'language of man' in the logical precepts of classical geometry. 'All men have the same organism, the same functions . . . the same needs', he wrote. 'Deep within us and beyond our senses' exists 'a resonance, a sort of sounding-board' vibrating with the 'geometrical truths' of 'axes, circles, right angles'. Even primitive man constructing a simple dwelling 'brought in order' to counter the 'disorder' of the 'forest . . . with its creepers, its briars and the tree-trunks which impede him and paralyse his efforts'. So much for the Victorians' organic trope, dismissed by Le Corbusier as 'chance, irregularity and capriciousness'. Although he believed human design must submit to 'the laws of nature', those laws were not red in tooth and claw but instead defined 'the inexorable realm of the mechanical'.[10]

Le Corbusier offered a cool portrayal of design based on universal geometric harmony discovered by the Greeks, submerged during centuries of ignorance and finally rediscovered

during the machine age. Reyner Banham considered Le Corbusier's machine classicism to be quaint and naïve, a product of his training in the eighteenth-century rationalism of the Swiss watch-making industry and his infatuation with 'an aircraft industry . . . barely out of the box-kite phase'.[11] Even so, Le Corbusier's clear, vigorous prose set a modernist agenda that long outlasted its usefulness. Early readers catalyzed by *Towards a New Architecture* included the American designers Walter Dorwin Teague, who replaced his French period furniture with tube-steel chairs and wrote trade journal articles promoting a neo-Platonic design philosophy, and Norman Bel Geddes, who reimagined the American city transformed by Corbusian towers in the park.

As with the Arts and Crafts movement, this is a familiar story. The point is not the story but the manifesto whose style of writing design propelled the modernist movement. Whether from personal visits or colour photographs, we all now recognize the dull, gray images accompanying Le Corbusier's text as bare abstractions of his actual work during modernism's early heroic phase. Visualize his signature structure, the Villa Savoye of 1929, with its open interior, spiral staircase, flowing inner ramp and sensuously curving rooftop screen, and the latter's sun-drenched white stucco contrasted against a deep-blue sky. Even the hedonism of Le Corbusier's typical roof garden was submerged in his flat, programmatic description of a modern bathroom and balcony: 'one wall to be entirely glazed, opening if possible on to a balcony for sun baths; the most up-to-date fittings with a shower-bath and gymnastic appliances', with a separate 'dressing-room' because it was 'not a clean thing' to 'undress in your bedroom'.[12] The austere, clinical tone of this foundational text contradicts the visual and tactile experience of his actual structures. And yet readers of this persuasive manifesto, hungry for a new vision, absorbed these abstract verbal representations and gray minimalist visuals. Early on, Le Corbusier's influence owed more to a genius for writing design than to his completed architectural projects. *Towards a New Architecture* imposed on the modern movement an austere Cartesian rationalism and a Puritan devotion to 'the word', both of which endured for thirty years as an exhilarating vision became a rigid straitjacket.

Le Corbusier's influence is obvious in most design writings of the mid-twentieth century, for example those published by the Museum of Modern Art (MoMA). An exhibition on 'machine art' in 1934 was nominally devoted to design, but its high-culture theme allowed curator Philip Johnson to ignore such mundane objects as a printing press that the museum's director Alfred H. Barr Jr. described in the catalogue as 'too complicated an arrangement of shapes for the human eye to enjoy aesthetically'.[13] Instead, the show favoured artefacts that followed Le Corbusier's exacting prescription: a large ball bearing, a small marine propeller, and a cross-section of a large woven wire cable, all removed from any contexts and displayed alone as art objects. Barr opened his catalogue essay on 'Machine Art and Geometrical Beauty' by quoting Plato as he invoked 'the abstract beauty of "straight lines and circles" made into actual tangible "surfaces and solids" by means of tools, "lathes and rulers and squares"'. Machines, Barr continued, 'are, visually speaking, a practical application of geometry', their beauty depending upon 'rhythmical as well as upon geo-

metrical elements—upon repetition as well as upon shape'. His and Johnson's comments were mostly definitional, setting out principles that designed objects either followed or violated. Believing that beauty proceeded from Platonic archetypes to verbal formulations, and finally to a more or less pure material embodiment, they sprinkled their texts with the prescriptive verbs 'should', 'ought', and 'must'. For Barr and Johnson, the phrase 'writing design' would have signified more than merely describing or interpreting things that already existed. Instead, to write design would have literally meant to *utter* it, to speak it into existence through words, a concept more Biblical than Platonic.

The potential was no longer so grand sixteen years later, in 1950, when MoMA published the primer *What Is Modern Design?* By then, design curator Edgar Kaufmann Jr. observed that the 'ideas' of 'three pioneering generations of modern designers and teachers' had been 'reduced to precepts'. Avoiding the prophetic or visionary, Kaufmann admitted that these 'precepts . . . should be taken with a grain of salt'. Even so, he produced a list of 'Twelve Precepts of Modern Design', each beginning with the phrase, 'Modern design should . . .'. Most resolved into a few concepts: simplicity, functionality, expressiveness of materials and uses and, somewhat redundantly, modernity. Addressing consumers rather than producers of 'good design', Kaufmann explained how the rules were 'meant to be tested against each object illustrated' so 'the ideas will acquire more real meaning and the objects, so different from each other outwardly and some of them strange looking, all will be seen to belong to the tradition of modern design'.[14] In fact, few were at all strange. Most were designed in response to modernist precepts running back to Le Corbusier. Prefiguring Robert Venturi's later complaint that 'less is a bore', most of the domestic objects illustrated were refined to essential lines and planes, machined or polished surfaces and restful abstract patterns. To quote again from Le Corbusier's manifesto, 'There are no symbols attached to these forms . . . there is no need of a key in order to understand them'.[15]

This rigid, brittle embodiment of modernism, which Kaufmann regarded with unwitting irony as a 'tradition', suggests the waning of a major cultural trend instigated by Le Corbusier's initial verbalization. The point here is not the decline of modernism, first announced around 1970, but the fact that modernism owed so much to its powerful verbal rhetoric: words, catchphrases, definitions, formulations, principles, statements, manifestos. Modernism, with all of its actual objects and structures, was a product or a crystallization of writing design.

MORPHING DESIGN

Our contemporary situation is partly similar to that of Victorians, who regarded design as a progressive process compatible with biological evolution but also oddly similar to that of modernists who celebrated a utopian machine age. A useful way to approach this conundrum is through the controversial exhibition 'Design and the Elastic Mind', curated by Paola Antonelli at MoMA in 2008. Catalogue essayists revived the heroic designer's role with a vengeance. Not since Leonardo da Vinci, wrote one, have designers carried so much responsibility for interpreting new sciences to the general public. Museum director Glenn

D. Lowry described 'one of design's most fundamental roles' as 'the translation of scientific and technological revolutions into approachable objects that change people's lives and, as a consequence, the world'.[16] Nanotechnology, recombinant DNA, cyborgs, virtual reality and the artificial re-engineering of the natural formed the backdrop to a heady mélange of exhibits. Exhibit labels and catalogue essays bristled with what a prominent historian of technology once dismissed as 'progress talk', a discourse that proclaims as virtually already existing that which is in fact no more than an idea.[17] Many pieces, such as Michiko Nitta's 'Body Modification for Love', which featured mock-ups of 'a technique for genetically growing selected body parts on your skin, allowing you to sport your partner's favorite mole on your shoulder, your ex-girlfriend's nipple close to your pelvic bone, or a patch of living hair on your arm to remind you of your mother', seemed more like conceptual art than design, as it is commonly understood.[18] Christina Cogdell's review of the exhibition in *Design Issues* points out the self-consciously evolutionary perspective of 'Design and the Elastic Mind'. According to her, exhibition labels 'repeatedly emphasized that scientists and designers are gaining control of information-based evolutionary processes of self-organizing complex systems at every scale, be it the molecular structure of DNA, the growth potentials of the cell, computational algorithms that mimic natural processes . . . or the fast exchange of all of this information and more via the Internet'.

Recasting Cogdell's assessment in terms of the writing design discourse I am outlining, we might regard 'Design and the Elastic Mind' as a series of statements, both verbal and visual, intended as utterances or prefigurings of 'the shape of things to come'. However, Cogdell maintains that MoMA's central focus on the 'idea of designer control' contradicts 'scientific understandings of self-organization, which by definition excludes all external influences, direction, or leadership imposed upon self-organizing systems'.[19] In other words, the designer-directed control of evolution hypothesized by the exhibition is fundamentally at odds with our inability even to conceive the totality of the systems to which we belong. Design's evolution, she would claim, is out of our hands.

Her position converges at a tangent with that of Anne-Marie Willis and Tony Fry, radical design sceptics, whose journal *Design Philosophy Papers* has, since 2003, theorized the unsustainability of contemporary design practice. According to them, the self-conscious shaping and transforming of material reality, by means of the generative ideational process I am referring to as writing design, is a short-lived historical phenomenon. Fry distinguishes three phases in the history of design. The first, lasting for millennia, encompassed, in his evocative phrase, 'design prior to its naming'. Under that rubric he places such unselfconscious developments as the expression of self-identity through tattooing, or communication through the fifty thousand characters of Chinese writing, or, presumably, the craft methods used before the industrial revolution. According to Fry, 'a vast amount of time existed between this projected essence of design and the constitution of design as a discourse', the latter a recent phase identical to the modernist era.[20] However, he and Willis insist, we now see the end of this delusional assumption of self-conscious, self-directed evolutionary control. As the result of an incomprehensible concatenation of millions of

individual design decisions, our global technological system is gaining hegemony, moving beyond the understanding of any individual or group. Rather than predicting, as in some science-fiction scenario, the merging of complex informational and technical systems into an all-encompassing, non-human consciousness, Willis suggests simply that 'designed things and systems have agency'. What she refers to as the 'already designed' is itself 'a designing force, not just of further design, but also of how people live and work, of what resources are used and with what impacts'.[21] In this state of 'meta-design', according to Fry, the 'designing object' replaces 'the designing subject'.[22] The designer becomes a servant of software and systems too complex for individual comprehension or control. Thus, the pattern-maker or form-giver of the industrial revolution is out of work. The old rhetoric of writing design has lost its generative power to transform the material world. And design itself, in their view, awaits its 'immanent disappearance as it folds totally into the technological'. Advocating 'sustainment' as the only alternative to the global ecological disaster that a designing humanity has engendered, they advise adopting a survival strategy of 'designing how *to be with technology*, rather than designing *with, for* or *by* technology'.[23]

Countering this gloom, one might note that designers still arrange hardware and software interfaces of digital devices, create fashions that provoke but not too much, devise signage for transportation systems, and fit the bulky apparatus of hybrid automobiles into aesthetically appealing bodies. They even engage in writing design, if not as confidently as Le Corbusier or Venturi. Critics such as Fry and Willis dismiss all that as the work of powerless servants to the system. However, one might ask whether they, along with their opponents, the technological cheerleaders from 'Design and the Elastic Mind', are not actually victims of the same word-spinning penchant that plagued both the Victorians and the modernists. Perhaps it is too easy to focus on a philosophical or ideological forest of design definitions and commentaries and thereby miss the solid oaks and maples of the material world in all its randomly branching specificity. Returning to the question of 'translating objects into words', I would finally like to cite the product designer Dieter Rams, famous for his minimalism. Writing in 1984, he stated that 'designers . . . cannot remain at the level of words, reflections, considerations, warnings, accusations, or slogans' but instead must 'transpose their insights into concrete, three-dimensional objects'.[24] The task of the design historian is not that of the designer, obviously, but the reverse of it, transposing objects back into insights, and reflecting on how and why we do that.

NOTES

1. Jeffrey L. Meikle, 'Preface to the Second Edition,' in *Twentieth Century Limited: Industrial Design in America, 1925–1939* (Philadelphia: Temple University Press, 2001), x–xii.
2. Eugene S. Ferguson, *Engineering and the Mind's Eye* (Cambridge, MA: MIT Press, 1992).
3. Adrian Forty, *Objects of Desire: Design & Society from Wedgwood to IBM* (New York: Pantheon, 1986), 120–55; Regina Lee Blaszczyk, *Imagining Consumers: Design and Innovation from Wedgwood to Corning* (Baltimore, MD: Johns Hopkins University Press, 2000), 158–9; Charles T.

Goodsell, *The Social Meaning of Civic Space: Studying Political Authority through Architecture* (Lawrence: University Press of Kansas, 1988); and Nicholson Baker, *The Mezzanine* (New York: Vintage, 1990 (1988)).

4. Baker, *The Mezzanine*, 124, 41.

5. Forty, *Objects of Desire*, 29–41.

6. John Kresten Jespersen, 'Originality and Jones' *The Grammar of Ornament* of 1856,' *Journal of Design History* 21, no. 2 (2008): 146.

7. Owen Jones, *The Grammar of Ornament* (London: Bernard Quaritch, 1910 [1856]), 16.

8. The phrase is from Robert Venturi, *Complexity and Contradiction in Architecture* (New York: Museum of Modern Art, 1966), 16.

9. Reyner Banham, *Theory and Design in the First Machine Age* (London: Architectural Press, 1960).

10. Le Corbusier, *Towards a New Architecture* (New York: Payson and Clarke, 1927), variously on 71–3, 136, 203, 211.

11. Reyner Banham, 'The Machine Aesthetic' (orig. 1955), in *Design by Choice*, ed. Penny Sparke (London: Academy Editions, 1981), 44.

12. Le Corbusier, *Towards a New Architecture*, 122.

13. Philip Johnson, *Machine Art* (New York: Museum of Modern Art, 1934), not paginated.

14. Edgar Kaufmann Jr., *What Is Modern Design?* (New York: Museum of Modern Art, 1950), 5, 7.

15. Le Corbusier, *Towards a New Architecture*, 211.

16. Glenn D. Lowry, 'Foreword,' *Design and the Elastic Mind*, ed. Paola Antonelli (New York: Museum of Modern Art, 2008), 4.

17. John M. Staudenmaier, *Technology's Storytellers: Reweaving the Human Fabric* (Cambridge, MA: MIT Press, 1985), esp. 134–48.

18. 'Portfolio 3,' in *Design and the Elastic Mind*, ed. Paola Antonelli (New York: Museum of Modern Art, 2008), 109.

19. Christina Cogdell, 'Design and the Elastic Mind, Museum of Modern Art (Spring 2008),' *Design Issues* 25 (Summer 2009): 94.

20. Tony Fry, 'Design Betwixt Design's Others,' in *Design Philosophy Papers Collection Two*, ed. Anne-Marie Willis (Ravensbourne, QLD: Team D/E/S Publications, 2005), 78.

21. Anne-Marie Willis, 'Introduction—Mega and Meta Designing,' *Design Philosophy Papers Collection Two*, 6, 4.

22. Fry, 'Design Betwixt Design's Others,' 83.

23. Willis, 'Introduction—Mega and Meta Designing,' 9; Fry, 'Design Betwixt Design's Others,' 84.

24. Dieter Rams, 'Omit the Unimportant,' *Design Issues* 1 (Spring 1984): 26.

2 DESIGN CRITICISM AND SOCIAL RESPONSIBILITY: THE FLEMISH DESIGN CRITIC K.-N. ELNO (1920–1993)

FREDIE FLORÉ

In the past few decades, the profession of design critic seems to have been invisible and almost non-existent in Belgium.[1] A limited amount of substantial reflections on product design or crafts are to be found in the margins of a few architecture and art journals. Strong opinion-makers with convincing or well-founded arguments or revealing insights have been lacking for years. To find prominent and interesting personalities who specialized in design criticism in Belgium, we have to go back to the 1950s and 1960s with such francophone authors as Pierre-Louis Flouquet (1900–67), editor in chief of the architectural journals *Bâtir* and *La Maison*, and Léon-Louis Sosset (1913–94), adviser and later chairman of the Brussels' organization Formes Nouvelles.[2] On the Flemish side of the country, K.-N. Elno (1920–93) set the tone. He started out during the war as an art critic, but by the late 1950s became one of the leading figures in design criticism and taste and design education in Flanders and the Netherlands.[3] As this chapter will illustrate, his oeuvre is quite different from that of his older francophone colleagues. One of the typical features of his work was an observant and reflective attitude, which enabled him to keep in close touch with the changing material world, and often led him to question and adjust his own ideological viewpoints. Today, thanks to this approach, we are able to find some clues as to why, around the late 1960s, Elno chose to gradually end his career. In short, his modernist-inspired education in taste proved, in the end, to be incompatible with the booming consumer world and the ever-growing amount of consumer goods. At the same time, Elno's reflective and observing attitude, this chapter argues, provides us with some compelling perspectives or questions through which to evaluate the poor status of contemporary design criticism in Belgium.[4]

THE PROBLEMATIC SOCIAL IDENTITY OF THE ARTIST

Elno's observing and reflective approach, which often led him to reconsider his own opinions, is exemplified in his writings on the social identity of the artist. He began to discuss this topic at an early stage in his career. Elno's first interest was in the expressive arts, a field in which he was active until the mid-1950s as a critic, gallery owner and publisher. During the war, for instance—still using his given name, Karel Horemans—he wrote art reviews for the Flemish nationalist daily *Volk en Staat*, continuing his career as art critic from the early 1950s onwards with several Flemish newspapers and periodicals.[5] Elno was

a champion of young abstract artists and, in 1951 in Antwerp, he and his wife opened a gallery to exhibit the work of young, mainly Belgian, abstract painters.[6] In the early 1950s, he also founded two journals. In 1950 the first issue of *Iris* appeared, an 'illustrated independent monthly on painting, sculpture, architecture, graphics, artistic crafts, decorative arts, advertising and book design'. Three years later, together with the modernist architect Huib Hoste, Elno launched *Ruimte*, a journal on architecture, urbanism, interior design and fine arts (Fig. 2.1).

As the multidisciplinary scope of these journals suggest, in the early 1950s Elno gradually broadened his interest to various forms of contemporary expressive and applied arts.

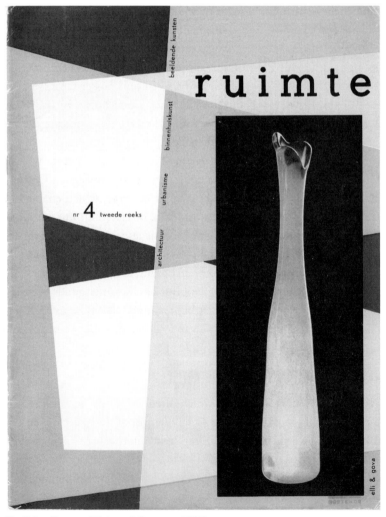

Fig. 2.1 Cover of *Ruimte* 4 (January 1956).

In the course of the 1950s, one of these disciplines in particular attracted his attention: contemporary design. This was largely the result of Elno's concern with the social identity of the artist. According to him, this identity had become unclear as a consequence of various social developments, such as the new role of the state as patron, the growing diversity of easy entertainment activities, and so on. Elno believed that art formed a decreasing part of daily experience, leading to a sharp decline in the social significance of artistic skill. Since the early 1950s, Elno's work was characterized by a search for a way out of this situation. In the first instance, he believed—as did others before him—that art could again be reconciled with life through its integration into architecture. If (abstract) art were to become 'spatial', it could develop along with architecture and make room for modern life.

Initially, Elno expected a great deal from the integration of art and architecture. In an article in the first edition of *Ruimte*, he enthusiastically pointed out that painters and sculptors were taking an increasing interest in 'the forms of expression that can be more readily integrated into architecture and are less suitable for display in the easel-oriented gallery'.[7] One of the examples he referred to was the abstract paintings by the French artist Edgard Pillet in the new buildings of the Mame printing office in Tours (1950–53), which were designed by the architects Bernard Zehrfuss, Jean Marconnet and Jean Prouvé.[8] According to Elno, the work of Pillet succeeded in adding human scale to the vast, rationally designed working space, and it introduced an atmosphere which corresponded with the psychology of the workers.[9] In Belgium, similar approaches between art and architecture were to be found. For example, Elno refers to a modernist social housing project in Antwerp by the architects Renaat Braem, Viktor Maeremans and Hendrik Maes that featured integrated sculptures and artistic paintwork[10] (Fig. 2.2). Interestingly, while discussing these projects, Elno also remarked that the increasing interest of artists in spatially integrated work had a significant impact on the work of the art critic, who still needed to inform himself through, and report on, regular art exhibitions, but, increasingly, to visit artist's studios, and even building sites, to keep in touch with current developments in the art world.[11]

Subsequently, however, Elno was forced to admit that the plan to reassign the artist a role in society, via the integration of art into architecture, was not working. Very often, something seemed to go wrong between artist and architect. In the essay 'Het Konflict' ('The Conflict'), Elno formulated the problem as follows:

> 'The Conflict'. The master builder who sees a potential villain in the sculptor or painter, whose meddling will in some way mutilate the structure or will impair its integrity. The expressive artist who thinks the most important area of his field of activity—wall and building—is placed under architectural sequestration and believes he recognizes an artistic boor in every architect.[12]

The space artists and architects were meant to share was, according to Elno, all too often entirely taken over by one of them or became a battleground. '*La Rencontre*, the

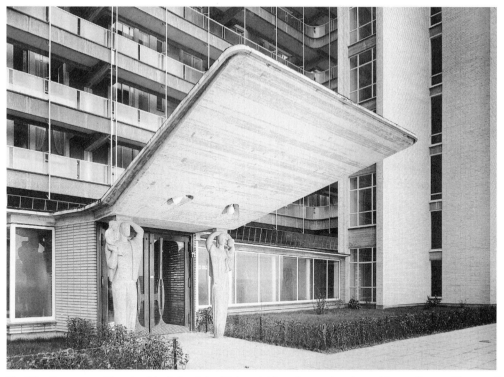

Fig. 2.2 Entrance of housing block A of the Kiel social housing project by architects Braem, Maes, and Maeremans in Antwerp. Archives of the Vlaams Instituut voor het Onroerend Erfgoed. Photo: F. Philippi, © SABAM Belgium 2011.

Reconciliation, the New Unification of the arts', heralded by Le Corbusier, was a far cry from reality.[13] Elno concluded his essay with the observation that a harmonious discussion between architects and expressive artists at the time was impossible.

NEW SOCIAL POSSIBILITIES FOR THE ARTIST

Nevertheless, it did not take long before Elno discovered new social possibilities for the artist. This time, the close relationship between the expressive arts and design, he thought, would bring a solution. In 1957, together with the Flemish painter Luc Peire, Elno organized an exhibition titled 'Vormen van Heden' ('Shapes of Today'), which aimed at shedding light on the modern language of form shared by contemporary expressive arts and design (Fig. 2.3). The exhibition took place in the municipal casino of Knokke and displayed furniture and fabrics by the Knoll International furniture company, combined with largely abstract expressive work from Belgium and abroad. The central feature of the open and geometrically structured plan for the exhibition consisted of four Knoll interiors surrounded by sculptures and paintings by artists including Jan Burssens, Pol Bury, Pol Mara, Luc Peire, Antoine Pevsner and Michel Seuphor. The curators believed that presentation of an interior by Florence Knoll, in the immediate vicinity of works by Bury or Bertrand, made clear that:

a unity of style exists in all the varieties of trends and intentions in contemporary design, which is difficult to describe but clearly observable and is felt in both free plastic design and industrial and traditional design, as well as in the pure product of imagination and the sensible utility object.[14]

Besides the close relationship between the expressive arts and design, Elno also noticed the development of a new phenomenon: alongside their purely artistic practice, various Belgian and foreign artists were also portraying themselves as designers. Harry Bertoia designed mass-produced furniture; the Flemish artist Octave Landuyt designed industrial sanitary fittings, and so on. Elno interpreted this evolution as a rapprochement between

Fig. 2.3 Exhibition 'Vormen van Heden', Knokke, 1957. © Atelier Luc Peire—Stichting Jenny en Luc Peire, Knokke.

the expressive arts and everyday reality. To him, it proved that the 'individualistic' artist was taking an increasing interest in 'present-day popular culture'. According to Elno, this was precisely where the 'social salvation' of modern art was to be found. As long as the artist tries to integrate himself, as a free artist, into architecture, things go wrong; but, as a designer, he automatically gains access to the interior and he can allow his work to form part of an experienced everyday environment. The implements designed by the artist then function as mass-produced works of art which, because they are actually used, become part of life and transform that life.

From this perspective, Elno developed an explicit, almost passionate interest in 'vormgeving' or 'design' (since the early 1950s, the English word was introduced and quickly assimilated in Flanders).[15] The emergence of the newly defined discipline of industrial design or 'industriële vormgeving' especially drew his attention.[16] From the second half of the 1950s, in various cities in Belgium and the Netherlands, symposia, lectures, exhibitions and courses on industrial design were organized. At the same time several journals began to devote explicit attention to the new discipline. This was also the case with *Ruimte*: in 1956 the subtitle changed from 'architectuur, urbanisme, binnenhuiskunst, beeldende kunsten' (architecture, urbanism, interior design, fine arts) to 'woninginrichting, architectuur, industriële vormgeving' (domestic arrangement, architecture, industrial design). Sosset and Flouquet had devoted articles to industrial design (or 'esthétique industrielle', as it was called in French) several years before Elno, but they did not share the quasi-utopian expectations attached to it by Elno. In a 1960 lecture, Elno explained:

> Industrial design is therefore: the elimination of the discord in industrial fabrication, the pursuit of unification of all those involved in manufacture. In the situation in which the industry currently finds itself, this can be nothing other than the confession of a just faith in the meaning of industry, the urge for fulfilment of the industrial act as human 'sign'. In one word: industrial design is a doctrine, a question of attitude, of ideology.[17]

According to Elno, industrial design was the path modern design should follow if it wanted to avoid isolation and be integrated into everyday life. He saw his confidence in the social 'mission' of industrial design supported by a series of large manufacturers, such as Adriano Olivetti, who, in his opinion, were able to combine 'technique, economy, social responsibility and art' harmoniously in their companies and in this way added great moral value to their products.[18]

Along the same lines, Elno, like many of his European colleagues, was suspicious of industrial design produced in the United States as being primarily aimed at stimulating shallow consumerism.[19] When, in the early 1950s, the autobiography of the American industrial designer Raymond Loewy was published and translated into several languages, Elno described it as a fascinating but very American and sensational book.[20] He wondered if Loewy was still able to draw a clear line between money-making and creative work and

whether his success prevented him from connecting with the human and spiritual values of the people for whom his products were intended. '[T]he typical American approach of industrial design,' he explained in 1954, risks neglecting 'the spiritual, especially moral, production factors in the process of making an object' which are 'sacrificed in the race towards showiness, seduction and technical sensation.'[21] Elno clearly believed that the 'American' model had to be avoided when trying to reconnect creative practice with everyday life and redefine the social identity of the artist. However, not every American-based firm was deemed questionable. As the exhibition 'Vormen van Heden' shows, Elno much appreciated Knoll. Yet it is quite possible that the strong and consciously developed relations of this company with Western Europe might have stimulated Elno's positive approach.[22]

THE SOCIAL RESPONSIBILITIES OF THE DESIGN CRITIC

According to Elno, design critics also had responsibilities towards society, and this had implications for his own work. Like some of his older colleagues, Elno's socioculturally inspired reflections stemmed from modernist ideas of the interwar period, and especially the belief that good, contemporary, well-produced design had moral value and denoted cultural quality. As a design critic, Elno considered it his task to inform and 'educate' others on the importance of design. He was much appreciated as a lecturer at the Academie voor Industriële Vormgeving (Academy for Industrial Design) in Eindhoven, the Rijkshoger Instituut voor Toneel en Cultuurspreiding (State Higher Institute for Theater and Cultural Distribution) in Brussels and the Hoger Instituut voor Bouwkunst Sint-Lucas (Higher Institute for Architecture Sint-Lucas) (Fig. 2.4). But he also taught outside formal education, often addressing an (intellectual) middle-class audience: for example, Elno gave more than a hundred lectures for adult training centres and cultural organizations with different ideological backgrounds.[23] Furthermore, in addition to his contributions to specialist journals, he regularly wrote design criticism for daily or weekly newspapers such as *De Standaard* or *De Nieuwe*. In the first issue of *De Nieuwe*, in 1964, Elno explained that he believed it was important to discuss design in the context of what he called 'totale publicistiek' ('total media'): 'This means: in a publication that also pays attention to politics, literature, religion, music, sports, crossword puzzling, theatre, gastronomy, tax law, television and (not only sexual) education.'[24] In addition, Elno believed that this kind of publication had to be based on a clear set of overarching values. In the case of *De Nieuwe*, this involved a pro-Flemish and Christian attitude and, as Elno explained, a deep respect for the everyday.[25]

Interestingly, Elno also regularly questioned his role as educator and design critic. His questioning derived from the critical approach of certain aspects of early modernist thinking. Along with some of his contemporaries and friends, such as architect Willy Van Der Meeren or architectural critic Geert Bekaert, Elno wanted to free the discussions on design, architecture and especially home culture of their often utopian, abstract, ideological

Fig. 2.4 K.-N. Elno in Eindhoven, from *West-Vlaanderen* 6 (November–December 1958): 367. The current name of this journal is *Kunsttijdschrift Vlaanderen*.

character. Instead he wanted to refocus attention on the concrete individual. For example, in a *Ruimte* article on architecture, he stated that the main aim of architecture is not 'the liberation of man', but 'the creation and equipment of such spaces where man can do entirely his own thing, the one who materially and mentally wants to liberate himself as well as the one who doesn't see the need for this'.[26] Elno was a charismatic advocate of good design and architecture, but, as this statement illustrates, contrary to the work of Flouquet or Sosset, his observations were simultaneously aligned with the growing international critique of modernist thinking and, particularly, of the tendency to regard the individual as representative of an average set of needs.[27] In his writing, Elno often asked what the rela-

tionships between specific individuals and their material surroundings could tell us about their personal views, wants or wishes.

However, Elno's criticism was not radical. Unlike the new generation of architects and designers of the 1960s, he did not wholly reject modernism. Instead, he continuously tried to reconcile modernist principles with concrete sociocultural reality. This becomes clear when studying his reflections on the domestic interior. In the 1960s, Elno wrote many articles on the interior and on the way new furniture, objects and appliances entered the domestic scene, in which his primary focus was relationships between objects and inhabitants. His interest was not primarily in the aesthetics, or the socially inspired genesis, of these objects, but in the way inhabitants personally related to them. According to Elno, these relationships and thus the quality of domestic interiors were not easy to judge. Criticizing an interior, he stated, should not be a hard-handed 'investigation of "domestic patients."'[28] Judging the value of an interior implied testing the authenticity of the social life within that interior and to do so, one had to act with 'a fundamental reservedness based on respect'.

The complexity of this task becomes clear when reading Elno's interpretation of the word 'kitsch'. According to him the 'authentic' or 'inauthentic' character of an interior is determined not as much by the shape or the genesis of things as by the way people live with them. As a consequence, he believed it was possible to develop an authentic relationship with kitsch objects. He stated that, despite their 'untruthful' design, these objects could contain unthreatened vital powers. Elno gave the example of a woman who, with great devotion, took care of a car-shaped flowerpot, filled with moss. At first he judged her taste to be bad, he explained, but after seeing her watering the moss with great care, his attitude changed: 'We agreed that the object moved us. Maybe we were even somewhat delighted that such a thing seemed possible, and there was no doubt that the caring owner, who enjoyed caring, added much to this feeling of sympathy which we aesthetically could not explain'.[29] Elno's carefully formulated observations are recalled in Daniel Miller's more recent plea to address kitsch, not in terms of taste, but with recognition of 'the experience of those who possess it and live through it.'[30] Elno considered himself an educator in good design, but at the same time, he, like Miller, drew attention to the sentimental value of kitsch, an aspect most denigrated by many taste reformers.

Elno explained, too, that the perfectly designed interior could also be 'untruthful' or have the shallowness that we often associate with kitsch—something Miller again echoes. In Elno's view, this is the case when the house is used for 'residing' instead of living, or when there is no substantial relationship between objects and users.[31] Judging whether an inhabitant is residing or living was, according to Elno, not an easy thing to do. After all, an interior is never 'authentic' in itself. Elno believed one could only recognize a 'truthfully' living inhabitant by the way he or she acts and sometimes by the presence of a few carefully collected useless objects: a fossil, a dried piece of fruit, an empty bottle (Fig. 2.5). According to the critic, these strange objects provided evidence of a desire to make oneself familiar with the house.[32]

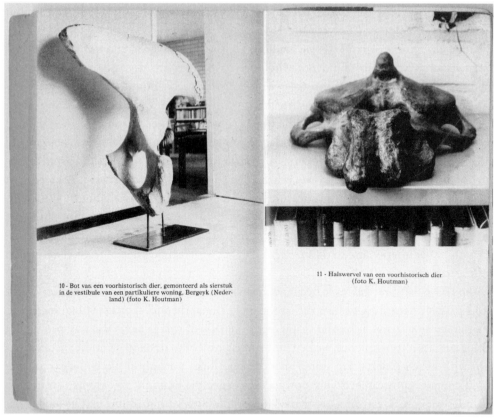

10 - Bot van een voorhistorisch dier, gemonteerd als sierstuk in de vestibule van een partikuliere woning, Bergeyk (Nederland) (foto K. Houtman)

11 - Halswervel van een voorhistorisch dier (foto K. Houtman)

Fig. 2.5 Two illustrations in Elno's book *Ruimte en beelding* showing the bone of a prehistoric animal on display in a domestic interior: K.-N. Elno, *Ruimte en beelding. Beschouwingen over architektuur, plastische kunsten, fotografie en typografie*, Series: *Vlaamse pockets* 157 (Hasselt: Uitgeverij Heideland, 1965). Photo: K. Houtman.

CONCLUSION

Elno's writings show his struggle in reconciling modernist principles with his personal observations of the place of objects within the social realm. This struggle is visible thanks to his specific style of writing, characterized by a continuous testing and rejecting of different, sometimes opposing, viewpoints. The question introducing a collection of Elno's writings, published in 1965, clearly illustrates this: 'And why not should we stimulate, intensify and deepen our thinking by playing in all seriousness with contradictions?' Elno's writings continue to be of relevance because they show that design criticism can be a lively, dynamic genre in which serious, and yet sometimes somewhat ironically formulated, arguments and counter-arguments on everyday material culture are evaluated.

With the development of the consumer society in the 1960s, Elno's design criticism, which emphasized the importance of a truthful and long-term relationship between object and user, gradually became outdated. People learned to live with many more things than

before and their personal possessions were adapted more easily according to the identities they wanted to construct for themselves. Opportunities or reasons to become attached to objects or stay true to them apparently decreased. Elno's writings show that he experienced difficulties in adjusting to this new period, something which might have led him to gradually end his career from the late 1960s onward. With his disappearance as a design critic, the coverage of design issues in Belgium was subsumed by the lifestyle industry.

However, instead of focusing on the outdated character of some of Elno's arguments, his work can be used to question the current state of design criticism in Belgium. For example, how can we define the social responsibilities of today's design critic, taking into account the range of possible relationships between objects and consumers? Furthermore, Elno's approach and choice of media can be seen as a challenge to develop a new, contemporary testing ground for serious design critical arguments, distinct from lifestyle journalism.

NOTES

1. In the last few years, concern about the lack of design criticism in Belgium has grown. For example, in 2004 the Flemish art centre TOR, with the support of the Flemish government, the Ghent Design museum, the art gallery Z33 and the organization Design Vlaanderen organized a workshop on design criticism in the hope of stimulating a revival in this field.

2. For an introduction to Flouquet, *Bâtir* or *La Maison*, see Anne Van Loo, ed., *Repertorium van de architectuur in België. Van 1830 tot heden* (Antwerp: Mercatorfonds, 2003), 143–4, 309, 413. For more information on *Formes Nouvelles*, see Fredie Floré and Mil De Kooning, 'Formes Nouvelles and the communication of modern domestic ideals in postwar Belgium,' in *ADDITIONS to architectural history: XIXth annual conference of the Society of Architectural Historians, Australia and New Zealand* (Brisbane: SAHANZ, 2002), 43.

3. Recently, the importance of Elno's oeuvre for Dutch design criticism was confirmed by Frederike Huygen who included Elno's work in her survey on Dutch design literature: Frederike Huygen, *Visies op vormgeving. Het Nederlandse ontwerpen in teksten. Deel 2: 1944–2000* (Amsterdam: Architectura and Natura Pers/Premsela, Dutch Platform for Design and Fashion, 2008), 87, 110–1, 121, 423.

4. This chapter is based on a larger study of Elno's collected writings. See Fredie Floré, 'Karel Elno' (master's thesis, Ghent University, 1997); Fredie Floré, 'Sociaal modernisme. De designkritiek van K.N. Elno (1920–1993),' *De Witte Raaf* 89 (Jan.–Feb. 2001): 6–8; Fredie Floré, 'K.-N. Elno,' in *Repertorium van de architectuur in België*, ed. Van Loo, 297; Fredie Floré, 'K.-N. Elno en De Vorm der Dingen,' in *[Im]perfect by design. 4e Triënnale voor Vormgeving* (Brussels: Design Vlaanderen/Koninklijke Musea voor Kunst en Geschiedenis, 2004), 59–68. In the following chapter, all Flemish quotations are translated by the author.

5. Karel Horemans was accused of collaboration for working with *Volk en Staat* and was interned for three-and-a-half years. K.-N. Elno stands for *K*(arel)-*N*(ora) (Kar)*el No*(ra). It is a combination of letters of the first names of Karel Horemans and his wife, Nora Horemans. The Flemish

newspapers and periodicals referred to are *De Spectator*, *De Periscoop*, *Het Handelsblad* and *De Standaard*.

6. The gallery was called 'Het Kunstkabinet K-N Horemans'. Abstract painters exhibiting in the gallery included Jan Saverys, Jo Delahaut and Jean Milo.

7. 'Schouw, gebeurtenissen waarin wij belang stellen,' *Ruimte* 1 (November 1953): 5–9.

8. 'Nouveaux ateliers d'imprimerie et de reliure. Usine Mame à Tours,' *Architecture* 53, no. 7 (1953): separate supplement of the journal.

9. 'Schouw,' *Ruimte* 1, 5–9.

10. Jo Braeken, ed., *Renaat Braem 1919 2001 Architect 2* (Brussels: ASA Publishers/Vlaams Instituut voor het Onroerend Erfgoed, 2010), 89–102.

11. 'Schouw,' *Ruimte* 1, 5–9.

12. K.-N. Elno, 'Het Konflict', *De Standaard der Letteren* 268–9 (24–25 September 1960) 9.

13. Elno, 'Het Konflict,' 9.

14. Luc Peire and K.-N. Elno, *Vormen van Heden* (Knokke: Gemeentelijk Casino van Knokke, 1957).

15. On the introduction and use of the word 'design' in Belgium, see Javier Gimeno Martinez, 'The Introduction and Dissemination of the English Word "Design" in the Belgian Context,' in *Words for design II*, ed. Haruhiko Fujita (Osaka: Japan Society for the Promotion of Science, 2008), 53–9.

16. On the development of industrial design in Belgium, see Mil De Kooning, Iwan Strauven and Fredie Floré, 'Le design mobilier en Belgique: 1945–1958,' in *Art Nouveau & Design: Les arts décoratifs de 1830 à l'Expo 58*, ed. Claire Leblanc (Brussels: Editions Racine, 2005), 174–91.

17. K.-N. Elno, 'Industriële vormgeving', sixth lecture of the work season 1960–1 at the Centrum voor Technische Opleiding of the Technologisch Instituut KVIV (Centre for Technical Training of the KVIV Institute of Technology), organized in cooperation with the Kommissariaat-Generaal voor de Bevordering van de Arbeid (the Commissioner General's Office for the Promotion of Labour). This text is also included in K.-N. Elno, *De vorm der dingen. Beschouwingen over industriële en ambachtelijke vormgeving*, Series: *Vlaamse pockets* 156 (Hasselt: Uitgeverij Heideland, 1965), 23–30.

18. K.-N. Elno, 'Adriano Olivetti, schepper van een ondernemingsstijl,' *Streven* 1 (October 1960): 49–54. Also published in Elno, *De vorm der dingen*, 135–6.

19. See, for example, Jane Pavitt, 'Design and the Democratic Ideal,' in *Cold War Modern. Design 1945–1970*, ed. David Crowley and Jane Pavitt (London: V&A Publishing, 2008), 73–93.

20. 'Schouw. Gebeurtenissen waarin wij belang stellen,' *Ruimte* 3 (March 1954): 5–10.

21. 'Schouw,' *Ruimte* 3: 5–10.

22. On the introduction of Knoll International into Belgium, see Fredie Floré, 'Architect-designed Interiors for a Culturally Progressive Upper-Middle Class: The Implicit Political Presence of Knoll International in Belgium,' in *Atomic Dwelling*, ed. Robin Schuldenfrei (London: Routledge, forthcoming).

23. The adult training centres and cultural associations included Stichting Lodewijk de Raet and Davidsfonds.

24. K.-N. Elno, ' "Total design" en totale publicistiek (groet aan zinnige lezer),' *De Nieuwe* 1 (3 April 1964): 3.

25. Elno, ' "Total design",' 3.

26. K.-N. Elno, 'Schouw,' *Ruimte* 4 (1954).

27. See Karina Van Herck, 'Architectuur en het volk: van "das Leben der Masse" tot "honky-tonk",' in *Dat is architectuur.' Sleutelteksten uit de twintigste eeuw*, ed. Hilde Heynen, André Loeckx, Lieven De Cauter and Karina Van Herck (Rotterdam: 010 Publishers, 2001), 856–70.

28. K.-N. Elno, 'Aan een ware wooncultuur zijn we nog niet toe,' *De Nieuwe* 66 (2 July 1965): 5.

29. K.-N. Elno, 'Het Open Oog,' *De Standaard* 348 (14 Dec. 1959): 10.

30. Daniel Miller, 'Things that bright up the place,' *Home Cultures* 3 (2006): 235–49. Elno does not thoroughly analyse the relationship between the flowerpot and his owner as Miller does with Marcia's interior.

31. For example, Elno, 'Het Open Oog,' 6.

32. For example, 'Vreemde dingen in huis,' in K.-N. Elno, *Ruimte en beelding. Beschouwingen over architektuur, plastische kunsten, fotografie en typografie*, Series: *Vlaamse pockets* 157 (Hasselt: Uit-geverij Heideland, 1965), 29–37.

3 THE METAMORPHOSIS OF A NORWEGIAN DESIGN MAGAZINE: *NYE BONYTT*, 1968–1971

KJETIL FALLAN

In the course of just a few years, around 1970, the Norwegian design magazine *Bonytt* underwent a profound metamorphosis. For three decades, it had been the only periodical produced by and for the professional design community in Norway, while, at the same time, it reached out to a wider congregation of readers with a culturally induced interest in design. *Bonytt* was founded in 1941 by two young men passionate about design: the interior architect Arne Remlov and the furnishings retailer Per Tannum. Tannum soon became a silent partner, while Remlov ran the magazine as owner and editor-in-chief for three decades. From the beginning, *Bonytt* was firmly rooted in the national design community, and from 1947 it became the official mouthpiece of the Norwegian Applied Art Association. Throughout the 1950s and 1960s, the magazine consolidated its position as the undisputed arena for professional debate within the design community and also as the quintessential vehicle for 'good design' propaganda (Fig. 3.1).

But as the modernist propaganda for which the magazine had been created ran out of steam in the late 1960s, *Bonytt* and its good design cause seemed increasingly out of step with the changing concerns of the professional design community. Arguing for a revitalization of intellectual critique, Bruno Latour claims that 'there is no greater intellectual crime than to address with the equipment of an older period the challenges of the present one.'[1] When progressive design theory and ideology was moving towards ergonomics, ethics and ecological concerns, a vibrant design critique would have had to reassess the relations between current scenarios of design practice and its own critical arsenal. Unable, or unwilling, to embark on such a renewal of design critique, *Bonytt's* editors and publishers abandoned the instrument of criticism altogether. Instead, they chose to completely change their publication, abandoning the modernist mission and disassociating the magazine from the professional design community, transforming the enterprise into something best described as a source of inspiration for the amateur interior decorator.

Probing the inner workings of this comprehensive and complex metamorphosis, this chapter aims to show how writing design is not a matter of fact, but a matter of concern, to borrow Latour's term.[2]

«Design for Living»
26. årgang 1966
Nr. 5/kr. 4.-

Nye norske møbler
Finsk dristighet
Møbler for gamle
Norske kontormøbler
Svenske møbler

Felt møbler
Tekstiler for møbler
Rullende bord
BONYTT intervju -
fantasi og dristighet

bonytt

Fig. 3.1 Cover of *Bonytt* 5 (1966). When the 'good design' propaganda still reigned. Courtesy of Hjemmet-Mortensen Media.

STUDYING DESIGN MAGAZINES

Magazines are receiving increased scholarly attention as important source material for design history. In 1984, Clive Dilnot wrote that:

> A history of the rise of the design journal as the vehicle for projecting the ideology or the value of 'design' would be an enormous contribution to understanding the profession's self-promotion of design values. To map the changing values, ideas and beliefs expressed or communicated in text and graphic layout could, in a sense, map the history of the professions. Is the history of design literally contained in the glossy pages of *Domus* or *Industrial Design*?[3]

Perhaps because Dilnot hid this intriguing remark in a footnote, his challenge seems to have been little acted on. In my opinion, a 'history of the professions' would require a far wider spectrum of sources, but I agree with Dilnot that design magazines such as *Domus, Industrial Design,* or *Bonytt* are vital sources in 'understanding the profession's self-promotion of design values'. Magazines can also form the primary source material when investigating more specific discourses through case studies.[4]

To my knowledge, a comprehensive history of design magazines as called for by Dilnot has yet to be written. But his request for greater attention to their value as historical sources is slowly being met. Grace Lees-Maffei has observed that channels of design mediation, such as magazines and advice literature, have recently become valued as design historical sources because they provide the historian with a focus attentive to negotiations between the spheres of production and consumption.[5] Likewise, in their introduction to a special issue of the *Journal of Design History* on the role of magazines in the making of the modern home, Jeremy Aynsley and Francesca Berry argued that:

> Publishers [of interior design magazines] negotiated the intersection between manufacturers, retailers, designers and the consumer; they addressed the householder interested in matters of taste and decoration as well as providing specialized knowledge of the art and decorating professions.[6]

There are, in other words, many reasons why design magazines such as *Bonytt* are interesting and important historical sources, and most of them seem to hinge on the unique position of the magazines as a site of mediation, negotiation and domestication. To borrow a concept from Ruth Oldenziel et al., design magazines comprise an excellent source for studying 'the mediation junction'.[7]

However, as magazines do not merely *transmit* design discourse but also contribute to its *transformation*, they become interesting objects of study in their own right. It follows that concerns about the magazine's background, context and networks are vital when assessing its status as source material. As Eugene Ferguson observed in a discussion on the use of technical, or trade, journals as sources:

> In order to use those journals intelligently as historical sources, we should know what was on an editor's agenda, how his ideology influenced the words we read, what hobby or obsession or loyalty may stand behind the campaigns and crusades we encounter . . . The motives and purposes of editors (and publishers, when an editor was not also publisher) were varied and full of subtleties, but we can be sure that few editors saw their calling as merely a job do be done in order to collect a weekly pay envelope.[8]

Ferguson's point is not to discourage historians' use of this material but to stress that the explicit programmes, the implicit ideologies and the more-or-less hidden agendas that underpin publications such as technical journals or design magazines must be duly considered by the conscientious historian for them to become good sources. This chapter accepts

this challenge, studying in some detail the editing of the design magazine *Bonytt* during a transitional phase when it was quickly transformed from a modernist propaganda vehicle into a commercial interior decoration magazine.

LAUNCHING *NYE BONYTT*

In an editorial in the last issue of 1967, *Bonytt*'s editor-in-chief, Arne Remlov, presented the outline for some quite drastic changes in the magazine's character:

> On February 1st [1968] we present a New Bonytt, more oriented towards providing service to the individual reader who struggles with home- and furnishing questions . . . This is made possible because we from 1968 get more pages, take on new associates, and shift to offset [printing] which gives us more colours.[9]

To emphasize the changes and symbolize the new era, the name of the magazine was altered from *Bonytt* (capitalized) to *nye bonytt* (in lower-case letters) (Fig. 3.2). Remlov sought to convince his constituency, though, that introducing this new, more populist liturgy would not mean abandoning the gospel of 'good design':

> As a matter of form, we stress that this reorientation does not mean any rupture with Bonytt's former line . . . We will still be the only magazine [in Scandinavia] which aims to be a magazine for architecture, interior design, art, applied art and industrial design, and we will still be the official mouthpiece for the Norwegian Applied Art Association.[10]

Of course, giving amicable advice on interior decoration had always been part of *Bonytt*'s mission. But from now on, this would become the core activity, taking precedence over what had hitherto been the magazine's primary role as a forum for professional debate and ideological negotiations. It seems plausible that such a reorientation was motivated in part by a desire to reach a broader audience, and that a policy of what has since been termed 'infotainment' was considered more likely to appeal to the general public. As *Bonytt* had long since become mandatory reading in the design community, there could not have been much room for expanding the circulation there. Judging from letters to the editor, one can safely say that this strategy worked. One new reader, who previously considered *Bonytt* an elitist and inaccessible publication for those in the know, applauded the reorientation and was happy to discover that 'it was no [longer] an advanced art magazine, but truly a genuine "home" magazine'.[11] But many of the loyal readers of the 'old' *Bonytt* were correspondingly disappointed and did not hesitate to notify the editors. A letter from the weaver and architect couple Eva and Ragnvald Bing Lorentzen proclaimed that:

> Other places we read about environmental debate, student riots, warfare, third world problems . . . And we open NYE BONYTT in order to find the designer's commitment. We do not expect articles on politics and national economy . . . But, BONYTT, we expect reactions within *your* sphere of influence.[12]

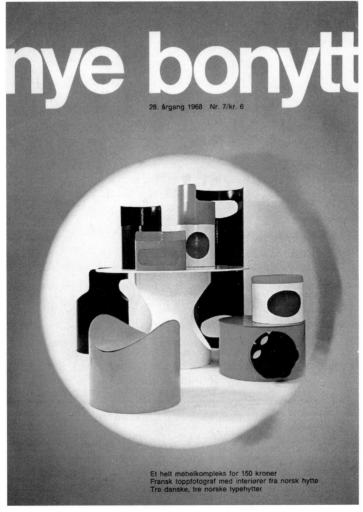

nye bonytt

28. årgang 1968 Nr. 7/kr. 6

Et helt møbelkompleks for 150 kroner
Fransk toppfotograf med interiører fra norsk hytte
Tre danske, tre norske typehytter

Fig. 3.2 Cover of *nye bonytt* 7 (1968): replacing the mould of 'Scandinavian design'. Featured furniture: plastic-reinforced cardboard furniture made by Strongpack A/S, designed by Terje Meyer. Courtesy of Hjemmet-Mortensen Media.

In short, the magazine quickly lost its reputation as an arena for debate and development of the design professions. The interior architect Kirsti Skogholt put it quite bluntly: 'I am sorry to say that I think *Bonytt* as a professional periodical is deteriorating, and the content more and more resembles that of popular woman's magazines.'[13]

nye bonytt did not prove these voices wrong, nor did it try to. The closest thing to critical debate was a 1969 series of essays by the philosopher Arild Haaland. In these texts, he pondered fundamental and momentous topics such as social fetishism, urban sprawl, children and urbanization, the presence of the past, the social and cultural hazards of the economic

rationale, and the mechanics of value-based choice. But, probably because he was an academic philosopher not affiliated with the design community, Haaland's contributions were utterly disconnected from the professional debate. He did not, at any point, reflect on the designer's role in creating, handling or solving the problems he raised. Haaland's pensive and reflective texts thus appeared more like extraneous matter than contributions to a new design critique.

RATIONALIZING REFORM

In the editorial cited above, Remlov identified three factors for realizing the reorientation. Firstly, space: the magazine now had the financial resources to increase the number of its pages. The page total was 652 in 1970 and 816 in 1972; it was estimated to reach 1,112 pages in 1975.[14] That these extra pages were to be dedicated to information and advice on interior decoration, rather than to debate and the development of the design professions, is consistent with the targeting of a broader audience.

The second factor was new associates: coinciding with the premiere of *nye bonytt*, Liv Schjødt stepped down after twenty-one productive years. She first came to the magazine in 1946 as subeditor, was made assistant editor in 1959 and co-editor from 1964, and had, throughout, been one of the most published writers. In her place, Asbjørn Andresen entered the scene in 1968 as subeditor and was made editor later the same year. Andresen came from a job as journalist in the popular men's magazine *Vi menn*, but he had also studied painting and would later undergo more academic art training and make a name for himself as a sculptor. At about the same time, other long-standing and frequent contributors highly devoted to the cause—such as architect Bernt Heiberg, art historian Knut Greve, goldsmith Torolf Prytz, designer and writer Ferdinand Aars, architect and designer Arne E. Holm, ceramist Jens von der Lippe, architect Odd Brochmann, journalist Harriet Clayhills, art historian Alf Bøe and industrial designer Roar Høyland—also disappeared from the magazine's columns. In their place came a new generation of writers—many of them interior designers and mostly women—who lacked their predecessors' roots in the applied art movement (Fig. 3.3).

The third factor Remlov identified as contributing to the reorientation of the magazine was neither personal nor structural but technological: the introduction of offset printing. Remlov seems to have considered offset technology to be a non-human actor. It executed tasks—producing consistently high-quality colour images rapidly and economically—which had been delegated to it, and its role in the reorganization process was presented more-or-less on a par with, and related to, those played by human actors (new associates) as well as the structural factors involved (for example, improved financial prospects).[15] Remlov bestowed significant agency to the new technology. He seemed to imply that there was some sort of natural causality between a more extensive use of colour illustrations afforded by offset printing and the reorientation of the editorial policy towards an increased focus on interior decoration.

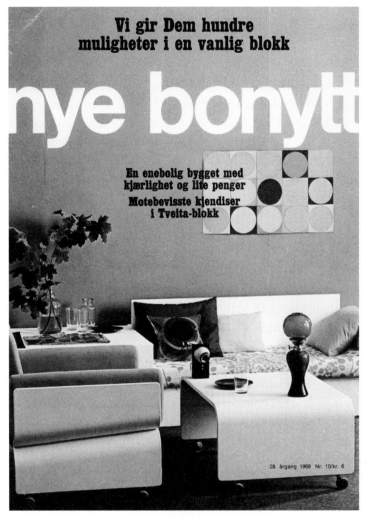

Vi gir Dem hundre
muligheter i en vanlig blokk

nye bonytt

En enebolig bygget med
kjærlighet og lite penger

Motebevisste kjendiser
i Tveita-blokk

28. årgang 1968 Nr. 10/kr. 6

Fig. 3.3 Cover of *nye bonytt* 10 (1968): introducing pop-aesthetics for fashionable interiors. Featured furniture: Dokka Møbler *Uni-Line*, designed by Mona Kinn. Courtesy of Hjemmet-Mortensen Media.

NEW BROOMS: CLEANER FLOORS?

Andresen left his editorial post after a couple of years and was replaced by Tore Giljane, in the summer of 1970. After studying graphic design at the National College of Art and Design, Giljane had entered the publishing business. In 1965, he joined the staff of *Bonytt* as a graphic designer and publishing editor for Forlaget Bonytt A/S, the publishers of the magazine. The fact that the new editor came from the publishing business and not from the sphere of design practitioners, educators and theoreticians is, I would assert, symptomatic of the professionalization (in terms of publishing), de-ideologization and popularization of *nye bonytt*.

The editorial committee line-up from 1966—art historian Alf Bøe, industrial designer Roar Høyland, architect Nils Slaatto and artist Håkon Stenstadvold—remained in service throughout the three first volumes of *nye bonytt*; 1968 to 1970, when it was dissolved. Bøe had just been made director of the Norwegian Design Centre, an institution devoted to industrial design as a rational, 'problem solving' activity. Høyland combined a similar rationalism with radicalism, boldly proclaiming that, 'It is irresponsible to use design as a selling point for any given sofa bed model',[16] and was—in his capacity as lecturer at the National College of Art and Design—the man who in 1968 invited Victor Papanek to Oslo (Papanek even boarded at Høyland's home during his stay).[17] It may seem paradoxical, then, that these two figures stayed on the editorial committee of *nye bonytt* as it transformed into an interior decoration magazine. But the editorial policy and the contents did not change overnight; Remlov had maintained that the reorientation would 'not mean any rupture with *Bonytt*'s former line'. Also, *nye bonytt* remained the official mouthpiece for the Norwegian Applied Art Association until the end of 1970. Moreover, whereas previously the editorial committee members had been highly active as writers, they became much more secluded and passive. For instance, they contributed only four small articles to the 1968 volume, and nothing at all to the 1969 volume.

The magazine's owner structure also underwent major changes. Ever since co-founder Tannum left *Bonytt* in the late 1940s, editor-in-chief Remlov had been the principal shareholder of the publishing company *Bonytt* A/S. In the late 1960s, it felt an increasing competition from foreign design magazines, and colour printing was seen as important in this respect. But the shift to offset printing was a costly process, and Remlov felt it was too risky and sold his shares.[18] Giljane bought a majority share of the company and thus ran both the publisher and the magazine.[19] It would seem most probable that these organizational changes also affected the editorial policy. Remlov stayed on as editor-in-chief until the spring of 1972, but he wrote less and less, and from the spring of 1968 he even left the editorials to Andresen, Giljane and the other new faces.

The new generation of contributors quickly made their mark on *nye bonytt*. The interior architect Ranveig Getz joined *nye bonytt* early in 1970 as subeditor, but soon left this post to the graphic designer Tone Schultz and contributed instead as a freelance writer. From 1970, the photographer Bjørn Rines was hired as the magazine's first staff photographer; previously, the published pictures had come from various sources. This move can be seen as consistent with the revised editorial policy, as an attractive and coherent presentation of interiors and products now became imperative. This new focus on photography must also be understood in connection with the more extensive use of colour illustrations afforded by the shift to offset printing.

Whereas *Bonytt* contributors traditionally came from the design community, the new writers were recruited from other places. The philologist Else Michelet, who joined the editorial staff in 1970, worked as a secretary at the publisher Forlaget Bonytt A/S. This recruitment and Giljane's dual role as graphic designer and publishing editor indicate that a very tight relation between the publishing house and the magazine's editorial staff was

being forged. While the publisher had initially been created as merely a subordinate, practical service function enabling the production and distribution of *Bonytt*, it seems it had now developed into a self-asserting independent entity. The editors used to fully control the publishers—now the balance of power seemed to have been reversed.

THE NEW ORDER: FROM ADVOCACY TO ADVICE

With the first issue of 1971, the magazine's reorientation was complete, but it had gone much further than Remlov's plans of a little over three years earlier. Despite his previous assurances, the agreement making the magazine the official mouthpiece for the Norwegian Applied Art Association had now been terminated, leaving *nye bonytt* completely free from organizational affiliations and ideological regulations. Even the editorial committee—which from *Bonytt's* genesis had been composed of persons with impeccable design expertise, profound dedication and explicitly normative agendas—had been dissolved. The description of the magazine's scope, published in every issue, was also altered in 1971 from 'Bonytt is [a] periodical for interior design, architecture, art, applied art and industrial design' to 'Nye Bonytt, speciality magazine for house, home and interior design'.[20] Gone was any mention of both applied art and industrial design. The focus had thus shifted from process to result, from profession to consumption, from advocacy to advice (Fig. 3.4).

In the first issue of 1971, editor Giljane presented the manifesto of *nye bonytt* under the heading 'our world of things':

> Today, the problem in Norway is no longer to procure [the] necessities of life, but to choose in the jungle of things . . . The world of production is tied to the demand for ever increasing profit in order to meet the competition and the obligations to creditors, employees and society . . . We believe it is more important to ask; 'what can I get by with" than "how much must I have'. A wise man has once said: 'Have nothing in your house that you do not know to be useful, or believe to be beautiful.' This quote can function as a motto for the policy we will follow . . . We wish to help our reader to choose . . . i.e. by . . . focusing more on consumer advice . . . [and] giving our readers detailed answers to the small and big furnishing problems they care to ask us.[21]

Pointing to a hundred-year-old quotation from William Morris as the motto for *nye bonytt* may seem rather strange, but it is also highly illustrative. The manifesto opens with statements that indicate an attitude towards the industry and market which appears just as resigned and pessimistic as that of Morris. Furthermore, the quote is indicative of a concern limited to the domestic sphere. This conforms to the new description of the magazine's scope as being reduced from 'interior design, architecture, art, applied art and industrial design' to 'house, home and interior design'. Giljane's promise to help the readers to solve their home decoration problems thus explicitly marked the transition of *nye bonytt* from an arena for fervent advocacy and professional debate to a forum for inspiration and friendly advice.

In view of the key figures describing the magazine's development, the decision to reorganize seems quite sensible. The revenue from both subscriptions and advertising increased

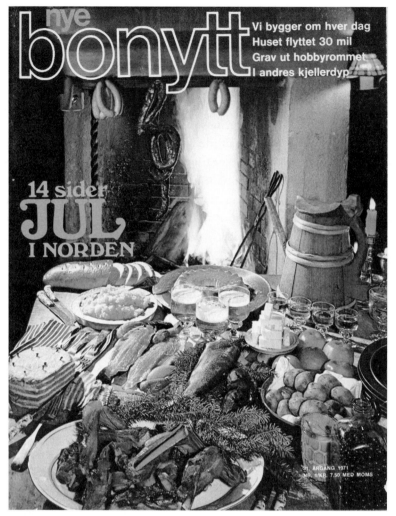

Fig. 3.4 Cover of *nye bonytt* 1 (1971): modernism and rationality gave way to traditions and comfort. Courtesy of Hjemmet-Mortensen Media.

by 320 per cent between 1968 and 1972, while that from individual sales rose by 170 per cent, making the overall increase in revenues over this period 290 per cent. At the same time, the production costs went up by 235 per cent and administrative costs by 245 per cent, so *nye bonytt* was still no goldmine.[22] The growth managed to keep the company afloat, but life as an independent publisher became increasingly hard for Forlaget Bonytt A/S, and in 1989 it sold out to Hjemmet A/S, a major publishing house with a large portfolio of periodicals, including an interior decoration magazine called *Hjem & Fritid* [*Home & Leisure*] with which *Bonytt* was to merge.[23] The cultural practice of running a magazine is profoundly embedded in and intertwined with economic, political and societal developments, and the transformation of *Bonytt* should therefore not be explained in moralistic

terms, as the end of a virtuous adventure, as 'selling out' to commercial interests, but rather understood as part of a broader sociocultural dialectic.

Another illustration of how the reorientation helped sustain the magazine through what proved to be a turbulent period in the publishing industry—characterized by marked changes in technological infrastructure, business structure and consumer behaviour—can be gauged from circulation numbers. Eleven thousand copies of the first issue of 1969 were printed,[24] whereas the average circulation number per issue in 1974 had nearly quadrupled, to forty-two thousand.[25] The strategy of shifting focus from professional design discourse to popular interior decoration advice was thus a great success in terms of reaching a broader audience. In addition, the change of tone might also have had a positive effect on the penetration of the message. Lees-Maffei has argued that what she calls 'advice literature' (such as post-1968 *nye bonytt*) could be considered both more effective and more 'democratic' or sensitive in its mediation of modern design than the top-down propaganda (such as pre-1968 *Bonytt*) because its audience is much more active and receptive.[26] One may ask, then, whether the magazine in its new and more popular guise perhaps wielded a greater influence on public taste and design consumption than it did in its original form.

A NEW KIND OF CRITICISM?

My rendering of *Bonytt*'s metamorphosis during this short period around 1970 might seem somewhat overstated or simplified. One can, of course, adduce evidence to indicate that remains of the 'old regime' can be found in *nye bonytt* beyond 1971. Also, the 1971 *nye bonytt* manifesto can be interpreted slightly more along the lines of social criticism or at least criticism of consumption ('ask; "what can I get by with", [rather] than "how much must I have"'), and in the manifesto Giljane also mentioned intentions to debate environmental issues. These aspects are clearly present in *nye bonytt* in the early 1970s. An example is an article on consumption criticism by ad-man-turned-environmentalist Erik Dammann,[27] one of Norway's most dedicated, radical and idealistic promoters of social change in the 1970s, best known for his 1972 book *The Future In Our Hands* and the organization bearing the same name, founded in 1974.[28]

Ambitions in this direction, albeit in moderate versions, are visible in the first efforts at outlining an official editorial policy for *nye bonytt* after the transitional phase was completed. A memo on editorial policy was drafted in 1972 by Tor Bjerkmann, a librarian by training and publisher by vocation, founder and director of the leftist, culture radical publishing house Pax Forlag. Acting as a consultant to Forlaget Bonytt, Bjerkmann began his memo by stating that in the reorientation phase since 1968, *Bonytt* 'changed character *from* being a specialized magazine for professionals and for readers with a special interest in architecture, applied art and art, *to* being a magazine for inspiration and information about the home environment, written for the general, non-professional audience' (emphasis in original). He goes on to mention how the editorial board with its guardians of 'good design' had been dissolved and that Remlov was out of the picture, stating, 'All this confirms that the old foundation for the magazine has ceased to exist, something which also

was a prerequisite for the reorientation.' The problem, according to Bjerkmann, was that the reorientation 'was also a shift from a relatively well-defined agenda and target group to a looser and more intuitive editorial policy'. In his call for a more stringent policy the consultant offered a number of criticisms and suggestions. Arguing that the professional integrity was threatened, he asserted that 'it is obvious that much of the [editorial] material is made with the intention of recruiting advertisers' and lamented, 'No trained architects or interior architects are now on Bonytt's editorial staff on a permanent basis . . . I believe that *Bonytt* today generally relies more on the editorial staff's good taste than on its professional credibility.' In his closing remarks, Bjerkmann bemoans a 'lack of editorial character', but asserts that he 'do[es] not believe in a reorientation of the magazine in the direction of social commitment. People do not wish [for] such material in home magazines.' Rather, he advises, 'Bonytt will be able to strengthen its hold on the readers by expanding on concrete family material', and the editors would do well to keep in mind that 'the material is to interest "ordinary people" and not just the upper classes—therefore affordable houses, cabins, and interiors which are within reach for many must dominate' (Fig. 3.5).[29]

This last comment reveals a rationalist attitude that was certainly well-intended and may well have proved wise strategically, but it ignores the fact that interior decoration magazines are also theatres of dreams. As Aynsley and Berry point out: 'Magazines made the home visible in text and image . . . and as such, the home was made to function as an object of mass distraction and mass consumption. Crucially, magazines insist that modernity is performed not through actual consumption of the modern home but in reading about that consumption.'[30]

Bjerkmann's critique and advice provided the basis for a discussion that produced a document outlining the official editorial policy of *nye bonytt*. Editor Giljane did not accept all of the consultant's suggestions, but the 1977 editorial policy document reveals that many of them were followed. However, the most striking feature of the document is the strong presence of anti-consumerist ideas. The opening statement reads: 'The home is increasingly turned into an object.' Giljane then claims that one 'becomes a victim of an ever increasing consumption . . . of unnecessary things . . . we are led to believe are necessary. The "things" are cleverly used as substitutes for vague psychological needs—and they are in no way satisfied.' In addition to these rather current ideas, residue from the old regime of 'good design' propaganda is still evident: 'All too often it is the seemingly beautiful, the extraneous accomplishment, the false ornament that is emphasised, lauded.' Following these more general remarks, the document lists twelve points for *nye bonytt*'s editorial policy. The first point predicates 'respect for the individual's taste and needs—that is, no harassment of ordinary people's poor taste . . . we must emphasise the good examples when we produce material aimed at the user'. The first part of this argument seems refreshingly non-moralist, but it then becomes apparent that the desire to reform taste persists. More progressive in this respect is the dictum in point three that 'D.I.Y. must be encouraged—emphasising the joy first and foremost, then the originality . . . economy and use value'. Point four explicitly states: 'Anti-consumption and anti-growth ideologies should be emphasised—keep the

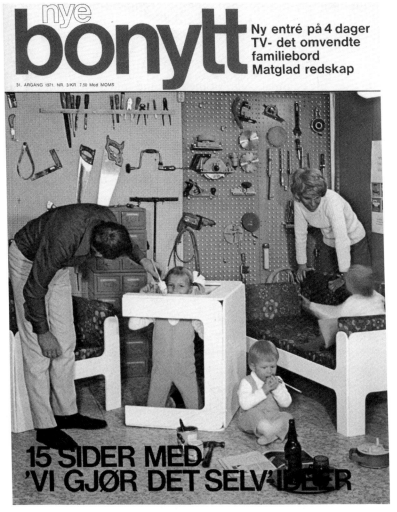

nye bonytt

Ny entré på 4 dager
TV- det omvendte
familiebord
Matglad redskap

31. ÅRGANG 1971. NR. 3/KR 7.50 Med MOMS

15 SIDER MED
'VI GJØR DET SELV'-IDÉER

Fig. 3.5 Cover of *nye bonytt* 3 (1971): DIY material became a favoured way of
courting 'ordinary people'. Courtesy of Hjemmet-Mortensen Media.

old, exploit the existing, but inform of news that can ease repairs and the idea of conserva-
tion.' And point ten stresses: 'Analyses and material are to represent *attitudes*, not tastes.'
Writers should make sure to base their articles firmly in the readers' actual situation and
'discuss problems based on the readers, not on general politics'.[31]

These guidelines for *nye bonytt*'s editorial policy show that the 'good design' didactic
approach was seen as old hat and that a new, more respectful attitude towards the readers'
tastes was promoted—although not always convincingly. Moreover, they demonstrate how
ideas of anti-consumerism and architectural conservation—which were very current top-
ics at the time—were appropriated and mediated by the magazine. Although such ideas
can clearly be considered critical, and although they were certainly relevant to professio

design discourse, they did not make up a new design critique that measured practice against progressive developments in design theory and ideology.

CONCLUSION

These insights from the editorial policy of the early and mid-1970s, revealing the presence of a tempered consumption criticism, at least on the ideological level, might suggest a modification of my initial claim that *nye bonytt* entirely abandoned criticism. However, notwithstanding their ambitions, the editors and publishers of *nye bonytt* were never willing or able to fully pursue the new and pressing issues concerning ergonomics, ethics and ecological concerns that rose to the fore of the critical design discourse in the 1970s. They chose instead to place the publication firmly within the category of commercially motivated and oriented interior decoration magazines. If a new kind of criticism did emerge, it was one that tapped in to professional design discourse and practice to a lesser degree. Thus, the professional design periodical *Bonytt* was transformed into the popular interior decoration magazine *nye bonytt* in a process that can be seen, both literally and figuratively, as a case of re-writing design.

NOTES

1. Bruno Latour, 'Why Has Critique Run out of Steam? From Matters of Fact to Matters of Concern,' *Critical Inquiry* 30, no. 2 (2004): 225–48.
2. Latour, 'Critique,' 231.
3. Clive Dilnot, 'The State of Design History, Part II,' *Design Issues* 1, no. 2 (1984): 19, note 95.
4. For example, Kjetil Fallan, 'Heresy and Heroics: The debate on the alleged "crisis" in Italian design around 1960,' *Modern Italy* 14, no. 3 (2009): 257–74.
5. Grace Lees-Maffei, 'Studying Advice: Historiography, Methodology, Commentary, Bibliography,' *Journal of Design History* 16, no. 1 (2003), 3.
6. Jeremy Aynsley and Francesca Berry, 'Introduction: Publishing the Modern Home: Magazines and the Domestic Interior 1870–1965,' *Journal of Design History* 18, no. 1 (2005): 1–5.
7. Ruth Oldenziel, Adri Albert de la Bruhèze and Onno de Wit, 'Europe's Mediation Junction: Technology and Consumer Society in the 20th Century,' *History and Technology* 21, no. 1 (2005): 107–39.
8. Eugene S. Ferguson, 'Technical Journals and the History of Technology,' in *In Context: History and the History of Technology*, ed. Stephen H. Cutcliffe and Robert C. Post (Bethlehem, PA: Lehigh University Press, 1989), 67–8.
9. Arne Remlov, 'Redaksjonelt,' *Bonytt*, 11/12 (1967): n.p.
10. Ibid.
11. Alan Langsem, 'Herr redaktør!,' *nye bonytt* 6 (1968): 2.
12. Eva and Ragnvald Bing Lorentzen, 'Kjære BONYTT!,' *nye bonytt* 6 (1968): 2.
13. Kirsti Skogholt, 'Herr redaktør!,' *nye bonytt* 6 (1968): 2.
14. Publishing statistics for *nye bonytt*, in the *Bonytt* archive at The Norwegian Museum of Cultural History (henceforth called *Bonytt* archive).

15. On the notion of non-human actors in design studies, see Kjetil Fallan, 'Architecture in Action: Traveling with Actor-Network Theory in the Land of Architectural Research,' *Architectural Theory Review* 13, no. 1 (2008): 80–96.

16. Harriet Clayhills, '"Design=Ekonomi" og kultur,' *Bonytt* 25 (1965): 279.

17. Roar Høyland in conversation with the author, 28 Mar. 2007.

18. Arne Remlov interviewed by Eldar Høidal, 4 Nov. 1996 (Norsk Møbelfaglig Senter archive).

19. Tore Giljane in conversation with the author, 30 Sep. 2009.

20. *nye bonytt* 8 (1970): 76; *nye bonytt* 1 (1971): 78.

21. Tore Giljane, 'Vår verden av ting,' *nye bonytt* 1 (1971): 13.

22. Memo on policy and economy signed editor Tore Giljane, dated 7 Nov. 1973, in *Bonytt* archive.

23. Contract between Bonytt A/S and Hjemmet A/S dated 1 June 1989, in *Bonytt* archive.

24. Memo on editorial policy signed Tor Bjerkmann, undated (1972), in *Bonytt* archive.

25. Publishing statistics for *nye bonytt*, in *Bonytt* archive.

26. Grace Lees-Maffei, 'From Service to Self-Service: Advice Literature as Design Discourse, 1920–1970,' *Journal of Design History* 14, no. 3 (2001): 187–206.

27. Erik Dammann, 'Omsetningskarusellen,' *nye bonytt*, no. 1 (1971): 16–17, 28.

28. Erik Dammann, *The Future in our Hands: What We Can All Do Towards the Shaping of a Better World* (Oxford and New York: Pergamon Press, 1979 [1972]).

29. Memo on editorial policy signed Tor Bjerkmann, undated (1972), in *Bonytt* archive.

30. Aynsley and Berry, 'Introduction: Publishing the Modern Home', 5.

31. 'BONYTTs redaksjonslinje 1977' (Editorial policy document) signed Tore Giljane, undated, in *Bonytt* archive.

4 WRITING CONTEMPORARY DESIGN INTO HISTORY

STEPHEN HAYWARD

Placing contemporary design within an historical framework is not easy. While a few prominent designers look like the natural heirs to the modern movement—one thinks of Jonathan Ive, whose work wins praise from Dieter Rams—much contemporary design finds its inspiration elsewhere:[1] in the imitation of natural forms and processes; in objects that many modernists would have regarded as kitsch; in rituals such as the Japanese tea ceremony; and in the sort of cultural enquiry more usually associated with fine art. How are design historians to make sense of this variety, and what are the implications for our research agenda? These are some of the questions I will be attempting to answer. My method is to focus on a version of the 'contemporary' which emerges from a number of recent books and exhibitions. The advantage of this approach is that it narrows the field by focusing on objects that the design world finds significant. The disadvantage is that it may not correspond with popular ideas of the significant or memorable, and in focusing on *things* I may be undervaluing the importance of non-physical manifestations of design—not least the emerging field of service design.[2] I apologize in advance for these limitations.

Let me begin by establishing some parameters beginning with the concept of 'contemporary design': what is its timescale? Where is it located? How is it constituted? The questions suggest that we begin our search among the custodians of the canon, the institutions which set out to promote the idea that things usually encountered in a shop window can have an enduring cultural value. My first case study is a catalogue co-produced by the Denver Art Museum and Indianapolis Museum of Art in 2008: *European Design since 1985: Shaping the New Century*. This publication is a useful demonstration of the dialectical reading of contemporary design.[3] A young avant-garde vies with a middle-aged establishment in a design world composed of international colleges, professional competitions, specialized magazines and the annual Milan furniture fair. In the past two decades, the leading edge of design has oscillated between styles that are minimal and conceptual and those that are symbolic or decorative. From the curatorial perspective, the strength of this approach lies in how it reinforces the continuing validity of the canon. Jasper Morrison's (b. 1959) geometric minimalism of around 1990 reveals the continuing importance of the Bauhaus and the Eames', while the neo-decorative 'response' of Tord Boontje (b. 1968) from around 2005 endorses, and makes newly relevant, nineteenth-century historicism as interpreted by the postmodernists. And yet there are anomalies: most obvious is the way that designers such as Philippe Starck (b. 1949) constantly change direction. Potentially more serious, from the historiographical viewpoint, is the fact that a 'connoisseurial' emphasis minimizes

the role of context. The issue is apparent in the overall structure of the *Shaping the New Century* catalogue. We are presented with an extensive checklist of the cultural landmarks of the past generation: the fall of the Berlin Wall, the development of the Internet, the rise of China, the threat of global warming and so on—but there is little of discussion of how this 'cultural' background relates to the 'material' foreground.

Given the intellectual development of design history since the 1980s, the emphasis on style may seem puzzling. In the wake of such books as Adrian Forty's *Object of Desire* and the epic analysis of early modern consumption initiated by John Brewer, Roy Porter and colleagues, not to mention the new field of material culture studies, it has become second nature to conceptualize objects in terms of their contexts of use.[4] Given all that we know about the relationship between social identity and things, why does *Shaping the New Century* give so much attention to what art historians call the 'will to form'?[5] Why do the illustrations present fax machines and mobile phones in pristine isolation, recalling a convention that goes back to the 1930s and the Museum of Modern Art's (MoMA) presentation of industrial design as an adjunct to cubism and abstract art?[6]

One answer, which emerges at different points in the *Shaping the New Century* catalogue, is that today's avant-garde has a tendency to solipsism; to be design for design's sake, to understand functionality not in terms of the discourses of modernity, such as the enhancement of hygiene and efficiency, to paraphrase Forty, but in terms of aesthetic gratification. This is certainly the thinking behind the entry of a new term into the design lexicon.[7] 'Design/art', as it has emerged in the last decade, refers to objects that tend to be limited editions or prototypes, things that barely enter the 'production-consumption circuit' conventionally studied by historians of industrial design.[8] Instead, these objects make use of the rarefied atmosphere of the gallery to offer an oblique comment on the everyday, even while adopting a visual language that appears to be banal. A case in point is Tejo Remy's 1991 *Milk Bottle Lamp* for the Dutch design group Droog (Fig. 4.1). In the landscape of contemporary design, this is a seminal example of how design can act as a stimulus to the imagination. The object 'works' in what is essentially a metaphorical sense by confounding our expectations of what is normal for a ceiling light, then rewarding us with a solution that is playful, nostalgic and surreal.

The *Milk Bottle Lamp* is just part of a trend in contemporary design which involves the use of ambiguity and illusion. In addition to reimagining the chandelier, using components as diverse as recycled party poppers and fibre optics, contemporary designers have exploited the paranormal qualities of mirrors, silhouettes, shadows, magnetism, even cremated materials. Why is this? What is the problem to which these 'poetic' effects and experiences are the solution? For an answer, I want to consider an exhibition that focuses on the 'anthropological' tendency in recent design. In 'Strangely Familiar: Design and Everyday Life' we are introduced to the idea that the study of mundane rituals and their associated emotions can lead to products and interactions that enhance well-being and benefit the environment.[9] There is the suggestion, more widely promoted under the banner of 'product value sustenance', that while consumer culture is competitive, stressful, over-mediated and

Fig. 4.1 Tejo Remy, *Milk Bottle Lamp* for Droog, 1991.
Photo: Gerard van Hees.

throwaway, a poetic approach develops products that connect us with our true selves, and as embodiments of meaningful experiences, they are less likely to be cast off as waste.[10] The argument resonates with a number of strands in current social thought: the contention that industrialized societies are plagued by status anxiety or affluenza; the impetus, provided by global warming, to reconsider what we really *need* as opposed to what we merely *want*; and a sense that true happiness lies in the intensification of ordinary experiences.[11]

With regard to these 'essential' products, the analogy is with those objects to which we form life-long attachments, like the favourite childhood toy or 'transitional object', the gift from a loved one or those living possessions such as plants or pets for which we have a daily responsibility.[12] In visual terms these 'emotionally durable' products tend to a language that is minimalist, ambiguous or incomplete. The designer is viewed as a facilitator, and the eventual product results from what has been called 'co-design'.[13] Thus, in the 'Do create'

series (2001), as envisioned by KesselsKramer and Droog, the objects are offered for sale in an unfinished state. In *Do hit* a rough template of a metal chair invites the consumer to hammer out what might become a cherished heirloom. *Do swing* evokes childhood memories of the playground by providing a light fitting that doubles as an adult's trapeze.

In representing the emotional life of objects, 'Strangely Familiar' adopts the technique of the staged scenario. Our attention is drawn to the kinds of behaviour that an object can bring about. This is especially important in Dunne and Raby's 'Placebo Project' (2001) where the central focus is our 'superstitious' need to find emotional significance in obscure objects and technologies.[14] As with much of Dunne and Raby's work, the 'Placebo Project' is couched in terms of a scientific experiment, enlivened by a sense of playfulness and irony. In the case of the *Compass Table* for example, volunteer users were invited to document their experiences of a minimalist table, stripped of all 'consumer cultural noise',

Fig. 4.2 Anthony Dunne and Fiona Raby, *Compass Table Portrait*, 2001. Photo: Jason Evans.

as it were, prior to being ornamented with twenty-five magnetic compasses (Fig. 4.2). On the evidence of a scenario that evokes a De Chirico painting, the table is a contemporary Western version of a fetish object, mediating between an invisible world of natural forces and everyday domestic routines.[15]

Dunne labels such work 'post-optimal', and this is a clue to its historical significance.[16] It is argued that design has reached a watershed in terms of technical performance, and the creative challenge now lies in questioning received ideas of progress and exploring previously marginalized emotions. To an extent Dunne and Raby's initiative can be aligned to what the business sector calls the 'experience economy',[17] the way that progressive companies and service providers now look on emotional enrichment as a key to brand development. And yet this would be to undervalue the subversive aspect of the post-optimal. In reimaging our everyday interactions, Dunne and Raby are questioning the normative role of design. In a post-optimal world, playfulness is as likely to be disruptive as therapeutic.

With this in mind, one of the closest historical parallels for today's design/art is probably the 'new domestic landscape' as envisaged by Italian designers in the 1960s and early 1970s. The phrase refers to the MoMA exhibition that brought this phenomenon to world attention in 1972.[18] Reacting against the functionalism of the post-war era, and wary of the environmental consequences of unrestrained consumerism—much as today—Italian design was said to be proceeding in three directions.[19] The first, the *conformist*, corresponded with the journey of aesthetic exploration that we have already seen in conjunction with the 'Shaping the New Century' exhibition. In the 1960s, this meant an alignment with the aesthetic outlook of Pop Art. The second, *reformist*, tendency is similarly comparable with the anthropological approach as seen in relation to the 'Strangely Familiar' show. Back in the 1960s, designers such as Sottsass and Colombo were producing one-off objects and environments that advocated a more mobile, hedonistic and unencumbered lifestyle. Finally, and this is where the comparison breaks down, the representatives of *contestation* carried the critique of consumer culture to a logical extreme. Under the influence of the student radicalism of 1968, groups such as Archizoom and Superstudio declared a moratorium on the design of new commodities, adopting photomontage, films and installations to illustrate the contradictory nature of capitalism and the possibility of a life without objects.

Forty years on, while the visual impact of the anti-design scenarios remains impressive, the message can appear unnecessarily bleak and misguided. Not only have we witnessed the fall of communism and the rise of an economic orthodoxy, which insists that development can be 'sustainable', but also the avant-garde has stepped down from its position of social leadership—as we saw in 'co-design'—and the design profession as a whole has joined the ranks of the 'creative industries'. This is why the most prescient designs of the 1960s are those that speak of incremental change via a re-evaluation of everyday behaviours.

We can illustrate the point by recognizing the influence of a Pop sensibility on contemporary design. In another recent survey of the design/art phenomenon, entitled '(Art)ifact'. 'Re-recognizing the Essential of Products', the wit and ingenuity of Paolo Lomazzi, Donato D'Urbino and Jonathan De Pas's *Joe Sofa* (a giant baseball glove first produced in 1971) is

much in evidence.[20] That said, it would be misleading to understand today's design/art as merely a playful reaction to functionalism, if only because the movement deals with such a wide range of sometimes uncomfortable emotions. Among the projects featured in '(Art) ifact', several simultaneously shock and beguile. Among them, Van Eijk & Van der Lubbe's *Baby Sitter* (2004), a high chair modelled after an electric chair and Karin Van Lieshout's *Road Kill Carpet* (2001), which contemplates the paradox of accidental beauty.

The uncanny nature of such objects points to an artistic pedigree prior to the 1960s and Pop. Marcel Duchamp was experimenting with the contradictory meanings of a bicycle wheel attached to a stool as early as 1917, and during the 1920s and 1930s surrealist artists such as Man Ray, Meret Oppenheim and René Magritte were evoking scenarios that we might today call 'post-optimal'. Think of the Magritte-like qualities of the *Milk Bottle Lamp*. On the evidence of the '(Art)ifact' collection, it would appear that displacement, changes of scale, anthropomorphism and incongruous juxtapositions are firmly established within the contemporary repertoire. As to whether these works should be regarded as design/art or fully-fledged surrealism, I would draw attention to a persistent concern with problem solving. For example, Vlieger & Vandam's *Guardian Angel* handbags (2004) have an obvious affinity with the black humour of Elsa Schiaparelli.[21] The bags are embossed with the shapes of a revolver and a kitchen knife. However, on reflection, one discerns a practical application. In a climate of fear, a visible weapon may reassure and deter on the same principle as a dummy burglar alarm.

The *Guardian Angel* handbags show how contemporary design is often inspired by social or psychological observation. A seemingly trivial improvisation can give rise to a new product solution. For instance, an adjustable seat (*Bale Chair* by Mio, 2004) may be derived from the sight of a pile of books being used as a stool, while a bookshelf (*Hey chair, be a bookshelf!* by Maarten Baas, 2005) can take its cue from the jumbled contents of a lumberroom. As revealed in the subtitle of the '(Arti)fact' survey—*re-recognizing the essential of products*—the process is couched in terms of a return to basics. By working with innate behaviours and 'real' emotions, as opposed to generating more 'false' desires, contemporary design has arrived at a new level of authenticity.

Anthropological observation is only one method of realizing this goal. Another is by incorporating the imagery and associations of childhood. In 2008, the Victoria and Albert Museum highlighted this approach in the exhibition 'Telling Tales: Fantasy and Fear in Contemporary Design'.[22] For our purposes, 'Telling Tales' not only demonstrates the currency of the magical but also the enduring impact of the cultural movement that succeeded Pop: *postmodernism*.

According to the historiography of design, the postmodernism of the 1970s and 1980s was variously: a continuation of the Pop interest in the power of the sampled image; an attack on the hegemony of good design; and—in the context of architecture especially—a reassertion of premodernist values, such as the use of colour and historical ornament to express corporate authority or a sense of place.[23] 'Telling Tales' revealed how the kitsch-inspired work of the Italian group Memphis and the revived classicism of architect Michael

Graves were still forces to be reckoned with, if only because contemporary design has taken object-making as cultural argument to new levels.

Alongside the revivalist, fairy-tale imagery of Jurgen Bey's *Linen-Cupboard-House* (2002) or Tord Boontje's *Fig Leaf* wardrobe (2008) were works that engaged with evolutionary theory, the meaning of luxury in post-Soviet Russia, and the post 9/11 climate of fear. Given my point above about the recent design emphasis on personal well-being, it is tempting to read the former, the intimate world of the fairy story, as a refuge from the latter, the public world of globalization and terrorism. And yet, in keeping with another theme in this chapter, the prevalence of ambiguity, 'Telling Tales' offered no simple solutions. The allusions to the fairy story recognized both the fantasy and the fear of childhood, and when commenting on the present, as in Dunne and Raby's minimalist panic room *Hide Away Type 02* (2004), the tone was coolly objective. Moreover, by filtering several of the projects through a surrealist lens—there were many unusual combinations of materials and changes of scale—these twenty-first-century tellers of tales invited their audience to work out its own salvation.

TOWARDS A HISTORY OF POST-OPTIMAL DESIGN

This chapter has touched on the many personalities of the contemporary designer: the poet and cultural commentator, the anthropologist and advocate of sustainable consumption, the storyteller and even the therapist, in so far as these stories contribute to a sense of identity and well-being. If these different roles constitute a new paradigm, to what extent must we rethink history? Bearing in mind the way that earlier generations of scholars such Nikolaus Pevsner, Siegfried Giedion and Reyner Banham sought to 'undergird' avant-garde practice with a relevant tradition, to what extent is it necessary to reimagine the past?[24]

The issue occurred to the design historian Nigel Whiteley when considering the implications of the Pop movement from the vantage point of the postmodern 1980s.[25] At a time when pluralism and playfulness were once more in vogue, it seemed appropriate to rearrange the canon; to accommodate the nineteenth-century cult of styles together with those twentieth-century expressive movements, such as art deco and streamlining, which modernism had exorcised on the grounds of morality and taste. Thirty years or so later, it still seems relevant to consider the fairy-tale imagery of the 'Telling Tales' show in the context of the medievalism of Mackay Hugh Baillie-Scott (1865–1945), though, of course, historical revivalism is only one of the ways in which contemporary design communicates. More significant perhaps, given what I have said about the currency of the 'ready-made' approach, is the relationship to 'typical' mundane objects.

In modernist histories of design, inconspicuous yet serviceable everyday things, such as bentwood chairs, have long enjoyed a special status.[26] In the 1920s, the architect Le Corbusier famously argued that such *objet-types* represent an aesthetic ideal, their functional refinement transcending the vagaries of fashion.[27] Today many more objects, such as the Zippo lighter and the Post-it note, have won the sobriquet 'humble masterpiece', though it is still the belief—in this tradition—that the principles of good design can be observed in

the biographies of exemplary things.[28] By contrast, in the work we have been considering the situation is more complex. The source material is approached in a more 'mischievous' spirit. A humble form, which may or may not be a functional 'masterpiece', is reassigned to a new context. As with the *Milk Bottle Lamp*, the process questions any simple relationship between appearance and application and wins its argument with a new kind of functionality; the light fitting which is variously a visual pun, a ready-made sculpture and an intriguing metaphor.

If appropriation and ambiguity are seen as the key features of contemporary design, then it is not surprising that this movement will have an uneasy relationship to the past. While the narrative principle builds on the idea that objects have a history and transmit 'cultural DNA', the act of reassignment disengages this project from the technological imperative of modernism. As a consequence, a post-optimal version of design history is less likely to concentrate on the evolution of the 'tool-like' capacity of everyday objects—Giedion's approach in the seminal work *Mechanisation Takes Command* (1948)—than what might be called the 'emotional efficacy' of things: their ability to amuse, to disturb, to trigger memories, to solicit playful interactions.

It will be appreciated that this is an enormous field of enquiry, and in the limits of this chapter I can only consider one aspect by way of illustration—the magical or ambiguous property of things. Consider, for example, how the design partnership The Design Can has explored the cultural heritage of an especially complex typology: the mirror (Fig. 4.3). Their *Death Wish* (2006) and *Self Portrait* (2004) mirrors mobilize the rich anthropological and psychological heritage of this object: the mirror as status symbol, as the centre of a daily grooming ritual, as *memento mori*, as portal to a supernatural world, as a fortune-telling device.[29]

Clearly, in a history devoted to the elusive quality of things, the mirror would be significant. Likewise, the tradition of *trompe l'oeil* decoration, optical illusions and magic; metamorphic toys, gadgets and automata.[30] Consider again the psychological continuities between a celebrated example of design/art: the mechanical dress designed by Hussein Chalayan as part of his One Hundred and Eleven collection (2006) and the 'defecating duck' exhibited by the leading automata maker Jacques Vaucanson in the 1730s.[31] Although separated by more than two hundred years, both devices have the ability to enchant and amaze, primarily by confounding our sense of what is artificial and natural and bringing an inanimate form to life.

Alongside metamorphic objects and showmanship, we might investigate two other areas of ambiguity: 'liminal' technologies which have yet to become normalized, as when synthetic plastics were heralded as wonder materials in the twentieth century—the parallel is with nanotechnology, DNA and digital visualisation[32]—and objects which are culturally 'out of place' in the sense of being exotic curiosities or 'bygones'. This brings us to the museological perspective on post-optimal design.

In the main, the modern museum has been charged with the development and promotion of systematic knowledge, of putting things in their place.[33] The out-of-place object

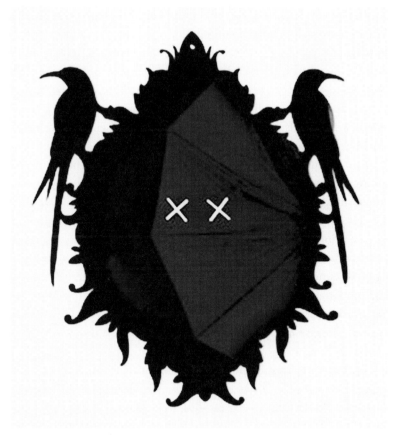

Fig. 4.3 The Design Can (Jeannie Chloe and Steven Tomlinson), *Death Wish Mirror*, 2006. Produced by Areaware, New York.

betokens a more fluid or sensationalist tradition, such as the *Wunderkammern* of the seventeenth century or the freak show in the industrial era.[34] That said, official systems of knowledge can fall into abeyance, as was the case in what might be called the quintessential museum of the post-optimal object: the Henry Wellcome collection. As a guide to the relaunched museum explains, its founder's attempt in the 1900s to document the entire development of human health was out of step with academic opinion.[35] On the one hand, progressive anthropologists were increasingly engaging in fieldwork, to establish the distinctiveness of cultures, as opposed to their position on an evolutionary tree; on the other, the medical establishment was sceptical about a museum that commemorated the continuing importance of superstitions. For our purposes, though, it is the very strangeness of the Wellcome collection that makes it an analogue for post-optimal design. Objects that are culturally alien, sometimes uncanny and frequently 'strangely beautiful' set up a cognitive dissonance. Puzzling over their original meaning by reference to our own behaviours, the effect is intriguing, poetic and playful.

As suggested above, the history of the marvellous constitutes only one, albeit significant, strand in the cultural development of contemporary design. A comprehensive analysis of design/art would have to consider how new technology may be giving rise to unprecedented ways of seeing and feeling and a sense in which this new category is a result of recent commercial pressures (like investors looking for an affordable alternative to fine art), or a response to a new kind of audience willing and able to perceive design as art.[36] In this respect there may be parallels with how other 'industrialized' cultural forms such as film, photography and television have won artistic 'respectability'.

My final qualification is addressed to those readers who are mindful of the specificity of things. Surely there is a major difference between the meaning of any object at the time of its appearance and how it is perceived by subsequent generations. Over the past three decades this point has been made repeatedly in studies of the global migration of objects and how representations of the past have been subject to continuous reinvention.[37] Does this then mean that it is misleading to compare, say, the experience of 'using' a mirror in the 1600s with the same activity performed four hundred years later? Perhaps so, in so far as the mirror is no longer a precious object and the norms by which we now 'fix our faces' are very different. But what of the experience of playing a 300-year-old violin or driving a veteran car? Clearly, it is necessary for us, as historians, to reflect deeply on our understanding of experience and use.

One way to do this is to consider how contemporary design is illuminating the psychological complexity of our interactions with things. While the explosion of interest in the history of consumption has told us a great deal about objects as status symbols or 'tools' in the formation and expression of a 'modern' identity, the life of an object as placebo or plaything, its role as a *memento mori* or a 'transitional object' is, with a few notable exceptions, a relatively unexplored field.[38]

Thus I end with a call for future partnerships: between designers who are interested in unlocking the emotional potential of objects and historians who are interested in recovering the personal significance of things.

NOTES

1. Dieter Rams interviewed in Gary Hustwit's documentary film *Objectified* (2009).
2. John Thackara, *In the Bubble: Designing in a Complex World* (Cambridge, MA: MIT Press, 2006); Colin Burns, Hilary Cottam, Chris Vanstone and Jennie Winhall, *Transformation Design*, Series: Red Paper 02 (London: Design Council, 2006).
3. R. Craig Miller, *European Design since 1985: Shaping the New Century* (London: Merrell, 2008).
4. Adrian Forty, *Objects of Desire* (London: Thames and Hudson, 1986); John Brewer and Roy Porter, eds., *Consumption and the World of Goods* (London: Routledge, 1993); Chris Tilley, Webb Keane, Susan Kuechler, Mike Rowlands and Patricia Spyer, eds., *Handbook of Material Culture* (London: Sage, 2006).
5. E. H. Gombrich, *Art and Illusion* (New York: Pantheon Books, 1960), 17–18.

6. Alfred H. Barr Jr., *Cubism and Abstract Art* (New York: Museum of Modern Art, 1936).

7. Alex Coles, *Design and Art* (London: Whitechapel Gallery/MIT Press, 2007).

8. John A. Walker, *Design History and the History of Design* (London: Pluto, 1989), 70.

9. Andrew Blauvelt, *Strangely Familiar: Design and Everyday Life* (Minneapolis: Walker Art Center, 2003).

10. Ed van Hinte, ed., *Eternally Yours: Time in Design. Product Value Sustenance* (Rotterdam: 010 Publishers, 2004).

11. Clive Hamilton and Richard Denniss, *Affluenza: When Too Much is Never Enough* (London: Allen and Unwin, 2005); Richard Layard, *Happiness: Lessons from a New Science* (London: Penguin, 2005); Mihaly Csikszentmihalyi, *Flow: The Psychology of Happiness* (London: Rider 1992); Wendy Parkins and Geoffrey Craig, *Slow Living* (Oxford: Berg, 2006).

12. Donald Wodds Winnicott, *Playing and Reality* (London: Tavistock/Routledge, 1971).

13. Stanley King, Merinda Conley, Bill Latimer and Drew Ferrari, *Co-design: A Process of Design Participation* (New York: Van Nostrand Reinhold, 1989).

14. Stuart A. Vyse, *Believing in Magic: The Psychology of Superstition* (Oxford University Press, 1997).

15. Anthony Shelton, ed., *Fetishism: Visualising Power and Desire* (London: Lund Humphries, 1995).

16. Anthony Dunne, *Hertzian Tales: Electronic Products, Aesthetic Experience and Critical Design* (London: RCA CRD Research Publications, 1999).

17. B. Joseph Pine and James H. Gilmore, *The Experience Economy: Work is Theatre and Every Business a Stage* (Cambridge, MA: Harvard Business School Press, 1999).

18. Emilio Ambasz, ed., *Italy: the New Domestic Landscape: Achievements and Problems of Italian Design* (New York: Museum of Modern Art, 1972).

19. Ambasz, *Italy*, 19–21.

20. Viction:ary, ed., *(Art)ifact: Re-Recognizing the Essential of Products* (Hong Kong: Viction:ary, 2007).

21. Ghislaine Wood, ed., *Surreal Things: Surrealism and Design* (London: V&A Publications, 2007).

22. Gareth Williams, *Telling Tales: Fantasy and Fear in Contemporary Design. Narrative in Design Art* (London: V&A Publications, 2009).

23. Michael Collins, *Post-Modern Design* (London: Academy Editions, 1990); Charles Jencks, *The Language of Post-Modern Architecture* (London: Academy Editions, 1977); Dick Hebdige, *Hiding in the Light: On Images and Things* (London: Routledge, 1988).

24. Nikolaus Pevsner, *Pioneers of the Modern Movement from William Morris to Walter Gropius* (London: Faber and Faber, 1936); Siegfried Giedion, *Mechanization Takes Command: A Contribution to Anonymous History* (New York: Oxford University Press, 1948); Reyner Banham, *The Architecture of the Well-tempered Environment* (London: Architectural Press, 1969); Reyner Banham, *Theory and Design in the First Machine Age* (London: Architectural Press, 1960).

25. Nigel Whiteley, *Pop Design: Modernism to Mod* (London: Design Council, 1987).

26. Herwin Schaefer, *The Roots of Modern Design: The Functional Tradition in the Nineteenth Century* (London: Studio Vista, 1970).

27. Philip Steadman, *The Evolution of Designs: Biological Analogy in Architecture and the Applied Arts* (Cambridge: Cambridge University Press, 1979).

28. Paola Antonelli, *Humble Masterpieces: 100 Everyday Marvels of Design* (London: Thames and Hudson, 2006).

29. Sabine Melchior-Bonnet, *The Mirror: A History* (London: Routledge, 2002).

30. Simon During, *Modern Enchantments: The Cultural Power of Secular Magic* (London: Harvard University Press, 2002).

31. Jessica Riskin, 'The Defecating Duck, or, the Ambiguous Origins of Artificial Life,' in *Things*, ed. Bill Brown (Chicago: University of Chicago Press Journals, 2004).

32. Troika, Connie Freyer, Sebastien Noel and Eva Rucki, *Digital by Design: Crafting Technology for Products and Environments* (London: Thames and Hudson, 2008); Paola Antonelli, ed., *Design and the Elastic Mind* (New York: Museum of Modern Art, 2008).

33. Michel Foucault, *The Order of Things: Archaeology of the Human Sciences* (London: Tavistock/Routledge, 1970); Peter Vergo, ed., *The New Museology* (London: Reaktion, 1989).

34. Lorraine Daston and Katharine Park, *Wonders and the Order of Nature 1150–1750* (New York: Zone Books, 2001).

35. Ken Arnold and Danielle Olsen, *Medicine Man: the Forgotten Museum of Henry Wellcome* (London: British Museum Press, 2003).

36. On design/art and new technology, see Troika, *Digital by Design* and Antonelli, *Design and the Elastic Mind.*

37. Arjun Appaudurai, *The Social Life of Things* (Cambridge: Cambridge University Press, 1986); David Lowenthal, *The Past is a Foreign Country* (Cambridge: Cambridge University Press, 1985).

38. Gaston Bachelard, *The Poetics of Space* (Boston: Beacon Press, 1964); Susan Stewart, *On Longing: Narratives of the Miniature, the Gigantic, the Souvenir, the Collection* (Durham, NC: Duke University Press, 1993).

PART 2 MEDIATIONS—BETWEEN DESIGN AND CONSUMPTION

INTRODUCTION

GRACE LEES-MAFFEI

The second part of this book concerns the role of writing in mediating design. Mediation has become a richly useful focus within design history, which complements work focussed on production and consumption.[1] The mediation emphasis in design history is characterized by three interrelated strains: it extends design history's consumption turn by subjecting channels which mediate between producers and consumers, such as magazines and didactic discourse, to close reading, thereby revealing the ways in which such sources form consumption practices and public understanding of design; it recognizes that the range of mediating channels are themselves designed artefacts worthy of formal, as well as content, analysis; and design historical work on mediation investigates the role of designed goods in mediating between the individual and the social, material and natural worlds.[2]

Part Two echoes its predecessor in beginning with a chapter which takes a long view, followed by three chapters which provide more recent case studies. In Part Two, however, the case studies following the first chapter share a tighter time period, from the First World War to the period directly following World War II. All four chapters in Part Two exemplify the first tendency noted above, in providing close readings of discourses which seek to mediate design to consumers or viewers. The mediating channels under analysis here range from the ruminations of a diarist and an art critic, to an influential work of architectural criticism in a literary magazine, instruction manuals, trade literature and advertising, and the marketing rhetoric of a glass company. Each chapter demonstrates the semantic value of explicit emphasis on issues of mediation.

Anne Hultzsch's 'Thinking in Metaphor: Figurative Conceptualizing in John Evelyn's *Diary* and John Ruskin's *Stones of Venice*' introduces the emphasis placed on architecture in three of the chapters in Part Two. Hultzsch compares Evelyn's enlightenment approach to the production of plain, rational and observational writing with what we might term (though Hultzsch does not) Ruskin's romantic approach to the way in which places can accommodate and stimulate emotions, paying particular attention to the use of metaphor and simile.

In her chapter, 'Regulating the Body in Army Manuals and Trade Guides: The Design of the First World War Khaki Service Dress', Jane Tynan demonstrates several aspects of the mediation emphasis as she reveals something of khaki's polyvalence.[3] Her close reading of First World War instruction manuals makes clear their role, as prescriptive texts, in informing the production of designed artefacts such as military dress. In turn, uniforms

mediated between individuals, and between individuals and the state, 'to describe rank and to embody social class'.

John Stanislav Sadar's ' "Vita" Glass and the Discourse of Modern Culture'[4] continues Tynan's examination of the role of the body and physical health in the project of modernity (and Evelyn and Romanticism are mentioned, too). As Henry Petroski has argued, failure is essential to success,[5] and therefore it is an important focus of study. Sadar here contributes a case study of the failure of mediation, where a mismatch of product and marketing rhetoric led to commercial disappointment. The marketing board for 'Vita' Glass communicated their message, but it was ultimately misguided and ineffectual.

Glass is also central to Ann Sobiech Munson's chapter 'Lewis Mumford's Lever House: Writing a "House of Glass" '. Both Sadar and Munson show that glass and light were seen as central motifs in the visual and verbal rhetoric of modernist design. While chapters in Part One take a single magazine title and the work of an individual design critic as their subjects, and Hultzsch in Part Two provides a detailed comparison of the work of two authors, Munson narrows the focus still further, examining a single article: Lewis Mumford's 'House of Glass' for the *New Yorker*. Munson contextualizes the article before subjecting it to an almost forensically detailed analysis, a method which has its roots in the 'thick description' of ethnographer Clifford Geertz, the New Historicism in literary analysis and what Lynn Hunt termed 'the New Cultural History'.[6]

Glass and discourse each have a mediating function; whereas mediating discourses operate between producer and consumer, prescription and practice, and fact and fiction, glass also exists between two phenomena, indoors and out, shelter and the elements. Glass, like discourse, enables us to look, but not touch.

NOTES

1. Grace Lees-Maffei, 'Introduction' Section 11: Mediation in *The Design History Reader*, ed. Grace Lees-Maffei and Rebecca Houze (Oxford: Berg, 2010), 427–8.

2. Grace Lees-Maffei, 'The Production-Consumption-Mediation Paradigm,' *Journal of Design History* 22, no. 4 (2009): 351–76.

3. On 'khaki's poetics' see Catherine Moriarty, 'Dust to Dust: A Particular History of Khaki,' *Textile: the Journal of Cloth and Culture* 8, no. 3 (November 2010): 304–21.

4. See also John Sadar, 'The Healthful Ambience of Vitaglass: Light, Glass and the Curative Environment,' *arq: Architectural Research Quarterly* 12, nos. 3–4 (2008): 269–81.

5. Henry Petroski, *To Engineer is Human: The Role of Failure in Successful Design* (New York: Vintage Books, 1992 (1982)); Henry Petroski, *Success through Failure: the Paradox of Design* (Princeton, NJ: Princeton University Press, 2006).

6. Clifford Geertz, *The Interpretation of Cultures* (New York: Basic Books, 1977 (1973)) and *Works and Lives: the Anthropologist as Author* (Stanford, CA: Stanford University Press, 1988); Lynn Hunt, ed., *The New Cultural History* (Berkeley and Los Angeles: University of California Press,

1989). See also James Clifford and George Marcus, eds., *Writing Culture: The Poetics and Politics of Ethnography* (Berkeley: University of California Press, 1986) and James Clifford, *The Predicament of Culture: Twentieth-Century Ethnography, Literature and Art* (Cambridge, MA: Harvard University Press, 1988); John Brannigan, *New Historicism and Cultural Materialism* (New York: St Martin's Press, 1998).

5 THINKING IN METAPHOR: FIGURATIVE CONCEPTUALIZING IN JOHN EVELYN'S *DIARY* AND JOHN RUSKIN'S *STONES OF VENICE*

ANNE HULTZSCH

What does it mean if one object is employed to describe another? What does it reveal about the perception of architecture if buildings are referred to as books, ships or stage sets, if they move, speak or hide? Starting from these questions, I focus here on two English writers, both famous for their very different descriptions of architecture. Seventeenth-century diarist John Evelyn used verbal images only rarely in his travel accounts, while John Ruskin's *The Stones of Venice*, written two centuries later, overflows with figurative language. Through a close reading of some short passages in Ruskin's and Evelyn's texts, this chapter explores some of the processes involved in looking at a building or space, thinking about it and, finally, putting pen to paper and describing it in words so that others can mentally recreate it. Particularly, this chapter discusses the role that metaphor occupies in this representational process as well as the power it bestows on language. When is what one sees, and understands, determined: before or after putting it into words? And which faculties—intellectual or emotional—are involved? As I will show, the concept of metaphor is crucial for understanding the process of translating objects into words, written or spoken, whether for study, education or entertainment.

With reference to recent research in cognitive linguistics, this chapter argues that it is language—verbal expression—which determines the very notion of what it is to 'see'. By using image metaphors and personifications of varying sorts, Evelyn and Ruskin establish two very different models of vision through their verbal descriptions. While Evelyn's wording enables a separation between intellect and emotion, resulting in a detached kind of 'seeing', Ruskin absorbs emotional responses into his visual descriptions as well as judgements.

UNDERSTANDING THROUGH METAPHOR

In 'The Nature of Gothic', a chapter of *The Stones of Venice* (1851–53), John Ruskin expresses his own concept of metaphor in the famous interpretation of buildings as books to be read like prose or poetry.[1] In Victorian times, it was generally felt that architecture needed to communicate more directly than language; buildings themselves needed to express a meaning which was comprehensible to the observer. Ruskin, specifically, expected his readers to be 'reading a building as we would read Milton or Dante, and getting the

same kind of delight out of the stones as out of the stanzas'.[2] As Edward N. Kaufman has remarked, 'It was the book's capacity to communicate ideas, rather than any specifically literary quality, which recommended it to architects as a metaphor.'[3]

This metaphorical link between one domain—poetry—and another—architecture— appears in a new light when recent developments in the relatively young field of cognitive linguistics are considered. It was here that figurative language first began to be regarded as a specific mode of conceptualizing the exterior world.[4] The publication of George Lakoff and Mark Johnson's *Metaphors We Live By* in 1980 marked a turning point in the understanding of metaphors and continues to be much quoted. Rather than conceiving metaphor as part of poetic and literary contexts only, the authors argued for it being part of the most basic everyday language. Even if their definition of metaphor might appear fairly loose, it is precisely this wide and inclusive view that is crucial for the argument of this chapter. They claim that the 'essence of metaphor is understanding and experiencing one kind of thing in terms of another'.[5] In other words, the usage of one object, or concept, to implicitly describe another refers directly to the speaker's way of making sense of the external world. For example, if we use expressions such as 'to go through life', 'to set out to be an architect' or 'to cross that bridge when you come to it', this means that we conceive, as well as experience, life as some form of journey. Verbal images are understood to render abstract situations in concrete experiences—a journey is a more concrete and physical experience than the more amorphous concept of life, for instance. These examples show that our bodily interaction with the physical world helps us to understand and express more abstract concepts. Ruskin's 'book metaphor' works in this way—reading books is a more familiar and concrete experience than understanding the meaning of a building. Significantly, such metaphors determine specific meaning because, while they help to express and highlight certain characteristics of a concept, they simultaneously conceal other facets. In general, definitions of metaphor vary greatly, but of interest here is any transfer of one object's qualities to another, both in cases where the thing described is claimed to *be* something else (metaphor), as well as in those where it is said to be *like* another thing (simile).[6]

Ruskin is famous for the profusion of metaphors and other rhetorical ornaments in his writing and uses them abundantly in describing specific buildings and places. For instance, he refers to the buildings of Torcello, an island in the Venetian lagoon, as 'a little company of ships becalmed on a far-away sea'.[7] Ruskin seems here to read Venice's naval identity into those buildings which he portrays as expressing an exotic otherness, of something 'far away'. If, following Lakoff and Johnson's reasoning, this is an expression of what Ruskin experienced, how he saw and understood those buildings in that moment, then understanding architecture must have been, for him, based on more than direct visual observation. Evidence is identified, in his writings, of how, exactly, he understood the perceptual process.

Interestingly, this concept of metaphor can be traced back to the early seventeenth century. Francis Bacon, natural philosopher, reformer of learning and knowledge, and now regarded as one of the protagonists of the so-called 'scientific revolution', insisted that knowledge could only be constructed and passed on through sober prose, free of ornament

and figurative expression. Still, his definition of metaphor and allegory appears conspicuously similar to what we have learned from twentieth-century linguistics: discussing poetics in his *Advancement of Learning* from 1605, Bacon claims that 'as hieroglyphics were before letters, so parables were before arguments'.[8] Transferring this idea to the development of human knowledge, he later resumes:

> in the infancy of learning, and in rude times, when those conceits [i.e. ideas] which are now trivial were then new, the world was full of parables and similitudes; for else would men either have passed over without mark, or else rejected for paradoxes, that which was offered, before they had understood or judged.[9]

By maintaining that new ideas or thoughts are expressed with the help of verbal images before they are widely understood and accepted, Bacon in essence concurs with Lakoff and Johnson's claim that metaphors render abstract and complex concepts in more concrete and familiar form. In a sense, then, metaphors seem to simplify complicated issues, to make them more accessible for the human intellect—a good enough reason to propose that they are indeed at the basis of thought.

Amongst Bacon's followers was John Evelyn, the seventeenth-century English diarist who had travelled in Italy two-hundred years before Ruskin and left a diary which included many architectural descriptions. He was a learned man who applied Bacon's teachings in order to establish a new knowledge base originating from observation and experiment. One of the aims of the Royal Society, which he had co-founded, was to instigate a new style of scientific reporting free of rhetorical embellishment. Appropriately, Evelyn uses metaphors far less frequently than Ruskin. Nonetheless, at times he employs idiomatic expressions as, for instance, when he describes Venice's St. Mark's Basilica where he notes that one of the entrances 'looks towards the Sea'—as if that entrance could actually 'look'.[10]

One of the few passages where Evelyn did make more significant use of metaphor is his description of Genoa:

> The City is built in the hollow, or boosome of a Mountain, whose ascent is very steepe, high & rocky; so as from the Lanterne, & Mole, to the hill it represents the Shape of a Theater; the Streetes & buildings so ranged one above the other; as our seates are in Playhouses: but by reason of their incomparable materials, beauty & structure: never was any artificial sceane more beautifull to the eye of the beholder.[11]

As was common in travel accounts of his time, Evelyn copied a large part of his descriptions of Italian architecture from other authors.[12] Also, this verbal image of Genoa as theatre was not Evelyn's invention and is very likely as old as the harbour of Genoa itself. However, according to his twentieth-century editor Esmond S. de Beer, Evelyn's use of the word 'scene' is original; with help from this term and its semantic history I will show how Evelyn uses the characteristics of language to express his cognitive impressions of the place.[13] In fact, one can regard this passage as a double metaphor: firstly, the city-as-theatre—the 'Shape of a Theater'—and secondly the city-as-stage—the 'artificial sceane'.

If today's reader understands the term 'scene' here as a 'view or picture presented to the eye (or to the mind) of a place', such as a painted scene of a landscape, a contemporary of Evelyn would probably have not made this link. Indeed, this current meaning of scene is a relatively new semantic addition to the lexicon; it is derived from a metaphorical use of the word in its original reference to the theatrical act or stage set, a metaphor which seems to have become widely used only in the later 1600s.[14] Such metaphorical usage is a common system by which words extend their meaning over time with the 'new' figurative meaning gradually coming to be perceived as literal and direct. Without arguing that Evelyn was the first, or even among the first, to use this word in a metaphorical sense, one can assume that he was, at the very least, more aware of its figurative character than we are today. In this short account of Genoa, Evelyn thus combines the layout of a theatre—possibly with curved rows of seats arranged on terraces—that is seen from afar with the immediacy and performative character of a theatrical scene. He therefore bases his descriptions on two distinctly incongruous viewpoints—the sea off Genoa's harbour and the streets within the town's centre.

Genoa's topographic situation on the slopes above the sea certainly renders it very suitable for a transfer into a two-dimensional picture which has been, indeed, painted and engraved countless times.[15] Arriving by boat, as Evelyn and most travellers did at the time, an elevation of the city was easily grasped. The fact that Evelyn refers to a scene or stage set, however, does not match the view from afar as it contains 'close-ups' and changes in scale. Evelyn does not adhere to a strict sequence of large scale to small scale as would be observed while approaching a city from afar and then entering it; quite the reverse, he transcends the apparent linearity of language. He does not subdivide these stages of perception but, on the contrary, is capable of spatially understanding the general and the specific at once and of putting this into words. This simultaneity is impossible to capture in graphic representations, though these are often held to be the fullest representations of the visual sense experience. Exploiting language's lack of spatial restraints, in a Cartesian manner of speaking, Evelyn's combination of the layout of a theatre and the theatrical scene allows for the simultaneous representation of physically discontinuous spaces. These spaces cannot be visually perceived at once in reality but are evoked as a mental understanding of the text. In this sense, the text here expresses, as Lakoff and Johnson have argued, an appropriated experience rather than 'pure' vision, if such a thing could ever be recorded. The city is experienced as theatre, as stage and as auditorium, and Evelyn places himself and the inhabitants in the role of both observer and actor.

ACTING BUILDINGS

In Ruskin's writing another type of metaphor—the personification of inanimate objects—is prominent throughout, whereas it is much rarer in Evelyn's travel accounts. Lakoff and Johnson write that personification 'allows us to comprehend a wide variety of experiences with nonhuman entities in terms of human motivations, characteristics, and activities'.[16] Both Evelyn and Ruskin use the human body as a reference for the behaviour of buildings,

but they predominantly do so in terms of physical movement rather than, say, how a human would think, feel or conjecture. Ruskin describes how walls 'raise' a roof, a book 'settles itself' on the pulpit or how St. Mark's 'lifts itself' from the ground, its square 'opened from it in a kind of awe' and 'waves of marble . . . heave and fall in a thousand colours along the floor'.[17] Ruskin here shows that he experiences movement in static objects which in reality cannot move (nor be moved, in most instances). This is, at first sight, similar to Evelyn's diary where personifications often refer to the bearing of loads or structural forces rendering the transfer to the human body easily comprehensible. In Genoa's harbour, for instance, Evelyn portrays the pier as 'stretching it selfe for neere 600 paces into maine Sea'.[18] And in Oxford Cathedral, described on a tour through England in 1654, a column 'spreads its *Capitel* to sustaine the roofe'.[19] There is movement in these sentences, or rather a sort of growing, but unlike Ruskin, Evelyn does not set the object itself in motion nor change its position; only its form or shape is altered. In other words, Evelyn's personifications are internal to the independent, static object, while those in Ruskin's writing tend to require an external observer who, by being stationary, marks the movement of the object. This is expressed very clearly when Ruskin describes the view back to the lagoon of Venice:

> Beyond the widening branches of the lagoon, and rising out of the bright lake into
> which they gather, there are a multitude of towers, dark, and scattered among square-set
> shapes of clustered palaces, a long and irregular line fretting the southern sky.[20]

Here, buildings 'rise', 'gather' and 'cluster', like a crowd of people, while the 'skyline' is conceived as a line which 'frets' the sky like embroidery adorning a piece of fabric. Inanimate objects are conceived as living beings—and experienced as such. Ruskin not only feels that buildings have to express meaning in a 'legible' manner but he also sees them as actors behaving in certain ways, thus collapsing cognitive 'reading' and perceptual 'seeing' into one, so that perceiving and meaning become one. At the same time and by means of these metaphors, he assures his readers that the buildings and places described comply with his standards for beautiful architecture; they express their meaning in a 'legible' manner and to the 'delight' of the viewer-reader. As has been widely argued, Ruskin bases these thoughts on the idea that buildings are living organisms. My point here is not that this is a new insight but, rather, that this understanding originated also in Ruskin's model of perception and is reflected in the words he uses to describe buildings.

When the architect George Edmund Street, a contemporary of Ruskin, described his first impressions of Venice in his *Notes of a Tour in Northern Italy* he used a phrase similar to Ruskin's: 'At last . . . the broad watery level of the Lagoon is reached; Venice rises out of the water at a distance of some two miles.'[21] Ruskin's and Street's Venice rises out of the water, as if it had been submerged before and was surfacing when they arrived—a common enough phrase but also a concealed metaphor because, of course, the city does not really 'rise' as in 'get higher'. Why is it used here, and what is implied through it? Both Street and Ruskin express with it the apparent increase in size of an object as one approaches it. Instead of describing their own state of motion, however, both Ruskin and Street turn over the acting

power to the object, to the buildings of Venice. They hide their own presence and essential activity—moving—by shifting the emphasis to the inanimate object, thus brought to life. I would suggest that this produces a framed kinetic image from which the narrator-viewer is excluded by the frame which is, in turn, constructed by the metaphor focusing our textual understanding on one motion—Venice rising—and blocking out another—the author approaching. By suppressing his own presence, Ruskin also conceals the active process of perception (and its verbal translation). The viewing subject is here absent—or is it? Inevitably, the subject is of course the motor of the kinetic action that makes Venice 'rise'. Conversely, in Evelyn's expressions—when the pier 'stretches' itself into the sea or the column 'spreads' its capital—the observer does not seem necessary for these actions to take place. Evelyn's object appears independent from its viewer while Ruskin resolutely places the construction of its appearance, meaning and potential beauty, within the viewer's perceptual understanding.

PERCEPTUAL METAPHORS

As a letter from Italy to his father in 1852 shows, Ruskin's notion of looking at and understanding buildings is closely connected to the act of description. He writes: 'There is the strong instinct in me which I cannot analyse to draw and describe the things I love . . . I should like to draw all St. Mark's, and this Verona stone by stone, to eat it all up into my mind, touch by touch.'[22] When Ruskin here exclaims that by describing a building he wants 'to eat it all up', he equates description with the process of nutrition and the building with food on which he (or rather his mind) urgently relies. He thus uses that most primary of references which Lakoff and Johnson identify—his own body—in order to understand what it means to look at architecture. The existential necessity of describing and drawing what he observes is emphasized, and its other aspects, such as technical properties of his writings and drawings or the aim to later publish them, are hidden. Writing about and drawing what he sees become part of observation itself and, more, they determine it and imply the very notion of what it is to 'see'.

Turning back to linguistics, one finds that the metaphorical link between eye and mind, or vision and the intellect, is one of the best documented in the field.[23] According to linguist Eve Sweetser, we use the sense of sight to understand and represent our own cognition and mental processes. For example, arguments can be 'crystal-clear' or rather 'muddy', we might call someone very clever 'sharp-eyed' or 'clear-sighted', as opposed to someone who is 'in the dark' whom we might try to 'illuminate'. This seems to be due to two capacities which vision and reason have in common: both are able to focus, something that is difficult or impossible for the other senses, and, both vision and reason are capable of overcoming physical distance and of deriving data remotely.[24] The concept of 'intellect', as abstract as any, is understood and experienced as 'seeing' because this sense is primary and thus more concrete and comprehensible for us. The passage from Ruskin's letter to his father shows, however, that, for him, seeing—in a figurative sense—has to become touching and, moreover, internalizing through ingestion, to overcome distance. Any remoteness between him

and the observed object is hidden in this expression as he mixes seeing with eating and touching. This suggests that, at least as far as he is concerned, vision alone is not enough to describe cognition.

Linking vision metaphorically with the intellectual faculty means that the act of seeing—rather than hearing (as hearing stories, hearing knowledge being passed on)—is experienced as knowing and thus positioned above other senses. Etymologically, this connection is as old as Indo-Germanic languages, even if narratives of ocular centricity often place the scientific revolution with its emphasis on observation and experiment at the beginning of the modern hegemony of vision.[25] Bacon himself used optics as a metaphor for knowledge claiming that 'the truth of being and the truth of knowing are one, differing no more than the direct beam and the beam reflected'. Knowledge must be a direct, a visual, reflection of the truth; the use of this optical metaphor here stands in the context of others—Bacon speaks later of 'the three beams of man's knowledge'.[26]

Indeed both Ruskin and Evelyn make use of another metaphor that stands directly for the perceptual process: it is the eye itself that repeatedly serves as a simile for perception and thus reveals further clues to the authors' concepts of the perceptual process. In Ruskin's *The Stones of Venice*, this occurs often in common idiomatic expressions, like 'far as the eye can reach', a phrase which shows that the visual field as such is understood and experienced as a container with objects being contained within it ('in sight') and without it ('out of sight'). More importantly, there are also passages in which the eye acts itself (for example, it 'cannot penetrate') or receives a feeling, as when a surface is 'delightful to the eye'.[27] Or, more explicitly, Ruskin describes how in the church of Torcello a 'subtle diminution of the bases is in order to prevent the eye from feeling the greater narrowness of the shafts'.[28] Conversely, in Gothic architecture the eye is said to be protected 'from being offended by the sharp point of the gable' through the position of a shield.[29] The eye is thus capable of sensing both positive (delightful) and negative (offensive) emotions, but it is also the locus of understanding. In St. Mark's, the specific arrangement of the thin alabaster slabs on the walls 'enable the eye to comprehend more thoroughly the position of the veins' running through the stone.[30]

When the sense of vision is linked metaphorically to the intellect, both are habitually conceived as objective and rational because they are, as we have seen, positioned at a distance to the object. Conversely, touch and taste are often perceived as more subjective due to their spatial intimacy with it. Touch and taste are thus connected with emotion as subjective experiences, as opposed to an objective, rational intellect signified by vision. However, examination of Ruskin's use of the eye metaphor suggests that this is not valid, in this case. Some of his expressions do indeed refer to intellectual properties, when the eye 'comprehends' architectural details, but also when it 'penetrates' (i.e. understands) or 'loses itself in' (i.e. cannot recognize) the tiny details high up on St. Mark's towers.[31] However, both expressions contain, also, a haptic notion and link the intellect to the sense of touch. Also, 'far as the eye can reach' refers to the space which he can possibly describe; beyond this he can neither see (nor know) for sure. In these expressions, it is therefore not only

the eye that is metaphorized but also the adjacent verbs which are used figuratively: the eye 'reaches' and 'penetrates', it does not see but instead touches. It is touch that is linked to knowing and understanding and not exclusively vision. Can the eye, then, stand, in Ruskin's writing, as a signifier for the objective intellect? After all, it is the explicit recipient of feelings such as delight and offence, and it 'feels', rather than 'sees' spatial qualities such as narrowness. I would suggest, instead, that emotion and intellect cannot be separated in Ruskin's writing and, furthermore, that intellect relies on emotion. To 'read' a building one needs to 'feel' it, too, and be receptive to its expression and meaning on an emotional level as well as an intellectual one.

Evelyn also makes use of the metaphorized eye from time to time; even if he does so far less prominently than Ruskin, he employs it in a distinct manner. First, as in the description of Genoa's topography, the observed object is compared to all other objects that the eye has seen. For instance, in a Genoese palace he encounters fountains 'of the purest white marble that ever myne eyes beheld'—the eye as memory container, hinted at also by the verb 'be-*hold*'.[32] Second, the eye helps to indicate the direction into which one should look; for example when he recommends 'turning your eyes more northward [to] those pleasant & delicious Villas of St. Pietro d'Arena'.[33] Third, Evelyn employs the eye to ascertain a certain visual ability on the part of the observer to judge an object, as well as simultaneously evaluating the quality of what is presented to it. Hence, a room in the Vatican 'is so exquisitely painted, that 'tis almost impossible for the skillfullest eye to discerne whither it be the worke of the Pensil upon a flatt, or of a toole, cutt in a deepe Levati of stone'.[34] Here, the eye is misled by illusionistic painting—however 'skillfull' the eye may be, it cannot distinguish between representation and reality, and this confirms the quality of the contemplated artwork. In all these passages, the eye is passive unless it literally looks, and thus does what it is supposed to do naturally. It does not touch or eat, as in Ruskin's writing.

However, Evelyn metaphorically links perception to nutrition at least once, as Ruskin would do in the letter from Italy to his father, quoted above. In his account of S. Giorgio Maggiore in Venice, Evelyn writes that he and his companion had 'fed our Eyes with the noble prospect of the Iland of St. George, the Gallies, Gudolas, & other Vessells, passing to & froo'.[35] Importantly, it is the eye which is 'fed' here, not the mind as in Ruskin's letter, and there is no link to a representation of the seen. Similar expressions were also used by Evelyn's contemporary Richard Lassels who published his *Voyage of Italy* in 1670. He writes, after his first day in Florence, that 'getting vp betimes the next morning, I gaue my eyes such a breakfast as Princes eyes would bee glad to feed vpon'.[36]

Similarly, he stated that he returned often to see a painting in S. Georgio as he 'could never satiate my eyes with such a rare peece'.[37] While Evelyn's and Lassels's eyes are 'fed', have 'breakfast' and cannot be 'satiated', it is Ruskin's mind which 'eats' buildings by recording them verbally and graphically—a mind which relies equally on feeling as on reason, as we have seen. Seeing, for Evelyn and Lassels, seems to belong solely to the process of observation and not to the intellectual faculty. Furthermore, seeing is a primarily passive

act: the eye receives, while the intellect then sorts the perceived, in an apparently separate process. For Ruskin, in contrast, seeing is feeling and understanding, at the same time, through an active eye. All these sensual experiences are not in any way distinct from the intellect. Moreover, there appears a necessity in Ruskin to represent—to 'eat'—these combined visual-emotional-intellectual experiences by drawing and describing them.

The varying relationship between vision, reason and emotion emerges here as a key difference between the two writers. In Evelyn's usage of the eye metaphor there is, as far as I can discover, no reference to emotion; this is not surprising because Evelyn, as a member of the Royal Society, would have followed Bacon's directives about an unadorned, factual and apparently objective prose. There is a deliberate and clear separation between reason and emotion, very different to what we see in Ruskin's use of metaphors of vision. While for both Evelyn and Ruskin, direct observation is the basis of architectural experience and knowledge, in Ruskin's writing this vision does not exclude emotion, gained from sense experience, but rather depends on it.

CONCLUSION

Central to this chapter is the concept that the rendering of sense experiences into language not only records what is observed, but also determines the very perception and understanding of things. In this attempt to investigate how architectural writers characterize the act of seeing, two writers, Evelyn and Ruskin, from two periods, the 1600s and the 1800s, served to show how the use of metaphor reveals their different grasp of their own perceptual processes. Thus, image metaphors can emphasize certain aspects of an object's appearance and perhaps even transcend the capacities of graphic imagery. Conversely, personifications of inanimate objects can shift emphasis and acting power to the described object and thus hide the presence of the viewer while actually using the viewer's presence as a motor for the action ascribed to the object. Most explicitly, perhaps, the use of the metaphorical eye showed the main difference between the two writers: the way in which they link vision, emotion and reason.

In a section of *The Stones* entitled 'The Pride of Science', Ruskin explains the difference between the sciences and the arts; this passage serves here to summarize his grasp of architectural perception:

> Science studies the relations of things to each other: but art studies only their relations to man: and it requires of everything which is submitted to it imperatively this, and only this,—what that thing is to the human eyes and human heart, what it has to say to men, and what it can become to them: a field of question just as much vaster than that of science, as the soul is larger than the material creation.[38]

In the contemplation of any artefact, therefore, vision (the metaphorical eye), emotion (the metaphorical heart) and the intellect need to act collectively. The 'thing' speaks to both hearts and eyes and, in so doing, opens up a 'field of questions' summoning reason to find answers. Unlike Evelyn, who separates visual perception from emotion, Ruskin allows

the two to merge and, moreover, he deems it indispensable. Through an investigation of description (rather than straightforward quotations, such as the one above, which served here only to underline prior findings), this chapter has shown that language shapes the understanding of perception. It is in the moment when the seen is reproduced that concepts of the perceptual process are articulated. Even if 'seeing' is understood as a primary sense experience, as it perhaps was by the Baconians who relied on it to derive a 'truth' from their experiments, it is only language that determines what it is to 'see'. And, ultimately, it is this linguistically construed reflection that is *seen*.

NOTES

1. This recurs frequently throughout Ruskin's writing. See, for example, John Ruskin, 'The Stones of Venice: Volume II,' in *The Works of John Ruskin: Library Edition*, ed. E. T. Cook and Alexander Wedderburn (London: George Allen, 1903–12), vol. 10, 130, 106, 169.

2. Ruskin, 'Stones,' in *The Works*, vol. 10, 206.

3. Edward N. Kaufman, 'Architectural Representation in Victorian England,' *Journal of the Society of Architectural Historians* 46, no. 1 (1987): 30. As Kaufman relates here, Ruskin did not, of course, invent this metaphor; it had also, famously, been used by Victor Hugo. See Neil Levine, 'The Book and the Building: Hugo's Theory of Architecture and Labrouste's Bibliothèque Ste-Geneviève,' in *The Beaux-Arts and Nineteenth-Century French Architecture*, ed. Robin Middleton (London: Thames and Hudson, 1982), 138–73.

4. See George Lakoff and Mark Johnson, *Metaphors We Live By* (Chicago: University of Chicago Press, 1980); and, more specifically, Rosario Caballero, *Re-Viewing Space: Figurative Language in Architects' Assessment of Built Space* (Berlin: Mouton de Gruyter, 2006).

5. Lakoff and Johnson, *Metaphors*, 5.

6. See Caballero, *Re-Viewing Space*, 68.

7. Ruskin, 'Stones,' in *The Works*, vol. 10, 18.

8. Francis Bacon, *The Advancement of Learning*, ed. G. W. Kitchin (London: Dent, 1973), 83.

9. Bacon, *Advancement of Learning*, 143–4.

10. John Evelyn, 'Kalendarium, 1620–1649,' in *The Diary of John Evelyn*, ed. Esmond S. de Beer (Oxford: Clarendon Press, 1955), 2: 437, 440.

11. Evelyn, 'Kalendarium, 1620–1649,' 172–3.

12. See the comments of his editor, Esmond S. de Beer in Evelyn, 'Kalendarium, 1620–1649,' 573–4; John Evelyn, 'Introduction and De Vita Propria,' in *The Diary of John Evelyn*, ed. Esmond S. de Beer (Oxford: Clarendon Press, 1955), 1: 85–101.

13. See Evelyn, 'Kalendarium, 1620–1649,' 172–3, n. 3.

14. *OED Online*, 'scene, n.,' November 2010, Oxford University Press, accessed 24 Jan. 2011, http://www.oed.com/view/Entry/172219?redirectedFrom=scene.

15. For a comprehensive selection of such illustrations, see Ennio Poleggi, ed., *Inconografia di Genova e delle riviere* (Genoa: Sagep editrice, 1977).

16. Lakoff and Johnson, *Metaphors*, 33.

17. Ruskin, 'Stones,' in *The Works*, 10: 20, 30, 82, 88.

18. Evelyn, 'Kalendarium, 1620–1649,' 96.

19. Evelyn, 'Kalendarium, 1650–1672,' in *The Diary of John Evelyn*, ed. de Beer (Oxford: Clarendon Press, 1955), 3: 109.

20. Ruskin, 'Stones,' in *The Works*, 10: 18.

21. George E. Street, *Notes of a Tour in Northern Italy* (London: Waterstone, 1986), 166.

22. Ruskin, 'Stones,' in *The Works*, 10: xvi.

23. Kathryn Allan, *Metaphor and Metonymy: A Diachronic Approach* (Chichester: Wiley-Blackwell, 2008), 39–51.

24. Eve Sweetser, *From Etymology to Pragmatics: Metaphorical and Cultural Aspects of Semantic Structure*, Series: Cambridge Studies in Linguistics, vol. 54 (Cambridge: Cambridge University Press, 1990), 38–40.

25. See Sweetser, *From Etymology to Pragmatics*, 33; and Martin Jay, *Downcast Eyes: The Denigration of Vision in Twentieth-Century French Thought* (Berkeley: University of California Press, 1993), 21–82.

26. Bacon, *Advancement of Learning*, 28, 105.

27. Ruskin, 'Stones,' in *The Works*, 10: 17, 29, 81.

28. Ibid., 10: 444.

29. Ibid., 10: 263.

30. Ibid., 10: 104.

31. Ibid., 10: 104, 29, 79.

32. Evelyn, 'Kalendarium, 1620–1649,' 175.

33. Ibid., 178.

34. Ibid., 296.

35. Ibid., 445.

36. Richard Lassels, *The Voyage Of Italy, Or A Compleat Journey through Italy: In Two Parts. With the Characters of the People, and the Description of the Chief Towns, Churches, Monasteries Tombs, Libraries Pallaces, Villa's, Gardens, Pictures, Statues, and Antiquities. As Also of the Interest, Government, Riches, Force, &c. of all the Princes. With Instructions concerning Travel* (Paris: V. du Moutier, 1670), 1: 155.

37. Lassels, *Voyage of Italy*, 2: 416–17.

38. John Ruskin, 'The Stones of Venice: Volume III,' in *The Works of John Ruskin: Library Edition*, ed. E. T. Cook and Alexander Wedderburn (London: George Allen, 1903–12), 11: 48.

6 REGULATING THE BODY IN ARMY MANUALS AND TRADE GUIDES: THE DESIGN OF THE FIRST WORLD WAR KHAKI SERVICE DRESS

JANE TYNAN

Literary accounts have been widely used to interpret First World War experience, whereas instructional texts have commanded little academic interest. Propaganda brings to mind images such as recruitment posters, not the War Office publications that guided new recruits. However, from 1914, these economical texts characterized the official approach to training, equipping and preparing British recruits for war. This chapter considers what these books, together with trade sources, reveal about the official drive to refashion civilian men's bodies during wartime. Scholarly work has explored the role of the body in modern social education and reform projects,[1] and recent historical studies position men's bodies as a key site for social and material transformations during the First World War.[2] By exploring the official wartime texts used to guide military dress and behaviour, this chapter considers how they described the preparation of the military body and their role in designing men's bodies for war.

The pedagogical qualities of both instructional manuals and advice literature are clear. In her study of British advice literature from 1920 to 1970, Grace Lees-Maffei demonstrates how it incorporated material and social concerns.[3] Elsewhere, she argues that using this literature to study domestic discourse and design advice raises key issues which 'dissolve some of the implicit boundaries in design and cultural histories such as those between production and consumption, prescription and practice, fact and fiction, advising and advertising and professionalism and amateurism.'[4] The texts considered here raise similar questions, in particular the boundaries between production and consumption. Due, in part, to the historical associations that link femininity with consumption, military design has instead favoured the symbols of production to describe how design is performed in army culture.

Military design might be decidedly masculine, but during the early twentieth century it also emphasized functionality. Modern forms of power, according to the French philosopher Michel Foucault, represent a specific reorganization of knowledge.[5] His power/knowledge configuration offers an ideal model through which to interpret documentary sources that mediate design processes. When Foucault introduces the theme of docile bodies, he uses the soldier as an example to describe the role of the body in a larger political project: 'the soldier has become something that can be made; out of formless clay, an inapt

body, the machine required can be constructed.'[6] His description suggests that the modern army sought to build the ideal soldier, and his bio-political project draws attention to the architecture of reform: the objects, practices and texts that activate military projects.

DOCUMENTING THE CIVILIAN SOLDIER

This chapter considers both army instructional manuals for the discipline and training of the body and drafting guides used by the tailoring trade to make military uniform. Both refashioned civilian bodies during the First World War. Foucault may not have examined fashion among the social practices he explored in his work, but for him knowledge and power were inseparable. Governmentality is not just about state government but involves many actors and organizations that exert power over human conduct.[7] If schemes for uniform clothing create new kinds of knowledge, then the texts about army uniform and behaviour produced by the War Office between 1914 and 1918 can offer insights into how men were expected to behave in the new army. The khaki service dress worn by British soldiers on the western front came to symbolize a new utility. This functional clothing formed part of a whole system of objects, practices and ideas which were designed for purpose. Army rationalization required a network of texts that centred on War Office publications, a process Foucault might have thought characteristic of modern forms of institutional power, which situate individuals in a 'network of writing' that he termed a 'field of documentation'.[8]

Dress regulations, field service regulations and trade guides might offer a sense of what soldiers looked like, but they also reflected official views about how civilians were expected to become soldiers following recruitment. Wartime systems for the production of military uniform responded to the demands of mass mobilization and relied upon a growing body of documents to make the civilian soldier. During the First World War, rationalized modes of representation echoed Foucault's description of how modern institutions technologize bodily experience: 'The human body was entering a machinery of power that explores it, breaks it down and rearranges it.'[9] The pedagogical thrust of these instructional manuals is clear. Despite their status as army textbooks, they can also be read as representations of hegemonic masculinities used to support this national project of collective discipline.

Concerns about the military became a national problem when the Munitions of War Act in July 1915 was passed to tackle problems of manpower resourcing. Mobilization requirements may have placed men's bodies under official scrutiny, but it was a powerful visual culture which normalized active service when posters, newspaper features and advertisements all used the image of the soldier as a desirable figure of masculinity. However, army regulations and manuals played a more official role to enforce uniform appearance. Manuals offered detailed descriptions of what was expected in terms of military behaviour and dress, but their rationalized language suggested the official investment in technological views of the body. Manuals raised soldiers' consciousness of their corporeality by holding every movement and aspect of their appearance to account.

By adopting the language of wartime economy, the army displayed concern with the design of the civilian body as a distinctly masculine matter. Manuals were used to promote correct appearance, but this was less a matter of pleasure and vanity, more a means by which to observe discipline. The War Office published detailed uniform regulations, a practice going back to the 1820s, and by the First World War there were two main publications that governed British army clothing, the *Dress Regulations for the Army 1911* for officers' clothing and *Clothing Regulations for the Army 1914* for rank and file.[10] Further, the 1909 operational manual *Field Service Regulations* set out the formula for recruits' behaviour in wartime conditions. Dress regulations may have originated with the King's Regulations, but by the twentieth century these new books took on the 'modern' quality of the manual. Their presentational style became economical, in line with the increased utility of the design of the British army uniform and kit.

A vogue for guidelines and training manuals reflected the modernizing forces in the army, which favoured the military skills that could be acquired through practice rather than the Victorian reliance upon soldierly character.[11] Regulations and manuals suggest an army invested in the transforming potential of disciplinary techniques, and by 1914 the male body was a focus for reform and education. If the War Office first depended upon systems of independent purchase to meet the excessive clothing demands of new recruits, by 1915 the Territorial Force and Pal Battalions were eventually brought under its direct control, when a unified system for clothing supply was established.[12] *The Priced Vocabulary of Clothing and Necessaries* of 1915, a War Office guide to clothing costs, in turn allowed the army to evaluate loss, damage and neglect.[13] A dazzling display of detail included prices of articles issued from clothing depots, rates for completed articles to pay soldiers, allowances for upkeep of clothing and rates for making up, fitting, completing, altering, washing and marking clothing. By costing clothing on a scale required for war, the army systematically evaluated its resources. Discipline was an organizing principle that not only prepared each body for the battlefield but also sustained the supply of material goods.

While many manuals were issued for the battlefield, some aided army training. Dress regulations were about uniform design and supply. Rank-and-file soldiers looked to army command to issue their uniforms, while for officers it was between them and their tailor. These distinct systems of provision were reflected in the language used in each publication. Regulations for rank-and-file soldiers had references to the keeping of ledgers, but those designed for officers focused more on the aesthetics of military dress. Measurement indicated the tighter control of clothing supply for the rank and file to meet the challenge of mass production, 'men are measured by the serjeant-tailor once every six months during the first two years of service, and once a year afterwards.'[14]

Before they outsourced clothing manufacture, the sergeant-tailor measured men and fitted uniforms, closely supervised by army personnel.[15] In the presence of the officer commanding the company, each man was paraded at the quartermaster's store, while the tailor took his measurements and then selected and fitted his garments. The commanding officer inspected the full company of men and noted alteration requirements.[16] Official dress

regulations, reinterpreted for the tailoring trade by drafting guides, were cross-referenced with a cost-payment system called the *Military Log*. Excerpts from War Office dress regulations were often reproduced in trade papers accompanied by instructions on drafting and cutting, all of which enabled tailors to exploit war business.[17] Thus, War Office publications were specialist documents, but through distribution and republication their content reached a variety of social groups inside and outside the army.

For officers, however, dress regulations instructed them and their tailors on the correct uniform design. The closely-fitted tunic worn by officers is described in the 1911 regulations as a garment that accentuates the male body,[18] in contrast to the looser tunic worn by other ranks (Fig. 6.1). From 1912, officers also wore the open-neck pattern with collar and tie, to replace the closed collar stipulated in the 1911 regulations as 'turn down (Prussian) collar to fasten with one hook and eye'.[19] To enable the tailoring trade to adapt its practices to the new pattern, these new universal service dress regulations of 1912 were reprinted in tailoring trade papers such as the *West End Gazette*. It announced, 'The latest development in connection with military tailoring is the introduction of a new style of Service Dress for field wear.'[20] The trade paper also offered full instructions on draft-

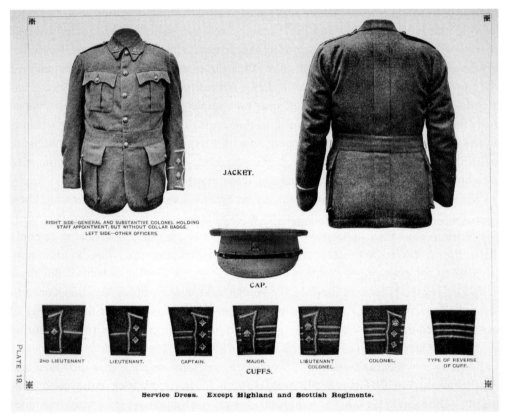

JACKET.

RIGHT SIDE—GENERAL AND SUBSTANTIVE COLONEL HOLDING STAFF APPOINTMENT, BUT WITHOUT COLLAR BADGE.
LEFT SIDE—OTHER OFFICERS.

CAP.

PLATE 19

2ND LIEUTENANT LIEUTENANT. CAPTAIN. MAJOR. LIEUTENANT COLONEL. COLONEL. TYPE OF REVERSE OF CUFF.

CUFFS.

Service Dress. Except Highland and Scottish Regiments.

Fig. 6.1 Service Dress Jackets in *Dress Regulations for the Army*, 1911, Plate 19 © The British Library Board. Shelfmark: 8820.d.10.

ing the jacket. These trade papers and publications sought to make sense of changes and alterations to uniform during the conflict to ensure that they could continue to exploit war business.

A drafting guide published official War Office illustrations of the new service dress sealed patterns with the changed collar.[21] Early in the War, this collar change caused some anxiety, reflected in a debate in Parliament in November 1914, where it was suggested that this distinction would make officers a target in the field.[22] In the context of new strategic approaches to dress, distinctive marks became an issue in uniform design. Khaki service dress resolved many of these problems by offering standardized, plain, utility clothing, dress techniques more closely associated with the design of the uniform for the rank and file. The economical presentation of the texts might suggest that military discipline alone could refashion bodies for army purposes. However, regulations for the design of officer's uniform deployed the more traditional language of tailoring to imply negotiation and gentlemanly leisure. Thus, despite the move to utility, scrutiny of dress regulations reveals that army clothing continued to be used to describe rank and to embody social class.

'WHY AREN'T YOU IN KHAKI?'

Due to national concerns about military fitness and the drive to increase active participation, in wartime Britain, khaki became a visible signifier of conformity. Men's bodies came under official scrutiny and became a focus for public interest.[23] As a result of the decline in recruitment between October 1914 and February 1915, when the total number of soldiers dropped to below one hundred thousand for the first time since the outbreak of war,[24] a persuasive poster campaign targeted civilians who so far had failed to enlist. A 1915 poster, 'Why aren't you in Khaki?',[25] broadcast a recruitment message with explicit reference to the khaki service dress worn by soldiers on the western front. This poster judged civilian men's sartorial choices harshly, despite the fact that conscription would not be made law until January 1916. Every man was brought under scrutiny in this atmosphere of mass volunteering and later with conscription.[26] Instructional manuals took on a similar tone, offering civilian recruits a no-nonsense, easy-to-use formula for soldiering. In reality, they were designed to set out army practices for quick army expansion and mobilization. Just as manuals sought to reform and educate the body, popular culture became preoccupied with refashioning masculine appearance.

By taking on a more rationalized appearance, the design of military uniform reflected the conditions of its production. An ambitious mass-clothing project, khaki production bore the weight of the national desire for efficiency. Khaki developed in British colonial campaigns, but it came to symbolize this conflict, particularly the war on the western front. Khaki was in many ways a technological solution to the problems of the wartime body. As Foucault argued, disciplinary techniques replaced notions of honour, and this move from spectacle to surveillance modernized the soldier's appearance.[27] When Cecil Gordon Harper, a subaltern with the 10th Battalion Gordon Highlanders was mobilized for France on 8 June 1915, he mentioned the soldiers' efforts at camouflage by covering

more conspicuous parts of traditional army clothing. In the trenches, tactical rather than fashionable dressing became key to military success. Just as any distinctive dress for officers caused problems in the field, tartan was also conspicuous, as were shiny buttons, which men kept dull to reduce visibility: 'Bright light on polished metal could give away one's position and attract snipers. Tartan was a mark in the open, and the distinction of officers' uniform made them a prime target for German marksmen.'[28]

A new visual economy on the battlefield meant that military plumage was no longer used to daunt the enemy, and tactical camouflage devices such as khaki replaced the traditional redcoat. Physical appearance had become a tactical matter. The army took appearance more seriously not just in terms of strategy, but also in the whole field of body management. Active service in the context of such large-scale civilian recruitment meant an official focus on the visibility of the male body and a preoccupation with masculine appearance. Khaki service dress suggested the body was a new kind of object, and in Foucault's terms, one that could be rearranged and remade. Despite the fact that in peacetime a man required eleven months training from basic drill to divisional exercises, Secretary of State for War Lord Horatio Kitchener reduced this period to six months for the new armies.[29] With such a swift transformation from civilian to soldier, a 'field of documentation' managed the entry of a growing number of civilians into the army. By adopting the language of wartime economy, publications and documents were key instruments to support the military project of collective discipline.

'FASHIONS AT THE FRONT'

Instruction manuals were concerned with advising and instructing recruits on appearance, grooming, hygiene and dress. If appearance was evidence of bodily discipline, then standardizing practices such as grading and measuring were used to aid the acquisition of uniform behaviour. Men were instructed on personal hygiene and grooming, as well as dress. A 1915 training manual emphasized the role of private grooming routines to build the army's strength: 'They are taught, for instance, that scrupulous cleanliness of body, clothing, and surroundings is essential for the health of the troops in barracks, in training camps, or in the field. They must, therefore, be clean, smart and tidy as a matter of habit at all times.'[30] By presenting army efficiency in terms of self-management rituals, manuals illustrated the value placed on the inculcation of habit to build discipline in wartime. The documentation that guided army clothing production bore the marks of a system for building disciplined soldiers. Utility clothing sought to emphasize hygiene, grooming and uniformity. Thus, the manuals not only exemplify official interest in the appearance of the civilian army but also its careful management.

While it might be tempting to suggest that the War Office deployed fashion discourse to encourage new recruits to manage their bodies, this does not accurately reflect their concerns. Instead, the manuals studiously avoided language that might suggest that the transformation from civilian to soldier was informed by anything as feminine as fashion. While civilian and trade papers linked fashion and uniform, the War Office was not so keen. A 1917 trade paper article, entitled 'Fashions at the Front,' used fashion to describe sol-

diers' improvizations and novel issues such as goatskin jerkins and khaki shorts.[31] Manuals were careful to avoid such comparisons. Everything about this new army uniform denied the work of fashion so that khaki service dress could embody social practices desirable to mass mobilization; manuals described khaki service dress through the language of discipline rather than beauty. However, the focus on clothing did offer the War Office a language through which to suggest the total and complete transformation of the body.

Foucault's view of history considers how people are materially constituted as subjects.[32] In an atmosphere of compulsion, the materiality of wartime clothing was an ideal focus for recruitment. The challenges of war uniform production could no longer rely upon the Army Clothing Factories and contracts went to public competition, as the tailoring trade became increasingly involved in khaki contracts. By the First World War, dress regulations enabled mobilization by supplying tailors, manufacturers and the army with techniques for describing soldiers' bodies. Trade guides for the drafting and cutting of military uniform were the conduit between state and trade. The wartime publication for the tailoring trade, *The Cutter's Practical Guide to the Cutting and Making of all Kinds of British Military Uniforms*, demonstrated approaches to cutting various garments including frock coats, mess jackets, vests, trousers and puttees.[33] Instructions on buttons, badges and cuffs corresponded precisely with dress regulations, but interpreted textual descriptions in visual form to explain how pieces were made up. A flat draft diagram of the officers' universal service dress jacket indicated all bodily measurements.[34] Official requirements were presented in a language that meant various divisions of the tailoring trade could get involved in clothing contracts.

In the drive to form the ideal recruit, detailed instructions on dress and behaviour became an official concern. The state and the tailoring trade were drawn together by the clothing requirements of the war, which resulted in a massive clothing production project. United by their interest in the production of military clothing, the army and the tailoring trade both carefully analysed the soldier's body. Army clothing production may have come under increased regulation, but sources could diversify so long as the War Office kept control of the systems of supply. Clothing the army became a shared project, involving a range of social groups, but the visual language adopted by the army and the tailoring trade in these texts was used to rationalize the male body. Despite the considerable involvement of the tailoring trade, khaki contracts were primarily about achieving uniformity, promoting discipline and encouraging active participation. The various manuals and guides issued by the War Office and generated by the trade kept to the spirit of this military project and created a visual and textual language uncontaminated by fashion references.

The rapid expansion of warfare, and the deployment of national resources and manpower, meant this conflict could be described as 'total war'.[35] The wartime clothing project had the unlikely effect of drawing together the state and the tailoring trade; army clothing requirements during the First World War were on such a scale that the state was forced to use the civilian tailoring trade. In March 1916, Parliament debated the clothing of recruits: 'There are five important articles of clothing, boots, shirts, socks, jackets and trousers,

of which the normal annual provision was 1,900,000, and we have provided up to now 117,090,000.'[36] Clearly, clothing the army was a matter of national importance. A staggering three million goat- and other skins were provided to make fur-lined coats for soldiers and the total expenditure on clothing since the outbreak of war was £65,000,000.[37] Not surprisingly, a 1917 trade paper supplement boasted that the role of the clothing trade in the Great War was a 'triumph of industrial organization' and that British manufacturers 'completed the biggest clothing contracts in history'.[38] Drawing on civilian trades was bound to lead to official anxieties about adherence to regulation. While it would be a mistake to suggest that strict uniformity was achieved with First World War British army uniform, the project itself was remarkable. Indeed, their reliance upon a body of documents made the design of a mass civilian army conceivable.'

CONCLUSION

Lees-Maffei's suggestion that design advice highlights the boundaries between fact and fiction is particularly poignant for texts that sent British men to fight in the First World War. They were designed as pedagogical manuals, but the fictive qualities of these didactic texts are now most apparent. Particularly striking is their blind optimism, as are their naïve claims that success lay in being prepared. Military design favoured the symbols of production that described how design would perform changes to civilian bodies. However, Foucault's nightmare of bio-political control is probably more accurate. Khaki service-dress worn by British soldiers on the western front symbolized a new utility, one which was imposed onto fragile, fleshy bodies. The service dress and kit had limited capacity to render the civilian body durable in the face of projectiles on the battlefront. Now, these texts tell us more about how fantasies of hegemonic masculinities were used to support mass mobilization. The interdependence of a range of instructional manuals and trade guides now offer us insights into how the military used material objects, but most troubling were their designs on civilian bodies.

NOTES

1. Chris Shilling, *The Body and Social Theory* (London: Sage, 1993).
2. Joanna Bourke, *Dismembering the Male: Men's Bodies, Britain and the Great War* (London: Reaktion, 1996); Gabriel Koureas, *Memory, Masculinity and National Identity in British Visual Culture, 1914–1930* (Aldershot: Ashgate, 2007).
3. Grace Lees-Maffei, 'From Service to Self-Service: Advice Literature as Design Discourse, 1920–1970,' *Journal of Design History* 14, no. 3 (2001): 187–206.
4. Lees-Maffei, 'Introduction, Studying Advice: Historiography, Methodology, Commentary, Bibliography,' *Journal of Design History* 16, no. 1 (2003): 10.
5. Joseph Rouse, 'Power/Knowledge,' in the *Cambridge Companion to Foucault*, ed. Gary Cutting (Cambridge: Cambridge University Press, 1994), 92.
6. Michel Foucault, *Discipline and Punish: The Birth of the Prison* (London: Penguin, 1991), 135.

7. Jonathan Xavier Inda, *Anthropologies of Modernity: Foucault, Governmentality and Life Politics* (Oxford: Blackwell, 2005), 6.

8. Foucault, *Discipline and Punish*, 189.

9. Foucault, *Discipline and Punish*, 138.

10. *Dress Regulations for the Army 1911* (London: HMSO, 1911); *Regulations for the Clothing of the Army 1914* (London: HMSO, 1914). Imperial War Museum, Department of Books.

11. Edward Spiers, *The Army and Society 1815–1914* (London: Longman, 1980); Gwyn Harries-Jenkins, *The Army in Victorian Society* (University of Hull Press, 1993).

12. Peter Simkins, *Kitchener's Army: The Raising of the New Armies, 1914–16* (Manchester: Manchester University Press), 256–77.

13. *Priced Vocabulary of Clothing and Necessaries* (London: HMSO, 1915).

14. *Regulations for the Clothing of the Army 1914*, 43.

15. Ibid., 156–9.

16. Ibid., 157.

17. 'British Military Service Dress Uniforms,' *The Tailor and Cutter*, 18 Nov. 1915, 834–7.

18. *Dress Regulations for the Army 1911*, 9.

19. Ibid., 9.

20. 'New Universal Service Dress,' *West End Gazette*, reprinted in R. L. Shep, *The Great War: Styles and Patterns of the 1910s* (California: Mendocino, 1998), 81–3.

21. 'Official Illustrations of Service Dress Jackets and Frocks,' *The Cutter's Practical Guide: British Military Service Uniforms* (London: John Williamson), 9.

22. 'Officers' Tunics,' 18 Nov.1914, 5th series, vol. 68, [426], Commons, Parliamentary Debates, British Library.

23. Bourke, *Dismembering the Male*.

24. Simkins, *Kitchener's Army*, 104.

25. 'Why aren't you in khaki?' IWM PST 5153.

26. Before conscription (Military Service Act 1916) voluntary enlistment was the primary means by which new soldiers were recruited to the army, which involved training a large number of civilians without military experience. Spiers, *The Army and Society 1815–1914*; John Morton Osborne, *The Voluntary Recruiting Movement, 1914–1916* (London: Garland, 1982).

27. Foucault, *Discipline and Punish*, 135–8.

28. Cecil Gordon Harper, *A Subaltern's Memoir of the 10th Battalion Gordon Highlanders from July 1914 to July 1915*, ed. Beryl Blythe and Stuart Blythe, Jan. 1998, 28, IWM 98/2/1, Dept. of Documents.

29. Andrew Rawson, *British Army Handbook 1914–1918* (Gloucestershire: Sutton Press, 2006), 27.

30. Captain E. John Solano, *Drill and Field Training*, Imperial Army Series (London: John Murray, 1915), 7.

31. 'Fashions at the Front,' *Men's Wear*, 18 Aug. 1917, 143.

32. John Rajchman, 'The Story of Foucault's History,' *Social Text* 8 (Winter 1983–1984): 11.

33. W.D.F. Vincent, *The Cutter's Practical Guide to the Cutting and Making of all Kinds of British Military Uniforms* (London: The John Williamson, n.d.), London College of Fashion Tailoring Archive, University of the Arts London.

34. Vincent, 'Cutter's Practical Guide,' 51–5.

35. Roger Chickering and Stig Förster, eds., *Great War, Total War: Combat and Mobilization on the Western Front, 1914–1918* (Cambridge: Cambridge University Press, 2000), 35–6.

36. 'Provision of Clothing and Equipment,' 14 Mar. 1916, 5th series, vol. 80 [1939] Commons, Parliamentary Debates, British Library.

37. Ibid.

38. 'The Clothing Trade and the Great War,' supplement to *Men's Wear*, 1 Sept. 1917, i.

7 'VITA' GLASS AND THE DISCOURSE OF MODERN CULTURE

JOHN STANISLAV SADAR

Among the defining characteristics of the interwar period was a rising fascination with health and physical culture. This fascination was articulated through daily practices, which saw the ascendancy of fitness regimes and spectator sport. But it was also articulated in the built environment, where buildings adopted a new relationship to the natural world— whether in the form of larger windows or roof terraces—underpinned by portrayals of the physically fit, tanned, disease-free body in the emerging mass-media. For instance, in May 1928, *The Times* London published the forty-page *Sunlight and Health Number* supplement illuminating the burgeoning interest in the relationship between light and health, with contributions from correspondents, physicists and physicians who addressed the nutritional and therapeutic role of sunlight and the benefits of open-air living, relating both to new innovations in artificial sunlight and window glass (Fig. 7.1). Fifteen pages of advertisements for health products—resorts, food and nutrition, clothing, products for the home, convertible automobiles and window glass—further demonstrated the degree to which health and sunlight became a popular concern and central to marketing messages.

Such discussions typified the ubiquity of the health issue and of hopes for a curative environment in the discourses of both the popular media and the medical profession in interwar Britain. This discourse found an explicit embodiment in the mid-1920s emergence of ultraviolet health glass, which for a brief moment captured the imaginations of those who would turn buildings into utopian panaceas. Groundbreaking in its day, British 'Vita' Glass was developed in direct response to medical science discourse and its manifestations in popular and corporate culture (Fig. 7.2).

EMERGING DISCOURSE: SUNLIGHT AND HEALTH

While concern about the British atmosphere—namely, its pollution and lack of sunshine— reached as far back as the Middle Ages and continued into the nineteenth century, it received a new impulse following Icelandic-Danish medical researcher and Nobel laureate Dr. Neils Finsen's identification of the germicidal qualities of the ultraviolet spectrum of sunlight and success with light therapy. The positioning of the natural world as a source of pure, divine wisdom in Romantic literature had rekindled a Mediterranean reverence for the sun, which reached back to classical sun worship as practiced at the Egyptian city of Heliopolis, at Greek asclepieions and at Roman sun baths.[1] English concerns with urban air quality reached back as far as thirteenth- and fourteenth-century legislation to curb coal-burning in London, and continued through John Evelyn's *Fumifugium* of 1661, to

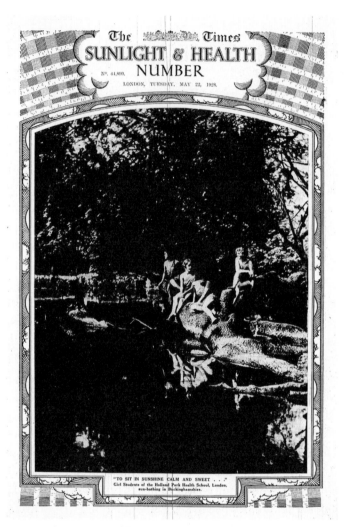

Fig. 7.1 Cover image of *The Times Sunlight and Health Number*, 22 May 1928. © NI Syndication/*The Times*, 1928.

its dovetailing with concerns around moral duty and cleanliness in the nineteenth cen-
tury sanitary and public health acts.[2] This reached its most influential form with Florence
Nightingale's *Notes on Hospitals*, which connected cleanliness, hygiene, morality and order
with good health.[3] However, understanding of the relationship between light and germs
remained vague until Dr. Finsen's 1896 investigations of smallpox and lupus vulgaris found
that the ultraviolet component of sunlight had a germicidal, and hence therapeutic, effect.[4]
Building on the relationship between disease and microbes established by Louis Pasteur
and Robert Koch, only a general link had so far been made between the blue part of the
spectrum and bactericidal action. Using statistical methods and controlled, direct observa-
tion, Finsen sought to mechanize the sun, by understanding, controlling and standardizing
it in a systematic way.[5]

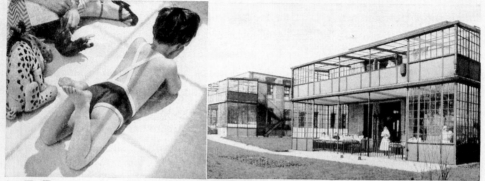

LET IN THE HEALTH RAYS OF

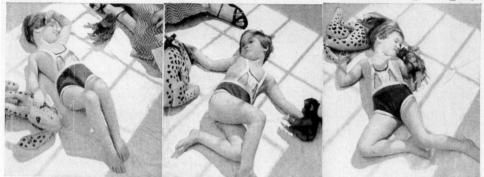

DAYLIGHT PERMANENTLY THROUGH

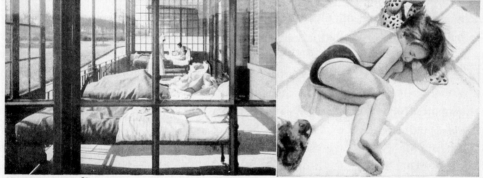

"VITA" GLASS WINDOWS

Ordinary window glass shuts out the ultra-violet health rays of daylight. "Vita" Glass admits them permanently. The properties of "Vita" Glass do not fade away in a year or two; they are guaranteed permanent, and that guarantee has been confirmed by tests made by the Building Research Station. (Write for copy of report 62/B.R.S. 36/12/4—Nov. 1933.) Two views are shown above of the "Vita" Sun Balconies at Harrogate Infirmary. Roof glazing in $\frac{3}{16}$

"Vita" cathedral by Mellowes & Co. Ltd., Sheffield. Side glazing in $\frac{5}{32}$ plate "Vita" Glass. "Vita" Glass is obtainable from local glass merchants, plumbers, glaziers and builders. "Vita" is the registered trade mark of Pilkington Brothers, Limited, St. Helens, Lancs, whose Technical Department is available for consultation regarding properties and uses of glass.

Fig. 7.2 'Vita' Glass advertisement from *The Architectural Review*, January 1935. Courtesy of Pilkington Bros.

Spurred by Finsen's success, various practitioners and hospitals developed light therapy through the 1930s. But while London Hospital installed its first Finsen lamp for lupus treatments in 1899, Finsen's influence was felt most extensively in Switzerland, where sun therapy hospitals were established by Oskar Bernhard in St. Moritz in 1902 and Rollier in Leysin in 1903. Rollier popularized his successes in treating surgical tuberculosis in his influential 1923 publication *Heliotherapy*. After its publication, his clinic soon became the largest and most famous of a growing number of Swiss sun clinics, as Switzerland became a leading destination for those seeking the heliotechnic treatment of disease. Switzerland also became a centre for the scientific study of sunlight when Carl Dorno opened his Meteorological-Physical Observatory in Davos in 1907. Given the disfiguring effects of treating tuberculosis surgically, the success of sun therapy offered an attractive option, and the medical use of light spread to Britain, led by the influential medical journalist Caleb Saleeby, physiologist and Royal Society Fellow Leonard Hill, and heliotherapist Henry Gauvain, each of whom wrote on and lobbied for the therapeutic value of sunlight. By the late 1920s, recognition of the medical benefits of light was widespread, and medical light departments were established at such hospitals as West London, the Royal National Orthopædic, King's College, Guy's, St. Bartholomew's and St. Mary's.[6]

Thus, while the therapeutic qualities of sunshine were known at the turn of the century, they were not popularized until the 1920s, motivated by developing medical knowledge and rising health consciousness. Ten years after Casimir Funk's 1912 coining of the term 'vitamins', Edward Mellanby identified rickets as a product of vitamin D deficiency. Otto Rosenheim and Thomas Webster's 1926 discovery of the pro-vitamin ergosterol, which was transformed into vitamin D by ultraviolet light, made hitherto vague connections between rickets and light explicit, and literature on the medical applications of ultraviolet light proliferated. Meanwhile, the aftermath of the First World War and the influenza pandemic, the nagging realities of tuberculosis and rickets, and concerns for the declining economic productivity of the nation, made health a popular concern. Global competitiveness, which had emerged as an issue of public discussion in the late nineteenth century, became increasingly important into the twentieth, as the economic and productive health of the nation was seen as ultimately tied to the physical health of its citizenry.

With communicable disease the primary fear in urban centres, the notion of the curative power of sunlight, as a natural disinfectant and stimulator of biochemical processes, came to be embedded in everyday life.[7] The widespread change in attitude bestowed by heliotherapy challenged Victorian-era physical modesty and contributed to the early-twentieth-century physical culture (Fig. 7.3). Whereas Finsen was once alone in seeing the sun as a force of vitality, by the interwar period, the suntan came to be seen as having medicinal and social value and as emblematic of the good life.[8] The connection between sunlight and disease also precipitated a renewed interest in atmospheric pollution, spurring the formation of lobby groups that saw it as robbing city centres of the germicidal sunrays. As dark interiors and polluted urban atmospheres were deemed harmful, pollution became more than a nuisance; it became a health hazard which ought to be curbed for the good of the

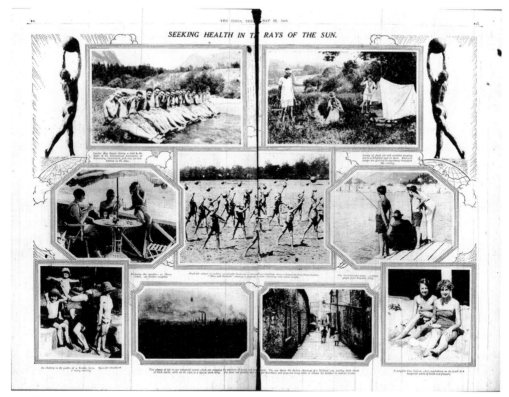

Fig. 7.3 The centrefold of *The Times Sunlight and Health Number*, 22 May 1928. © NI Syndication/*The Times*, 1928.

nation. But, if the sun could not penetrate the urban atmosphere, artificial phototherapy with carbon arc lamps provided a means by which the curative power of the sun could be reproduced not only by clinics and hospitals, but also by homeowners seeking the best in preventive and therapeutic health measures. Thus, the germicidal rays of Alpine and Mediterranean health clinics could be replicated in sun-deprived, northern regions, and within a few short years, the relationship between light and health was widely broadcast via propaganda campaigns for both organizations and products.

DISTRIBUTION AND PRACTICE: THE POPULAR CULTURE OF THE SUN

Precipitated by the rising concern surrounding public health, the rarefied discourse of medical practitioners entered mainstream culture through a number of vectors. As miasmatic hygiene met bacteriology and the need for a germ-free environment infiltrated everyday life—from social conduct and public amenities to antiseptic cleaners and a reverence for sunlight and ventilation—expectations of cures were high, but treatments were still minimal.[9] In this context, a group of interrelated organizations formed with the aim of stemming the perceived degeneration and sickliness of British society and transforming it through a variety of means into a healthy and vital population. On one hand, these groups sought to strengthen the degenerating body directly. The Health and Strength League,

founded in 1906 and personified in Eugen Sandow, saw the fit body as emblematic of a fit society and advocated a regime of weight training, personal hygiene and austerity to counter the detrimental influence of civilization on the health and strength of the body.[10] The League assumed the rhetoric of National Efficiency and was instrumental in shaping the British government's National Fitness Campaigns of 1931 and 1937.[11] Meanwhile, the Eugenics Society, founded in 1908 with the support of Saleeby, argued for race regeneration through hereditary measures and social reform, ranging from parental education to ensuring maternal health.[12] On the other hand, these groups lobbied for improved living conditions. The People's League of Health, founded in 1917 by such figures as heliotherapist Henry Gauvain, health reform advocate Saleeby, and physiologist Leonard Hill, lobbied the government on the issues of sanitary and housing reform and improved nutrition.[13] Its successor, the New Health Society, founded in 1925, viewed disease as the by-product of civilization and advocated changes to dietary, physical culture, sunbathing and hygiene regimens in becoming the centre of interwar health activism.[14] The Society's offshoot, the Men's Dress Reform Party, founded in 1929, advocated clothing reform as a means to better health, arguing for patterns and textiles which would allow for easier movement and greater exposure to the sun and air.[15] A parallel group, the Sunlight League, founded by Saleeby in 1924, advocated sun exposure and open-air living and schooling, and campaigned against atmospheric pollution, which prevented sunlight from reaching British cities.[16]

Collectively, these organizations traced a needy body, found in dark and damp urban living conditions, where it was poorly parented and nourished and possessed hereditary health problems. This body was physically weak, poorly clothed and sunlight-deprived. As countermeasures, these organizations promoted the primitiveness of naturism and extant nineteenth-century practices of holidays, sport and leisure, sun-tanning and open-air living, looser and less clothing, hygiene, vegetarianism and temperance. They also advocated the new consumer products appearing under the guise of particular health claims, such as vitamin pills, artificial sunlamps and irradiated foodstuffs, as possible antidotes to a needy body. The membership propagating the needy body and its various antidotes included those at the forefront of British public life: prime ministers Asquith (1908–16), Lloyd George (1916–22) and Chamberlain (1937–40); Medical Research Council Tuberculosis Committee Chairman Charles John Bond; industrialist Henry Wellcome; zoologist Julian Huxley; and the progeny of Charles Darwin.[17] Their views of a healthier life based on proximity to nature and the new technological means were brought into the mainstream through their active participation in exhibitions and demonstrations, the publication of their own journals, and the emerging, mainstream mass-media.

Fuelled by the development of advertising, such discourse quickly spread through the culture, impacting upon daily life. Industrialization held the promise of lower overall costs, but shrouded them in high capital investments and manufacturing volumes. A relative overproduction of goods resulted in decreasing costs and profits, and economic depression through the 1880s. As products could no longer be expected to sell themselves, advertising became essential to the engineering of needs, becoming an organized system of persuasion,

using particular combinations of images and text to evoke emotional responses. With the shift from a war economy to a consumption economy, advertising developed psychological tactics which positioned consumables as capable of satisfying needs, preventing disease and misfortune, and building the nation.[18] Expanding scientific knowledge and an increasing rate of transmission of that knowledge meant that the public was susceptible to health claims and fear, just as nationalist sentiments meant that they were susceptible to patriotism and guilt. To that end, persuasive techniques such as the use of pseudoscientific language, extravagant claim-making, logical argumentation, and association were all utilized to appeal to guilt, fear and patriotism.[19] Such tactics were employed to not only explain the utility of new inventions but also to brand basic commodity goods, from flour to window glass.[20] For instance, halitosis could be combated with mouthwashes and dentifrices, listlessness could be combated with vitamin pills, nerves could be treated with nerve tonics, and body odour could be combated with deodorants.[21] Sunlight became central to both advertising claims, such as the 'liquid sunshine' of cod liver oil, and products themselves, as with the 'natural daylight' of artificial sunlight fixtures. Despite often dubious claims, the use of such products soared, and during the interwar years the annual sum spent on patent medicines was equivalent to the annual budget for hospitals.[22] With medical professionals out of reach of the majority of the population, patent medicines offered the public affordable hope.

Given such forces, this discourse entered into the cultural mainstream rather quickly in the 1920s and certainly influenced designers, initially in the German-speaking states, where open-air culture quickly became part of the making of interwar life. In coastal and Alpine areas, it was disseminated with particular zeal. The 1930 Swiss Werkbund film *Die Neue Wohnung*, directed by Hans Richter to publicize the new housing exhibition in Basel with its message of light, air and sun, broadcast both the new open-air lifestyle and its explicit architectural manifestation in transparent, lightweight and reflective materials and uncluttered organizations.[23] Such ideas were also established in France, as manifested perhaps most explicitly in the proto-modern architectural works of Tony Garnier and Henri Sauvage. The horizontality, lush planting and roof gardens of Garnier's visionary project of 1918, *Une cité industrielle,* embraced open-air living, while its architectural geometry and surface treatment suggested hygienic considerations. Sauvage's Paris housing commissions for the *Société anonyme de logements hygiéniques à bon marché* in the 1910s and 1920s provided each dwelling its own sunlit outdoor space through a ziggurat section clad in hygienic, vitrified tiles and collective athletic facilities for the physical strengthening sought by the Health and Strength League. Preceding both, Ebenezer Howard's schemes for garden cities, which would ring London, sought to reconcile the technological amenities of urban settings with the sunlight and air-quality of the countryside. Perhaps the ultimate popularization was Gabrielle Chanel's legendary return from a 1923 yachting holiday sporting a suntan.[24] On one hand, health concerns fuelled the rise of destination sun resorts in the Alpine states and the southern shores of Italy, France and Spain. On the other, it also fuelled technological developments aimed at maximizing exposure to sunlight at every opportunity, such as with the development of the convertible car (Fig. 7.4).[25]

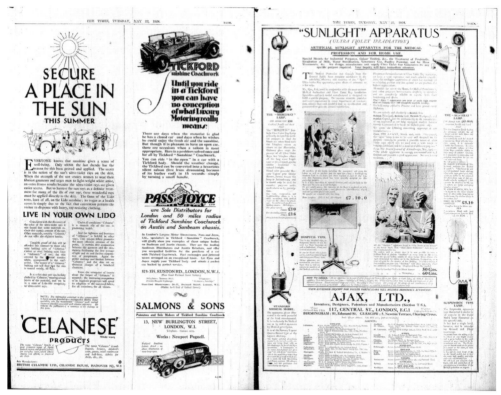

Fig. 7.4 Left: Advertisements for Celanese artificial sunlight apparatus and Tickford convertible automobiles. Right: Advertisement for Ajax artificial sunlight apparatus. Both in *The Times Sunlight and Health Number*, 22 May 1928.

PILKINGTON, CHANCE AND LAMPLOUGH'S 'VITA' GLASS

Given the extent of the discourse on health and sunlight, it is perhaps unsurprising that attention turned to the window. Building on the Swede Erik Johan Widmark's experiments in 1889, which had compared light transmitted through quartz with that through glass, Dr. Finsen found that ordinary soda-lime window glass impeded the transmission of bactericidal ultraviolet radiation.[26] Recalling that Finsen clarified the relationship between sunlight and microbes and established ultraviolet radiation as crucial in the treatment of disease, such a revelation meant that windows were not in themselves an answer to the health issues that so captured the population. To ultraviolet light, transparent glass is opaque. The issue, as identified by Sir William Crookes in 1914, was that oxidized, ferric iron effectively absorbs ultraviolet radiation, while transmitting most visible light, whereas ferrous iron transmits both.[27]

Thus, by the 1920s the link among sunlight, ultraviolet light, glass and health was explicit. The issue then, at least to medical professionals, was not merely about windows and daylight, but about the composition and quality of the transmitted light (Fig. 7.5). This led physiologist Leonard Hill to note, 'Ordinary window glass allows the passage of no rays

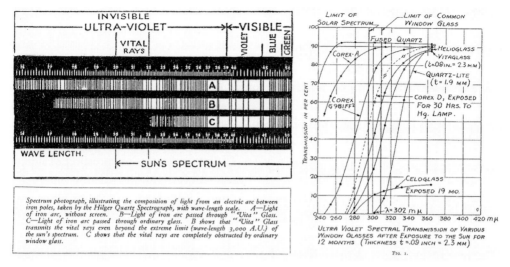

Fig. 7.5 Left: Comparison of the spectrum transmitted by 'Vita' Glass in relation to ordinary glass. Courtesy of Pilkington Bros. Right: Graph of the ultraviolet transmission of various glasses, including 'Vita' Glass from a report by W.W. Coblentz for the US Bureau of Standards on 'Recent Developments of Window Materials and Fabrics for Transmitting Ultraviolet Radiation,' 1929.

below 313μμ and few below 330 . . .,'[28] and, 'Ordinary window glass filters out the protective rays, and light entering a room through glass is robbed of these, hence rickets arise in tenement dwellings from deficient diet and want of sunlight.'[29]

For Hill, indoor and outdoor light were vastly different things, and the indoor life of Britons directly contributed to the general malaise of the population.[30] It was this discursive body that prompted glass technologist Francis Everard Lamplough to turn to glass chemistry to enable ultraviolet-rich light to penetrate glass, with the promise of transforming buildings into heliotherapeutic devices. In the years following the publication of Otto Schott's and Ernst Abbe's glass catalogue of 1886, glass chemistry evolved so that glass could be designed to fit particular performance criteria, whether to withstand thermal shock or to refract by a precise amount. By the interwar years the malleable characteristics of glass had expanded its field of use to encompass improved labware, bakeware and the burgeoning automotive industry.[31] Following the logic, Lamplough was able to develop a glass of extremely low iron content, which enabled increased ultraviolet transparency.

Lamplough's 'Vita' Glass was seen as a welcome development and found support from Hill and Chalmers Mitchell, of the London Zoological Society, who commissioned its initial production for their experimental monkey house in 1925, followed by installations at the permanent, new lion, monkey, and reptile houses.[32] The New Health Society was a keen advocate; it publicized the 1926 London Zoo installations and recommended 'Vita' Glass installation in hospitals and schools.[33] The Society also included 'Vita' Glass in its New Health Exhibitions and fitted its Bedford Square offices with it.[34] Saleeby and the Sunlight League were also supporters and in turn were offered financial and technical

support for their public 'Vita' Glass presentations.[35] The level of optimism around ultra-violet health glass was so high that many saw its potential as capturing the entirety of the glass market.

With a history of glass innovation pre-dating the Crystal Palace, Chance Brothers of Smethwick licensed production from Lamplough. Anticipating a global demand for 'Vita' Glass, Chance took the radical step of sub-licensing the technology to Pilkington Brothers of St. Helens to leverage its polished plate technology and superior manufacturing capacity. To oversee marketing, the companies jointly created the 'Vita' Glass Marketing Board as a dedicated, independent propaganda agency. For Chance, there was the prospect of signifi-cant income, while for Pilkington, which had invested heavily in the recently superseded drawn cylinder production, there was an opportunity to maintain an aura of innovation after its competitors invested in the superior flat drawn process.

To stimulate sales and sell the message of indoor health through windows, the Board used a variety of techniques, encompassing print, demonstrations, lectures and exhibitions, all of which sought to lift 'Vita' Glass out of the glass market and into that of proprietary health products and luxury goods (as seen in Fig. 7.2). In engineering demand, the ad-vertising firm put in charge of 'Vita' Glass, F. C. Pritchard, Wood & Partners, employed the technique of *organized persuasion*, which involved scientific data collection in order to identify markets, measure campaign effectiveness and develop strategies of changing popular attitudes to align with those embodied in the product.[36] Fleetwood Pritchard, brother to industrialist and designer Jack Pritchard, assisted by partners Sinclair Wood and John Gloag, the design critic and historian, employed a rational argument of technical ef-ficacy through *reason-why* copy alongside suggestive imagery of the good life, creating an ambience for the product and associating it with health, happiness and the sun (shown in Fig. 7.2).[37] Meanwhile, their work explicitly presented ill-health as related to a lack of ul-traviolet light, which 'Vita' Glass alone could remedy by providing a *more natural* interior atmosphere. Thus 'Vita' Glass appealed rationally to medical science and the possibilities of science-driven manufacturing technology, while it also suggested the Romantic reverence of the natural world. Such a message found support amongst architects, from Le Corbusier, who alluded to 'Vita' Glass in *La ville radieuse*, to William Lescaze, who suggested it for his 1928 design for An American Country House, to Richard Neutra, who used a similar glass throughout his Lovell Health House.

RELIANCE ON DISCOURSE AND THE FAILURE TO DIFFUSE

The discourse around technical sophistication and efficacy that 'Vita' Glass campaigned on was itself very narrow and inherently problematic. In the first case, 'Vita' Glass was hindered in its attempts to gain market share by an absence of reliable data to substan-tiate its claims. Precisely those markets it was interested in gaining—hospitals, schools and agriculture—were those most interested in hard data. It did not help that third-party testing revealed a host of technical problems. 'Vita' Glass was found to perform poorly when dusty, making continued maintenance critical, particularly in polluted, sooty urban

atmospheres. Similarly, the ultraviolet transparency of 'Vita' Glass was found to degrade under ultraviolet exposure in a process known as *solarization*. While all glass is affected by ultraviolet light and hindered by dust, such problems were particularly troubling for a glass which traded on ultraviolet transmission levels. Testing also revealed that in everyday installations, clothing blocks much of the beneficial ultraviolet light anyway and that minutes spent outdoors would offer greater ultraviolet light exposure than months indoors behind a wall of 'Vita' Glass. Most importantly, however, were those tests which revealed it to lag behind competitors in ultraviolet-light transmission levels (see Fig. 7.5, for example).[38] In this last regard, the 'Vita' Glass Marketing Board unknowingly advanced the cause of rivals by educating the public on the general connections between sunlight, glass and health. In addition, 'Vita' Glass sales may well have been a victim of the product being seen as second best to the direct sun. An open window or time spent outdoors were always viewed as preferable to a wall of 'Vita' Glass. In portraying health as a fundamentally technical problem, which one could solve with the installation of the right glass, 'Vita' Glass suffered from its own marketing and reliance on a particular and quickly developing scientific discourse.

Another issue was that the particularities of medical knowledge and physical culture upon which 'Vita' Glass was founded were also fleeting. In particular, the therapeutic value and panacea qualities of sunlight were increasingly questioned; health risks associated with ultraviolet light, including cataracts and skin cancer, were being identified by the 1920s. Yet, although the health risks of ultraviolet light were already acknowledged in 1920s literature, they were sidelined in favour of the health benefits of ultraviolet light for rickets, tuberculosis and overall well-being. By the 1930s, the link between ultraviolet radiation and risks of biological damage began to receive greater publicity, and heliotherapy ceased to be seen as a panacea.[39] In addition, more efficient and convenient options began to appear, such as sulfa drugs and antibiotics, and the 'artificial sunlight' of electrical carbon arc lamps (shown in Fig. 7.4). Heliotherapy, while successful, was not a quick cure. Rollier had his patients build up their sun exposure over months and came to consider heliotherapy a lifestyle, as he opened sun schools and work colonies and encouraged the convalescent patient to '. . . renounce forever the city life which caused him to develop the disease.'[40] Considering that Hill suggested a minimum of twelve months of heliotherapy for lasting curative effects, the emerging technologies of chemo- and phototherapy were simply more practicable that years spent in an Alpine heliotherapy clinic or behind a wall of 'Vita' Glass.[41]

The politico-economic climate surrounding 'Vita' Glass was also quickly changing, with the economic boom of the 1920s yielding to the depression of the 1930s and a contemporaneous rise in militarism. Owing to its expensive manufacture, 'Vita' Glass commanded a significant premium over the price of ordinary glass. In the booming 1920s, this was seen as a benefit, adding to its cachet as a luxury item and proprietary health product while removing it from the ordinary window-glass market.[42] But, in the aftermath of the 1929 economic crash, as the conspicuous consumption of the 1920s leisure society became the price-conscious desperation of the 1930s, the appetite for luxuries lessened, corporate and governmental priorities changed, and the price issue was discussed at length in Board

meetings as a barrier to its widespread adoption. Although pricing did shift, at times 'Vita' Glass cost as much as six times the price of ordinary commodity glass. In some instances, installations in buildings such as schools were entirely reliant on specific fundraising efforts for their 'Vita' Glass installations, as regular sources of funding would not suffice. In addition, rising militarism and the eventual onset of war shifted national priorities. Although physical culture continued to play a role in Britain through the 1930s, driven by competitiveness as evidenced in the National Fitness Campaigns, the onset of war meant that, for instance, Hill's writing shifted from extolling the benefits of climate therapy to lamenting the lack of clothing and food in Britain by the mid-1940s, just as the glass business was itself transitioning into security issues.[43] After the Second World War, there was scarcely a mention of ultraviolet-light therapy, and by the 1950s, the issue seemingly died along with its chief protagonists: Rollier, Saleeby, Gauvain and Hill. Production of 'Vita' Glass ceased in the early 1930s, as quickly as it started, and remaining stock was sold off by the end of the decade.

Through it all, the Board was fraught with problems of corporate rivalry. So long as the future was optimistic, problems remained minimal. But, while the propaganda campaign succeeded in generating product consciousness, it did not produce sales, and with a growing surplus by the late-1920s, the problems became more pronounced. Chance Brothers viewed the larger Pilkington Brothers with suspicion and feared Pilkington Brothers regarded the Board itself as an inconvenience, relative to its own sales organization. The Board's composition was another point of difficulty, as its director had been selected for his capacity to sell ideas, not glass, and was often at odds with Pilkington's own sales representatives on how to best create the 'Vita' Glass market. Such problems were exacerbated by the particular arrangement surrounding the Board, which prohibited it from speaking on other Pilkington products or selling its own. Likewise, the Pilkington sales team could not speak on 'Vita' Glass, but could sell it. Furthermore, as the smaller Chance Brothers collected royalties only from Pilkington 'Vita' Glass sales, its success mattered more for Chance than for Pilkington. Chance suspected Pilkington of taking a loss on 'Vita' Glass marketing, utilizing the publicity to instead draw attention to other Pilkington products, and desiring to replace the Board with its own organization. These suspicions were well-founded: by the 1930s, Pilkington had absorbed the Board and retained Pritchard for its own marketing.

CONCLUSION

'Vita' Glass emerged in the space between the development of diagnostic science and that of therapeutic technologies, and between the promise of materials science and a yearning for the natural world (seen in Fig. 7.2). That space was also characterized by a discursive gap that enabled buildings to be viewed as possessing truly remedial possibilities. With the discourse about health and the environment again shaping our materials for design, the 'Vita' Glass demise provides an example of how changing discourses dovetailed with technological developments in determining the production of building materials. In hind-

sight, 'Vita' Glass failed because it placed too much faith in a singular discourse: ultraviolet radiation kills germs and stimulates vitamin D production, therefore ultraviolet radiation delivers health. To that end, in place of heliotherapy's complex regimen of diet, exercise, hygiene and sunlight, it placed a sheet of glass, reducing health to a mere technical issue. This argument was both enabled and unhinged by the accelerating interwar culture: what was regarded as sound science in the mid-1920s was considered unreliable by the mid-1930s. As luxury spending fell, and health shifted from being a personal cost to being a shared national responsibility, products of this sort quickly fell from favour. While its legacy surrounds us in today's variety of architectural glass, the story of 'Vita' Glass reminds us to retain a degree of scepticism regarding our moment and to push for nuance in our understanding of the interface between the artefact and the world.

NOTES

1. Wilbert M. Gesler, *Healing Places* (Lanham, MD: Rowman and Littlefield Publishers, 2003).
2. Anthony Kessel, *Air, the Environment and Public Health* (Cambridge: Cambridge University Press, 2006), 52.
3. Florence Nightingale, *Notes on Hospitals*, 3rd ed. (London: Longman, Green, Longman, Roberts and Green, 1863).
4. Philip E. Hockberger, 'A History of Ultraviolet Photobiology for Humans, Animals and Microorganisms,' *Photochemistry and Photobiology* 76, no. 6 (2002): 564; Kirsten Iversen Møller, Brian Kongshoj, Peter Alshede Phiipsen, Vibeke Ostergaard Thomsen and Hans Christian Wulf, 'How Finsen's Light Cured Lupus Vulgaris,' *Photodermatololgy Photoimmunology and Photomedicine* 21, no. 3 (2005): 118–24, 120.
5. Paul De Kruif, *Men Against Death* (New York: Harcourt Brace, 1933).
6. 'Sunlight and Health Number,' *The Times* London, May 1928.
7. Erwin Heinz Ackerknecht, *Therapeutics from the Primitives to the 20th Century (with an Appendix: History of Dietetics)* (New York: Hafner Press, 1973); Nancy Tomes, *The Gospel of Germs: Men, Women, and the Microbe in American Life* (Cambridge, MA: Harvard University Press, 1998), xiii.
8. De Kruif, *Men Against Death*; Andrew McClary, 'Sunning for Health: Heliotherapy as Seen by Professionals and Popularizers, 1920–1940,' *Journal of American Culture* 5, no. 1 (1982); Henry W. Randle, 'Suntanning: Differences in Perceptions Throughout History,' *Mayo Clinic Proceedings* 72, no. 5 (1997); Paul Fussell, 'The Art of Sunbathing,' *Harper's* 261, no. 1564 (1980).
9. Tomes, *The Gospel of Germs*.
10. Ina Zweiniger-Bargielowska, 'Building a British Superman: Physical Culture in Interwar Britain,' *Journal of Contemporary History* 41, no. 4 (2006): 595–610.
11. Simon Carter, *Rise and Shine: Sunlight, Technology, and Health* (New York: Berg, 2007), 67.
12. Barbara Burman, 'Better and Brighter Clothes: The Men's Dress Reform Party, 1929–1940,' *Journal of Design History* 8, no. 4 (1995): 275–90.

13. Carter, *Rise and Shine*, 67.

14. Zweiniger-Bargielowska, 'Raising a Nation of "Good Animals": The New Health Society and Health Education Campaigns in Interwar Britain,' *Social History of Medicine* 20, no. 1 (2007): 73–89.

15. Burman, 'Better and Brighter Clothes,' 277.

16. Zweiniger-Bargielowska, 'Raising a Nation,' 77.

17. Jane Lewis, 'Health and Health Care in the Progressive Era,' in *Medicine in the Twentieth Century*, ed. Roger Cooter and John V. Pickstone (Amsterdam: Harwood Academic Publishers, 2000).

18. Gillian Dyer, *Advertising as Communication* (London and New York: Methuen, 1982), 46–50.

19. Raymond Williams, 'Advertising: The Magic System,' in *Problems in Materialism and Culture* (London: Verso, 1980).

20. Dyer, *Advertising as Communication*, 29–31.

21. E. S. Turner, *The Shocking History of Advertising*, rev. ed. (Harmondsworth: Penguin, 1965), 186–90.

22. Turner, *Shocking History*, 227.

23. Andres Janser and Arthur Rüegg, *Hans Richter, New Living: Architecture, Film, Space* (Baden, CH: Lars Müller, 2001).

24. David B. Morris, 'Light as Environment: Medicine, Health, and Values,' *Journal of Medical Humanities* 23, no. 1 (2002): 7–29, 9.

25. Morris, 'Light as Environment.'

26. Frederick Urbach, 'The Historical Aspects of Sunscreens,' *Journal of Photochemistry & Photobiology, B: Biology* 64, nos. 2–3 (2001): 99–104; De Kruif, *Men Against Death*, 100–1.

27. William Crookes, 'The Preparation of Eye-Preserving Glass for Spectacles,' *Philosophical Transactions of the Royal Society of London. Series A, Containing Papers of a Mathematical or Physical Character* 214 (1914).

28. Leonard Hill, *Sunshine and Open Air: Their Influence on Health, with Special Reference to the Alpine Climate* (London: E. Arnold, 1924), 84.

29. Ibid., 97–8.

30. Ibid., 28–32.

31. Charles R. Kurkjian and William R. Prindle, 'Perspectives on the History of Glass Composition,' *Journal of the American Ceramic Society* 81, no. 4 (1998): 795–813.

32. *The Times*, 'Sunlight and Health Number.'

33. Carter, *Rise and Shine*, 68.

34. Zweiniger-Bargielowska, 'Raising a Nation.'

35. '[Meeting between V.G.M.C. And P.B., 26.10.28],' (1928).

36. Fleetwood Pritchard, 'Persuasion,' *Public Relations* 2, no. 4 (1950).

37. Dyer, *Advertising as Communication*, 40–1.

38. 'Vita Glass Technical Opinions,' (n.p., n.d.); 'Issues Regarding Vita Glass Sales in the USA and UK,' (n.p., n.d.).

39. Michael R. Albert and Kirsten G. Ostheimer, 'The Evolution of Current Medical and Popular Attitudes toward Ultraviolet Light Exposure: Part 3,' *Journal of the American Academy of Dermatology* 48, no. 6 (2003): 909–18.

40. Auguste Rollier, 'Heliotherapy: Its Therapeutic, Prophylactic and Social Value,' *The American Journal of Nursing* 27, no. 10 (1927): 815–23.

41. Hill, *Sunshine*, 3.

42. *The Times*, 'Sunlight and Health Number.'

43. Zweiniger-Bargielowska, 'Building a British Superman.'

8 LEWIS MUMFORD'S LEVER HOUSE: WRITING A 'HOUSE OF GLASS'

ANN SOBIECH MUNSON

Writing about architecture is often thought to be auxiliary, supplementary or accessory to the actual experience of the built environment; writing occupies a place subordinate to the built thing itself. Some may concede that writing is not alone in its supporting role. Drawings and photographs also represent built spaces, but these visual media are often considered 'mere' representations of the built thing. The idea that representation is somehow less important than the tangible artefact makes some sense in terms of experience. One cannot smell, touch or taste text or image. However, in the cultural life of buildings, *representations* no longer 'merely' represent. Many more people 'know' buildings through such representations. Text and image extend the reach of the built environment in the mythologies of a particular time and place. As such, textual and visual representations move from 'mere' to 'mirror'—objects in themselves, reflecting and inflecting the cultures they inhabit. They mediate the built environment and its life in contemporary culture.[1] The specific framing of these representations adds to the construction of their architectural subjects, thus contributing to the social-historical record of the built artefact.

This chapter explores the force of writing as mediation through one very particular case: Lewis Mumford's architecture column for the *New Yorker* magazine, published on 9 August 1952.[2] Through a close reading of Mumford's 'House of Glass,' we uncover a carefully crafted image of Lever House in words that contribute to its status as an iconic American, modernist building and begin to construct its role, in Mumford's own arguments, for the future of architecture. Verbal representations of architecture become analogous to drawings, models, photographs and other projections or records of architectural experience. Each mode of representation interprets, speculates, evaluates and reveals in proprietary ways. In the case of Mumford's Lever House, I first provide historical background of the building itself, through its appearance in professional architecture and design publications. I then take up the specific contexts of the popular magazine the *New Yorker* in 1952 in relationship to the broader currents of modernism running through architectural production at the time. After considering Mumford's place as architecture critic in the world constructed by the *New Yorker* at the mid-twentieth-century, I propose a re-construction of Lever House using Mumford's own terms. In this way, his writing becomes the object of study, one that not only reflects the built object Lever House but also inflects back into the icon Lever House and becomes complicit in the construction of the world it inhabits.[3]

Upon first examination, we notice the virtuosity of Mumford's writing craft. Pushed further, study of Mumford's language uncovers the role of the critic in mythologizing the building. As his account moves forward, we see the ways in which this text—taken from the popular press, at a specific moment, in a specific context—participates in and advances prevailing attitudes of the time toward hygiene, work and urban design.

CANON: LEVER HOUSE AS AMERICAN ARCHITECTURE

In their canonical architectural history textbook, Marvin Trachtenberg and Isabelle Hyman signal Lever House's role in the dissemination of modernist architecture: 'The point of departure for the Late Modernist skyscraper was the aesthetic program of High Modernism, filtered through International Style doctrine and reinterpreted by Gordon Bunshaft (of the firm Skidmore, Owings & Merrill) in the Lever House of 1950–52 . . .'[4] It is no accident that this quote also appears on the popular go-to site for architectural references, 'Great Buildings Online', which summarizes the building's style in two words—'High Modern'—and provides the succinct note, 'Curtain wall pioneer—first in New York.'[5] The building was constructed in the early 1950s as the American headquarters for Lever Brothers, a British manufacturer of soap and detergent. It included an open public plaza on its ground level, along Park Avenue between 53rd and 54th Streets, and had no other tenants. Its blue-green glass surfaces, narrow depth and modest height distinguished Lever House from its contemporaries (Fig. 8.1). Upon its completion in 1952, many heralded it as the future of architectural office buildings; this proved to be true in at least one sense, when in 1980 it received a 25-Year Award from the American Institute of Architects, and in 1982 it was designated a New York City Landmark.[6] Its sale in 1998 made headlines, and the curtain wall replacement in 2001 launched debates about methods of preservation and the preservation of mid-century architectural specimens.[7] This replacement resulted in another round of numerous awards for Skidmore, Owings & Merrill (SOM), the architect of the initial 1952 building.[8]

SOM unabashedly describes the 1952 Lever House building as 'a watershed in U.S. architecture' and notes that, 'Within a decade of its construction, the initial enthusiasm for Lever House gave way to a universal recognition of its pivotal importance to American architecture.'[9] While this blurb on the architect's website benefits from hindsight and a list of honours acquired since the building's opening, the building received a great deal of press attention in the early 1950s. Two examples provide a sense of the building's place in the professional publications of the time: an article in *Architectural Record* (*AR*), published in June 1952, and another in *Progressive Architecture* (*PA*), published in October of the same year.[10] Both of these journals included Lever House in a collection of examples exploring office environments.

The June issue of *AR* devoted its 'Building Types Study Number 187' to office buildings. The introduction distinguishes between speculative office buildings, built by a developer for unknown lessees, and 'the client who builds for his own use'.[11] The latter has an ability to be 'bold' and experimental; for *AR*, 'his buildings are the pioneers'. Further, in some

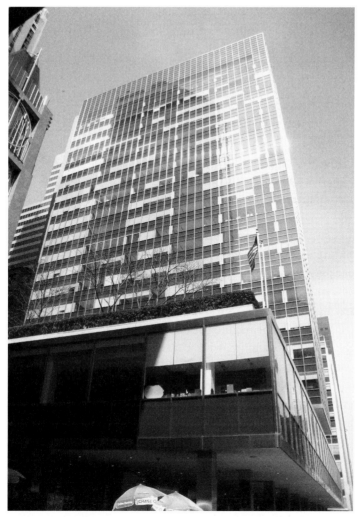

Fig. 8.1 Lever House, March 2009. Photo: Ann Sobiech Munson.

examples, 'The private owner sees in these new ideas a means of impressing himself, his company or his product indelibly on the public consciousness.' Lever House appears in the list of such examples.[12] Other characteristics of these buildings include attention to occupants' comfort, especially in the provision of light and air; means of moving people and goods through the building; experiments with thin walls and framing systems; and integration of equipment in the structure.[13]

'Lever House: Glass and Steel Walls' lists the parties involved in the construction of the building, provides text to highlight some of the technical and material developments in the space, and presents photos and drawings that depict a range of elements of the building, from the massing of the building in its urban context to details of its construction. The opening phrase, '24 stories of blue-green heat-resistant glass and stainless steel', has

become commonplace in descriptions of the Lever House.[14] Along with the glass façade and its integrated gondolas for window-cleaning, much is made of the cost of the technical assemblies and the open plan of the buildings' interiors.[15] After discussion of some of the details of the exterior, the building is deemed '. . . monumental, if not in expression certainly in its fundamental regard for the citizens of New York'.[16] On the interior, the design of the open plan on a narrow slab 'is an enlightened venture in public relations, and is to be applauded.'[17] The article concludes with a discussion of the building's mechanical systems, pronouncing Lever House 'marvelously ingenious'.

While the *AR* article provides highly technical details of the building, the *PA* piece focuses on the interior and its occupants; Lever House appears in a collection of examples of 'employe [sic] facilities' in its 'interior design data' feature. The introduction begins by declaring 'the provision of employe [sic] lounge and recreation space . . . no longer considered a luxury . . . in American business and industry' but instead 'a functional necessity, contributing to personnel efficiency'.[18] Criteria for such spaces include being near to the work space but providing 'a real change of scenery'; selecting interior finishes and furnishings to create a 'cheerful atmosphere' and to provide durability and ease of maintenance; connecting to the outdoors where possible; and considering air, light, and sound controls.[19] For *PA* in 1952, 'the reigning criteria seem to be constant—cheerfulness, comfort, and durability'.[20] Lever House, with its interior design by Raymond Loewy Associates, appears as one of four exemplary spaces for employees. Here, a panorama of the interior of the employees' lounge appears. Lighting, partitions and fabric all play key roles in 'the creation of an airy, informal atmosphere'.[21] Design data includes details of furniture, upholstery, screens, planting boxes, draperies, lighting, flooring, ceiling and windows.

These are but two examples of architecture and design journals from the period to have highlighted the innovations of Lever House. Unlike accounts in the popular press, these articles provided technical information regarding the design and construction of the building and its interiors, as well as demonstrating the status of Lever House as a major contributor to the development of American architecture. Many of the themes present in these publications surface in other discussions of the building, but in terms more accessible to readers untrained in design, engineering or architecture. And it is these readers we turn to next as we consider the *New Yorker*, circa 1952.

CONTEXT: THE *NEW YORKER*, CIRCA 1952

In her study of the *New Yorker* magazine in the middle of the twentieth century, Mary F. Corey describes the magazine as 'both a mirror and a map'; according to Corey, the years following World War II, into the 1950s, represent the magazine's 'greatest period of cultural potency'.[22] Ben Yagoda, whose own study of the magazine includes a personal connection to this time period, calls it 'the only cocktail party in town'.[23] The *New Yorker* was 'a kind of talisman for Manhattan sophistication' and 'a paragon of English prose, critical acumen, and political judgment'.[24] The Manhattan journal that had started in 1925

quickly spread its influence beyond New York, establishing the careers of numerous writers and telegraphing the cultural currents of post-World-War-II America. In order to consider Mumford's Lever House, we must first get to know this world.

Corey asserts that through reading the magazine at mid century, one could identify 'a recognizable *New Yorker* reader, habitat, and geography of the mind'.[25] The magazine was funded through advertising and subscriptions; as such, it provides a unique lens through which we might perceive its aspirational culture. Corey cites a 1946 pamphlet marketing the magazine to advertisers, describing subscribers as 'intelligent, well-educated, discriminating, well-informed, unprejudiced, public spirited, metropolitan-minded, broad-visioned, and quietly liberal'.[26] The magazine itself sent out surveys to subscribers in 1949 to determine various characteristics of their demographic. While it was true that many subscribers had attended college and earned well above the median household income at the time, Corey points out that 13 per cent of subscribers had not attended college at all, and 25 per cent had incomes less than $5,000 a year.[27]

Corey also traces the geographical location of subscribers to the magazine. When the *New Yorker* was first printed in 1925, nearly all of its subscribers resided in New York City. By 1929, over half of its subscribers resided outside of New York State; by the late 1940s, 10 per cent of its subscribers were in foreign countries, 39 per cent were from areas designated as West Coast, South, or select Midwestern states, and 20 per cent lived in towns with populations less than ten thousand.[28] These figures suggest that while many subscribers fit the promotional ideal, many others simply aspired to it. Yagoda attributes the success of the magazine in this time period to what he calls 'loyal, prosperous, striving readers'.[29] Not only did the magazine represent a world that existed, it suggested possibilities for a world that might be.

No matter where the readers lived and from what socioeconomic class they came, the numbers indicate great success. Between 1950 and 1964, circulation grew 40 per cent, advertising pages grew 70 per cent, and ad revenues grew 400 per cent.[30] Yagoda and Corey attribute the social force of the *New Yorker*'s reach to specific trends in post-war America. Both claim that increased access to higher education and the burgeoning post-war middle-class expanded the magazine's readership. In 1949/50, nearly half a million college degrees were earned by Americans, twice as many as those earned in 1940.[31] Overall, the number of Americans with college degrees rose from 12.1 million in 1950 to 19.9 million in 1966.[32] This increased access to education contributed to a fluidity of social classes, producing 'a new kind of literary consumer for whom reading was a form of currency'.[33] Yagoda goes further to cite the role of gender in the cultural currency of the magazine. He notes that more college-educated women were at home with more children than ever in American history, and 'a significant number of them flocked to the *New Yorker*, representing as it did one of the few ways they could exercise—and in some cases advertise—their learning and culture'.[34] As a result of all of these forces, the *New Yorker* became a sort of 'global intellectual village' that provided readers with 'a substitute urban space and a vocabulary with which they could construct their desires'.[35]

Mumford inhabited this 'substitute urban space' as art and architecture critic for the magazine, supplying some of the 'vocabulary' with which its readers might both experience and construct their ideas of the built environment of this world.[36] Corey concludes, 'An examination of any single issue of the magazine reveals the way the post-war *New Yorker* served its readers by acknowledging both the ideal of a triumphant America united in affluent consensus, and the troubling dilemmas of a less-than-perfect democracy.'[37] In this context, we turn to one single issue of the *New Yorker*.

OBJECT: 'HOUSE OF GLASS', 'THE SKY LINE', THE *NEW YORKER*, 9 AUGUST 1952

The 9 August 1952 issue of *The New Yorker* corroborates the arguments made by Corey and Yagoda about its readership. It also reinforces the fascination with new materials and American identity present in the architectural journals of the time. The boats strewn about the cover image by Garrett Price suggest summer holiday. Philip Hamburger reviews the just-released film *Ivanhoe,* and Lois Long spends a few pages discussing hats; there are letters from Helsinki (A. J. Liebling at the Olympics) and Paris (Genêt) and a poem by Theodore Roethke. Advertisements tout the virtues of synthetic fabric (American Viscose Corporation: 'How rayon became a parent's pet!') and air travel (Northeastern Airlines: 'Skyway to all New England!'). Others promote Raleigh bicycles, Weimeraner pups, stainless steel spoons, school uniforms, and 'gifts for Him'. A full-page, full-colour Lincoln ad on page nine—one in a series of ads appearing in 1952—declares, 'Lincoln lets you take modern living with you'. Accompanied by domestic scenes, Lincoln provides the perfect vehicular companion to the modern-day house: 'And like the glass-walled home, Lincoln surrounds you with up to 3,721 square inches of glass.'

'House of Glass' is the title of an instalment of 'The Sky Line' column, contributed by Mumford to the 9 August 1952 issue.[38] His first sentence indicates the popularity of the new Lever House office building through the strain the crowds placed on its circulation system. 'Throngs of people' waited in line to tour the place, and they 'demanded admission so insistently' that the elevator was 'overtaxed'. To further situate the appeal of the building to the masses, Mumford refers to it as 'the eighth wonder of the world'.[39] From the first one-and-a-half sentences, we feel the press of crowds begging to be let in, people lining up to see the latest thing in town. We have no idea yet what the building may look like or feel like—that comes in a minute—but we participate in the contagious anticipation. We move through sixty-two words before we catch our first glimpse of Lever House,

> . . . this house of glass approached through an open forecourt that is paneled with glistening marble, punctuated by columns encased in stainless steel, and embellished by a vast bed of flowers and—last touch of elegance against the greenish-blue glass and the bluish-green spandrels of the oblong building that rises above it—a weeping willow tree.[40]

First Mumford builds excitement, and then he slowly moves us through the first steps of the building, much as we might have done in person. He carefully nuances the description

of the curtain wall by noting the 'greenish-blue glass' as distinct from the 'bluish-green spandrels'. But even at this early stage we have pronouncements that betray the time and place of this icon. Of course, 'house' refers literally to Lever *House*. And this phrase, 'house of glass', helps us understand the title of the column. But also consider the Lincoln ad some thirty-nine pages earlier in this issue, in which both private residence and automobile are 'glass-walled'. Immediately, 'house of glass' signals the building's modernity.

For Mumford, 'this popular curiosity . . . is justified.'[41] He calls Lever House 'a building of outstanding qualities, mechanical, aesthetic, human . . .' However, he notes that the building 'breaks with traditional office buildings in two remarkable respects: it has been designed not for maximum rentability but for maximum efficiency in the dispatch of business, and it has used to the full all the means now available for making a building comfortable, gracious, and handsome'.[42] So the building presents innovation beyond its glassy modernist surface. We begin to see the texture of Mumford's own argument for modern living, for which he will continue to use Lever House as an example. Not only does Lever House work, not only is it a thing of beauty, but it also embodies 'human' qualities that elevate it above its contemporaries. 'Maximum rentability' and 'maximum efficiency' are not synonymous, nor do they result in equal benefits. Mumford develops this argument as he observes, analyzes and evaluates the building. We will focus here on three threads: advertising, hygiene and egalitarian access to amenities.

Mumford pronounces 'the whole building chastely free of advertisement'. For him, the building itself becomes a new kind of ad. Through its 'avoidance of vulgar forms of publicity, it has become one of the most valuable pieces of advertising a big commercial enterprise could conceive'. Note the use of 'chaste' and 'vulgar' in these statements; Mumford's assessment assigns moral virtue to this new means of promotion. Such promotion may even present justification for the extravagance of the all-glass façade, with its fixed windows and its built-in cleaning equipment:

> For a company whose main products are soap and detergents, that little handicap of the sealed windows is a heaven-sent opportunity, for what could better dramatize its business than a squad of cleaners operating in their chariot, like the *deus ex machina* of Greek tragedy, and capturing the eye of the passerby as they perform their daily duties? This perfect bit of symbolism alone almost justifies the all-glass façade.[43]

In this way, Lever House becomes 'a show place and an advertisement'.[44] But what does it advertise?

Lever House represents the company's expansion into the United States in the form of its New York corporate headquarters. The company manufactures soap and other cleaning products, capitalizing on the twentieth-century obsession with hygiene and cleanliness. Mumford's review supports the role of the building in promoting these ideals, both through the new phenomenon of advertising and through the building's hygienic qualities. When criticizing the decoration of the executives' offices on the top office floor, Mumford compares the '*clean*, shapely clocks' of the other offices to 'fussy, ornamented

clock' at this level.[45] In general, this 'dismal flaw' in the building at the executives' level defies 'the *clean* logic' of the rest of the building.[46] As he compares Lever House to another twentieth-century office building, Frank Lloyd Wright's Larkin Building in Buffalo, he includes an aside—'It, too, was a by-product of the soap industry'—as if to suggest that the connection to the soap industry aided in the conceptualization of a modern office building and, perhaps, plays a role in developing the distinct American character of these two buildings.[47]

Both of these elements—the new form of advertisement, the 'clean logic' of the building—contribute to its success on a human scale. This criterion surfaces repeatedly in Mumford's discussions of the built environment and city planning. He begins very early in the piece, before he even mentions the architect, to contrast the mania for tall buildings with the role they play in public and private life. This echoes the professional journals, which mentioned the civic generosity of the building's design and the consideration given to employee experiences of the interiors. But Mumford pushes this further, in layman's terms, and heroic tones. While the contest to build the tallest building in the city embodies a 'now deplorably old-fashioned spirit', Lever House presents the possibility for a new kind of competition in the realm of business and building, 'a competition to provide open spaces and a return to the human scale'.[48] In the way the building uses the site, it displays 'self-discipline' as it provides access to light on three sides. As he describes the plan of the building on each floor, he highlights the role of the open court at the ground level: 'There is no vestige of wall, or even of shop-front window, to shut out the passerby.'[49] The interior decoration has been 'richly humanized' in contrast to the severity of the blue-green glass exterior.[50] Finally, he deems the client (Lever Brothers) and the architect (Bunschaft of Skidmore, Owings & Merrill) 'entitled to a civic vote of thanks for taking this important step toward sane planning and building'.[51] The building becomes more than an effective or pleasant office space; it becomes a receptacle for human-centred values working in concert with the technologies of the machine age.

The human-ness of Lever House has something to do with its egalitarianism in the use of light and colour; the building's luxuries are equal-access. In this way, the building mirrors the shifting classes in American culture and the mid-century dream of prosperity for all. As he writes about the plan of the office floors and their connection to the exterior, Mumford declares, 'Even the least-favoured worker on the premises may enjoy the psychological lift of raising her eyes to the clouds or the skyscape of not too near-at-hand adjoining buildings. I know no other private or public edifice in the city that provides space of this quality for every worker.'[52] The cafeteria is not just efficient, but is 'able to hold its own in elegance with any restaurant on Park Avenue'.[53] In one of the better-known passages from the review, Mumford compares 'the fundamental unit . . . the desk', around which the building was planned, to the way a 'sensible farmer' plans around his cows.[54] And one of Mumford's few critiques of the space targets the lack of open passage around the building at the garden level, which he calls a gesture of 'empty formalism'.[55] All of these elements highlight the significance of the experience of the workers and the 'human scale' that pervades Lever

House. Ultimately, for Mumford, with these considerations 'Lever House . . . anticipates the "Century of the Common Man"'.[56]

DISCOURSE: LEWIS MUMFORD'S LEVER HOUSE

Mumford's declaration regarding the 'Century of the Common Man' loads Lever House with significance beyond its design and engineering achievements. Through this short piece of writing, Mumford develops Lever House into an icon charged with the issues of the day and embodying a possible response to the difficult questions posed by mid-twentieth-century American urban life. And he does this in the context of an educated, aspirational and mobile middle-class readership. These ideas likely circulated through his readers, and Mumford himself would continue to use Lever House as a symbol in this way in other discussions, often positing the recently built United Nations (UN) Secretariat building, also in Manhattan, as a counterexample.

Not long after this review appeared in the *New Yorker*, Mumford gave a talk to students at the Architectural Association in 1953, where he declared, 'The battle for modern architecture has been won . . .'[57] The question at hand, he continued, 'is whether we are moving in the direction of good architecture, or whether we are fast approaching the end of a blind alley'.[58] In this talk, he defines a 'folly-architecture' that 'consists in creating a monument to the architect and not a solution of his client's problem'.[59] His first example of such architecture is the UN Secretariat building. Here and elsewhere he contrasts this example, of modernist architecture gone awry, to 'an example of a good solution of the problems presented': Lever House in New York.[60] Two photographs of Lever House accompany the published talk. But more striking than the images is this verbal description:

> . . . it is the best place from the point of view of light, air, and pleasantness of outlook for the office workers that I have discovered anywhere. It is a luxurious solution, but if you are condemned to be a stenographer, a filing clerk or a minor administrator, I cannot think of a happier building to work in than Lever House, New York.[61]

This statement continues work begun in his *New Yorker* columns, in which he deems Lever House 'superior' to the UN Secretariat 'on almost every point'.[62] Unlike the UN Secretariat, Lever House emphasizes quality over quantity:

> . . . the United Nations is the last of the old-fashioned skyscrapers, in which importance was symbolized by height, while Lever House is the first of the new office buildings, in which the human needs and purposes modify cold calculations of profit and nullify any urge to tower above rival buildings.[63]

He continued the contrast in a February 1953 piece for the *New York Times Magazine*. Under the question, 'Which will the New York of the future resemble?', images of the two projects appear. Again, it is not the images but the text that gives us Mumford's answer. While he calls the Secretariat building an 'ironic apotheosis' of the office building, he high-

lights 'the new luxury of space' in Lever House. 'Using but half the land and providing a public patio were more radical innovations in Lever House than the glass façade.'[64]

Through its 'impeccable achievement' and 'highly useful experiment',[65] Lever House embodies a new direction for architecture at this moment that holds its own against the flashy box of the UN Secretariat. While Lever House's glassy surface might signal its modern character, Mumford reiterates that 'its special virtues are most visible not in the envelope but in the interior that this envelope brings into existence, in which light, space and colour constitute both form and decoration'.[66] Both innovative and elegant, it demonstrates both Gordon Bunschaft's response to the architectural conditions of the day and Lewis Mumford's recommendations for the future of urban life. Mumford extrapolates as he concludes the review: 'Fragile, exquisite, undaunted by the threat of being melted into a puddle by an atomic bomb, this building is a laughing refutation of "imperialist warmongering," and so it becomes an implicit symbol of hope for a peaceful world', or the productive future aspired to by his American readers in the aftermath of World War II.[67] By the end of his assessment, Mumford abandons the question of the client's demands and focuses on the building itself as a citizen: 'I don't know whether that is what the corporation had in mind when it built this structure, but that, it seems to me, is what Lever House itself says.'[68] Lever House not only provides for humans, it becomes one, demonstrating 'self-discipline' and ultimately 'saying' what it means. Mumford even erases his own participation in the symbol-making enterprise, moving from observer to critic to this new role, the claim that he merely translates what the *building itself* says. In this way, Mumford-as-critic vaults Lever House into a world beyond professional accounts of its achievements, beyond the blocks near Park Avenue, into the discourse of modern American architecture itself.

NOTES

1. Thanks to Kjetil Fallan for suggesting that these representations may aptly be termed 'mediations' and to others who offered comments at the Design History Society annual conference, *Writing Design: Object, Process, Discourse, Translation*, hosted by the University of Hertfordshire, 3–5 September 2009, where this study was first presented, and in the 'WiPS' series at Iowa State University.

2. Lewis Mumford, 'House of Glass,' The Sky Line, *New Yorker*, 9 Aug. 1952, 48–54.

3. Consider Roland Barthes's discussion of the Eiffel Tower as an analogy (*The Eiffel Tower, and Other Mythologies*, New York: Farrer, Straus and Giroux, 1979); in this case, Lever House consists of a collective set of representations.

4. Marvin Trachtenberg and Isabelle Hyman, *Architecture: From Pre-history to Postmodernism* (Englewood Cliffs, NJ: Prentice Hall, 1986), 545.

5. *Great Buildings Online*, s.v. 'Lever House,' accessed 11 Nov. 2010, http://www.greatbuildings. com/buildings/Lever_House.html. This reference indicates something of the building's place in popular culture.

6. SOM.com Skidmore, Owings and Merrill, 'Lever House,' accessed 11 Nov. 2010, http://www. som.com/content.cfm/lever_house.

7. See Peter Grant, 'Lever House Sold Germans Win Landmark,' *New York Daily News*, 27 Oct. 1998; David W. Dunlap, 'Commercial Real Estate: Designing a Restoration, and Words to Describe It,' *New York Times*, 29 Dec. 1999.

8. SOM.com Skidmore, Owings and Merrill, 'Lever House—Curtain Wall Replacement,' accessed 11 Nov. 2010, http://www.som.com/content.cfm/lever_house_curtain_wall_replacement.

9. SOM.com, 'Lever House.'

10. 'Office Buildings,' Building Types Study No. 187, *Architectural Record* 111 (June 1952): 121–51; 'Employee Facilities,' *Progressive Architecture* 33 (October 1952): 123–9.

11. 'Office Buildings,' 121.

12. Ibid.

13. Ibid.

14. Ibid., 131.

15. Ibid.

16. Ibid., 131–2.

17. Ibid., 132.

18. 'Employee Facilities,' 123.

19. Ibid.

20. Ibid.

21. Ibid., 126–7.

22. Mary F. Corey, *The World through a Monacle: The New Yorker at Midcentury* (Cambridge, MA: Harvard University Press, 1999), x.

23. Ben Yagoda, *About Town: The New Yorker and the World It Made* (New York: Scribner, 2000), 16.

24. Ibid.

25. Corey, *World through a Monacle,* xiv.

26. Ibid., 10.

27. Ibid., 12.

28. Ibid., 12.

29. Yagoda, *About Town*, 310.

30. Ibid., 309.

31. Corey, *World through a Monacle,* 13.

32. Yagoda, *About Town*, 311.

33. Corey, *World through a Monacle,* 13.

34. Yagoda, *About Town*, 311.

35. Corey, *World through a Monacle,* 13–14.

36. Mumford wrote 'The Sky Line,' from 1931–63 and reviewed art for the magazine 1932–7.

37. Corey, *World through a Monacle,* x–xi.

38. Mumford, 'House of Glass,' 48–54.

39. Ibid., 48.

40. Ibid.

41. Ibid.

42. Ibid.

43. Ibid., 50.

44. Ibid., 54.

45. Ibid., 51, my emphasis.

46. Ibid., 52.

47. Ibid., 53.

48. Ibid., 48.

49. Ibid., 49.

50. Ibid., 50.

51. Ibid., 53.

52. Ibid., 48.

53. Ibid., 49.

54. Ibid.

55. Ibid.

56. Ibid., 54.

57. Lewis Mumford, 'Follies of Modern Architecture: Lewis Mumford tells AA students of "backward step,"' *Architects' Journal*, 9 July 1953, 56.

58. Mumford, 'Follies,' 56.

59. Ibid., 58.

60. Ibid., 59.

61. Ibid.

62. Mumford reviewed the United Nations Secretariat in his *New Yorker* columns of 15 and 22 Sept. 1951.

63. Mumford, 'House of Glass,' 52.

64. Lewis Mumford, 'Architecture: Beautiful and Beloved,' *New York Times Magazine*, 1 Feb. 1953, 23.

65. Mumford, 'House of Glass,' 53–4.

66. Ibid., 53.

67. Ibid., 54.

68. Ibid.

PART 3 DESIGNING *WITH* AND *THROUGH* LANGUAGE

INTRODUCTION

GRACE LEES-MAFFEI

Writing is not only, nor even primarily, used in the design field to understand and communicate the process and products of design *after the fact* in the manner of the mediation studies considered in Part Two. Part Three of *Writing Design* looks, in various ways, at design practice which employs the medium of words as its raw material. It does so using a shorter chronology than the two preceding parts, examining just over one hundred years from the mid-1920s to the present.

A new tradition of screen-based text is now developing. The analyses of the materiality of writing presented here make a timely contribution, therefore, when writing is increasingly experienced as pixels of light on a screen, rather than ink on a page, for large numbers of people in a range of contexts. Both Polly Cantlon and Alice Lo's visual analysis of key texts in the development of modernism, 'Judging a Book by its Cover: Or Does Modernist Form Follow Function?', and Barbara Brownie's analysis of post-postmodern digital artefacts, 'Fluid Typography: Construction, Metamorphosis and Revelation', seek to understand the impact of the material composition of writing just as e-readers and tablet computers have achieved significant market penetration.

Modernism is well-documented, but Cantlon and Lo contribute an original analysis of the linkage between form and content in four seminal texts published between 1923 and 1960. They subject the published output of leading design commentators to the same level of scrutiny that they have accorded to the designs of others. Cantlon and Lo's chapter has a pedagogical frame, and they close with a challenge to design history: by following their example, and subjecting works of design history and design theory to an analysis attentive to the relationship between form and content, we can overcome what Mhairi McVicar, in the following chapter, terms the 'theory/practice split'.

McVicar's chapter, 'Reading Details: Caruso St John and the Poetic Intent of Construction Documents' comprises an extremely detailed analysis of the way in which the design process is carried out, partly or primarily, through text. While several of the chapters in Parts One and Two displayed increasing levels of focus, from the work of an individual design commentator, to a single magazine title, to a sole article, here McVicar's scrutiny centres upon a 4-mm joint on a museum facade. McVicar considers the memos sent from architect to contractors, lodged in the job files of the architectural practice, as evidence of the complex and meticulous process of transformation from design as conception to design as building. McVicar makes clear how the architect's specialized textual skills compare

with the builders' and contractors' textual reticence, creating an unfair playing field upon which philosophies of practice are stated and restated as disagreements are aired and, ideally, resolved. This chapter is a distillation of broad questions about authorship, intention, communication, neutrality and hierarchy; McVicar's micro-analysis shows the work put in to a tiny but extremely significant detail, as a counterpoint to the grand narratives of architecture.

Of course, words are spoken as well as written. In 'Applying Oral Sources: Design Historian, Practitioner and Participant', Chae Ho Lee continues the pedagogical emphasis of Cantlon and Lo's chapter by reviewing work which integrates oral history into the design process and produces objects which blend material and narrative qualities in intriguing, and often moving, ways. Lee thereby contributes to a growing literature on oral history and design,[1] as well as demonstrating a model for overcoming a theory/practice split discussed in the two preceding chapters and revisited by Michael Biggs and Daniela Büchler in the final part of this book. Lee's discussion is acutely attentive to issues of space, place and provenance as they inform social and cultural experiences, and the designs which respond to those experiences.[2]

In the final chapter of Part Three, 'Fluid Typography', Barbara Brownie returns us to graphic design and, specifically, contemporary digital practice which uses words or letterforms. For Brownie, words and objects are not distinct entities; rather they can transform into one another in ways surprising, delightful and disconcerting. Brownie's analysis offers a clear dissection of the processes at the root of such transformations and provides a coherent set of critical terms with which to interrogate 'fluid typography'.

The chapters in Part Three show the fundamental importance of writing as part of the design process itself, whether in the connection between form and content in published design commentary, the role of documents as tools in the design process, or as a medium. Each chapter contributes, therefore, to our understanding of the significance of designing *with* and *through* language.

NOTES

1. See, for example, Linda Sandino, ed., Special Issue: 'Oral Histories and Design,' *Journal of Design History* 19, no. 4 (2006).

2. On Participatory Action Research (PAR) and the relationship between image-making and social experience, see Wendy Luttrell and Richard Chalfen, 'Lifting Up Voices of Participatory Research,' *Visual Studies* 25, no. 3 (December 2010): 197–200.

9 JUDGING A BOOK BY ITS COVER: OR DOES MODERNIST FORM FOLLOW FUNCTION?

POLLY CANTLON AND ALICE LO

This chapter, considering the relationship of content, form and style in the design of books on modernist design theory, arose from our teaching programmes for graphic design students at the University of Waikato, New Zealand. It considers how the formal analysis of exemplar texts can reveal much about design practice, as well as indicate disjunctions between ideals and practice. In so doing, it allows for reflection on the nature of intentions and constraints in graphic design and specifically the relationship of textual content with visual form and style in book publication. In conclusion, it evaluates the use of the methodology with students and offers a challenge for design writing.

In first year studio and design history courses, our students learn the formal language of the elements and principles of graphic design. Elements include line, shape, tone, space, texture and colour; principles are emphasis, movement/rhythm, repetition/pattern, balance and unity. While these elements and principles always act in combination, they can be treated as a vocabulary of visual imagery and teased apart in formal analysis. Sometimes dismissed by text-based theorists, formal analysis serves our students well, allowing them to develop visual understanding of their own practice and engage with theoretical approaches. Within this method, form is defined as the physical attributes of construction, and style as the conscious use of the elements and principles of design. Students write about design and consider the design of writing by analyzing printed material in order to explore the communication values of form and style, as well as to consider social and commercial purposes, and audiences. When deconstructing graphic design, the students' understanding of Saussurian denotation (the literal content) and connotation (the messages carried in or implied by form and style) allows for an exploration of the message of style and the relationship between the signified and the signifier.

It is instructive for students to consider various attitudes to 'style'. Beatrice Warde's description of graphic design as 'superficial surface characteristics' arranged by a bunch of 'flashy little stylists'[1] is contrasted with that of Bruce Mau, co-designer and publisher of Zone books. For Mau style is 'a decision about how we will live. Style is not superficial. It is a philosophical project of the deepest order. Style is intrinsically rhetorical, the expression of a series of more or less convincing propositions about life and the way it might be ordered'.[2] Students become aware that all writing embodied in a book has intrinsic visual style and that changes in established conventions of form and style in Western printed

books—size, page layout, typography, ornament and image—had many causes. Form and style in the artefact of the book hold traces of the design activity, and materialize attitudes to design. To study design writing in this way is particularly rewarding for the understanding of modernism because of its clear visual programme of reform.

The modernist design quest for universality of principle and practice has been much discussed, as has the way modernist form was developed to symbolize the reformed, socially progressive and mechanized environment. Graphic design has received less attention in modernist design histories than architecture, furniture or product design, perhaps because it is felt to have been compromised through its multiple interactions with mass culture or because it has been deemed to be relatively transient. A possible exception is the vehicle of learning, the book; book designers were early exponents of modernist approaches to visual production which influenced other fields such as painting and architecture. The book was, crucially, the main channel through which modernism was theorized and debated; it functioned moreover as a vehicle for the embodiment as well as the communication of modernist ideals. Throughout the 1920s and early 1930s, books and magazines on modernist architecture published in the USSR, Germany, Holland and Czechoslovakia provided showcases of avant-garde page design. Architecture and design for print shared the same basic principles and drew on the resources of the same institutions and the talents of the same artists/designers/theoreticians.[3]

The book is both a vehicle for a message and a message itself, embodying ideas in its text and in its visual and material form and design. Books have always been commercial objects, their existence determined by complex systems of demand, supply of materials, available technology, transport and distribution networks, balance sheets and editorial policies. Embedded in these networks, books can be seen as the quintessential objects of structural modernity. The union of content and style is a highly valued quality,[4] and we were interested in whether such integration would characterize books that were important to the revolution of modernism. Would the book design be an embodiment, enrichment or extension of its content? Would the writing fulfil itself in the design? We chose four books, in their first hard cover editions, for our enquiry. In chronological order, they are *Staatliches Bauhaus Weimar 1919–1923* (1923), edited by Walter Gropius and László Moholy-Nagy; *Pioneers of the Modern Movement: From William Morris to Walter Gropius* (1936), by Nikolaus Pevsner; *Mechanization Takes Command: A Contribution to Anonymous History* (1948), by Siegfried Giedion; and *Theory and Design in the First Machine Age* (1960), by Reyner Banham.

STAATLICHES BAUHAUS WEIMAR 1919–1923

Staatliches Bauhaus Weimar 1919–1923 was written in German and first published in Munich in 1923. We analyzed the facsimile edition by Kraus Reprint, Berlin, 1980. The first 28 of the 225 pages feature theoretical writing by Bauhaus masters; the remainder of the publication comprises black-and-white photographs illustrating faculty work. *Staatliches Bauhaus Weimar* was both an exhibition catalogue and the first statement of the changed

intent of the Weimar Bauhaus, from a craft-based expressionism towards a rational approach to technology characterized by geometry and simplification. The book is, unconventionally, almost square (24.6 cm by 23 cm), and the use of photographs for illustration accords with a new commitment to objective, mechanized processes of reproduction. The cover, designed by student Herbert Bayer, emphasizes the format by filling it with the title in uppercase block lettering. The geometry is further reinforced by each half of a line having a counter-change letter colour of primary blue and red on the background of black.

Inside, 'The New Typography' by newly recruited Master Moholy-Nagy contains his now famous dictum:

> typography is a tool of communication. It must be communication in its most intense form. The emphasis must be on absolute clarity since this distinguishes the character of our own writing from that of ancient pictographic forms. . . . Legibility of communication must never be impaired by a priori esthetics. Letters must never be forced into a preconceived framework, for instance a square. The printed image corresponds to the contents through its specific optical and psychological laws, demanding their typical form.[5]

Moholy-Nagy calls for versatility, elasticity and 'uninhibited use of all linear directions',[6] and the title page he designed for *Staatliches Bauhaus Weimar* clearly enacts these principles. According to graphic-design historian Philip Meggs, the radically different page structure with text in upper case sans serif is based on a 'rhythmic series [of type] at right angles. Stripes applied to two words create a second spatial plane'.[7]

The pages of text are set in a single block; left and right margins are of equal width, which reveals an underlying symmetrical organization (Fig. 9.1). This creates a strong structural geometry on the page, while the placement of the images is variable. The choice of a transitional (seventeenth century) roman typeface for body text is the only anomaly in the clear modernist form and represents Moholy-Nagy's as yet unsuccessful quest for a font suitable for the modern age. The text has been set at 13 point, left aligned, with generous leading and wide letter spacing. Line length in the square format is unusual, an average of 103 letters per line compared to a more accepted 40 to 50 letters per line. A strong contrast is achieved with the use of a bold sans serif typeface for chapter headings and captions, with artist or designer names in full capitals. The heading font is in the style of the influential Akzidenz Grotesk type family, developed by the Berthold Foundry of Berlin between 1898 and 1906. Its use here by Moholy-Nagy indicates the strong influence of Peter Behrens' typographic work and Russian Constructivist graphic design. The typographic variations function to create a clear hierarchy of information, and the setting of captions in both vertical and horizontal directions adds dynamism to the pages. The placing of the photographic illustrations, designs and diagrams, either left or right aligned or centred on the page, shows no evidence of an underlying grid. The book is not fully unified by formal structures but has coherence through some repetition of layouts, which play against the visual expression of liveliness and experimentation.

Fig. 9.1 Double-page spread, *Staatliches Bauhaus Weimar 1919–1923*, ed. Walter Gropius and László Moholy-Nagy, designed by Moholy-Nagy, 1923. Facsimile edition Berlin: Kraus Reprint, 1980: 140–1. © Laszlo Moholy-Nagy/Bild-Kunst. Licensed by Viscopy, 2011.

While teaching layout and typography at the Bauhaus, Moholy-Nagy collaborated further with Gropius to plan, edit and design the fourteen *Bauhausbücher*, and the periodical *Bauhaushefte*, as exemplars of the new approaches to print design he introduced with *Staatliches Bauhaus Weimar*. His quest for a rational, scientific reform of letterforms for body-text type that would be unified, clear and precise, led him to promote sans serif typefaces free of contrasts, which were used in all the *Bauhausbücher*. Futura, designed by Paul Renner, and Bayer's universal alphabet, both of 1925, followed this impulse.

PIONEERS OF THE MODERN MOVEMENT

Nikolaus Pevsner's *Pioneers of the Modern Movement: from William Morris to Walter Gropius*, was published by Faber and Faber in London in 1936. While there has been no formal consensus among design historians as to the foundational texts in their field, this book (better known by its subsequent title, *Pioneers of Modern Design*) is, along with Giedion's *Mechanization Takes Command*, often situated as the text against which subsequent narratives have been written.[8]

In content the book is principally concerned with architecture and the way tendencies of contemporary art and design coincide with and bear 'upon those of the architectural style of the Modern Movement'.[9] Several of Pevsner's examples of these tendencies—Art Nouveau magazines, the publications of the Doves Press, and the modern typeface designs of Behrens—can legitimately be considered as graphic design, although Pevsner does not acknowledge them as such. He charts the achievements of modernism through an acceptance of mechanization and new technology, and the creation of new objective

5. *William Morris: Hammersmith Carpet*

now. His very simplicity of approach led him to
forms more traditional. When for example, in 1878,
he decided to make carpets, he saw that certain
oriental patterns were almost exactly what he
wanted. Hence his Hammersmith Carpets (*fig.* 5) are
very much like oriental designs, though he em-
phasised that he wanted them 'obviously to be the
outcome of modern and Western ideas'.⁴ This is re-
markable. Morris was so far from inventing decora-
tive forms for invention's sake that, if he found
models however remote in space or time which met
his purpose, he made use of them or at least came
under their spell, even if this happened against his
own will.

Herein lies the explanation of the dependence of
58

6. *The 'Honeysuckle' Chintz, designed by William Morris*

Fig. 9.2 Double-page spread, *Pioneers of the Modern Movement from William Morris to Walter Gropius*, Nikolaus Pevsner (London: Faber and Faber, 1936), 58–9. Image reproduced with the kind permission of the Estate of Nikolaus Pevsner, 1936, 1960 and 1975.

forms of honesty, simplicity, economy and lightness. *Pioneers of Modern Design* shares with *Staatliches Bauhaus Weimar* the attachment of social and moral values to modernism, to the extent of equating the new geometric simplicity of Behrens' post-1900 typefaces to a healthier social environment, indicated by the German Youth Movement (Wandervogel).[10] For Pevsner, to be modern was to be in every way progressive.

Pioneers of the Modern Movement was produced in portrait format (16 cm by 22.7 cm). The card cover is a quiet grey, with the title and author names set at 18 point in a sans serif typeface. Both the book title and the name of the author are left aligned and placed at the top-right-hand corner of the cover, creating a clear focus and balance within the otherwise plain undecorated space. The layout of the book's 240 pages is ordered by a strict symmetrical grid with the illustrations sized precisely and consistently to align with the width of the body text (Fig. 9.2). Vertical images, such as that of William Morris' Daisy wallpaper, occupy a whole page and mirror the size and placement of body text set oppo-site in a double-page spread. Landscape-format images exactly occupy the top half of the page. Inside, page margins are wide and unequal, with the right and bottom margins the greatest. Body text is set left aligned in 12 point Bodoni typeface, and leading and word spacing is generous.

The style communicated is of clear formal rules and conventions of order, in other words standardization, a high modernist ideal. This ideal was not shared by Moholy-Nagy, at the time a fellow émigré in London, who continued to promote his belief that new photo-mechanical processes, combined with a modern consciousness, would take the book to a new visual-typographical level. He foresaw a coherent sequence of designed pages, where 'the nature and purpose of the communication . . . determine the manner and use of the typographical communication'.[11] Moholy-Nagy criticized modern books for not progressing in design, unlike 'newspapers, posters, and job printing, since typographical progress has been almost entirely devoted to this area'.[12] He envisaged different, more dynamic balances replacing the traditional symmetrical equilibrium so clearly evident in *Pioneers of the Modern Movement*, which displays the stronger influence of Jan Tschichold's 1928 Bauhaus-inspired text, *Die Neue Typographie*.

Die Neue Typographie can be seen as a graphic-design equivalent of *Pioneers of the Modern Movement* in that it considers both the antecedents and explains the principles of the new style. *Pioneers of the Modern Movement* acknowledges Tschichold's call for 'pure and direct expression of the contents'[13] through standards of simplicity and clarity. It achieves a unity of content and form in the use of the appropriate elemental letterform, sans serif, on the cover and title page. The body text choice of Bodoni, popular in the nineteenth century and necessitating superior standards of printing because of the high x-height and extreme contrast between thick and thin strokes, does not, however, appear to follow Tschichold's advice. He had suggested that until a truly functional typeface was designed, an acceptable compromise for continuous text should be the most unobtrusive roman typeface, defined as one where period or origin is least evident.[14] Bodoni's modern roman, once accused of poor legibility, was undergoing a revival in the 1930s, despite American Type Founders earlier release of two serviceable sans serif typefaces for body text, Franklin Gothic and News Gothic.

Britain took no part in the radical, 'heroic' phase of modernism advanced by Moholy-Nagy and Tschichold. Book production of the 1930s and 1940s has been described by commentators, such as Robin Kinross,[15] as having been embedded in formal and stylistic conventions. Still, British typography and layout trod its own path towards simplicity, exemplified by Edward Johnston's Railway Type, and Eric Gill's Gill Sans. Stanley Morison's article 'First Principles of Typography' of 1930, Beatrice's Warde's lecture 'The Crystal Goblet, or Printing Should Be Invisible' of the same year, and Gill's *Essay on Typography* of 1931 all advocated the observance of tradition and a moderate progression to typographic clarity. There was also an influence from the increasing presence of European émigrés, which from 1935 included Berthold Wolpe, former calligrapher for type designer Rudolf Koch at his Offenbacher Werkstatte. Wolpe taught at the Royal College of Art and from 1941 designed book covers for Faber and Faber. In 1935, the launch of Penguin Books in England signalled a new practical and aesthetic approach to book production. By 1936, Faber and Faber, which was founded in 1929, was prospering financially, and Faber designer Richard de la Mare was responsible for a range of books that demonstrated a level of

attention to design that was unusual in Britain at that time, with the exception of Penguin. Faber's book designs appear to support the reasoned modernism of Morison, Warde, Gill and others.

The first edition of *Pioneers of the Modern Movement* can be appreciated, perhaps surprisingly, as a fulfilment of modernist principles through a quiet unity of content and style. In its precision it is exact; in design it is elegant. The unexpected choice of Bodoni gives the body text a lightness which, combined with the use of clear white space on the page, creates a style that embodies the high moral and aesthetic value Pevsner accorded to modernist architecture, that of lightness and airiness, an 'aetherialisation'[16] achieved, here, in the architecture of the page.

MECHANIZATION TAKES COMMAND

Siegfried Giedion's *Mechanization Takes Command: A Contribution to Anonymous History*, published in New York by Oxford University Press in 1948, is our second modernist 'foundational' text. As the title suggests, it responds to Pevsner's focus on 'heroes' by considering the history, development and spread of everyday forms of mechanization, from swivel chairs to bathrooms and washing machines, which cannot be attributed to any one designer. Giedion contributed to modernist theory his belief that 'the mechanistic outlook of the late nineteenth century, involving interest in every detail, lost the power to integrate. Our century is gradually rebuilding new universal conceptions as the basis of scientific research'.[17] In text and image, *Mechanization Takes Command* celebrates the modernist aesthetic in many forms, 'the tubular steel chair is as truly a part of the heroic period of the new architecture as are the transparent shells of glass that replace bearing-walls'.[18] The text acknowledges no graphic design, but the many black-and-white images of advertisements for new mechanical products show a progression of modernist style in popular print, towards simplicity and direct communication through the use of photographic images, clear white space, and sans serif typography, in both heading and body text.

This book is physically the heaviest and most impressive in size of our four, implying weighty and serious content. The tall portrait format is 24 cm by 18 cm and the book has 743 pages. The slipcover is completely typographic, with an organized play of yellow and white sans serif type against a black background. Emphasizing the geometrical alignments are three fine rules, two horizontal, one vertical, in white, yellow and red, which advance from the edges. The layout of the recto pages (Fig. 9.3) employs a symmetrical grid for the text, with narrow margins of unequal distance on all sides. The body text is set in 11 point Bodoni, justified left and, despite open leading, has tight letter and word spacing, creating a dark texture of print. Frequent sub-headings and short paragraphs with double spacing between provide an antidote of white space. Overall the imprint is undistinguished, with the letterforms lacking crispness and clarity. The placement of the black-and-white photographic images and diagrams, cropped arbitrarily or occasionally bleeding off the page, appears unrelated to the text grid. This lack of a discernible or unifying system for the illustrations creates a feeling of disorder and randomness in

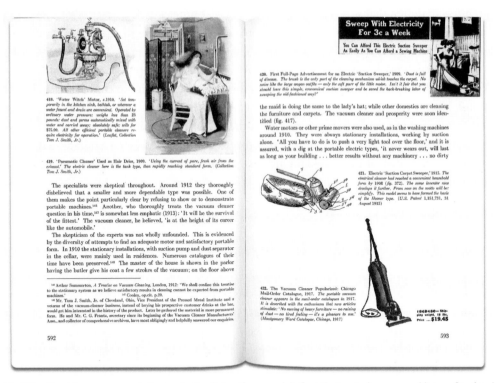

Fig. 9.3 Double-page spread, *Mechanization Takes Command: A Contribution to Anonymous History*, Siegfried Giedion (New York: Oxford University Press, 1948), 592–3. By permission of Oxford University Press.

the book's otherwise systematic, if unremarkable, form. Significantly, this publication provides a telling contrast to the clear, modernist design of Giedion's earlier European publications *Bauen in Frankreich, Bauen in Essen, Bauen in Eisenbeton* (*Building in France, Building in Iron, Building in Iron Reinforced Concrete*) published in 1928 by Burckhard & Bermann, and *Moderne Schweizer Architektur* (*Modern Swiss Architecture*) published in 1942 by Verlag Karl Warner.

Giedion was a friend of Moholy-Nagy, who had designed *Bauen in Frankreich*, with its powerful cover of upper case sans serif letters in orange and white, and alternate left and right alignments set against a negative image of a steel frame. *Moderne Schweizer Architektur* shows clearly, in its layout, the Swiss influence of co-author Max Bill. Giedion's critical awareness of graphic design and the integration of content and style should be expected, as it has been said that for him the notion of style 'assumed an internal coherence'.[19] Published shortly after World War II, *Mechanization Takes Command* may be excused any technical or material deficiencies. The slipcover is modernist, yet inside the layout conveys a more traditional approach that may be the result of economic considerations, the attitudes of the publishers towards book design, or perceptions of the intended market for the book. Unfortunately Giedion does not include book production as part of his anonymous history

of mechanization, although his critical judgements of how 'today man is overpowered by means'[20] and his request for restoration of 'the lost equilibrium between inner and outer reality'[21] may provide metaphors for this publication.

THEORY AND DESIGN IN THE FIRST MACHINE AGE

Reyner Banham's *Theory and Design in the First Machine Age* was published by the Architectural Press in London in 1960. It is a thorough and comprehensive account of modernism, which Banham called the scientific, rational approach, as the movement was coming to an end. It has several points of connection to the preceding texts: Pevsner was Banham's teacher; Banham includes a favourable critique of Giedion in the book, acknowledging the influence of his 1941 publication *Space, Time and Architecture*, as well as *Mechanization Takes Command*. He similarly praises Moholy-Nagy, considering 'Moholy-Nagy's own Bauhausbüch as a summa aesthetica of what the school stood for'.[22] This book, *Von Material zu Architektur*, 1928, Banham describes as 'one of the most sophisticated products of the Elementarist tradition . . . [which] puts typography at the service of pedagogy, to produce the first primer of modern design'.[23] *Theory and Design* is the most critical account of modernism, the distance in time and technology bringing Banham to the conclusion that 'the apparent symbolic relevance of these [simple, geometric, modernist] forms and methods was purely a contrivance, not an organic growth from principles common to both technology and architecture'.[24]

The slipcover of *Theory and Design* appears as an unconvincing pastiche of modernist geometric preferences. Set against a black ground, a flat grid of dark green lines is penetrated by angled planes, creating a contradiction in spatial perspective. A further three flat rectangles hold images of modernist architecture, and a central rectangle frames a Bauhaus tubular steel chair. The author's name and the book title are also set in rectangles, using a condensed, block sans serif font we were unable to identify, the title white and in uppercase. The book has 338 pages in a narrow portrait format of 23 cm by 14.7 cm. The title page has three centre-aligned lines of text identifying the author, title and publisher. The overall effect is simple but unadventurous, and at odds with the slipcover, as the author's and publisher's names are set in an upper case transitional roman font. The title is in the lower case block sans serif of the slipcover, with capitalized first letters to each word. Throughout the book, chapter and section headings remain centre aligned in this font and all other text is transitional roman. As part of his post-war transformation of Penguin Books, in 1947 Tschichold produced a four-page booklet of 'Penguin Composition Rules'. Several of his guidelines, such as avoiding mixing old style text with modern face fonts, and the need to letter space all words set in upper case, are not demonstrated here despite his guide being 'plagiarized and borrowed, to good effect, by typographers and publishers at many other firms and in many other countries—and could, with good effect, be borrowed by many more'.[25]

The task of identifying fonts used in *Theory and Design* is difficult because of the poor quality printing, which renders letter thicknesses and the weights and shapes of the serifs

inconsistent. The book's layout has a symmetrical grid across each double page with a single column of justified body text (Fig. 9.4). There are very narrow margins, leading and word spacing. The typeface is set at 10 point and, in combination with the lack of crispness and definition, creates a heavy texture. On pages with few paragraph breaks, the closed column of type appears almost impenetrable. The black-and-white photographic illustrations have poor definition and are grouped separately to the text, often distant from their references and variously sized and aligned.

Against the increasing sophistication of mass print technology, in this case offset print-ing based on photographic technology, *Theory and Design* appears to continue a process of decline in the relationship of form, style and content in book production. This decline is not only in the influence of modernist ideals but also in standards of unity, coherence and progression within book design itself, established over the long history of the book. Some commentators see this as a feature of the post-war years: 'when production methods tended to increase the gap between design and execution, control became harder to achieve'.[26] De-spite the publisher having a reputation for progressiveness, the decisions that created such

Fig. 9.4 Double-page spread, *Theory and Design in the First Machine Age*, Reyner Banham (London: The Architectural Press, 1960), 40–1. Image reproduced with the kind permission of Elsevier, and the Reyner Banham Estate.

a book suggest economic rather than editorial- or design-driven values, a change in the status of the book, and an acceptance of the pragmatics and power of the post-war market place.[27]

As an object of print, *Theory and Design* cannot be compared to a crystal goblet, as the form is insufficiently unobtrusive to serve the communication of the message, while the design of the book presents a series of increasingly unconvincing propositions in the way writing on design may be ordered. Yet Banham argues against Pevsner, insisting that the modernist dream of unchanging, stabilized types or standards should be rejected as fallacious. He suggests that instead of seeking spurious universal forms, architects (and, by extension, all designers) must keep up with the increasing speed of technological progress by emulating the futurists, jettisoning the past and adapting to constant change.[28] However, while Pevsner's theoretical formalism was expressed in a book of practical and aesthetic appropriateness, even honesty, Banham's is singularly disappointing. *Theory and Design* relays the very opposite signification to its text: a message of an unsophisticated and unquestioning use of conventions of form and an apparent disregard of imaginative, visual or communicative values. In the words of Warren Chappell and Robert Bringhurst, 'Such books teach us a sad lesson: not to judge the book the author wrote by the book we feel and see. It is a hard lesson to learn.'[29]

CONCLUSION

The consideration of the relationship of content to form and style in books of modernist theory highlights significant changes, as the printed production of writing about design moved from practitioners to theorists, and from its origins in Europe to the more traditionalist and commerce-driven Anglo-American market. As a pedagogical exercise, studying such changes diachronically, as we have done here, can give students a practical methodology for understanding the complexities of modernism. It also stimulates their further exploration of the contexts of graphic design, such as a consideration of responses to the marketplace and the world of consumer demand; the roles of technology and of theory and practice; the corporatization of print; the autonomy of the individual designer or author; the politics of the design, and use, of typefaces. The multiple possibilities for further research that arise can motivate students by allowing them to initiate, and follow, a direction of individual interest.

The books sampled for this study signal an increasing disjuncture between design writing's denotation and the connotations embodied in designed form and style when, in the case of modernist theory, a strong and aesthetically valid relationship of all the attributes of a book would seem, if not axiomatic, then certainly appropriate. Graphic design students often demonstrate disinterest, even resistance, to theoretical writing. Perhaps if the relationship of content to form and style were examined more extensively, and the form in which design history writing is presented became more integrated and expressive, design history might better engage present design students.

NOTES

1. Beatrice Warde, 'Typography in Art Education,' in *The Crystal Goblet: Sixteen Essays on Typography*, ed. Henry Jacob (Cleveland: World Publishing, 1956), 84.

2. Bruce Mau, *Lifestyle* (London: Phaidon Press, 2000), 27.

3. Jaroslav Andel, *Avant-Garde Page Design 1900–1950* (New York: Delano Greenidge Editions, 2002), 228.

4. See M. M. Smith, 'Form and its relationship to Content in the Design of Incunables,' (PhD diss., Cambridge University, 1984), 75–80. Other examples include the books of Aldus Manutius and the Kelmscott Press.

5. László Moholy-Nagy, *Moholy-Nagy*, ed. Richard Kostelanetz (London: Allen Lane, 1971), 75.

6. Ibid., 75.

7. Philip Meggs, *A History of Graphic Design* (New York: John Wiley and Sons, 1998), 281.

8. Such as Adrian Forty's *Objects of Desire: Design & Society since 1750* (London: Thames and Hudson, 1986). See Victor Margolin, 'Narrative Problems of Graphic Design History,' in *The Politics of the Artificial: Essays in Design and Design Studies* (Chicago: University of Chicago Press, 2002), 236.

9. Nikolaus Pevsner, *Pioneers of The Modern Movement From William Morris to Walter Gropius* (London: Faber and Faber, 1936), 94.

10. Ibid., 193.

11. László Moholy-Nagy, 'Contemporary Typography,' in *The Bauhaus*, ed. Hans M. Wingler (Cambridge, MA: MIT Press, 1969), 79.

12. Ibid., 80.

13. Jan Tschichold, *The New Typography*, trans. Ruari McLean (Berkeley: University of California Press, 1998), 67.

14. Ibid., 74.

15. See Robin Kinross, *Modern Typography: An Essay in Critical History* (London: Hyphen Press, 2004).

16. Pevsner, *Pioneers*, 202.

17. Siegfried Giedion, *Mechanization Takes Command: A Contribution to Anonymous History* (New York: Oxford University Press, 1948), 719.

18. Ibid., 488.

19. Joseph Rykwert, 'Siegfried Giedion and the Notion of Style,' *The Burlington Magazine* 96, no. 613 (1954): 123–4.

20. Giedion, *Mechanization Takes Command*, 714.

21. Ibid., 720.

22. Reyner Banham, *Theory and Design in the First Machine Age* (London: Architectural Press, 1960), 285.

23. Ibid., 300.

24. Ibid., 328.

25. Warren Chappell and Robert Bringhurst, *A Short History of the Printed Word*, 2nd ed. (New York: Hartley and Marks, 1999), 257.
26. Ibid., 270.
27. See Penny Sparke, *An Introduction to Design and Culture: 1900 to the Present*, 2nd ed. (London: Routledge, 2004), 186.
28. Reyner Banham, *Theory and Design*, 329–30.
29. Chappell and Bringhurst, *A Short History of the Printed Word*, 270.

10 READING DETAILS: CARUSO ST JOHN AND THE POETIC INTENT OF CONSTRUCTION DOCUMENTS

MHAIRI MCVICAR

In architectural practice, the poetic intent of a design conceived in the office is translated into constructed reality through a complex and multi-layered network of communications between architects, clients, building contractors, engineers and the numerous consultants, specialists and advisors required by contracts, insurance and regulations. This professionalized context demands, above all else, certainty. To achieve certainty, the architect is advised by the profession to communicate through written and drawn documentation which is free of the ambiguity of poetic language. The language of construction documentation is supposed to be objective and factual. Yet, the inherently ambiguous poetic intentions underlying any architectural design remain inescapably embedded within even the most prosaic of construction documents, and their presence plays a critical role in the pursuit of quality in architecture. Analysing the letters, faxes and emails generated by the construction of one architectural detail—a joint on the west facade (Fig. 10.1) of Caruso St John Architects' Victoria and Albert Museum of Childhood entrance addition in Bethnal Green, London—this chapter explores the intentions and implications of the poetic intent embedded in technical communications.

A SIX MILLIMETRE MASTIC JOINT

'It is imperative', project architect David Kohn faxed on 27 September 2006, 'that the 6mm mastic joints are located on the outside edges of the red quartzite columns, and not in the middle of the column, in all instances. The joint in the middle should be a 4mm mortar joint. This is central to the architectural intent of the project.'

This fax from the project architect to the building contractor regarding the facade of Caruso St John Architects' 2006 entrance addition to the Museum of Childhood in Bethnal Green, London, can be read as a technical document; an objective, factual instruction regarding the correct placement and dimension of a joint accommodating movement between decorative cut stone panels on the facade. This fax speaks of technical matters, using a specialized vocabulary partly inaccessible to those outside the architectural profession. It is, seemingly, devoid of poetic content.

Conversely, this fax can be interpreted as a poetic statement speaking of the significance of ornamental expression, of relationships between technology, tradition and historical context, and of the pursuit of quality within contemporary architectural practice. This fax

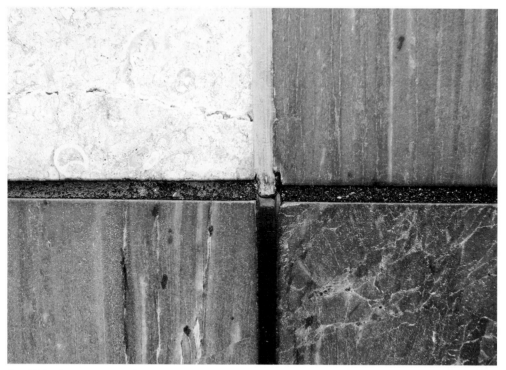

Fig. 10.1 A joint on the facade of Caruso St John Architects' 2006 Museum of Childhood entrance addition, Bethnal Green, London. Photo: Mhairi McVicar.

is one of hundreds of similar documents passed between the numerous members of a team assembled for the design and construction of this architectural project—a fragment of the written documentation which today plays a critical role in architectural design.

'Architects do not build buildings,' David Leatherbarrow observed in *Uncommon Ground,* 'they make drawings and models; at least that is what they do most of the time in most contemporary practices.'[1] Leatherbarrow here highlights a basic truth of architectural practice; that architects depend upon others to construct their designs and are dependent upon communications with others to achieve this. While architects may foreground drawing and model making, much of the time and effort of any contemporary architectural practice is devoted to writing. From initial expressions of interest and design statements to the contracts, technical specifications and the innumerable letters, faxes and emails generated during the construction of any architectural project, architecture is increasingly developed, described and built via the written word. Much of this written documentation could be described as bland and prosaic. This is not unintentional; guidance from professional, regulatory and advisory bodies, and the practice manuals and journals which define, protect and advise the architectural profession, emphatically advises against any ambiguity within technical documentation.

In the *Architects Journal,* Francis Hall advised that 'the one certain opportunity available for an architect to set down a definitive and enforceable expression of standard and

quality is by way of a properly drafted specification. If this is done, there is understanding and certainty all round.'[2] The written specification is here presented as the primary means of controlling standards in architectural construction. As a technical document charged with the task of empirically describing architectural design, written specifications have been in use for at least seven hundred years,[3] but they came into prevalent use in the United Kingdom during the early nineteenth century in response to building contracts which required contractors to guarantee fixed costs in advance of construction.[4] The need to predict and control costs demanded that all aspects of an architectural design be quantitatively defined. As the materials and methods of architectural projects became increasingly complex, numerous specialized professions emerged to advise upon, regulate and control such quantification. In a complex and multi-layered professionalized context, no longer can the architect claim direct familiarity with the parties and processes involved in the construction of architecture. Instead, precise empirical instructions today take on the role of disseminating the architect's poetic intentions to those on the construction site. Imprecise instructions, warn Osama A. Wakita and Richard M. Linde, authors of the *Professional Practice of Architectural Detailing,* are 'ambiguous and thus have no place in architecture'.[5]

Authors of the written specification have struggled to describe design intentions without ambiguity. The historian M. H. Port described an 1812 Parliamentary Select Committee which debated the core problem 'of so drawing up the specification as to cover every part of the design and all contingencies, complete with working drawings, and clear of ambiguities before operations were begun'.[6] No specification, the committee heard, had ever been found 'to ensure what is requisite; except in very small, plain or rough works'.[7] This point was echoed almost two hundred years later by Wakita and Linde, who conceded, 'Architects involved in Quality work find that there is never enough information on a set of drawings nor enough details drawn.'[8]

Quality work, this implies, requires something more than even the most definitive set of documents can provide. Despite recognition that technical language can never fully convey design intent, it remains the only means by which quality may be controlled in construction. Practitioners within architectural construction are advised to avoid using the poetic language which would typically be used to describe conceptual intentions; this distinction perpetuates a theory/practice split within architectural design

THE LANGUAGES OF THEORY AND PRACTICE

The implications of a theory/practice split are widely debated. Dalibor Veseley portrayed an architectural profession internally divided, turning to 'instrumental' language as a means of retaining control. 'Instrumental thinking', Veseley wrote, 'tends to impose its hegemony by creating a world it can truly control.'[9] One of the primary difficulties today faced by the architectural profession, Veseley argued, is its present inability to 'discuss technological problems from a non-instrumental point of view'.[10] Poetic language is denied in instrumental thinking as non-scientific and thus invalid.

Katherine Shonfield similarly evoked an image of a self-validating world of instrumental thinking, arguing that technical writing is intentionally bland in order to perpetuate and protect professionalized specializations. Construction, Shonfield observed is 'heavily protected by veils of self validating notions'.[11] Thus protected, only the initiated professional can access and control it. Both Veseley and Shonfield have drawn attention to the wider implications of the prevalent use of technical language as the primary means of communication in architectural practice, observing that the use of technical language actually creates, perpetuates and protects an instrumental world by denying ambiguity and poetic content.

The consequences of technical language are seldom reviewed in architectural theory. While Veseley observed that drawings are typically considered to be secondary to the architectural object, Katie Lloyd Thomas has noted that the written technical specification is further subordinated in architectural theory as merely 'supplementing' the drawing.[12] Deliberately bland, inaccessible to all but the most specialized of readers, and seemingly stripped of poetic and cultural content, the specification seems to offer little to theoretical considerations of architectural design. Yet, Veseley argued, the gulf between theory and practice may be misleading, and the daily pragmatics of practice may have more to offer than has been assumed. Architectural practice, Veseley proposed, 'is not always practical; in fact, it is more often theoretical. We need only look at the nature of a typical brief or program, the criteria of design, and the conditions of its execution to grasp this elementary truth.'[13]

Poetic intent may in fact be embedded within the most prosaic documents in architectural practice. This observation was applied to architectural drawings by Paul Emmons in his analysis of graphic diagramming in *Architectural Graphic Standards*, the self professed 'bible' of architectural drawings, which aimed to produce drawings 'purposely devoid of cultural content'.[14] Emmons argued that, far from achieving this aim, technical diagrams unavoidably reveal their cultural context: traces of the fashions, preferences, habits and viewpoints of the artist who drew them remain stubbornly attached. 'Diagrams', concluded Emmons, 'are not thin and factual, but rich with meaning.'[15] If poetic content is embedded within every drawing, so too might every word of a written specification, letter, fax and email be saturated with poetic content, and open to interpretation.

An analysis of technical writing in architectural practice begins by acknowledging that no text is free from individual interpretation. Although technical documents are advised to be unambiguous and closed to misinterpretation, Roland Barthes observed that once any text leaves the author's hands, the reader is free to interpret it as he or she wishes. The reader's previous experiences, cultural context and even the time, and place and circumstances of reading may affect the interpretation.[16] The reader, Barthes also observed, will simply skip text perceived to be dull, unimportant or irrelevant.[17] The reader remains in charge of the reading.

Proposing that the seemingly prosaic written statements, letters, faxes and emails of construction documentation offer valuable insights into the processes by which poetic intent is achieved in architectural practice, communications discussing the location and dimension of a joint on the facade of the Museum of Childhood's 2006 entrance addition are here ex-

amined. Embedded within these documents, a story emerges of contemporary architectural practice, and relationships between the technical and the poetic in architectural design.

CARUSO ST JOHN AND THE MUSEUM OF CHILDHOOD

The 2006 entrance addition to the Victoria and Albert Museum of Childhood in Bethnal Green was charged with providing an appropriately impressive presence for the Museum on its Cambridge Heath facade. An entrance was envisaged that would engender community pride and increase awareness of the Museum by projecting its significance to the local context and beyond.

The Museum of Childhood is housed in a nineteenth-century iron structure originally erected in 1856 as an addition to the Victoria and Albert Museum on its South Kensington site. Nicknamed the 'Brompton Boilers', and widely criticized for its utilitarian nature, the structure was dismantled in 1867 for relocation to Bethnal Green.[18] The architect J. W. Wild (1814–92), commissioned to create a new facade for the structure, proposed an intricately patterned brick facade in direct contrast to the corrugated iron cladding used at South Kensington. While the majority of the facade was completed according to Wild's proposals, an expansive and elaborate entrance sequence comprising a colonnade and several ancillary structures was omitted due to cost constraints, and a much reduced and largely utilitarian entrance structure was instead constructed. Consisting of a narrow entrance hall flanked by toilet blocks, this reduced entrance was criticized as inadequate, both functionally in its inability to accommodate large groups of visitors, and symbolically in its inability to convey the significance of the Museum as a resource of international importance.

In 2002, the Museum of Childhood selected London-based architectural practice Caruso St John Architects to master-plan the renovation of the Museum, the second phase of which proposed a new entrance addition. Caruso St John Architects, formed in 1990 by principles Adam Caruso and Peter St John, had by 2002 completed several projects receiving international critical recognition, including the Walsall New Art Gallery of 2000. In conjunction with constructed projects, the practice writes and publishes extensively. 'I think that the most significant writing by architects', Caruso observed, 'has been developed in parallel to their work in practice.'[19] The written and constructed work of the practice critically argues in favour of engagement with existing conditions and an acknowledgment of historic traditions. Rather than nostalgia, this critical stance is stated as a progressive strategy. 'A more radical formal strategy', Caruso wrote, 'is one that considers and represents the existing and the known. In this way, artistic production can critically engage with an existing situation and contribute to an existing and progressive cultural discourse.'[20]

In developing proposals for the entrance structure at the Museum of Childhood, Caruso St John focused on the possibilities of complex ornamentation offered by contemporary stone-cutting technologies, mediating evocations of the hand-laid decorative brick and mosaic patterning of Wild's facade with the precision, efficiency and control offered by contemporary stone cutting CNC (computer numerical controlled) processes. Early sketches and models (Fig. 10.2) culminated in what St John described, in discussions with

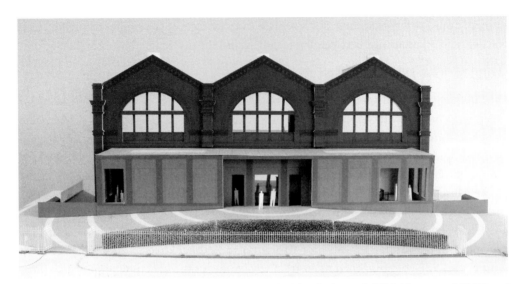

Fig. 10.2 Concept west elevation image of Caruso St John Architects' 2006 Museum of Childhood entrance addition, Bethnal Green, London. Image: Caruso St John Architects.

the author in May 2009, as a 'simple yet intense' box; a rectangular one-storey volume placed in front of the existing brick facade, tightly wrapped in a patterned stone skin. Caruso St John outlined its intent in a design statement:

> The elevation of the new front building is organised by a simple system of representational columns and beams, as employed in the elevations of the existing main hall. The rhythm of the columns has been carefully judged to give the new building a graceful and calm appearance . . . The elevations are to be finished in different red stones to compliment the brickwork of the existing building. The use of stone on the facades, as opposed to brickwork, allows a more richly decorative finish appropriate to the entrance of a civic building.[21]

This early description of the entrance facade highlighted continuity with the existing Museum through the rhythm, materiality and colour of the stone patterning (Fig. 10.3). 'The original Wild proposal for the front colonnade was highly decorative in the fashion of the day', Caruso St John wrote, continuing:

> In this proposal the facades of the new front building are also decorated to compliment the mosaic friezes on the north and south elevations of the main hall, providing further embellishment to the otherwise reduced brickwork of the main hall. The facades are to be clad in different coloured stone tiles with very fine joints, like marquetry. The smooth flat finish will be given depth through the use of repetitive illusionistic patterns in the infill panels.[22]

Historic decorative facades evoked in this twenty-first-century patterned skin included the patterned facade of Leon Battista Alberti's fifteenth-century *Santa Maria Novella* in

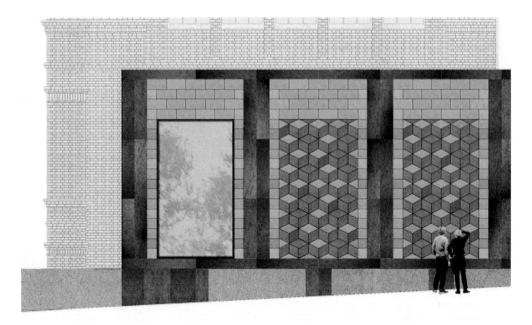

Fig. 10.3 Design development drawing of the west elevation of Caruso St John Architects' 2006 Museum of Childhood entrance addition, Bethnal Green, London, showing the setting out of decorative cut stone columns and infill panels. Image: Caruso St John Architects.

Florence (1456–70)[23] and eleventh- and twelfth-century *opus sectile* Cosmati pavements.[24] Rather than recreating historic craft, Caruso St John proposed a taut, flat skin exploiting the precise tolerances offered by contemporary technologies. 'In the 19th century', Caruso St John wrote, 'such decoration was carried out by hand. With the rise of industrialised processes in the building crafts, so decoration became prohibitively expensive. However, with recent advances in computer controlled stone cutting it is again possible to achieve complex decorations at an affordable price.'[25]

Initial proposals specified large prefabricated panels of ten-millimetre-thick stone tiles bonded to a honeycomb 'Fibrestone' substrate. This prefabricated assembly promised the ability to achieve the fine 'marquetry' joints Caruso St John had described, with joints as thin as four millimetres. As the project progressed, the project stonemasons advised the use of an on-site load-bearing assembly of CNC-cut stone blocks, laid by hand in a manner similar to a brick veneer wall—a significant departure from the original factory-assembled prefabricated panel. While this alternative construction was intended to achieve the same aesthetic appearance, the project architect, David Kohn, stressed that precise joints would remain a critical aspect of the design intentions. 'The only thing I would want to check', Kohn emailed the facade engineer on 18 October 2005, 'is that the patterned stone sections at the facade could be made to as tight tolerances as the Fibrestone panels.' (See Fig. 10.3, above.) Construction on site inevitably involves more risk than prefabricated assembly. While factory conditions are controllable and predictable, on-site construction is often chaotic and unpredictable.

Throughout the twentieth century, as building construction materials and processes became more complex, the desire to precisely control the processes of construction grew.

THE TOLERANCES OF CONSTRUCTION

Shonfield has discussed a 1969 *Architects Journal* article which envisaged 'a group of al-most white-coated, well paid workers, slotting and clipping standard components into place in rhythmic sequence on an orderly, networked and mechanized site, to a faultless programme, without mud, mess, sweat or swearing.'[26] Such promises remain largely un-fulfilled on the construction site. Sociologist Darren Thiel's studies of the construction site observed that it remains pre-modern, resistant to Fordist control, changing daily, some-times hourly in form, organized not by precise prediction, but through a continuously adaptive and responsive process of orchestrated chaos. Daily activities on the site cannot be definitively mapped or predicted, and the architect's instructions are often absent from decision-making processes on site. 'A thousand times a day', Thiel concluded, 'the builder must decide what is good enough.'[27]

Despite Fordist ideals of mechanization, there is always a moment on the construction site where prefabricated components meet each other or existing conditions. The more construction processes become component-based, Shonfield observed, the more joints will become a matter of concern. 'In matters of tolerance', Shonfield wrote, 'statistics are irrel-evant, for tolerance must be able to accommodate even the most extreme circumstances.'[28] While drawings and written specifications predict precise dimensional tolerances, the un-predictability of the construction site will inevitably exert its own influence. A moment of inattention, a misinterpretation of an instruction, a rainy or windy day may intervene; the builder is only human and works in unpredictable conditions. No matter how precisely the prefabricated components meet the precise requirements of the written specification, the joint between them remains in the hands of each worker on the construction site. No matter how precise the written instruction, the joint remains vulnerable.

As the most vulnerable aspect of the project, the joints between the pre-cut stone sec-tions at the Museum of Childhood received close attention in the written documentation. Throughout the project, Caruso St John sought to reduce the visual impact of large joints. 'We would like to work', Kohn faxed on 20 March 2006, 'towards there being no verti-cal movement joints on the west facade.' British Standards guidelines, however, neces-sitated movement joints, stating, in BS 8298 Section 3.11.4.3 *Movement joints* that 'the recommended allowance for joint width should not be less than 10mm per 6m length of cladding'. The '10mm per 6m length of cladding' guideline would, practically, be accom-modated by one movement joint per column. Visually, however, Caruso St John sought to emphasize the rhythmic patterning of piers and infill, by specifying two six-millimetre mastic movement joints, one on each side of the column, to emphasize the visual repre-sentation of the column. When the contractor questioned the need for two movement joints per column, where one would achieve the practical requirements, the response from Kohn was unequivocal; a fax on 22 August 2006 confirmed, 'As far as 6mm vertical expan-

sion joints are concerned, they have always been shown on either side of the red quartzite columns with a 4mm joint in the middle of the column. We will not accept changes to this.'

This insistence upon constructing the joints exactly as specified might be read as uncompromisingly functional. However, Kohn's instructions repeatedly referred to the 'central intent' of the project. It was the definition of the 'central intent', not the specified dimension of the constructed joint, which would determine the quality of the project. Returning to Kohn's instruction of 27 September 2006, 'It is imperative', Kohn had faxed, 'that the 6mm mastic joints are located on the outside edges of the red quartzite columns, and not in the middle of the column, in all instances. The joint in the middle of the column should be a 4mm mortar joint. *This is central to the architectural intent of the project.*' (Author's emphasis.) Close reading reveals this technical instruction to be, in fact, aesthetic and theoretical, conveying the poetic intention which defined the project. To achieve the poetic intent of an intensely patterned skin wrapping the facade, integral to the project from the beginning, it was critical that the joints did not visually disrupt the stone patterning. It was critical, too, that the construction workers understood this and did not substitute a purely practical solution which eroded the specified design intent; that they shared expectations of craft, skill and care. 'The dimensional precision and finish of these areas', Kohn had previously faxed to the contractor on 9 May 2006, 'is of critical importance to the building's appearance, and we will expect a very high level of workmanship.'

DESCRIBING INTENTIONS

The letters, faxes and emails upholding the written specifications and detailed drawings clearly aimed to coax a shared understanding between architect and builder of the significance of these joints as they were translated from poetic ideal to constructed reality. In any architectural project, the poetic ideal is inevitably translated, adapted, improved or compromised in construction. As Veseley observed, the act of drawing is itself an act of translation; the act of writing, similarly, is an attempt to translate a poetic ideal into a language for construction. In this translation, much depends on a shared understanding of design intentions, as David Pye argued in *The Nature and Art of Workmanship,* when he suggested that all workmanship 'is approximation, to a greater or less degree. Good workmanship is that which carries out, or improves upon the intended design.'[29]

Pye proposed that for workmanship to carry out, or improve upon, the intended design, the builder must first understand the underlying intention. Tolerances exist in even the most precise of specifications, and all construction, Pye continued, remains an approximation of intentions. Constructed quality, by implication, cannot be achieved solely by an exact adherence to the specified dimensions. Quality may emerge from a common understanding of design intentions, so that adjustments, when they do occur, remain in sympathy with, or improve upon, the intended design. The underlying hope of a written instruction may be that the builder will understand the poetic intent of the instruction, and undertake adaptations within this understanding.

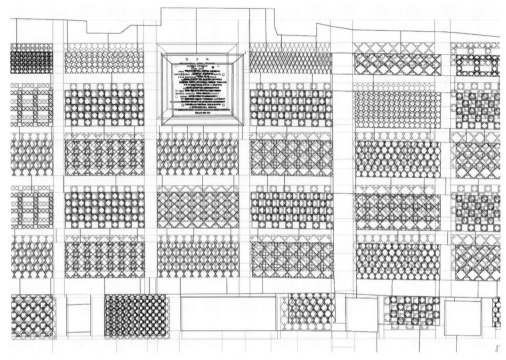

Fig. 10.4 'Perfect, Imperfect' overlay drawing of the differences between the geometric ideal and the 'as built' conditions of the twelfth century Cosmati pavement in Santa Maria in Cosmedin, Rome, surveyed by Louise Hoffman, James Paul, and Sabine Rosenkrantz in 2004 for David Kohn's Undergraduate Studio 5 at London Metropolitan University. Image: David Kohn.

The constructed joints at the Museum of Childhood do not, in fact, maintain the critical four- and six-millimetre dimensions. They vary, more or less, between two and ten millimetres. The pre-cut stones are occasionally chipped at corners; corners of individual stones do not precisely align; individual joints vary in width. Yet despite dimensional discrepancies, the poetic intent of the project is retained. The facade, as constructed, reads as a complex, carefully constructed, taut skin. Rather than demanding uncompromisingly precise adherence to exact dimensional specifications, the written specifications can equally be interpreted as a poetic device which sought to convey to the builder the significance and aim of the facade. Such an interpretation can be gleaned from Kohn's investigations into Cosmati pavements, which highlighted the difference between a geometric ideal and a constructed reality.

The Cosmati pavements, a series of renowned mosaic pavements throughout Europe, were constructed in the eleventh and twelfth centuries by four generations of the Cosmati family, whose reputation for skill and craft was, and remains, widely acknowledged. The intricate patterns, of varying stones laid out in complex geometrical patterns, are widely debated as holding cosmological significance.[30] As constructed, the pattern and dimensioning of the constructed pavements differ, sometimes widely, from the geometrical ideal. An architectural studio taught by Kohn measured a Cosmatesque pavement, developing a draw-

ing titled *Perfect/Imperfect* which overlaid the geometric ideal with the constructed reality (Fig. 10.4). Crucially, for Kohn, the difference between the geometric ideal and the constructed result did not signify a lack of craft or care, but rather demonstrated an essential aspect of construction: that the geometrical ideal can never quite be attained, even in the most exemplary of projects.[31] Despite geometric imperfections and ambiguities, the Cosmati pavements remain widely acclaimed as works of art, beauty, craft and care. Here, quality is understood as a projection of poetic and cosmological significance rather than adherence to unachievable demands to attain a perfect geometrical ideal. For the Cosmati pavements, in the context of care and skill, geometric imperfections are ultimately insignificant.

Although the technical instructions for the Museum of Childhood appear to insist upon uncompromised geometric perfection, the instruction that the joints are to be 'central to the architectural intent of the project' spoke of wider intentions than a geometric ideal. This phrase is inherently ambiguous: 'architectural intent' can be neither quantitatively described nor measured. It is precisely in this moment of ambiguity where the intent of this project is most closely communicated. As with the Cosmati pavements, the quality of this project did not depend upon exactly achieving four- and six-millimetre constructed joints. The poetic intent—a proportional system in which the representation of a pier and infill rhythm was to be enhanced by the placement and proportion of joints—was most clearly communicated, amidst the complex layers of professionalized specializations and bureaucracies, by an unquantifiable, poetic statement.

THE PROMISE OF POETIC LANGUAGE

Rather than attempting to describe a poetic intention whilst denying poetic language, using poetic language may simply be more direct. While technical documents in professional architectural practice continue to uphold the attainment of a geometric ideal as the sole indicator of quality, quality is more ambiguous by nature. In specifying precision, an underlying intention is the desire for care, skill and attention to detail. While each and every joint in an architectural design can be definitively expressed on paper, quality on the construction site still depends upon the builder understanding the wider intentions of the project. Rather than denying construction documents their poetic role, architectural quality could perhaps be better pursued by explicitly sharing the poetic intent of a project with those who construct it.

At the Museum of Childhood, a patterned stone facade was charged with the task of projecting the significance of the Museum to a local and national context. Referencing J. W. Wild's ornate brick facade, Alberti's *Santa Maria Novella*, and the perfect/imperfect balance of Cosmati pavements, the constructed facade embodies a critical stance regarding contextual and historical referencing mediated with contemporary methods and materials (Fig. 10.5). These aims are embedded within the letters, faxes and emails exchanged among the many professions who made up the design team for the construction of the Museum of Childhood entrance. Through these documents, the significance of the correct placement and proportion of a mastic joint was ultimately conveyed. This occurred not through the

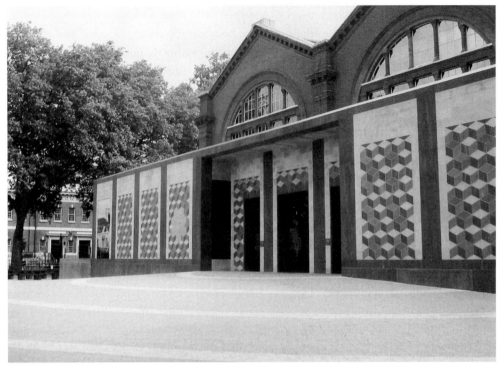

Fig. 10.5 Constructed west elevation of Caruso St John Architects' 2006 Museum of Childhood entrance addition, Bethnal Green, London. Photo: Mhairi McVicar.

technical reading of an objective and factual instruction, but through the poetic reading of the subjective and ambiguous statement: 'This is central to the architectural intent of the project.' While fulfilling a necessary and inescapably technical role, the written documents achieved their core aim by permitting poetic language to surface. In so doing, they urged all involved in the project to understand the poetic intent. Here, filed within prosaic technical documentation, buried in the midst of a complex layering of hundreds of specifications, drawings, emails, faxes and letters, a poetic description highlights a moment where architectural quality is achieved.

NOTES

1. David Leatherbarrow, *Uncommon Ground: Architecture, Technology, and Topography* (Cambridge, MA: MIT Press, 2000), 25.
2. Francis Hall, 'Specifying for quality,' *The Architects Journal* 199 (1994): 38.
3. Franklin Toker, 'Gothic Architecture by Remote Control: An illustrated building contract of 1340,' *The Art Bulletin* 67 (1985): 67–95.
4. M. H. Port, 'The Office of Works and Building Contracts in Early Nineteenth-Century England,' *The Economic History Review* 20 (1967): 94–110.

5. Osama A. Wakita and Richard M. Linde, *The Professional Practice of Architectural Detailing*, 3rd ed. (New York: Wiley, 1999), 51.

6. Port, 'Office of Works,' 98.

7. Ibid., 98.

8. Wakita and Linde, *Architectural Detailing*, vi.

9. Dalibor Veseley, 'Architecture and the Question of Technology' in *Architecture, Ethics and Technology*, ed. Alberto Perez-Gomez (Montreal: McGill-Queen's University Press, 1994), 31.

10. Veseley, 'Question of Technology,' 30–1.

11. Katherine Shonfield, 'Purity and Tolerance: How Building Construction Enacts Pollution Taboos,' *AA Files* 28 (Autumn 1994): 34–40.

12. Katie Lloyd Thomas, 'Specifications: Writing Materials in Architecture and Philosophy,' *Arq: Architectural Research Quarterly* 8 (2004): 277–83, 277.

13. Dalibor Veseley, *Architecture in the Age of Divided Representation: the Question of Creativity in the Shadow of Production* (Cambridge, MA: MIT Press, 2004), 12.

14. Paul Emmons, 'Diagrammatic Practices: The Office of Frederick L. Ackerman and Architectural Graphic Standard*s*,' *Journal of the Society of Architectural Historians* 64 (2005): 4.

15. Emmons, 'Diagrammatic Practices,' 15.

16. Roland Barthes, *Image, Music, Text,* trans. Stephen Heath (London: Fontana Press, 1977).

17. Roland Barthes, *The Pleasure of the Text,* trans. Richard Miller (London: Cape, 1976).

18. Alan Baxter and Associates, *The Museum of Childhood at Bethnal Green Conservation Plan* (Unpublished report prepared for the Museum of Childhood, 2004).

19. Adam Caruso, *The Feeling of Things* (Barcelona: Ediciones Poligrafa, 2008), 5.

20. Adam Caruso, 'The Tyranny of the New,' *Blueprint* 150 (May 1998): 24–5, 25.

21. Caruso St John Architects, *Stage E Report Rev A* (unpublished report, 2004), 11.

22. Ibid., 12.

23. Peter St John (Caruso St John Architects), in discussion with the author, 11 May 2009.

24. David Kohn (Caruso St John Architects), in discussion with the author, 1 May 2009.

25. Caruso St John Architects, *Stage E Report*, 12.

26. Shonfield, 'Purity and Tolerance,' 36.

27. Darren Thiel, 'Class in Construction: London Building Workers, Dirty Work and Physical Cultures,' *British Journal of Sociology* 58 (2007): 227–51, 231.

28. Shonfield, 'Purity and Tolerance,' 37.

29. David Pye, *The Nature and Art of Workmanship* (Cambridge: Cambridge University Press, 1968), 13.

30. Lindy Grant and Richard Mortimer, eds., *Westminster Abbey: the Cosmati Pavements* (Aldershot: Ashgate Publishing, 2002).

31. David Kohn (Caruso St John Architects), in discussion with the author, 1 May 2009.

11 APPLYING ORAL SOURCES: DESIGN HISTORIAN, PRACTITIONER AND PARTICIPANT

CHAE HO LEE

Words, written and spoken, are an integral part of design research and practice. Images, illustrations, designed forms and spaces need to be placed in a contextual framework in order to communicate a message and impart meaning. Design historians and practitioners identify themselves as experts and mediators of the visual form and thereby gain influence and power in determining which histories and designs are to be read, viewed and heard. However, what about participants in the research and design process who have not been identified or recognized as significantly affecting a research or design outcome? This chapter discusses the application of participatory action research (PAR) objectives and participant observation methods in informing an oral and participant-based design process demonstrated in eight graphic design student projects produced at universities in the Middle East and Pacific Rim. The study reveals the influence of social and cultural location, participant contributions, language proficiency and the notation of data and information in the research and design process.

Oral sources have always been an important source of evidence for historians.[1] Folk songs, oral narratives, spoken word performances and ritual are some of the only sources of information available documenting the daily life and achievements of past cultures and societies. Although the written word has remained a primary source of information for historians and designers, oral sources have been used in tandem with the printed word to record and communicate information accessibly. Carmen Luke claims: 'The traditional methods of oral communication through sermons, public preaching and town criers, coupled with the mass distribution of and accessibility to printed works, provided the means for rapid and radical change.'[2]

From the nineteenth century, interviews became a key method in obtaining oral information, meeting the informational demands of scholars, historians and early printers. The act of asking questions, consulting and documenting oral accounts resulted in developing evidence to prove an assumption or theory. However, oral sources also need to meet comparative standards in evaluation to validate the evidence they provide. Martha Howell and Walter Prevenier argue that oral sources need to be 'verified by means of external evidence of another kind' whether 'archaeological, linguistic or cultural'.[3] An interview may provide rich material, but that material must be collected and analyzed through accepted social, scientific and cultural methods. Theoretical paradigms enable comparative understanding

of historical and cultural trends in the perception and recollection of events and informa-
tion, thereby enriching and diversifying the historical record.

This chapter reviews eight projects from a group of eighty-eight student designs pro-
duced between 2005 and 2008 from BA and BFA graphic design students at Zayed Uni-
versity, Dubai, United Arab Emirates, and the University of Hawai'i at Mānoa, Honolulu,
Hawai'i, United States. The design students were asked to create a design project based on
interviews and research conducted with members from their local communities. Students
were encouraged to use oral sources as a primary information resource. The diverse content
of the interviews reflected the environmental, local and cultural interests of the graphic
design students. Three of the students identified here were enrolled as full-time students at
Zayed University, one of the first women's universities in the region. Zayed University is
comprised of a student body of Muslim women with shared religious and tribal affiliations
but surprisingly diverse ethnic, economic and educational backgrounds. The five remain-
ing students were enrolled as full-time students at the University of Hawai'i at Mānoa,
which has one of the most culturally and ethnically diverse populations of students in the
United States, with close cultural and economic ties to Asia and the Pacific. Participatory
action research objectives and participant observation methodologies were reviewed and
taught in the design classroom to educate the students about the importance of contextual-
izing a project, language usage, record keeping and informational analysis in the develop-
ment of design research and project outcomes.

PARTICIPATORY ACTION RESEARCH OBJECTIVES

PAR originated within the field of social psychology with the aim of 'advancing scientific
knowledge' and 'achieving practical objectives'.[4] Kurt Lewin, Milman Parry and Walter J.
Ong were primary figures in its early development.[5] Action research (AR) and participative
research (PR) are closely related to PAR, although PAR focuses upon local communities and
social change, as well as the research process as a creative act. AR positions the researcher as
an expert within a research project, often evaluating a situation through a professional lens
and recommending a course of action. PR addresses the improvement of skills and learning
in a group or organization. PAR research is a combination of participant observation meth-
ods with 'explicitly recognized action objectives and a commitment to carry out the project
with the active participation in the research process by some members of the organization
studied'.[6] PAR is a collaborative approach to research and data collection that focuses on
creative problem solving using both a flexible and reflective attitude. 'While the scientific
view insists on absolute quantifiability, the PAR view appreciates subjective reflection as a
form of data, giving credence and respect to intuitively driven moments and epiphanies.'[7]

PAR objectives were advocated during the research and design process of class projects
so that the students would develop design work that demonstrated a deeper understand-
ing of the individuals, sites and communities they represented. Students were encouraged
to define informants and collaborators in their projects as 'participants' and through this
interaction, points of discovery could be made, and a course of action determined, by both

designer and participant. PAR objectives were readily accepted by students and participants, who were motivated by a project that allowed parties to make connections to their communities, provided flexible research methods and fostered a sense of ownership derived from validating the unique perspective of all project participants.

PARTICIPANT OBSERVATION METHODS

Participant observation was developed in the field of anthropology by researchers such as Frank Hamilton Cushing, Beatrice Potter Webb, Margaret Mead and Bronislaw Malinowski.[8] The approaches to design reviewed in this chapter were principally informed by the work of Kathleen and Billie Dewalt[9] and their seminal achievement of collecting and compiling participant observation methodologies into a guide for anthropological and ethnographic fieldwork.

Participant observation researchers enter groups or communities by observing, building research relationships and attempting to obtain information. William Whyte notes that participant observation researchers use 'participation to gain access to members of a group or organization to observe behaviour as it occurs, and also to build relations of personal trust needed to elicit full and reasonably frank interview material'.[10] Participant observation methods focus not only on asking questions but also on establishing a relationship with the subjects that are being studied, as a means to discover relevant questions to ask and to generate and test theories. Participant observation methodologies were applied to the development of the student design projects to obtain information, analyze assumptions and create communicative work.

A limited form of participant observation was used in the design student projects, due to the fact that students could not actually live with their project participants. James Spradley's typology of the 'degree of participation' helped define the students' level of participation. The four participation levels included: non-participation, moderate participation, passive participation and active participation.[11] Non-participation occurs when observations are made outside the site of research. Passive participation includes observations made at the site of research with minimal interaction with research participants. Moderate participation is defined as observations made at the site of research with occasional or temporary interactions with research participants. Active participation is established when observations and cultural understandings are made at the site of research with as much interaction and active participation possible in the daily activities of research participants.

The participation level for most of the student projects were categorized from passive to active participation. Participation levels were often dependent on the motivation level and amount of time and resources students were willing to devote to their design projects. Students were encouraged to make regular site visits, and to join in daily activities with their participants. They were asked to take extensive field notes and, most importantly, observe with the intention of documenting their observations in careful detail. The remainder of this chapter reviews examples of student work to explain the benefits of participant observation methods for research and design processes.

CONTEXTUALIZING A PROJECT

Many design historians and designers engage in a level of non-participation with the people and organizations they are studying or interacting with. For the historian, context (the set of circumstances that shape a place, event or situation) may be developed through the examination of relevant documentary records. Designers often develop the context for a project through client meetings in their own design studio, or they choose to filter communications through a client manager or representative. Design historians and designers may better represent their subjects of research or clients by visiting research sites and collecting oral evidence. The immediacy and dynamic interaction between a subject and investigator, central to both historical research and design practice, cannot be replaced through other methods.

In the projects which form the case study here, design students used participation observation methods to develop their understanding of the environmental, social and historical context of their projects, such as circumstances which shaped events, places, traditions or situations. Creating a conceptual framework during the process of building research relationships with participants and accumulating research information allowed the students to form interview questions, understand the backgrounds, social position and motivations of their participants, and access a network of potential participants. Students were taught to use participant observation methods in the classroom and conducted topical literature reviews. Students then identified their research sites and participated in the daily activities of their participants. Unstructured, semi-structured and structured interview techniques were employed; the evidence gathered was vital in determining a social relevance and final form for their design projects.

Etsuko, a student originally from Japan, created a project based on a famous monkey pod tree in Hawai'i: The Hitachi tree or Kono ki nanno ki (What is this tree). The Hitachi tree is used extensively in the branding of the Hitachi Group and is well known in Japan due to a series of commercials that first ran on Japanese national television in 1973. Etsuko's design process was influenced by her visits to the site of the tree: Moanalua gardens, a twenty-six-acre public garden located on the island of O'ahu. The textual and visual information used in Etsuko's project was gathered from historical readings, online fan sites dedicated to the tree and on-site interviews. The final form for the project was a long, printed scroll that was identical to the girth of the Hitachi tree, and when rolled into a container made for the project, mimicked the rings of the tree's trunk. The scroll contained images and text gathered from the Hawai'i state archives, excerpts and descriptions from unstructured and semi-structured interviews (Fig. 11.1). The interviews were collected from groundskeepers who take care of the tree, botanists who study the tree and groups of Japanese tourists who purchase tour packages to visit and take pictures of the tree. Etsuko's regular site visits and extensive interviews revealed the diversity of attachments individuals have with the tree. The groundskeepers articulated a maternal connection to the tree, the biologists studying the tree were impressed by its size and symmetry, and the tree has

obtained a level of cult status among its Japanese visitors. Etsuko's project revealed the importance of contextualizing a subject of research through multiple viewpoints and the benefits of the interview in that process.

Kelli, a student from Hawai'i, created a project about a community theatre placed in the unusual setting of having a Hawaiian graveyard located directly in front of the theatre's main entrance. Kelli's interactions with the physical space of the theatre and Hawaiian graveyard as well as the individuals associated with both sites informed the physical form and contents of her design project. Kelli volunteered at the theatre and conducted structured interviews with the theatre's actors, production crew, groundskeepers and volunteers.

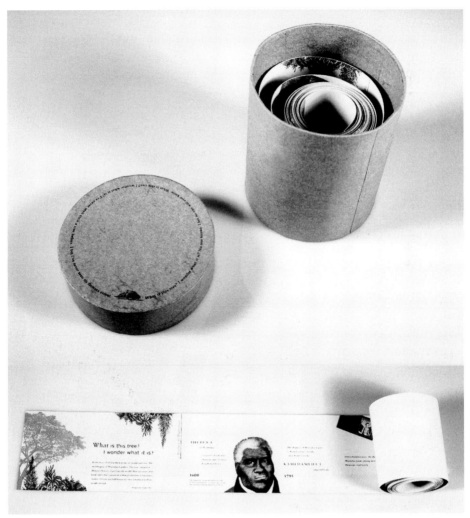

Fig. 11.1 What is this Tree? I wonder what it is? Monkeypod tree of Moanalua Gardens. Etsuko Ono.

Kelli applied her research to create a box (Fig. 11.2) that resembled a funerary box; the black walls shaped into a square evoked black box experimental theatre. Kelli placed a number of items within the box, including an accordion book with text containing interviews and additional information she was able to obtain from the neighbourhood historical society. Kelli also placed wrapped objects from the theatre's prop room into the box to commemorate some of the plays; the wrapping referred to the practice of wrapping cloth around the remains of the dead. A funeral and theatrical production are expressed in Kelli's project as forms of performance. The viewer interacts with her project through a series of physical actions such as sliding a cover open, unrolling covered objects and unfolding pages of text. Kelli was able to create a high level of interactivity in her design project because of her careful examination of the site and the establishment of a conceptual relationship between its two seemingly disconnected purposes.

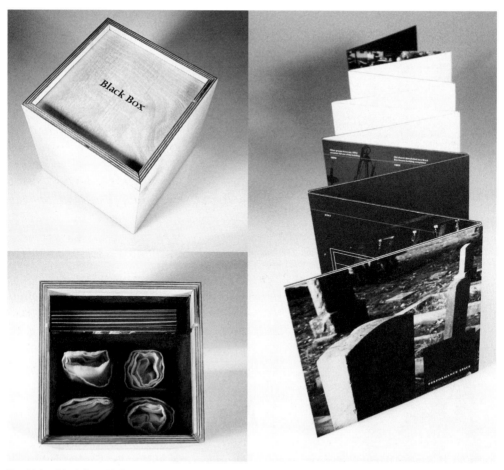

Fig. 11.2 Black Box, Kelli Ann Harada.

LANGUAGE AND CULTURE

Language proficiency in historical design research and design practice has often been ignored or overlooked. Through the study of a foreign language, a historian and designer may shift their own cultural perspectives and extend their historical and cultural knowledge. In an article entitled 'Why Designers Should Study Foreign Languages', Carma R. Gorman argues: 'The ability to think critically about language—and about the world views that languages necessarily impose upon their speakers—is, I think, only possible once one has learned enough of another language to be able to look at English from the outside'.[12] Languages contain unique structures and meanings that affect both context and content in a design. Languages are not merely forms of communication but ways in which societies have distinct worldviews.

Participation observation imperatives required our design students to learn, and actively use, the local languages of the cultures and societies investigated in their design projects. Language proficiency is essential in the effective communication of ideas. Words with the same spelling may have different meanings. For example, the Hawaiian word *i'a* translates into English as: fish or any marine animal; meat or any flesh food; a relish eaten with a starch staple; or the Milky Way Galaxy, depending on context. The omission of diacritical marks in Hawaiian words further changes their meaning. The Hawaiian word i'a without the *okina* (a glottal stop)—as in 'ia'—would change the word into a pronoun, he, she or it.[13] Requirements in language fluency were necessary for the design students in order to communicate effectively with their subjects, follow the flow of conversation, note the subtle and tacit meanings associated with words and terms, and develop a cohesive theme or direction for their design projects.

Aki, a student originally from Japan, conducted semi-structured interviews with a *Kumu* (teacher) who taught her the use of *la'au* (traditional Hawaiian herbs and medicines)[14]. Aki used both English and Hawaiian in interviews with her Kumu and created a book-form based on Hawaiian cultural terms drawn from the interviews. The Hawaiian words *Ao* and *Pō* were hand embossed onto the front cover of the book (Fig. 11.3) and have a conceptual relationship to the book's contents and its organization. Ao is a Hawaiian word, which translated into English means light, day, enlightenment and the regaining of consciousness.[15] The Hawaiian word Pō translated into English is night, darkness, obscurity, pertaining to the gods and ignorance.[16] The combination of both words reflected the books attempt to revive a Hawaiian cultural practice and spiritual connection to la'au. Aki's choice of Hawaiian terms taken from her interviews in order to contextualize her design, demonstrates the benefits, for a design project, of language proficiency.

Dina, an Emirate student from Dubai, was interested in examining the perception of her classmates and family to her mixed ethnicity; she's the child of a Dutch mother and Emirate father. She conducted unstructured interviews and structured questionnaires to solicit information from her classmates and family. Based on her interviews and questionnaires, Dina created an embroidered black *sheila* (a head scarf worn by most Emirate

Fig. 11.3 Ao/Pō, Aki Arios.

women) embroidered in white thread with Arabic words. Also embroidered on the scarf but in orange thread are aspects from the plans of a windmill owned by Dina's Dutch mother's family. Dina was not proficient in written Arabic, so she had to translate her thoughts and the outcomes of her research from English and Dutch to Arabic. Dina was able to bridge both cultures through the combined use of written and visual language. When worn, the sheila communicated as a garment that literally and symbolically tied her to both Emirate and Dutch cultures.

RECORDING OBSERVATIONS IN FIELD NOTES

Design historians typically develop note-taking techniques, but these do not always include the use of field notes. Designers often work through sketching and client briefs to establish content but tend not to fully utilize textual field notes because visual records seem more important to the development of a project than the written or printed record. The translation of diverse forms of notes into a visual form can enhance the communication experience for users of design research outcomes. Participant observation researchers use field notes extensively. For example, records must be made of when and where interviews occurred. It is also important to record the daily activities of participants, informal conversations and descriptive observations during and after site visits, to determine, or even alter, the course of research.

Careful documentation was encouraged throughout the development of the students' design projects which form the case study here, including expanded field notes, diaries, journals, logs, meta-notes/analytic notes and head notes.[17] The field notes students documented during and after their site visits often directed design decisions and provided content for their design projects. Jon, a student from Hawai'i, created a project about a large park in Waikīkī, Kapiʻolani park founded by the Hawaiian monarch King Kalākaua I in

1893. Jon undertook semi-structured interviews with individuals who had different experiences with the park, from those using the tennis courts and leisure facilities to a homeless individual who resided there. Jon created a map of the park based on Hawai'i state records and his field notes, to be used in conjunction with transparent overlays, with the panel sizes determined by the area that participants most often occupied within the park. Through examination of his field notes, Jon was able to determine unexplored spaces in the park. This prompted Jon to conduct further interviews to provide a more comprehensive geographic survey of park users, which further diversified his findings.

Amna, an Emirate student from Dubai, was interested in examining the pressure she felt from her family to marry and have children at an early age. Amna conducted unstructured and semi-structured interviews with many of her friends and family members who had married and established families before the age of twenty one. The observations Amna made in her notes of the presence of women dressed in aprons during the interviews led to the creation of an apron as a physical form in the communication of her design. The apron was made from a pattern in a home-economics book held by the university's library, and it was printed with illustrations of the women she interviewed and their children. Extra pockets were sewn onto the apron and informational cards inserted in each of the pockets. The fronts of the cards contained excerpts from the interviews she conducted and the reverse conveyed fears Amna's participants had about divorce rates, health concerns during pregnancy and spousal abuse in their community. Field notes were essential in determining the final form of Amna's project, and they provided a pattern of concerns among the women she interviewed that she used to contextually unify her design.

THE ANALYSIS OF INFORMATION

Design historians evaluate their work through a process of peer review at conferences and publication. The success of design work often depends on the extent to which it meets the communication and experience goals of a client. Though both evaluation processes are well established, a self-directed evaluation process prior to the dissemination of research and design outputs can reveal the flaws in a project and possibly redirect further outputs. Participant observation methods promote the questioning of conclusions and their validity for a given audience.

Through a final review of information collected from textual sources, interviews and field notes, our design students were asked to write up a report that analysed the impact of their research on their projects. Students were encouraged to note patterns and inconsistencies in collected information, examine evidence that did not support their ideas, and develop alternate project viewpoints. Through this formal analysis, the students often moved towards different conceptual directions, and connections were identified in the research that were overlooked during the research process.

Ben, a student originally from Thailand, was interested in a natatorium (swimming pool in its own building) in Waikīkī originally dedicated to soldiers from Hawai'i who had lost their lives during World War I (WWI). Ben examined the history of the memorial and

WWI in the Hawai'i state library and historical archives. Ben also interviewed veterans of WWI and other wars. Ben's initial intention was to create a tribute to WWI veterans, but in his final review, he noted a number of troubling concerns, most notably, the long neglect of the monument. From the review of his findings and especially the interviews with veterans, Ben recognized the need to make his project relevant to all war veterans, which led to further research into the compensation given to veterans sustaining a physical injury. This new research changed the final format of his project, from a photographic essay on the dilapidated condition of the memorial to a series of panels in the shape of figures that had missing parts or damaged segments, reflecting the condition of the physically and emotionally injured veterans (Fig. 11.4). The monetary compensation, a timeline of wars, and the lack of resources and worsening condition of the natatorium are related through text printed on a container in the shape of the natatorium's pool. Viewers of the project are confronted with how human life and physical suffering is valued through monetary compensation and are asked to question the way societies honour war veterans.

Alya, an Emirate student from Dubai, created a project that examined her fear of water. She initially investigated data on drowning and the dangers associated with recreational water-sports. As her initial ideas were clarified in her final project report, Alya found a direct connection between her father's death by drowning and her fear of the water. Alya's final project outcome eventually changed from a cautionary project on the dangers associated with water-sports to a project that presented her father's fondness for fishing and the unavoidable events that led to his death, and from a traditional book structure to an experimental multi-page document. The final form resembled a fish trap, based on traditional hand-made Emirate wire fishing nets, that contained printed fabric panels charting the events of Alya's father's death. The information on the fabric panels was taken from police reports concerning the incident, her father's death certificate and interviews she conducted with her mother and uncles. Alya's final design outcome changed due to a willingness to see her research as a primary and directing force in her work and her final project report as a place of self-evaluation and reflection.

CONCLUSION

When combined with participant observation methods, PAR objectives may produce an active and challenging process for design historians and practitioners alike, increasing their awareness of the levels of observation and participation within their research. Participant observation methods demonstrate the significance of textual and oral research, a sense of place, the role of participants, language proficiency, and the documentation and analysis of observations in the design research process. The projects presented here demonstrate how design students and their participants were able to illustrate unique points of view and to develop dialogues surmounting many personal, social, economic and cultural barriers. The students also cultivated a sense of responsibility towards their project partners, and identified both themselves and their participants as part of the research process. Research and design outcomes should not be dictated by the objectives and influence of just one

Fig. 11.4 The War Memorial (Natatorium): A Symbol of Veteran Care Today. Sumet. Ben Viwatmanitsakul.

individual. Well-executed research and design requires multiple perspectives and voices. Therefore, new research imperatives and methods that focus on oral sources, participation and rigorous analysis are advantageous.

NOTES

1. Martha C. Howell and Walter Prevenier, *From Reliable Sources: An Introduction to Historical Methods* (Ithaca, NY: Cornell University Press, 2001).
2. Carmen Luke, *Pedagogy, Printing and Protestantism: The Discourse of Childhood* (Albany, NY: University of New York Press, 1989), 71.
3. Howell and Prevenier, *From Reliable Sources*, 26.

4. William Foote Whyte, 'Advancing Scientific Knowledge through Participatory Action Research,' *Sociological Forum* 4, no. 3 (1989): 367.

5. Kurt Lewin, 'Action Research and Minority Problems,' *Journal of Social Issues* 2 (1946): 34–46; Milman Parry, *The Making of Homeric Verse: The Collected Papers of Milman Parry* (New York: Oxford University Press, 1971); Walter J. Ong, *Orality and Literacy: The Technologizing of the Word* (London: Routledge, 2000).

6. Whyte, 'Advancing Scientific Knowledge,' 369.

7. Emily Alana James, Margaret T. Milenkiewicz and Alan Bucknam, *Participatory Action Research for Educational Leadership: Using Data-Driven Decision Making to Improve Schools* (London: Sage, 2008), 2.

8. Frank Hamilton Cushing, *The Mythic World of the Zuni* (Albuquerque, NM: University of New Mexico Press, 1988); Beatrice Potter Webb, *My Apprenticeship* (Cambridge: Cambridge University Press, 1979); Margaret Mead, *The World Ahead: An Anthropologist Anticipates The Future* (New York: Berghahn Books, 2005); Bronislaw Malinowski, *Argonauts of the Western Pacific* (New York: E.P. Dutton, 1961).

9. Kathleen M. Dewalt and Billie R. Dewalt, *Participant Observation: A Guide for Fieldworkers* (Lanham, MD: AltaMira Press, 2002).

10. Whyte, 'Advancing Scientific Knowledge,' 368.

11. James P. Spradley, *Participant Observation* (New York: Holt, Rinehart and Winston, 1980).

12. Carma R. Gorman, 'Why Designers Should Study Foreign Languages,' *Design Issues* 20 (Winter 2004): 47.

13. Mary Kawena Pukui and Samuel H. Elbert, *Hawaiian Dictionary: Hawaiian-English, English-Hawaiian, Revised and Enlarged Edition* (Honolulu: University of Hawai'i Press, 1986), 93.

14. Ibid., 188.

15. Ibid., 26.

16. Ibid., 333.

17. DeWalt and Dewalt, *Participant Observation,* 144–56.

12 FLUID TYPOGRAPHY: CONSTRUCTION, METAMORPHOSIS AND REVELATION

BARBARA BROWNIE

This chapter contributes a new treatment of the design of writing and type in screen-based temporal environments. In particular, it discusses fluid typography, which treats writing as processual, or transformative, rather than concrete, material or static.

The history of typography has demonstrated that type is not a collection of arbitrary signs and that it is capable of more than the communication of linguistic information. From Guillaume Apollinaire to F. T. Marinetti, David Carson and Neville Brody, practitioners have extensively demonstrated that text can communicate visually, through properties of shape, form and colour. But, with the advent of readily accessible time-based displays, we now experience type that is capable of more than this: it is capable of performance and behaviour.[1] In numerous advertisements, credit sequences and digital artefacts of the past century, practitioners including Saul Bass, Kyle Cooper and Martin Lambie Nairn have demonstrated that, in temporal media, type can move and distort, and be subject to cinematic transitions. Type can interact with its surroundings (as in Robert Brownjohn's title sequence for *From Russia With Love,* 1963) and interact with itself (as in R/Greenberg Associates' title sequence for *Altered States*, 1980). All of these artefacts are readily located under the banner of 'kinetic typography',[2] or 'motion typography'.[3]

More recently, a new form of temporal typography has emerged that cannot readily be defined as 'kinetic typography' or 'motion typography'. These terms imply that 'motion' is the single defining characteristic of temporal typography; they are used widely to describe anything from 'the temporary appearance of static text',[4] to complex typographic performance. In many instances, these terms are misleadingly used, either where the type itself is static and merely appearing alongside moving images, or where motion is not the central aim of the typographer. In many contemporary examples, type, though in motion, is capable of more than just a change of location; it is capable of distortion and transformation. Here, the term 'dynamic typography'[5] may be more accurate, allowing for more complex forms of motion and change, but this term is still vague and does not adequately describe some contemporary artefacts.

One such artefact, which evades simple definition, is morphing typography, in which forms metamorphose into letters (as can be seen, for example, in Komninos Zervos' animation, *Beer*). Here, it is not the motion of the letters that is significant: it is the transformation of one form into another. The consequence of the exhibited behaviour is

aa ɜ ɒ b b

Fig. 12.1 A single form, as it may appear in several frames of a moving sequence, morphing from an 'a' into a 'b'. In the intermediate stages, asemic glyphs are created. Image: Barbara Brownie.

not only limited to a change of location or a rearrangement of letterforms but also includes the introduction of new identities, both visually and semiotically. As each letterform evolves, it loses its initial identity and then adopts a new one. The form (shown in Fig. 12.1) is singular, but it presents several different alphabetic identities over time (an 'a' and 'b'). Significantly, despite the introduction of new identities, no new forms are introduced. Each identity emerges from an existing form, and so each single form is potentially many letters. During the process of transformation, intermediate glyphs are created. These are not recognizable as typographic, only as indefinable abstract forms. Such forms can be described as 'asemic',[6] having the appearance of writing but without any specific linguistic meaning. This process—the loss of initial identities and the introduction of new meaning that occurs as a result of the transformation—is more significant than any 'motion' that may incidentally occur.

For definitions of this kind of typography, we must look beyond temporal media. During the 1980s and 1990s, Eduardo Kac produced a number of holographic poems ('holopoems'),[7] which exhibited the same inconsistency that is displayed in contemporary examples of morphing typography. In holopoetry, letterforms appear to change over time (Fig. 12.2). As the viewer moves around each piece, it not only appears to be in motion but also to 'exhibit . . . behaviour'. From different locations, viewers can observe different formations of letters. Kac describes his works as containing 'fluid signs', or signs that alter over time, 'therefore escaping the constancy of meaning a printed sign would have'. They are capable of 'metamorphoses between a word and an abstract shape, or between a word and a scene or object'.[8] This text does not have a fixed identity or a reliable, constant meaning; it is constantly in flux, presenting multiple identities over time.

The characteristics of fluidity, as defined by Kac, are now seen elsewhere. In Britain, the most prominent contemporary example is Channel 4's recent set of brand identities (MPC, 2004–present). Since Lambie Nairn's first Channel 4 ident in 1982, the Channel 4 logo has been constructed of parts which are capable of moving and relocating themselves, thereby constructing and deconstructing the Channel 4 identity as they converge and then disperse. In the more recent idents (including *Tokyo*, 2005, and *Pylons*, 2004), these parts adopt additional identities so that they blend seamlessly into the landscape. Only when they are viewed in a certain alignment are they revealed as part of the '4' configuration. These idents reveal a new relationship between text and image that is not possible on the

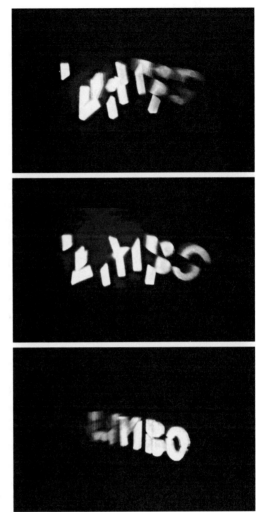

Fig. 12.2 Eduardo Kac, SOUVENIR D'AN-DROMEDA, 30 × 40 cm, digital transmission hologram, 1990. Collection Acquaviva-Faustino, Paris.

static page. Static examples that blur the divide between text and image, such as Apollinaire's *Calligrammes* (1913–16), display elements that operate simultaneously as type and image. Although fluid type also operates as both type and image, its multiple identities are not necessarily simultaneous; it transforms from one to the other. It may, in one instance, be typographic, then it may be architectural or abstract: its identity is constantly in flux. What is significant here is not the fact that type and image can exist within the same form but, rather, the process through which the 'type' and 'image' identities are revealed. It is the process of transformation that is the focus of this research.

THE TRANSFORMATION OF TYPE TO IMAGE

Transformative processes in temporal typography echo transformations that can be observed in nature, and in human behaviour. The 'continuous deformations' found in nature

can even result in a complete change in identity: a caterpillar can become a butterfly, or a tadpole can become a frog.[9] This naturally occurring flexibility and tendency towards change can be seen in the human drive to transform ourselves and our surroundings, from the moulding of natural materials into artificial tools and objects, to the personal transformations of performance. In the shadowgraphy of the 1890s, performers used a combination of physical distortion and props to transform their shadows into silhouettes of animals or objects.[10] This tradition continues today with the dance troupe *Pilobolus*; its performers transform their bodies through distortion and lighting effects. Metamorphosis also plays a central role in myths and legends, particularly creation myths,[11] as well as literature, ranging from Grimm's fairy tales, to Ovid's *Metamorphoses*.[12] In these fictional cases of transformation, change tends to be more readily accepted when it occurs within a single ontological category (living creatures become living creatures, inanimate objects become inanimate objects), or, when change operates across ontological boundaries, subjects commonly retain recognizable characteristics in order to preserve identity or familiarity.[13] In fluid typography however, a paradigm shift occurs.

In many contemporary examples of fluid typography, forms transcend paradigmatic boundaries. Type becomes image, and vice versa. Letterforms adopt the identities of flat pictorial forms or three-dimensional objects. They may even come to life, adopting the identity of one or many animals (as in BB/Saunders' Channel Five ident, *Midges*, 2005). Through this transformation, fluid type challenges established definitions of typography. 'We have been conditioned to view typography as being distinct from images',[14] yet if it is susceptible to change, its identity as type cannot be taken for granted. Indeed, it may not be reliably defined as either type or image, as it is, at different times, both or neither. Perhaps, therefore, the term *typography* is inappropriate to describe these artefacts,[15] or perhaps current understanding of the term *typography* needs to be modified in order to allow for the current cultural shift towards temporality, 'quick change'[16] and visual, rather than verbal, communication.

THE CONSTRUCTION OF MODULAR LETTERFORMS

Numerous contemporary examples of fluid typography involve lettering that is broken apart and rebuilt as an image, or parts of an image, that come together to build a letterform. Channel 4 idents, from Lambie Nairn's 1982 animated brand identity, to MPCs more recent equivalents, construct the figure '4' from an array of converging component parts to represent the bringing together of television programmes produced by numerous different production companies.[17] The component parts are abstract polygons, independently communicating no linguistic meaning, but collaborating to communicate the identity of the channel. Although perceived as a single, whole sign, the '4' is not a single, whole form: it is a configuration of separate forms, each with its own distinct abstract or pictorial identity. The process of letter creation through the convergence of parts is therefore reliant on the notion of the letter as a modular composition.

Modular lettering, constructed from 'primitives',[18] is not solely a feature of temporal typography. It has long existed in static type and is most prominently displayed in mod-

ernist typography. There are, for example, distinct similarities between the construction of the Channel 4 logo and Joseph Albers' *Stencil* (1925), Theo van Doesburg's typeface for *De Stijl* magazine (1917), and the lettering in Bart van der Leck's poster for *Delft Salad Dressing* (1919) and *Het Vlas* (1941), all of which feature letters that are constructed from geometric primitives. Central to these modular typefaces is the notion that component parts are interchangeable. A single component part can therefore play multiple different roles, and only a limited number of different primitives are required in the construction of an entire alphabet. A tall rectangle may, for example, serve as the stem of an 'h', 'l' or 'p'. Van Doesburg's cover for the first edition of *De Stijl* magazine and van der Leck's *Delft Salad Dressing* poster demonstrate a remarkable similarity between the primitives used to construct type and those used to construct image. Components of letterforms are similar, or in some cases identical, to the components of images and abstract pictorial arrangements. In van Doesburg's cover, the same black rectangles are used in the construction of letterforms as are used in the construction of the abstract pictorial arrangement which appears beneath, and in van der Leck's poster, a figurative image is reduced to coloured polygons, with similar polygons used to create type. Being interchangeable, these shapes do not have a fixed typographic identity; each block may be exchanged for another, with each rectangle having the potential to serve as both image and type.

Van der Leck referred to such typographic works as 'compositions',[19] describing letterforms that are built, as opposed to moulded, with each letter 'systematically' constructed 'as if it were a building'.[20] Conceived as a configuration of interchangeable primitives, the letter is capable of being dismantled and reassembled; component parts may be used to construct another letter or, as in MPCs Channel 4 idents, a pictorial scene. In the work of van Doesburg, Albers and van der Leck, this process of constructing or dismantling type is part of creating a final typographic product. In fluid typography, however, this process *becomes the product*: the audience is exposed to the process of construction and, therefore, to the multiple roles played by each component part. In MPC's most recent Channel 4 idents, component parts, at different times, serve different roles. Each of these idents introduces the viewer to an apparently everyday scene, then, defying the viewer's initial expectations, extracts objects so that they may serve as component parts of the '4' configuration. These objects initially serve a pictorial purpose, as part of the landscape, playing the role of architectural objects, but as they align to form the '4' configuration, they collaborate in the communication of a typographic identity.

Construction, as opposed to other methods of creation, leaves the component parts as whole forms or objects in their own right: part of a letter but still independent. The forms may still be identified as rectangles, even after they have been stacked to create the shape of a letter. These primitives are more complex than those used in the modular lettering of *De Stijl*. Their independent identities are meaningful enough that they may communicate a complex pictorial message even when standing alone in an image. In Channel Five's *Free* ident (BB/Saunders, 2006) (Fig. 12.3), the component parts of the typographic message are balloons. The balloons, drifting in the breeze, converge to form a typographic

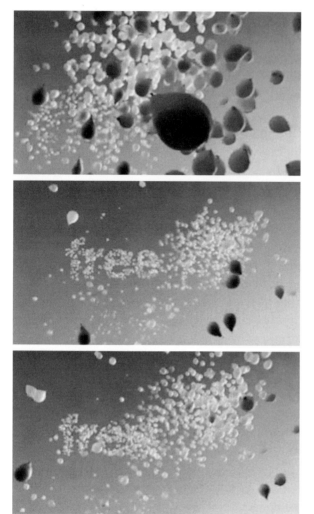

Fig. 12.3 BB/Saunders, *Free*, Channel Five ident, 2006.

configuration: the word 'free'. The word then breaks apart, allowing the balloons to drift away, themselves becoming *free*. Notably, the balloons themselves never change; each balloon remains a balloon, retaining its original identity throughout the introduction and dissipation of the typographic identity. There may be a hierarchy established, whereby the balloons become secondary to the more prominent text, but they are always present, and they are always balloons. The lettering therefore becomes a container for two simultaneous messages: one linguistic and one pictorial.

The Channel 4 and Five idents construct lettering in two distinct ways: *construction through navigation* and *construction through motion of parts*. The first of these processes, as with Kac's holopoems, requires viewer navigation to prompt the transformation of one letter or object into another. In Kac's holopoems, new identities are revealed as the viewer physically moves around each poem. In contemporary examples such as many of MPC's

Channel 4 idents, navigation also reveals the new identity, but this navigation is virtual and tracked by the camera rather than the voluntary movements of the viewer. In *Tokyo* (2005), the camera viewpoint, representing the viewer's point of view, navigates through an urban scene. This navigation reveals that some apparently architectural objects are in fact part of a '4' configuration. The architectural identity is replaced momentarily by a typographic identity as the 4 is constructed and then deconstructed according to the camera's viewpoint. This process is wholly reliant on the use of virtual three-dimensional or 'environmental' space.[21]

If the component pieces are capable of independent motion, then viewer navigation is no longer required to reveal the typographic identity. This is the case with other Channel 4 and Five idents, and with many two-dimensional examples of fluid typography. In MPC's *Lawn* ident (2004), and in Lambie Nairn's original Channel 4 idents (1982), the objects which construct the figure '4' move independently. They initially present themselves as abstract shapes or objects, then converge to become part of the larger typographic identity (the '4'). Two-dimensional equivalents include Harm van den Dorpel's *Type Engine* (2005), in which coloured rectangles are rearranged to form type.

METAMORPHOSIS BETWEEN LETTERFORMS

The transformation of one identity into another—image into type or type into image—may involve processes other than construction. As shown above (in Fig. 12.1), letterforms can metamorphose. Such change is exhibited in examples of fluid typography such as Komninos Zervos' Flash animation *Beer* (2005). *Beer* demonstrates an extreme process of warping in which letterforms are distorted to the extent that each initial identity is replaced by a new one in a languid process that resembles the properties of a drunken slur. Letters distort, become malformed, and then reform to present new letters.

The notion that a letter may morph into another form can be traced back to ideas developed during a study conducted at the French *Académie des Sciences* from 1695, in which letterforms were placed on grids in the creation of a new typeface, *Romain du Roi*. In the creation of the slanted ('penché') version of *Romain du Roi*, grids were skewed causing regular distortion of the letterforms contained within.[22] By placing a letterform onto a grid in this way, it is possible to stretch it to produce alternative weights and to skew it in order to or create slanted/oblique versions of any letterform.[23] The creation of a slanted version of *Romain du Roi* letterforms, through the manipulation of the grid, implicitly suggested that type, although static in print, has the potential to be manipulated. A single letter may, therefore, have multiple states, the forms of which are dictated according to the angle of the lines of the grid on which they are placed; a single form may evolve into many new, visually different forms which have the same alphabetic identity. The notion of deforming a typographic character allows for two very important ideas in relation to fluid typography: that a single form can have multiple alternative states or appearances and that those different states may belong to the same object/space but at different times.

As with the construction of modular lettering in modernist typography mentioned above, the ultimate goal of the *Académie des Sciences* was to develop a static typeface. The *Romain du Roi* typeface is intended for practical use without the grid, as in its first appearance in *Medailles sur les principaux evenements du Regne de Louis le Grand, Avec des Explications Historiques* (*Medals of the major events of the Reign of Loius Le Grand, with Historical Explanations*) in 1702.[24] Plates in *Descriptions des Arts et Métiers,* published decades later in several volumes between 1761 and 1788,[25] demonstrate the process of construction for each letterform, placed within a grid and alongside the circular outlines that are used to construct each letter. The presence of the grid in the plates published in *Descriptions des Arts et Métiers* indicates that the *Académie* considered the process to be of considerable importance: it was not only the appearance but also the method of design that distinguished *Romain du Roi* from earlier typefaces. When we consider that the aim of the *Académie* was to separate type from craft, establishing it as a mathematical product, we can conclude that the inclusion of the grid, as a diagram, acted as both illustration and proof of the new method of production, and hence the new way of thinking about the nature of the letterform. It is this process rather than the end-product that was most influential in the later development of temporal typography. Though these plates exhibit letterforms within the grid, drawing attention to the production process, letterforms are only displayed in their *before* and *after* states: upright and slanted. Without temporal environments, the process of typographic manipulation could only be described, not recorded. In temporal environments, however, the process of distortion and manipulation may become the focus of a final artefact, as in morphing typography.

Other than its display in temporal media, the most notable difference between fluid metamorphosis and the creation of an italic typeface such as *Romain du Roi penché* is that transformation occurs not between two forms of the same letter, but between entirely different forms, many of which are not typographic. Distortion occurs to the extent that a form may no longer be recognized as a letter, becoming first an abstract glyph, and then, in some cases, a different letter, or in others, an image or object. In Zervos' *Beer,* each form initially presents one letter and then morphs until it becomes another entirely different letter. This process occurs several times, with each form adopting many different identities over time. In this process of *metamorphosis,* identities are completely replaced. Unlike the balloons in Channel Five's *Free,* or the architectural components of MPC's Channel 4 idents, every morphing letterform must abandon its old identity in order to adopt a new one. In processes of *construction,* as discussed above, the second identity is a masquerade.[26] The letterforms are a performance, a disguise which can be easily removed as component parts dissipate and return to their original, separate selves. The architectural objects in MPC's Channel 4 idents remain architectural but momentarily fool the viewer into believing that they are in fact parts of a '4'. In *metamorphosis,* however, artefacts acknowledge that some things are inherently incompatible. There are some objects and forms that cannot coexist. And yet, by transforming from one to the other, they acknowledge that those two identities are connected. The two poles of transformation are often 'clichés of

opposition':[27] they are two identities that cannot coexist, but through transformation of one to the other, their connection is made evident. The transformation from one identity to another 'attempts to erase . . . binarism', and yet asserts 'sameness across difference'.[28] By destroying one identity to reveal another, transformation marks similarity, but also 'affirms a distance'.[29] In fluid metamorphosis, the image cannot regain its initial meaning once it has been transformed into type, and vice versa.

REVELATION OF EXISTING LETTERFORMS

There is a third category of artefact which offers audiences a similar experience, yet is fundamentally different to examples of *construction* or *metamorphosis*, in that no actual transformation occurs. In this final category, *revelation*, letterforms are revealed to the audience as already existing within an established scene. Here, as in *construction* and *metamorphosis*, the nature of a scene defies audience expectations: forms which are initially assumed to have one identity are ultimately revealed to have another. Unlike the first two categories, however, these artefacts do not show the creation of a typographic form; they reveal it, instead, to have always been present within the scene, but initially hidden from view. Fluidity does not require the literal transformation of a letterform; rather, an apparent or perceived transformation occurs, prompted by external changes, so that fluidity is imagined. A number of different events may cause a letter to be revealed including, principally, navigation, rotation and illumination. In virtual space, three-dimensional letterforms can assume 'architectural' qualities,[30] having multiple surfaces of different shapes. A virtual three-dimensional letterform may present different faces when viewed from different angles. An extruded letter 'M', for example, may present as a letter when viewed from the front, or an abstract rectangle when viewed from either side. These alternative identities may be accessed either through apparent navigation around the object or by rotation of the object itself. Kyle Cooper's title sequence for *True Lies* (1994) initially presents apparently planar letters spelling the word 'true'. These letters then revolve, revealing themselves to be three-dimensional, and simultaneously revealing the word 'lies', carved as voids into the sides of the existing letters. In this example, the viewer's initial assumptions about the nature of the on-screen space (apparently changing from two-dimensional to three-dimensional) and the nature of the type (apparently changing from 'true' to 'lies') are challenged as additional information is revealed.

Alternatively, revelation may reveal forms that have been initially concealed. Peter Cho's *Letterscapes (H)*[31] initially presents a single apparently abstract planar form. Through shifting illumination, provoked by the movement of the mouse, the form is revealed to be a pair of three-dimensional 'H's, placed back to back. Even once the letter identities have been revealed, further movement of the cursor causes shifts in tone and colour which again change the apparent nature of the object. The surface of each letter appears to shift to a new angle and location as the illumination is adjusted.

These processes are comparable to spectacles that occur outside of the field of typography: in particular, certain kinds of stage performance. In theatrical illusion, as in fluid

typography, there may occur 'a moment of surprise . . . when the spectator suddenly real-izes his expectations were wrong'.[32] An object which at first appears to be pictorial is in fact revealed to be typographic, just as an illusionist's wand is revealed to contain a bunch of flowers. In Sichuan opera, performers change their masks on stage, in full view of their au-dience, using sleight-of-hand.[33] Here, each mask is always present, but concealed until the time of revelation. This centuries-old tradition has been updated for Western contempo-rary television and cinematic outputs in the form of prosthetic disguises which are peeled back to reveal the true identity of a character (as in Brian De Palma's *Mission: Impossible* of 1996). A similar process occurs in temporal typography when typographic forms are revealed to exist within an apparently pictorial scene. Objects which were initially assumed to be pictorial or abstract are unexpectedly revealed as linguistic forms, as the viewer sud-denly encounters a new paradigm.

CONCLUSION

In temporal typography, fluidity may involve the construction of a configuration, in which component parts collaborate in the formation of a new typographic identity, or it may in-volve metamorphosis, in which one form must abandon its old identity in order to adopt an alternative identity from a different paradigm. In many cases of fluid type, fluidity is perceived but not actually performed: typographic identities are revealed as already existing within a pictorial scene. In all of these cases, fluid letterforms cannot be easily defined as typographic. They are constantly in flux, and only temporarily typographic. They are hy-brids of type and image but can never reliably be defined as either. The process of designing writing in fluid environments is no longer a process of conveying linguistic meaning but, rather, one of negotiating the relationship between several different paradigms in the cre-ation of fluctuating, hybrid forms. In temporal media, which are themselves hybrid,[34] fluid type may be a logical progression from the shift of text into image that we experience across all media.[35] Temporality allows change. It allows identities to transform, thereby removing reliability and consistency. It enables the focus to shift from the question of identity to the question of process. It is the process, and what occurs during transition from one form to the next, that is the most significant part of this new form of typography.

NOTES

1. Soo C. Hostetler, 'Integrating Typography and Motion in Visual Communication,' (lecture, *2006 iDMAa and IMS conference,* Miami, 2006), accessed 4 Jan. 2007, http://www.units. muohio.edu/codeconference/papers/papers/Soo%20Hostetler-2006%20iDMAa%20Full%20 Paper.pdf.

2. Hostetler, 'Integrating Typography'; Blake Engel, Patrick Ditterline and Brian Yeung, *The Ef-fects of Kinetic Typography on Readability* (2000), accessed 12 April 2006, http://crankyuser.com/ kinetic/kineticTypography.pdf; Johnny C. Lee, Jodi Forlizzi and Scott E. Hudson, *The Kinetic Typography Engine: An Extensible System for Animating Expressive Text,* (lecture, 15th annual

ACM Symposium on User Interface Software and Technology, 2002), accessed 24 Mar. 2007, http://www.cs.cmu.edu/~johnny/kt/dist/files/Kinetic_Typography.pdf.

3. Matt Woolman and Jeff Bellatoni, *Type in Motion: Innovations in Digital Graphics* (London: Thames and Hudson, 1999); Gerhard Bachfischer and Toni Robertson, 'From Movable Type to Moving Type—Evolution in Technological Mediated Typography,' (lecture, *AUC Academic and Developers Conference*, 2005), accessed 6 Jan. 2008, http://research.it.uts.edu.au/idwop/downloads/AUC_movingtype_GB.pdf.

4. Matthias Hillner, 'Text in (e)motion,' *Visual Communication* 4, no. 2 (2005): 166.

5. Heidi Specht, 'Legibility: How Precedents Established in Print Impact On-Screen and Dynamic Typography,' master's thesis, Morgantown, West Virginia University, 2000.

6. Tim Gaze, *Asemic Movement* 1 (Jan. 2008): 2, accessed 17 Aug. 2010, http://vugg.wippiespace.com/vugg/gaze/asemicmovement1.pdf.

7. Kac, Eduardo, 'Key Concepts of Holopoetry,' *Electronic Book Review* (1996), accessed 10 Apr. 2006, http://www.electronicbookreview.com/thread/electropoetics/uncontrollable; originally published in David Jacksin, Eric Vos and Johanna Drucker, eds., *Experimental-Visual-Concrete: Avant-Garde Poetry Since the 1960s* (Amsterdam: Rodopi, 1996), 247–57.

8. Ibid.

9. Jonas Gomes, Lucia Darsa, Bruno Costa and Luiz Velho, *Warping and Morphing of Graphical Objects* (San Francisco: Morgan Kaufmann Publishers, 1999), 4.

10. Matthew Solomon, 'Twenty-Five Heads under One Hat: Quick Change in the 1890s,' in *Meta-Morphing: Visual Culture and the Culture of Quick Change*, ed. Vivian Sobchack (Minneapolis: University of Minnesota Press, 2000), 3.

11. Marsha Kinder, 'From Mutation to Morphing: Cultural Transformations from Greek Myth to Children's Media Culture,' in *Meta-Morphing*, ed. Sobchack, 63.

12. Ovid, *Metamorphoses*, trans. David Raeburn (London: Penguin, 2004).

13. Michael H. Kelly and Frank C. Keil, 'The More things Change . . .: Metamorphosis and Conceptual structure,' *Cognitive Science* 9, no. 4 (1985): 407.

14. Jon Krasner, *Motion Graphic Design: Applied History and Aesthetics* (Oxford: Focal Press, 2008), 188.

15. Mike Hawkins, comments in response to Barbara Brownie, 'Fluid Typography: Defining a New Form of Temporal Typography,' (lecture, *New Views 2*, London College of Communication, July 2008).

16. Vivian Sobchack, 'At the Still Point of the Turning World: Meta-Morphing and Meta-Stasis,' in *Meta-Morphing*, ed. Sobchack, 131–58.

17. Woolman and Bellantoni, *Type in Motion*, 34.

18. Tara Rosenberger and Ronald L. MacNiel, 'Prosodic Font: Translating Speech into Graphics,' in *CHI '99 extended abstracts on Human factors in computing systems* (1999), 252, accessed 24 Jan. 2007, http://alumni.media.mit.edu/~tara/CHI1999.pdf.

19. David Ryan, *Letter Perfect: The Art of Modernist Typography 1896–1953* (California: Pomegranate, 2001), 40.

20. Ibid., 58.

21. J. Abbott Miller, *Dimensional Typography* (New York: Princeton Architectural Press, 1996), 2.

22. Jacques Andre and Denis Girou, 'Father Truchet, the typographic point, the Romain du roi, and tilings,' *TUGboat* 20, no. 1 (1999): 10, accessed 13 Sept. 2009, http://www.tug.org/TUGboat/Articles/tb20–1/tb62andr.pdf.

23. J. Abbott Miller and Ellen Lupton, 'Laws of the Letter,' in *Design Writing Research: Writing on Graphic Design* (London: Phaidon, 1999), 52–61.

24. Académie des inscriptions & belles-lettres, *Medailles sur les principaux evenements du regne de Louis le Grand, Avec des Explications Historiques* (Paris: De L'imprimerie Royal, 1702).

25. See plates reproduced in André Jammes, 'Académisme et Typographie: The Making of the Romain du Roi,' *Journal of the Printing Historical Society* 1 (1965): 71–95.

26. Scott Bukatman, 'Taking Shape: Morphing and the Performance of Self,' in *Meta-Morphing*, ed. Sobchack, 235.

27. Sobchack, 'At the Still Point of the Turning World,' 139.

28. Ibid.

29. Bukatman, 'Taking Shape,' 240.

30. Miller, *Dimensional Typography*, 2.

31. See www.pcho.net.

32. Peter Lamont and Richard Wiseman, *Magic in Theory: An Introduction to the Theoretical and Psychological Elements of Conjuring* (Hertfordshire: University of Hertfordshire Press, 2005), 50.

33. Jeffrey Scott, 'A Dialogue between Sichuan and Beijing Opera (review),' *Asian Theatre Journal* 25, no. 2 (2008): 372, accessed 16 July 2009, http://muse.jhu.edu/journals/asian_theatre_journal/v025/25.2.scott.html; Shiao-Ling Yu, *Chinese Drama after the Cultural Revolution: 1979–1989* (New York: Edwin Mellen Press, 1996), 13.

34. Lev Manovich, *Software Takes Command* (2008), accessed 7 Jan. 2009, http://softwarestudies.com/softbook/manovich_softbook_11_20_2008.doc.

35. David Crow, *Left to Right* (Swizerland: AVA, 2006).

PART 4 SHOWING AS TELLING—ON DESIGN
 BEYOND TEXT

INTRODUCTION

GRACE LEES-MAFFEI

While Parts One and Two of *Writing Design: Words and Objects* explored the relationships between design and writing, looking particularly at writing which seeks to reform design and writing which mediates between design and the consumer, variously defined, and Part Three analysed writing as a medium for and within the design process, this final part of the book examines instances in which design refuses text, in various ways.

We begin with Léa-Catherine Szacka's 'Showing Architecture through Exhibitions: A Taxonomical Analysis of the First Venice Architecture Biennale (1980)'. Szacka draws attention to Pascal Amphoux's proposition that the exhibition of architecture represents a pleonasm, or what we might call a redundancy of exhibition, in that architecture inherently exhibits itself. Her chapter begins with a useful synthesis of three models for understanding the ways in which exhibitions of architecture use a range of visual and material artefacts to mediate their narratives. Szacka then applies those models to the highly particular case of the first Venice Architecture Biennale. She is attentive to the narratives embodied in the context of the Biennale: the fact that the exhibition was fabricated by staff previously employed by the Roman film studio Cinecittà makes clear the connection between cinematic sets and props, and the staging of a temporary architectural exhibition at real-scale, while the setting of the exhibition in the Corderie dell'Arsenale enabled the exhibition of architecture in the form of a street, or Strada Novissima, which exploited the length of a building designed to house lengths of rope as they were assembled; this setting and its scale function to bring together the weaving of yarn and the weaving of stories about architecture. Although the exhibition generated text in the form of design press coverage, it communicated, primarily, through non-verbal means.

We stay in Italy for the next chapter: Gabriele Oropallo's portrait 'Design as a Language without Words: A G Fronzoni.' Both Oropallo's and Szacka's chapters share the interest in mediation demonstrated by the chapters grouped under that banner in Part Two: Oropallo recognizes that 'contemporary design is still largely mediated by writing. The network commonly referred to as "Italian" or "Milanese" design produces words as much as objects.' But, what distinguishes the analyses provided here, in Part Four, is a pre-eminent concern for communication without words. Both Szacka's analysis of the architectural exhibition and Oropallo's account of how Fronzoni consistently rejected textual communication in favour of an approach to print layouts which used text as a pictorial element are therefore most appropriately placed here. Oropallo goes on to identify an aesthetic connection between Fronzoni's approaches to graphic design and to architecture. He avoids the

temptation to make connections between Fronzoni and more recent exponents of expressive layouts, such as David Carson, preferring instead to situate Fronzoni carefully within the social, cultural and political context of post-war Italy.

Stina Teilmann-Lock uses Danish and British case studies in her incisive account of the difficulties attendant upon the legal necessity of translating objects into words, both in the registration of a design and in the courtroom dialogue which determines copyright in contested cases. 'On the Legal Protection of Design: Things and Words about Them' explains how, in the case of intellectual property rights, 'the shift from the protection of books to the protection of design was, notably, mediated through printing'. Teilmann-Lock develops some of the issues raised by Mhairi McVicar's chapter in Part Three about the poetic qualities of the apparently neutral language of architectural specification. Teilmann-Lock lucidly demonstrates the fact that design cannot always easily be translated into words, and a legal insistence on this myth of equivalency causes problems in the form of contradictory judgements as much as solving them.[1]

The last word is given to Michael Biggs and Daniela Büchler. Their highly original discussion of 'text-led and object-led research paradigms' describes an uneasy fit between a view of research derived from scientific models, which privileges empiricism and objectivity, and other views of research which value imagination and subjectivity. Although Biggs and Büchler do not use the term 'logocentrism', it is a useful label for the association of reason and words, and, by extension in this case, for the dominance of words and texts and the research methods and outputs built on them. The assessment of research, whether within the formal education structure of a research degree or in the evaluation of university researchers by funding bodies and government agencies, raises complex issues of definition, delimitation and equivalency, and thereby engages participants in determining the nature of research, and commonalities and specificities across disciplines. This chapter shows how context determines the development, and evaluation, of the processes and products of research. Dissatisfied with the compromise represented by the notion of 'practice-based research', Biggs and Büchler propose a research worldview in which designers can make a virtue out of what they term 'Doing without Words'.

NOTE

1. Related projects are 'Music and Dance: Beyond Copyright Text?', which examines the suitability of the law to protect music and dance copyright, and 'Beyond Text in Legal Education', which hosted dance, performance and visual arts activities designed to foster embodied knowledge as a challenge to legal reliance on textual sources. Both projects are based in the School of Law at the University of Edinburgh and funded by the Arts and Humanities Research Council's *Beyond Text* programme. http://www.law.ed.ac.uk/beyondtext/.

13 SHOWING ARCHITECTURE THROUGH EXHIBITIONS: A TAXONOMICAL ANALYSIS OF THE FIRST VENICE ARCHITECTURE BIENNALE (1980)

LÉA-CATHERINE SZACKA

ARCHITECTURAL EXHIBITION: A GENRE

The architectural exhibition is one of many media through which architecture is shown, revealed or explained to an audience. Often it also gives the public an occasion to experience, directly or indirectly, built form from the past, present or future. But the question of whether architectural exhibitions can be isolated, as a particular 'genre' of cultural manifestation, remains unanswered and official taxonomies or classifications are still to be established.

Architectural exhibitions are de facto very different from art exhibitions. They presuppose a specific challenge related to issues of representation. The paradox of this type of exhibition is the attempt to show something within the museum that is forever outside its walls. A way of overcoming this paradox is to exhibit building fragments or to reproduce part of a building that exists or existed elsewhere. Another way of exhibiting architecture is to use representational tools—drawings, photographs and models—to convey the idea of a building. In his famous book *Le Musée d'Architecture*, Werner Szambien explained that, in the eighteenth and nineteenth centuries, collections such as the Victoria and Albert Museum and the Musée des Monuments Français, exhibited architecture by displaying mouldings and fragments as models to copy or provide inspiration.[1]

This chapter discusses the difficult question of how to show architecture to the public through the medium of the exhibition. Since the late 1970s, architectural exhibitions have certainly experienced an exponential growth and have become one of the main instruments of architectural mediatization—meaning both the media coverage of architecture and the mediation between architecture and the public. They have acquired increased importance for architects and have become objects of study for architectural theorists and historians. Discussions centred upon architecture shows, architecture museums and related special events are increasingly prevalent.

With the aim of exploring how architecture is shown and told via the medium of exhibition, this chapter uses the work of several authors, namely Adrian Forty, Jean-Louis Cohen and Pascal Amphoux, to argue that architectural exhibitions are part of a particular 'genre' of cultural manifestation that still needs to be clearly defined. The first part of the chapter

presents different ideas on the possible taxonomies of the architectural exhibition, while the second part tests these ideas by applying them to a specific case study. By seeking to categorize the architectural exhibition, this chapter shows that although a number of different schemes of classification have been produced in various circumstances and for diverse reasons, none of them seem to be really efficient.

TAXONOMIES

In order to attempt a definition of the 'genre' that is the architectural exhibition, it is useful to review existing taxonomies. Although neither definitive nor official, scholars and historians have proposed various systems of classification including Forty's 'Ways of Knowing, Ways of Showing: a Short History of Architectural Exhibitions';[2] Cohen's 'Exhibitionist Revisionism: Exposing architectural History'[3] and Amphoux's 'Pléonasme: l'architecture naturellement s'expose'.[4] While Forty and Cohen are architectural historians, Amphoux is an architect and geographer (or urban geographer) and therefore looks at the problem of architectural exhibitions from another perspective.

Forty first developed his classification system for architectural exhibitions at a workshop held at London's Design Museum in 2007. Architectural exhibitions can, according to Forty, be divided into two main categories: (1) one-to-one, or real-scale, exhibitions and (2) representational exhibitions. The main distinction between these two categories is one of scale, linked to the form of the exhibition, rather than content, and each invokes the tradition of *simulacra*, albeit in different ways.

The one-to-one or real-scale category of 'live architecture exhibitions' is divided into: (1a) real-scale exhibitions that are permanent and (1b) those that are temporary. In the case of permanent exhibitions, Forty explains that they might feature replicas of historical or primitive buildings, as in the case of the Tivoli Garden in Copenhagen, which has, since 1843, displayed replicas of ancient Greek and Roman buildings, and the Borgo Medievalo in Turin, which displays Piemontese buildings 'assembled in 1884 by a group of local artists and antiquarians'.[5] Or, real-scale permanent exhibitions can also be made of 'original buildings (usually timber framed) that had been disassembled and then re-erected on the museum site'[6] such as at the Skansen Museum near Stockholm founded in 1891, the Frilandsmuseet near Copenhagen founded in 1901, or the open-air museum at Arnhem in Holland founded in 1918. Alternatively, the exhibitions might be composed of model houses or prototypes that are permanent structures; for example the now famous 1927 *Wiessenhof Siedlung* in Stuttgart or the series of Case Study Houses built in California between 1945 and 1966. Temporary real-scale exhibitions, however, are often tied to the tradition of the World's Fair and the 'pavilion'. Prominent contemporary examples of real-scale temporary exhibition in London include the Serpentine Gallery's Pavilion series (2000–)[7] and the temporary constructions built for the London Festival of Architecture.

Forty's other large category of exhibitions is the representational: 'Exhibitions that rely on media other than buildings themselves, most commonly drawings, photographs, and models.'[8] Here, Forty makes a difference between: (2a) the polemical and (2b) the encyclo-

pedic exhibitions, a distinction that concerns the content of the show more than its form. The polemical exhibitions are 'designed to shift perceptions and change paradigms',[9] while the encyclopedic ones 'aim to set out a field of knowledge, perhaps the architecture of a particular region, period, group of architects or a building type'.[10] As examples of polemical representational exhibitions, Forty lists a series of exhibitions produced at the Museum of Modern Art (MoMA) in New York between the 1930s and the 1960s (including, in addition to the famous 'International Style' exhibition of 1932, others such as 'Brazil Built' of 1943 and 'Architecture Without Architects' of 1964.)

Encyclopedic representational exhibitions can be further divided into two sub-categories: (2b.1) monographic and (2b.2) thematic. Monographic exhibitions display the work of an individual architect, and every major twentieth-century architect has had at least one show dedicated entirely to his work. In the case of certain great architects such as Frank Lloyd Wright, Mies Van Der Rohe or Le Corbusier, successive generations have produced monographic retrospectives of their work, each time throwing new light on their work. Thematic exhibitions regroup the work of several architects around a central theme. Examples include the 2004 Venice Architecture Biennale, which was organized around the idea of metamorphosis in architecture, and the 2006 MoMA 'On-Site' exhibition, which regrouped the work of many architects who had recently built in Spain.

To exhibit architecture is a pleonasm because, by definition, architecture exposes itself to the climate, to use and to wear: is it possible, therefore, to intentionally expose architecture? This is the question raised by the architect and urban geographer Amphoux in his essay 'Pléonasme: l'architecture naturellement s'expose' ('Pleonasm: architecture naturally exposes itself') published in 2003 in the Swiss magazine *FACES*. According to Amphoux, there are nine modes of exhibition for architecture (or nine ways to take architecture out of itself), and these occur by means of space, use or time. It is possible to extract and schematize Amphoux's classification system for architectural exhibitions into three groups, as follows.

The first group (1) concerns situations where the spatial context is modified, where architecture is moved or shifted, by the salvaging of an emblematic object or the presentation of a collection of objects out of their original special context. The first mode of shifting (1a) involves the dismantling and reassembling of a building out of its original context: the exhibition of the original Pergamon Altar at the Pergamon Museum in Berlin is a good example. The second mode (1b) concerns the reproduction at a real-scale or at a miniaturized scale, whether part of a building, an entire construction, or an existing site, as well as the more usual reproduction of a construction by means of drawings (plan-section-elevation) or models. Most museum exhibitions of architecture (including those presenting real-scale models) would enter this category. The third mode (1c), *simulation*, relates to a change of space and denotes architecture that modifies the relation between the real and the virtual. Most of the simulation produced from the manipulation of three-dimensional models would enter in this category. The 2007 exhibition 'Zaha Hadid Architecture + Design', at the Design Museum in London, is a good example of this type of architecture exhibition.

The second group of modes of exhibiting (2) concerns a change in the social context, or a change of use. The first of these (2a), *adaptation*, concerns the adaptation of a building to new social norms related to comfort or taste. The second (2b) is *reconversion*, a restructuring of a building by change of use, such as a shed transformed into a museum, factories transformed into apartments, or a metro station transformed into a swimming pool. Finally, the third mode (2c) concerning the change of use is *festivalization*, a staging of the city and its architecture which catalyses new uses for a city or its public spaces and proposes a new vision of the city and its architecture, as in the 2008 London Festival of Architecture.

The third group of exhibition modes (3) concerns changes in temporal context, where the architectural object escapes its own epoch. The first mode (3a) is the reconstruction of disappeared buildings or of an archaeological site: the Borgo Medievalo is a good example. The second mode (3b) concerns the classification of buildings as historical and implies the establishment of a certain hierarchy between buildings. Finally, the updating mode (3c), comprises the restitution of a building or the restoration of a damaged construction.

Amphoux has a particular way of seeing the problem of architectural exhibitions (perhaps due to his previous research in social sciences). For him, there is no difference between the exhibition and the buildings out there; buildings can also be considered as exhibitions of architecture and classification categories are not exclusive, allowing a 'work' to be placed in more than one category at once. This approach allows the paradox of exhibiting architecture to be relatively easily overcome.

In 1999, the architectural historian Cohen's article 'Exhibitionist Revisionism: Exposing Architectural History' appeared in the *Journal of the Society of Architectural Historians*. Cohen argued that architectural exhibitions are increasingly used by scholars and historians both as objects of investigation and as outputs for research. They are, Cohen writes, 'at the intersection of practice and history' and 'a major point of contact between the intellectual community and the public at large'.[11] Cohen emphasizes the variety of architectural exhibitions and questions the fact that 'they might legitimately be counted as part of a single field of cultural production'.[12] Rather than proposing a clear classification system for architectural exhibitions, the author lists nine functions that they fulfil. Cohen's classification is based wholly on the content of exhibitions and he remains indifferent to their form.

First, Cohen notes that the architectural exhibitions can 'set out to highlight contemporary or recent work that has been overlooked or that had developed outside of the mainstream'.[13] This first category (1) includes, for example, exhibitions on the work of young architectural practices, such as are displayed in small galleries or biennials and other similarly transient events. Secondly, Cohen identifies architectural exhibitions that 'resurrect a forgotten work of architecture, or a neglected aspect of a great artist's oeuvre'.[14] This category (2) encompasses, for example, 'Mies in Berlin', first presented in 2001 at MoMA (and counterpart to the exhibition 'Mies in America' presented simultaneously at the Whitney Museum), an exhibition that focused on previously neglected aspects of Mies' career. Thirdly, Cohen suggests that architectural exhibitions can serve to 'open new questions and present new material'. This third category (3) is exemplified by exhibitions

such as 'Mutations', a cultural event on the contemporary city presented at Arc en Rêve in Bordeaux in 2000, which used photographs and video of recent mutations in urban conditions to question our present way of living in urban centres. For Cohen, 'one particularly fertile approach has been the setting up of bilateral relations to study cultural crosscurrents in a broad range of disciplines, so that architecture is examined in parallel with art, literature, and music'.[15] A perfect example of this next category (4) would be the series of great exhibitions produced by the Centre Pompidou between 1977 and 1981: 'Paris-New York' (1977), 'Paris-Berlin' (1978), 'Paris-Moscow' (1979), and 'Paris-Paris' (1981). Equally, according to Cohen, exhibitions that focus 'on the urban scene and culture of a single city have been successful and intellectually rewarding'.[16] This type (5) is exemplified by the 2006 Venice Architecture Biennale, curated by Richard Burdett and titled 'Cities, Architecture and Society', which featured information about urban environments in London, Barcelona, Buenos Aires and New York.

Cohen goes on to note that exhibitions can be (6) 'a privileged means for institutionalization of a given generation or group of architects and have thus provided materials for the history of the contemporary scene'.[17] The 'Modern Architecture: International Style' and 'The Deconstructivists' exhibitions, respectively presented in 1932 and 1988 at MoMA, are emblematic examples. Cohen also mentions exhibitions that have promoted (7) 'paradigms shifts in contemporary theory';[18] again, 'The Deconstructivist' exhibition is an apt example. Towards the end of his text, Cohen says that exhibitions can be an occasion for (8) 'presenting an architectural theme, or inquiry, to a broad range of the general public as well as to an emerging generation of students'.[19] Finally, some exhibitions have (9) 'an agenda of critique, or even denunciation'.[20] The exhibition 'Living Bridges', presented at the Royal Academy in London in 1996, fits both categories. Indeed, 'Living Bridges' was a thematic exhibition as well as a show intended to reanimate the argument about the construction of inhabited bridges and the redevelopment of the area around the River Thames.

CASE STUDY: THE 1980 VENICE ARCHITECTURE BIENNALE

So far, we have established that architectural exhibitions are subject to various interpretations. The three classification schemes presented here share some similarities, but, overall, they are based on different systems of values (reflecting the authors' approaches as historian, curator, geographer, etcetera) The usefulness of these interpretations as a basis for understanding the nature and function of the architectural exhibition will now be tested through application to a particularly significant example of architectural exhibition *genre*: the First Venice Architectural Biennale (1980) entitled 'La Presenza del Passato' ('The Presence of the Past'). This exhibition was seen as a historical milestone by many architects. According to the architectural critic Charles Jencks, this exhibition did for postmodernism what the *Weissenhof Siedlung* did for modernism: it put it 'on the map'.[21] As well as marking the zenith of postmodernism in architecture, it symbolized the renewal of an important cultural institution (the Venice Biennale); used and mixed many different techniques of display for architecture; travelled to France and the United States; and was accompanied

by a catalogue available in three different languages (Italian, English and French). Yet, this exhibition has been almost entirely neglected by historians, until now.[22]

Held between July and October 1980, 'The Presence of the Past' was the first international architecture exhibition of the Biennale's new (1979) architecture section. It was divided into eight different sections, including: exhibitions dedicated to the architects Philip Johnson (Fig. 13.1), Ignazio Gardella, Mario Ridolfi and Ernesto Basile; the Strada Novissima (Fig. 13.2), an artificial street built in the Venice Arsenal; and two temporary constructions by Aldo Rossi, the exhibition's entrance portal and the Teatro del Mondo[23] (Fig. 13.3). However, it is principally for its Strada Novissima that the First Venice Architecture Biennale is remembered. The Strada Novissima was a manifesto exhibition, a collective display of the work of twenty architects[24] from nine different countries.[25] For the show, each architect was 'asked to design a facade expressing his own particular sense of form, with special reference to the theme of the "presence of the past"'; to create a 'reflection on history as an active basis for planning'; and, behind the facade, to present a 'one-man exhibition of the designing architect'.[26] Each facade could be of a maximum dimension of 7 by 9.5 metres. Each architect had a space of 42 square metres in which to display drawings, photographs or models, as they preferred. The result was a 70-metre-long street in the central nave of the Corderie dell'Arsenale, an abandoned naval rope factory that was once at the heart of Venice.

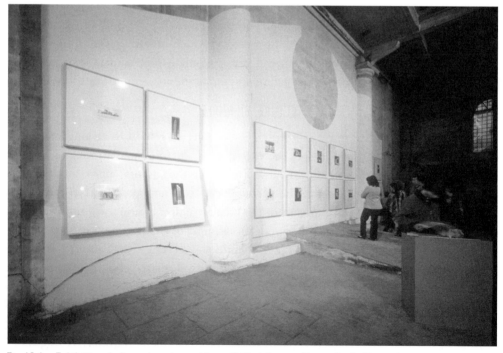

Fig. 13.1 Exhibition dedicated to the architect Philip Johnson. Photo: Paolo Portoghesi.

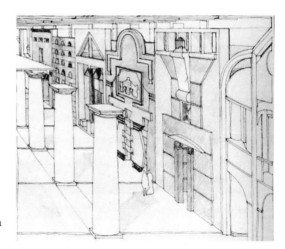

Fig. 13.2 Preparatory axonometry, Strada Novissima by Francesco Cellini.

The exhibition 'The Presence of the Past' cannot be classified in either of the two main branches of Forty's classification system, as it is both a real-scale exhibition and a representational one. Each facade of the Strada Novissima was designed by one of the twenty participant architects and built in real-scale by unemployed technicians of the cinema studio of Cinecittà. Similarly, the Teatro del Mondo and the entrance portal were beautiful real-scale temporary constructions designed by the architect Rossi. These assemblages were not models, since they were not representations of an architecture that already existed or was to be built. They were, rather, pure acts of imagination, extracted from the architect's dream world.

According to Pascal Amphoux, a simulation is a representation of architecture that modifies the relation between the real and the virtual. Amphoux was probably thinking of modelling and other numeric representation, yet in the case of the Strada Novissima, the relation between the real and the virtual is also present, and it is instructive to look at the exhibition as a form of simulation. According to Gilles Deleuze: 'It may be argued that the virtual is the precondition of the real; the real, is an image first, before fulfilling its promise of becoming.'[27] Like a cinema set, the real-scale constructions shown in this exhibition were abstract and ideal representations of an architecture yet to be made and never to be made. It was the apogee of so-called 'paper architecture'. The real-scale parts of 'The Presence of the Past' were mainly temporary: although the facades travelled to France and the United States, and the Teatro del Mondo had existed since the winter of 1979 and had travelled by sea for a few months, all these constructions were eventually dismantled.

Each boutique-like space of forty-two square metres hosted a representational exhibition by one of the architects of the Strada Novissima: Studio GRAU overloaded the walls with architectural drawings imitating the eighteenth-century Paris *Salons*; Robert Venturi proposed a photographic strip that ran along the space with a large photo of the Vanna Venturi house in central focus; Charles Moore placed large vertical strips of translucent

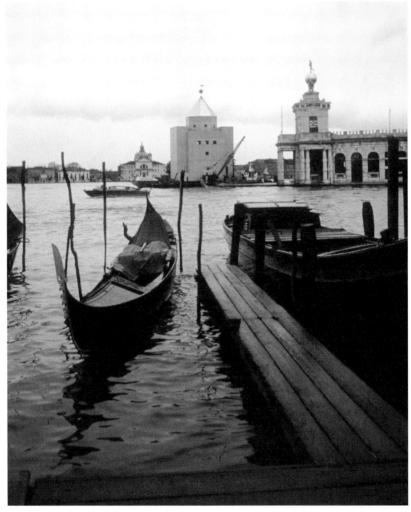

Fig. 13.3 Teatro del Mondo, Aldo Rossi. Photo: Paolo Portoghesi.

papers with plans of his Piazza d'Italia around the space; Oswald Mathias Ungers chose to cover the walls with a German cityscape and to arrange a series of models on pedestals. Therefore, behind the innovative real-scale facades, the visitor was presented with conventional architectural exhibitions.

In Forty's classification system, representational exhibitions are divided between the polemical and the encyclopedic. Here again, it is impossible to place 'The Presence of the Past' in either of these two categories, because it matches both. It was encyclopedic in that the exhibition was arranged as a series of boutiques, a succession of many separate but identical spaces where a number of architects of a similar alignment were assigned a separate, rather confined, space in which to represent their work as they wished. Yet, while other

parts of the exhibition dedicated to Johnson, Gardella, Ridolfi and Basile were definitely monographic, the overall result was polemical: it gathered a group of architects under the banner of postmodernism and generated a great amount of debate in the press.[28] In an article entitled 'The Construction of the Strada Novissima', Francesco Cellini and Claudio D'Amato, two architects involved in the building of the exhibition, commented that the artificial street was an 'expositive invention', an idea 'intended to provoke an answer capable of being demonstrated to the public, in the coherence between individual expressivity and collective obligation, the overcoming of the proud individuality of late-modern architecture'.[29] This exhibition was a collage of many different personalities or languages. As in a shopping mall or a commercial fair, each architect had a space to sell himself. The form of the street with its twenty boutique-like spaces also recalls another postmodern preoccupation: consumerism.

Within Amphoux's classification system, it is difficult to see where to place the real-scale facades of the Strada Novissima, which, like the entrance portal and the Teatro del Mondo, is neither a reproduction nor a 'real' construction. There is, however, one of Amphoux's categories which is worthy of deeper examination: festivalization. As noted above, festivalization can, according to Amphoux, propose a new vision of the city and its architecture and catalyse new uses for a city, or its public spaces. 'The Presence of the Past' exemplified festivalization as it catalysed a new use for the Arsenale and proposed a somehow enchanted vision of the Punta della Dogana thanks to the presence of the Teatro del Mondo.

'The Presence of the Past' was also an occasion to exhibit the exhibition space, the Arsenale, a building long forgotten and suddenly brought back to life (Fig. 13.4). This exemplifies the 'reconversion' category proposed by Amphoux: the restructuring of a building through change of use. Yet, the Arsenale was also changed via temporal context; it was updated through the restoration of the construction. And if the Strada Novissima was a curatorial invention that made a lot of noise in the architecture world, Biennale Architecture Director Paolo Portoghesi's idea of presenting his exhibition in the unused Arsenale di Venezia permitted the addition of a second layer of signification to the idea of 'exhibiting architecture'. Moreover, this act of curatorial genius responded directly to the exhibition's title: 'The Presence of the Past'.

Reviewing Cohen's ideas on architectural exhibitions, we can see that here, too, 'The Presence of the Past' fits more than one category. It highlighted contemporary or recent work, as it showcased the work of many architects, few of whom had built much before 1980; the Arsenale's mezzanine was used to show the work of fifty-five young, and mostly little-known, architects, and it also 'resurrected' Basile, an architect not much talked about at the time. 'The Presence of the Past' also presented new materials (the twenty original facades) and stimulated new debates about postmodern architecture (Fig. 13.5). If the exhibition as a whole was not really cross-disciplinary, the Teatro del Mondo, at least, fulfilled this function, having been created for a joint event aimed at fostering bilateral relations between the Biennale's 'architecture' and 'theatre' sections. By 1980, architecture which

Fig. 13.4 Construction of the Strada Novissima inside the Corderie dell'Arsenale di Venezia. Photo: Paolo Portoghesi.

reacted to the modern movement had been current for about fifteen years, disillusionment with modern architecture was opening the door for new aesthetic proposals and architects were facing a moment of important change. 'The Presence of the Past' did not announce the birth of postmodern architecture, rather it brought current architectural debates to public attention and functioned to 'institutionalize' postmodern architecture; it prompted a paradigm shift, a watershed in the history of architecture, marking the end of the period of development of postmodernism and the beginning of its period of realization. The exhibition anticipated an era of economic wealth corresponding, more or less, to the Reagan and Thatcher governments. Finally, it introduced themes such as imagination, game and the return to history, and promoted these ideas within a new generation of architects. And it was definitely an operation of both critique and denunciation.

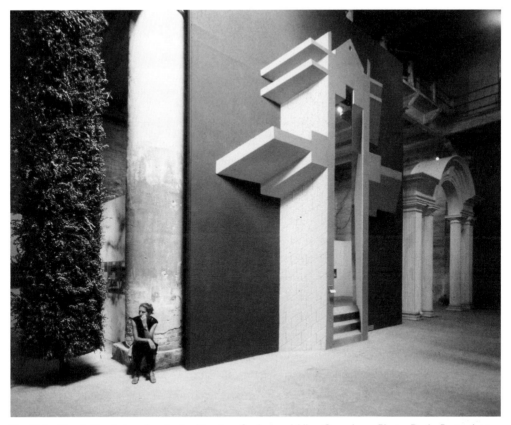

Fig. 13.5 Strada Novissima, facades by Massimo Scolari and Allan Greenberg. Photo: Paolo Portoghesi.

CONCLUSION

This chapter has used texts by Forty, Cohen and Amphoux as tools with which to analyse the 1980 Venice Architecture Biennale. It is not often that all of the identifiable categories of architectural exhibitions are demonstrated in one single example, but this is the case with the First Venice Architecture Biennale (1980). While each of the schemes follow a particular and coherent system of values, in some cases—such as the 1980 Venice Architecture Biennale—they are difficult to apply and may, therefore, be deemed inefficient. Yet, it might also be argued that the success of this highly particular exhibition lies precisely in this combination of many different elements. First, the incorporation of the 'theatrical' element, through the simulacra of cinema-derived technique: the idea of recreating, inside the exhibition space, a set that seems true but is, in reality, false. Second, the inventiveness of the street format, which also gave well-known architects the chance to create self-portraits expressing their personality, outside any (or almost any) restriction or building constraint. Third, there is the idea of exposing the building itself. Therefore, we may be tempted to conclude that it is precisely this rejection of categories in favour of a combination of

interconnected elements that secured the success of the exhibition 'The Presence of the Past', while ingenuously overcoming the paradox of the exhibition of architecture.

NOTES

1. Werner Szambien, *Le musée d'architecture* (Paris: Picard, 1988), 8.
2. Adrian Forty, 'Ways of Knowing, Ways of Showing: A Short History of Architectural Exhibitions,' in *Representing Architecture. New Discussions: Ideologies, Techniques, Curation,* ed. Penny Sparke and Deyan Sudjic (London: Design Museum, 2008), 42–61. Forty is Professor of Architectural History at The Bartlett, School of Architecture at University College London. He is the Programme Director of the MSc programme in Architectural History.
3. Jean-Louis Cohen, 'Exhibitionist Revisionism: Exposing Architectural History,' *Journal of the Society of Architectural Historians* 58 (1999): 316–25. Jean-Louis Cohen is an architect and architectural historian. He has taught in Europe and North America and is now the Sheldon H. Solow Professor in History of Architecture at New York University's Institute of Fine Arts. Between 1998 and 2003, Cohen helped set up the Paris Cité de l'architecture et du patrimoine.
4. Pascal Amphoux, 'Pléonasme: l'architecture naturellement s'expose,' *Faces* 53 (2003–4): 18–22. Pascal Amphoux is an architect and urban geographer. He is currently professor of architecture at the Ecole Nationale Supérieure d'Architecture de Nantes (ENSAN).
5. Forty, 'Ways of Knowing,' 45.
6. Ibid., 45.
7. Serpentine pavilions have been realized by Zaha Hadid (2000), Daniel Libeskind with ARUP (2001), Toyo Ito with ARUP (2002), Oscar Niemeyer (2003), Alvaro Siza and Eduardo Souto de Moura with Cecil Balmond (2005), Rem Koolhaas and Cecil Balmond with ARUP (2006), Olafur Eliasson and Kjetil Thorsen (2007), Frank Gehry (2008), SANAA (2009), Jean Nouvel (2010) and Peter Zumthor (2011).
8. Forty, 'Ways of knowing,' 49.
9. Ibid., 52.
10. Ibid., 54.
11. Cohen, 'Exhibitionist Revisionism,' 316.
12. Ibid.
13. Ibid.
14. Ibid., 317.
15. Ibid.
16. Ibid., 318.
17. Ibid.
18. Ibid.
19. Ibid.
20. Ibid.

21. Charles Jencks, Interview by the author and Eva Branscome, 19 June 2009, London.

22. In 1980, the Italian magazine *Controspazio* published a special edition on the *Presence of the Past* while the English magazine *Architectural Design* published a retrospective special edition on the *Presence of the Past*; Enrica Roddolo, *La Biennale: arte, polemiche, scandali e storie in Laguna* (Venice: Marsilio, 2003), 135–52.

23. The Teatro del Mondo was built in 1979 for the Theatre Festival of the Biennale. After touring many cities, it was moored in Venice's *Punta della Dogana* for the 1980 Venice Architecture Biennale.

24. The exhibitors of *Strada Novissima* were (from the entrance to the end of the street): Costantino Dardi; Michael Graves; Frank Gehry; Oswalt Mathias Ungers; Robert Venturi, John Rauch and Denise Scott-Brown; Léon Krier; Joseph-Paul Kleihues; Hans Hollein; Massimo Scolari; Allan Greenberg (on the left side); Rem Koolhaas and Elia Zenghelis; Paolo Portoghesi, Francesco Cellini and Claudio d'Amato; Taller de Arquitectura Ricardo Bofill; Charles W. Moore; Robert A.M. Stern; Franco Purini and Laura Thermes; Stanley Tigerman; Studio GRAU; Thomas Gordon Smith; Arata Isozaki (on the right side). The French architect Christian de Portzamparc was also part of the group but withdrew at the last moment, deciding that his façade should not be built inside the Arsenale. Therefore, Portoghesi's facade, first designed as the entrance portal to the street, was built in place of Portzamparc's facade.

25. Austria, Germany, Holland, Italy, Japan, Luxembourg, Spain, United Kingdom and United States.

26. Charles Jencks, et al., *The Presence of the Past: First International Exhibition of Architecture—Venice Biennale 1980* (London: Academy Editions, 1980), 38.

27. Nicolas de Oliveira and Nicola Oxley, *Installation Art in the New Millennium: The Empire of the Senses* (London: Thames and Hudson, 2003), 42.

28. Amongst others, the famous battle between Paolo Portoghesi and the historian Bruno Zevi.

29. Francesco Cellini and Claudio D'Amato, 'The Construction of the Strada Novissima,' *Controspazio* 1–6 (1980): 11.

14 DESIGN AS A LANGUAGE WITHOUT WORDS: A G FRONZONI

GABRIELE OROPALLO

Practice and verbalization in design are intimately connected. Designers write to present and pitch their work, quote their influences, describe their methods and formulate their views on design history and theory. Against this landscape, the Italian designer A G Fronzoni[1] represents a remarkable exception: despite having started his career as a journalist and worked for many years as a design educator, he only produced a handful of writings, mostly refusing to dedicate himself to this form of creation. If we consider design itself as a text, nonetheless, we can read in his work the use of several very subtle linguistic strategies. His work is considered a prime example of a design language based on simplicity and reduction to the basic elements and therefore a faithful continuation of the values traditionally associated with modern design. However, a close reading of his work uncovers a different understanding of design, which is read as a means to convey messages without hermeneutic mediation, as an attempt to picture the world and show rather than tell.[2]

In 1997, the designer and design writer Giorgio Camuffo set out to survey the state of graphic design in Italy in a book featuring a selection of recent and classic works produced in the country. He invited some of Italy's recognized masters to contribute short essays to the project.[3] Amongst them was A G Fronzoni, who was known as the most 'Swiss' of Italian graphic designers because of his 'modernist rigour',[4] as well as the initiator of minimalism in Italy,[5] and a designer who used only two colours, black and white, both in his work and his personal life. Fronzoni's submission apparently resembled a page of Leonardo's journals: forty-two lines of mirror-image-looking text, white on black (Fig. 14.1). Nevertheless, the page, printed in tiny Futura typeface, revealed itself, on closer inspection, not to be an enlightening passage on typography or design ethics, and therefore nothing like the other essays written for the book. The words are apparently random juxtapositions of consonants and vowels. In its simple construction, the text is legible yet unreadable. Only the title actually makes sense, and even in reverse it clearly reads, in Italian: '*Che vergogna scrivere*', which translates as 'What a shame', or 'How embarrassing it is to write'.

Fronzoni's page, particularly in the context of the design anthology for which it was conceived, was not simply a witty joke. It encapsulated the principles that consistently characterized the work of this designer. His case is quite uncommon in the landscape of early contemporary design. Unlike many of his colleagues, for whom writing was a central part of the work of a design professional, Fronzoni almost systematically avoided

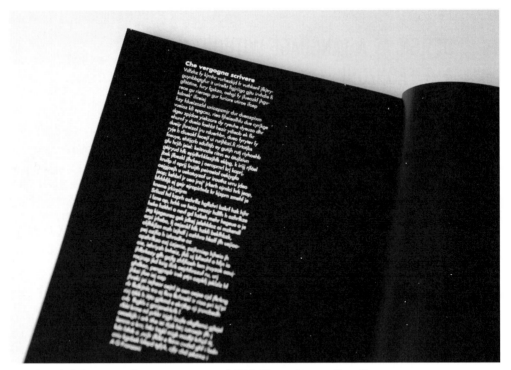

Fig. 14.1 A G Fronzoni, *Che vergogna scrivere* (1997). Photo: Giorgio Camuffo.

it. Fronzoni questions and reassesses the role of writing in European culture, replete with documents and archives, within which the written word is crucial. In Fronzoni's posters, and in the books and magazines he laid out, text is used very sparsely; often characters are exaggeratedly small and demand that the viewer makes an effort to come closer to the two-dimensional surface. Words are disassembled, sliced, hidden in the folds of the layout. They lose centrality and are pushed to the margins of the frame, to the point where their very readability is jeopardized. However, the designer and his collaborators were always careful to avoid overlapping messages and elements; therefore the end result remains legible and clear.

Born in Pistoia, Tuscany, Fronzoni (1923–2002) started his career as typographer, journalist and exhibition designer in the Lombard city of Brescia in the years immediately after the Second World War, before moving to Milan, where he opened an office with life-long collaborator Myrna Cohen. The first two decades after the Second World War were marked by an ideological approach to culture in Europe, and particularly Italy, where the majority of the intellectuals, and most architects and designers, were informed by the ideas of the modern movement, and openly supported those political forces interested in a radical renewal of society. Modernist ideas, such as those of Le Corbusier and of the Dessau Bauhaus, were attractive to governments that believed design (messages, objects, buildings,

cities) could contain and solve social unrest by engineering a new generation of more domesticated citizens—but they also fascinated architects and designers, who thought that planning every human activity could be a way to redistribute the excess wealth created by capitalist modes of production, eventually improving life for everybody.

Late modernism was rephrased between the end of the war and the mid-1960s as a markedly generational movement, supported by a narrative of opposition that saw young, revolutionary artists and designers overturning an established system of traditional art schools and mediocre industrial production with an honest, rational design based on an understanding of materials, functions and machinery. Such a stark opposition did not allow room for readjustments, compromise or hybridization. Modernism was perceived as a non-historical style because, in fact, it was supposed to be a non-style. Non-historical time is the time of myth-making, it is not the time of prose, but rather of the epic narrative, with orality being favoured for its timelessness.

The language adopted by Fronzoni's generation had been formed through the defining experiences of the fascist regime, an uncompromising, black-and-white dictatorship under which he had spent the first twenty-two years of his life. Andrea Branzi explains that Italian architects and designers had 'inherited a form of radicalism from the pre-war years, a radicalism that not only affected their design mentality but also their political ideas'.[6] This radicalism presented itself as a firm belief that rational design can rewrite society and with it the syntactic, horizontal relations between its elements. Initially, their approach was integrated into government policies. It was very constructivist and aimed at using the state of emergency represented by the reconstruction period as an opportunity to redesign society, along with material culture. In 1947, however, Italian left-wing parties were excluded from the government at the request of the Atlantic allies. The vast majority of Italian intellectuals continued to support left-wing parties, whose cultural policies at this point were shaped by the ideas of social theorist Antonio Gramsci.[7] In his *Prison Notebooks*, he emphasized the need to oppose the current cultural hegemony through the development of a counter-hegemonic discourse, which would change society, not through a frontal assault on a stronger establishment but rather by slow occupation of key sectors such as the education and the media. This non-oppositional strategy includes the figure of the 'organic intellectual', integrated and operating within the larger strategic framework of the party. It also provides space for those who, relieved from the responsibility of engendering a cultural revolution, are given the opportunity to experiment outside the constraints of immediate accountability.

In 1947, when Fronzoni was still twenty-four, he founded a journal, *Punta*, intended to be at the vanguard of the process of educating the masses through culture, thus taking the lead from another journal, the Milanese *Il Politecnico* edited by Elio Vittorini. The latter was, at that time, engaged in a debate with the head of the Italian Communist Party, about the role of intellectual Palmiro Togliatti's insistence on the freedom to explore and research outside strict party lines. These forward-thinking, radical journals and publishing houses functioned as hubs for discussions about the diffusion of culture and ideology

within society at large. The reach of these journals and other publications was, however, undermined by several constraints. Firstly, a journal had to be purchased in order for the ideas it carried to be accessed. This was a small but decisive limit, especially in a moment of material scarcity. Distance was another limit; in an age of relatively slow transportation of goods and communication, some journals experienced a limited geographical reach and could only be accessed by readers in specific regions. Finally, there was a crucial cultural constraint, in that literacy rates and the educational levels amongst the rural populations and the working class (the very sectors of the population that progressive politics aimed to reach) were low. Intellectuals were conscious of the gap between themselves and the readership with which they sympathized, and designers tried to bridge this gap using visual strategies aimed at facilitating access to the contents.

The layout of *Punta*, too, is inspired by *Il Politecnico*, which was designed by Albe Steiner, one of the most active contemporary graphic designers, and a protagonist of the Milanese progressive intellectual elite. Elements that characterize the layout of both journals are the two-colour print (with the colour red used in the journal headings and sometimes the headlines), a flexible grid and bold use of pictures. The photographs are presented as objective documents and an equivalency of text and image as vehicles of content is suggested. To this, *Punta* adds the use of graphic elements that emphasize its innovative approach to layout. For instance, on the first page of the first issue, the two articles are set in two interlocking L-shaped boxes, separated by a bold red line. In a smaller box beneath the journal heading, the editor-designer declares the ambitious mission statement: 'Humaneness has to be given back to humanity, and we want to spearhead this struggle: actions and events will gradually define our programme and say whether we are allied to the best individuals. We are not rising to rescue some values, but rather to create new ones that are necessary to life.'

The first issue of the journal featured an article by Giulio Carlo Argan, an influential art historian who later also become involved in politics, serving as first non-Christian Democrat mayor of Rome (1976–1979) and senator (1983–1992). In the years after the Second World War, Argan wrote a seminal monograph on Walter Gropius and the Bauhaus, one of the first books on the subject, which emphasized the pedagogic aspects of modernism and has since been translated into several languages.[8] A central figure in post-war Italian architecture and design, Argan pointed out that design's role is to mediate between society and industry, and thus it carried the potential to solve the tensions between quantity and quality typical of capitalism. Argan emphasized the educative role of design in his writings, as well as the importance of the Bauhaus pedagogic method, with the aim of presenting an emblematic model to follow. However, he also constantly referred to classical and renaissance architecture when discussing contemporary architecture. His aim was to build a bridge between modernity and tradition and subsequently save Italian rational-functionalist architecture from the criticism directed at other modernist vernaculars, as the limits of the modernist utopia became clear during the second half of the twentieth century. This approach was later criticized by historian Manfredo Tafuri who saw in it an ideological attempt at self-preservation, without directly challenging capitalist modes of production.[9]

One of Fronzoni's favourite quotations was from Argan himself: he 'who rejects design, accepts to be designed'. Fronzoni also claimed to support a collectivist approach to design and insisted that design should not be the reserve of a few professionals; instead, it should be a skill as widespread as reading and writing because 'designers design themselves in the first place'. In the 1960s, he would eventually put these ideas into practice and start working as a tutor in public art institutes. In the 1980s, he started his own school where students were collaborators and pupils at the same time. John Pawson compared Fronzoni's teaching philosophy to Shiro Kuramata's: in both cases it was a process of 'learning by doing'.[10] Extremely faithful to this principle, Fronzoni neither produced a textbook nor organized his working principles and practices in written form, a choice confirmed by his typographic essay *Che vergogna scrivere*.

This aspect of his persona is very remarkable when seen in the context of twentieth-century design history. The figure of the heroic, iconic designer dominates glossy design literature, yet the development of industrial design in post-war Italy can be attributed less to single innovators than to a network, with actors who were as proficient in creating design as in manipulating language. Based in Milan, this network included magazines, prizes, events and informal mentorship connections. Language is, in fact, one of the crucial elements in creating and maintaining a network, and its language dimension emerges more obviously if we refer to *translation* as denoting the process by which a vision, a set of ideas, is adapted and developed in order to engage other actors and interests.[11] Contemporary design is still largely mediated by writing. The network commonly referred to as 'Italian', or 'Milanese', design produces words as much as objects. Magazines such as *Domus*, *Casabella* and *Abitare*, for instance, are bilingual and are distributed worldwide, with local editions in Eastern European or Asian languages. Events such as the Milan Triennale, or the annual Design Week, aka the Salone del mobile, and the vast amounts of promotional material it produces, are central to the circulation of ideas and to the initiation of trends.

Despite his background, Fronzoni represents a different case, and his ideas have not been directly transmitted. As with a modern Socrates, his former students and collaborators are always keen on quoting him and recalling his words and deeds, thus unconsciously reiterating and learning his lessons by heart. His figure could well be studied in Freudian terms as a Moses-like founding father sublimated into a totemic authority. This status was suggested by the wave of indignation among Fronzoni's former pupils when Cappellini presented a new edition of Fronzoni's classical Serie '64 furniture system in 2009. Serie '64 was originally available only in black or white, and although Cappellini's re-edition was restricted to the primary colours, blue, red and yellow, reactions included accusations of 'profanation' and 'heresy'.[12]

Fronzoni's school was central to a whole generation of graphic and interior designers. But he preferred to transmit knowledge orally. In addition, in the few interviews he gave, his concepts are surprisingly consistent. Along the decades, even the wording is similar, as though he had standard answers that he mechanically repeated. A perennial debate runs through European culture on the relationship between speech and writing, with some

thinkers expressing scepticism about writing as an efficient way to communicate ideas and others regarding writing simply as a means to record language. In *Of Grammatology*, Jacques Derrida exposed the connection between presence and speech inherent in European culture and consequently criticized the centrality attributed by default to speech vis-a-vis writing.[13] In Fronzoni's case, however, the designer's rejection of writing is ultimately crucial to understanding his work and the way he dealt with the interpretation process that determines how a user/beholder associates signifier and signified. The following analyses illustrate this point in detail.

The first example is the poster for a 1966 exhibition of Lucio Fontana's works at the Genoese Galleria La Polena, an art gallery for which Fronzoni designed identity, interiors and communications until the 1990s (Fig. 14.2). Lucio Fontana (1899–1968) was an Italian-Argentinean artist famous for his *spatial concepts*. These works sometimes consisted merely of holes or clean-cut slashes on the canvas, a hint to the new dimensions anticipated by the science of the day, that in the post-war decades evoked scenarios at once fascinating and dreadful. Fronzoni designed a poster in which a single line of text with the basic information about the event is placed vertically across the white frame. There is no punctuation, the typeface is a plain Helvetica medium and the words are cut across their length, slashed like one of Fontana's most iconic canvases. The cut swells in the middle, to mimic a blade cut. The message is rich and legible. Yet the typography is minimal; the white void is predominant. There are no actual pictures of Fontana's artwork or any description whatsoever. There are two possible ways for the process of communication to work when someone examines this poster. In the first, the delivery of the message relies on the viewer's prior knowledge of Fontana's work, and on the connection they can make between the poster and the event. In the second, the whole textual dimension is sublimated into the purely symbolic, and the slash becomes a prelinguistic hint to follow: something that is showing rather than describing Fontana's art.

This relation of identity between the object and the design of the promotional material was extended the following year. In 1967, Fronzoni designed posters and ephemeral architecture for an exhibition of artworks by Giò Ponti at the Milanese De Neubourg Gallery (Fig. 14.3). Ponti is the influential Italian architect, artist and designer who founded *Domus* magazine in 1928, and, amongst his many projects, he also built the Pirelli tower (1960) in Milan. Ponti was fascinated by the triangular section and the diamond shape, elements he used repeatedly on both structural and aesthetic levels. In the poster for the show, Fronzoni used the image of a pyramid, a distillate of Ponti's aesthetic values: a shape that contains, in the fewest possible lines, his entire design philosophy. Fronzoni's poster did not simply attempt to represent Ponti's pyramid. A simple typographic print, the poster was made with two layers of cardboard, and when it was opened the two sides of an actual pyramid would emerge from the two-dimensional surface and project in to space towards the beholder. Moreover, not only is the pyramid a reference to Ponti's work, it is also the shape used for the exhibition stands in a complex game of references, in which authorship becomes blurry.

FONTANA GALLERIA LA POLENA GENOVA 1-28 OTTOBRE 1966

Fig. 14.2 A G Fronzoni, *Fontana Galleria la Polena* (1966), offset lithograph, 70 × 100 cm. Courtesy of architect Camilla Cristina Fronzoni, curator of the Archivio A G Fronzoni. The Archivio Fronzoni was acknowledged as collection of considerable historical interest by the Ministry of Cultural Activities and Heritage, according to the provisions of decree-law 490/99, title I.

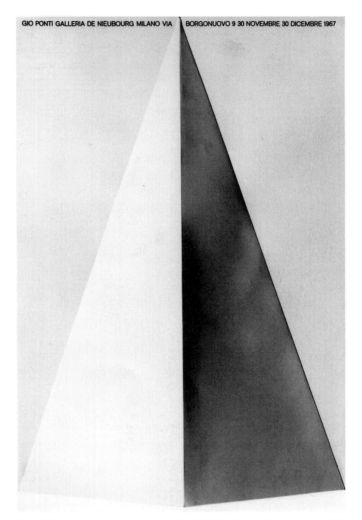

Fig. 14.3 A G Fronzoni, *Gio Ponti Galleria de Neubourg* (1967), typography, 69.5 × 49.5 × 12.5 cm. Courtesy of architect Camilla Cristina Fronzoni, curator of the Archivio A G Fronzoni.

In the eye of the beholder, these design solutions seem natural, in the sense that they seem to be the most appropriate and coherent way to present the material.

An intriguing take on the grid as a design tool is a 1967 poster that Fronzoni designed for an exhibition of young Milanese artists in the German city of Stuttgart (Fig. 14.4). The text is again, as with the Fontana poster, the only element here, and it is arranged as on a grid. The lettering, also in this case Helvetica medium capitals (almost the only sans-serif typeface available for the typesetting equipment used by Fronzoni at that time), gives basic information about the date and place, without punctuation. The dimension of the typeface and the distance between the characters reveal themselves to be painstakingly studied, because the characters do not *follow* a grid but rather literally *create* one. Many of the artists

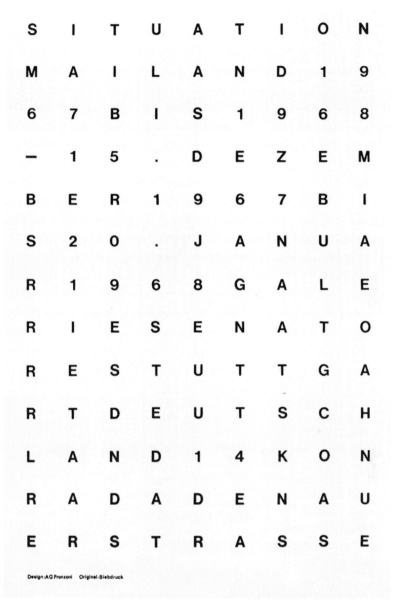

S	I	T	U	A	T	I	O	N
M	A	I	L	A	N	D	1	9
6	7	B	I	S	1	9	6	8
—	1	5	.	D	E	Z	E	M
B	E	R	1	9	6	7	B	I
S	2	0	.	J	A	N	U	A
R	1	9	6	8	G	A	L	E
R	I	E	S	E	N	A	T	O
R	E	S	T	U	T	T	G	A
R	T	D	E	U	T	S	C	H
L	A	N	D	1	4	K	O	N
R	A	D	A	D	E	N	A	U
E	R	S	T	R	A	S	S	E

Design:A G Fronzoni Original-Siebdruck

Fig. 14.4 A G Fronzoni, *Situation Mailand Galerie Senatore* (1967), screen-printing, 50 × 70 cm. Courtesy of architect Camilla Cristina Fronzoni, curator of the Archivio A G Fronzoni.

featured in the Stuttgart show were indeed experimenting with the grid in a *postmodern* fashion, trying to expose its presence in reality as an embedded substructure. Fronzoni's poster exposes the grid, but it also reinterprets it as a flexible structure that can actually be adapted.

Finally, if we subscribe to the point of view that architecture is a text, as argued by Tomás Maldonado in a famous lecture,[14] there is one particular project in which Fronzoni's

rejection of writing is articulated at its clearest. This is one of Fronzoni's few properly architectural works: his 1976 *translation* of a rural cottage into a holiday house on the small island of Capraia in the Tuscan archipelago. His raw material was a very simple stone construction on a plot of rocky land. In Fronzoni's account, the genesis of the project acquires a mythical aura, with the designer visiting the cottage for the first time to find inside an archetypal scene: an old woman clad in black, tending a white goat.[15] Black and white were the colours of Fronzoni's original Serie '64 furniture and of the tones of his monochromatic graphic design. He felt he could not add anything to the cottage without altering and jeopardizing the ancestral, archetypal balance of the construction. His solution was a witty tautology. He designed a second building, using exactly the same materials and proportions of the first one (Fig. 14.5). The two buildings are identical. One is a daytime area, with an open-plan kitchen and living room, and the other a night-time space with four identical bedrooms and four en-suite bathrooms. The houses stand on a gentle slope, and the skillion roof of the second cottage keeps the same gradient as the first. The second building appears to be a mere reproduction of the first, yet there is a complex message in it. In the same period, Fronzoni was working on another project in Piedmont, a museum of the German-speaking community, the Walser. The museum is placed in a traditional Walser two-storey cottage, in which the two floors are connected by an external staircase that represents a passageway and, at the same time, a linkage between outdoors and indoors, environment and dwelling. Fronzoni employs the same concept in the Capraia house, not with a new text, but rather with a synonym.

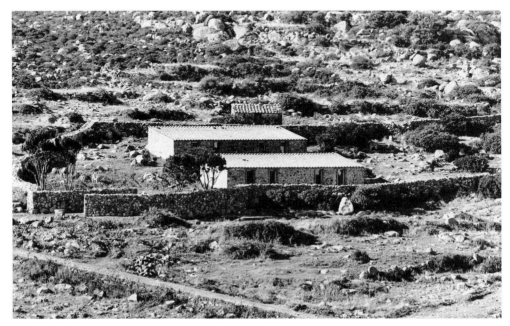

Fig. 14.5 Duplex House, Capraia, Italy. A G Fronzoni, 1976. Photo: Giovanni Berengo Gardin.

The quality of 'simplicity' recurs in reviews of Fronzoni's work, and it is regularly praised for its elegant and 'natural' forms. These appraisals are based on the assumption that simple design is immediately understood by the user and does not need to be processed: that which is simple acquires an aura of truth. One of the basic tenets of modernism is 'truth to materials'. If raw materials are concrete and steel, then this means revealing them in the final object, exposing the nature of the structural elements. When the raw material is information, staying true means staying faithful to the original content, avoiding and even *preventing* interpretation. By avoiding formal complexity, design immediately acquires a connotation of unquestionable, original *truth*. Extreme formal simplification can be interpreted as an elimination of all obstacles and as an approximation of the *signifier* to the bare, pure essence of the *signified*. Most commentators insist on this as a commitment of the designer towards readability and legibility and, ultimately, inclusion.

Fronzoni's style, however, although inspired by the modernist orthodoxy, does not closely follow it. Fronzoni's idiom is characterized by rhythm, directness, witty metaphors and wordplay. As we have seen, using these techniques it is possible to transmit multiple meanings in a very concise manner. But, this does not happen using a mutually agreed, rationalist, language. In Fronzoni's work, there is compression rather than reduction. His design is polysemic rather than minimalist. In the graphemes and glyphs that he designs, the goal is not to reduce and subtract but to add and include meanings. And what is more polysemic than silence? It can mean anything. We know that black is the colour that includes all light frequencies, and we call white noise a sound that contains many frequencies with equal intensities. Fronzoni designed new ideograms and pictograms of increasing conceptual intricacy. His personal challenge can be described as an attempt to create new—but self-explanatory—alphabets. In his design, conceptual density is emphasized over elaborate vocabulary, and, in this respect, Fronzoni also starkly contrasts with other postmodernist practitioners, albeit sharing with them a common departure from the quest for a universal language.

Simplicity is not necessarily a regression to nature, but it can be a very complex, semantically loaded strategy. It is clearly that the purpose of many designers is to create shapes that seem to have always existed, whose raison d'être is self-explanatory. In this sense, simplicity is a design approach that aims to conceal the very design intervention on the environment. The regular and the simple do not represent the default in the grammar of human perception. The default is the multiform, the multilingual. Senses are trained to expect the complex. In fact, a 'simple' shape requires a great deal of labour to be designed and manufactured. Symmetry, proportion, essentiality are almost other-worldly qualities that need a great effort to be brought into being and to be made to look 'natural', 'essential'. This labour anticipates and thus dispenses with the labour otherwise required of the viewer to disentangle what is complex.

At the beginning of the 1960s, while the landscape of contemporary design was gradually shifting towards increasing criticism of the international modernist canon, Fronzoni apparently adopted a severe, austere, rigorous version of it. The 'crisis of the object' that

many lamented in those years can be seen as a sort of semantic drift. At a 1980 conference in Berlin, Argan talked about an ongoing, severe 'crisis of design', linked to a lack of understanding of object semantics by designers and critics.[16] Argan's position here is radically different from the optimism towards industrial design he expressed in the 1950s; then, he, and many others, were convinced that design was to play a central role in the renewal of culture and society, and, ultimately, in the improvement of material and social conditions for all. 'There won't be any industrial design if not in the understanding that objects, having lost their old status of objects, have acquired the status of pieces of information.'[17]

The disintegration of the modernist grand narrative of 'good design' left a semantic vacuum in the object that was replaced with a micro-narrative of immediate satisfaction through indiscriminate consumption. Fronzoni, in a way, reacts to this hijacking of the communicative power within the designed object, and in order to prevent it, he tries to establish an identity of ethics and aesthetics in design—hence, also, his rejection of writing as an instrument with which to approach and explain design. This refusal is part of an overall interpretation of design as a 'language without words', the aim of which is to communicate its messages while eluding critical interpretation.

NOTES

1. In 1966, A G Fronzoni dropped the full stops after his initials, and towards the end of his life, he often simply referred to himself as AGF. His name has been consolidated as AG Fronzoni in some secondary literature, but this chapter retains the form A G Fronzoni.

2. On the implications of showing abstract concepts rather than interpreting them, see the work of Austrian philosopher Ludwig Wittgenstein, who exemplified these issues through the very construction of his writings. Ludwig Wittgenstein, *Tractatus Logico-Philosophicus*, trans. David Francis Pears and Brian F. McGuinness (London: Routledge, 1961); and Maurice Drury, *The Danger of Words* (London: Routledge, 1973).

3. Giorgio Camuffo, *Grafici Italiani* (Venice: Canal and Stamperia, 1997).

4. Richard Hollis, *Graphic Design: A Concise History* (London: Thames and Hudson, 2001), 204. For an overview of Fronzoni's work, see Franco Achilli, ed., *A G Fronzoni: Trentanove Poster di A G Fronzoni* (Milan: Aiap, 1992); and Christian Aichner and Bernd Kuchenbeiser, *A G Fronzoni* (Baden: Lars Müller Verlag, 1997).

5. Franco Bertoni, *Minimalist Architecture* (Basel: Birkhäuser, 2002), 78–94; Franco Bertoni, *Minimalist Design* (Basel: Birkhäuser, 2004), 74–79, 128–33. The latter's cover displays a silhouette of Fronzoni's *Serie 64* chair as an iconic piece of minimalist design.

6. Andrea Branzi and Michele De Lucchi, *Il design italiano degli anni 50* (Milan: Igis, 1981), 17.

7. See Antonio Gramsci, *Selections from Cultural Writings,* ed. David Forgacs and Geoffrey Nowell-Smith, trans. William Boelhower (Cambridge, MA: Harvard University, 1985).

8. Giulio Carlo Argan, *Walter Gropius e la Bauhaus* (Turin: Einaudi, 1951).

9. Manfredo Tafuri, *Architecture and Utopia: Design and Capitalist Development* (Cambridge, MA: MIT Press, 1979).

10. John Pawson, 'Shiro Kuramata,' *Domus* 858 (2003), 120.

11. Michel Callon, 'Struggles and Negotiations to Define What is Problematic and What is Not: The Socio-logic of Translation,' in *The Social Process of Scientific Investigation*, ed. Karin D. Knorr (Dordrecht: Reidel Publishing, 1980), 197–221.

12. Alessandro Mendini, 'Painting A G Fronzoni,' *Abitare* 494 (2009): 32–43.

13. Jacques Derrida, *Of Grammatology* (Baltimore: Johns Hopkins University, 1974).

14. Tomás Maldonado, *Es la arquitectura un texto?, y otros escritos* (Buenos Aires: Infinito, 2004).

15. Florencia Costa, 'A G Fronzoni: On the Unavoidable Task of Living,' *A+U* 338 (1988): 28. See also Christian Aichner, 'Doppelhaus auf der Isola di Capraia,' *Baumeister* 5 (1998): 36–45.

16. Giulio Carlo Argan, *Progetto e oggetto: scritti sul design* (Milan: Medusa, 2003), 203–23.

17. Ibid., 213.

15 ON THE LEGAL PROTECTION OF DESIGN: THINGS AND WORDS ABOUT THEM

STINA TEILMANN-LOCK

The task of the EU Office of Harmonization for the Internal Market (OHIM) is to register trademarks and designs. European regulation on design registration came into force in 2003; today OHIM receives approximately twenty thousand applications each year.[1] Such an office exists because the law aims to protect those who hold intellectual property rights to designs. Intellectual property rights make up an important part of the global economy today. And owning such rights to designs is a characteristic of the modern subject, whether as an entrepreneur or as an engineer, as a scientist or as an inventor. While such rights have only recently been enshrined in EU law, the practice of making exclusive claims to intangibles can be traced back more than five centuries.

As early as the 1460s—soon after the invention of printing—privileges were granted for the printing of specific books or classes of books. Within the Venetian Republic none but the privilege-holder was permitted to print a specific book, and the privilege was enforced by the Republic.[2] In England, as in other European countries, Royal Prerogatives or monopolies in the printing of specific books were first issued in the sixteenth century,[3] when we see also the first grants of letters patent on inventions.[4] To be awarded an exclusive privilege to print a book or a monopoly in an invention, the sixteenth century printer or inventor needed (in England) to petition the Crown.[5] Initially, there were no special requirements for such petitions: patent petitions usually consisted of a formulaic account of the labour, effort and cost expended by the inventor, and a claim for the benefit the invention might yield.[6]

This haphazard arrangement (obviously vulnerable to abuse, favouritism and royal whim) was replaced in 1557 by the grant of a monopoly to a guild: printing was now treated as a distinct skill, worthy of protection. The Company of Stationers had been the guild licensed to sell books in London; in 1557 it was granted by the Crown a monopoly on all printing. This meant that in England, over the next one-hundred-and-fifty years, the printing, publishing, selling and distributing of all printed matter was controlled by a single body. After the unregulated pamphleteering of the Civil War and Commonwealth, the restored Crown decided in 1662 to re-assert control over what was printed. The Company of Stationers had been granted a monopoly over printing, in much the way that cloth-makers or goldsmiths had been granted monopolies. The fact that printing involved 'intellectual content' as well as material skill had not been addressed; what was of utmost

concern was that what could be legitimately printed as a material object might be 'illegitimate' in its 'content'. The Press Licensing Act of 1662 was aimed at 'preventing the frequent abuses in printing seditious, treasonable and unlicensed books and pamphlets'.[7] The Stationers' Company was to be made accountable for what was printed and for keeping records: this law decreed that every printed item was to be licensed and registered at the Stationers' Hall.[8] Moreover, three copies of each publication were to be deposited in the Royal Library and in the libraries of Oxford and Cambridge universities.[9] This marks the beginning in English law of the link between the assigning of rights in books and their legal deposit.[10]

The system of privileges for printing lasted from 1557 until 1694 when the Press Licensing Act was allowed to lapse. It was replaced in 1710 by the world's first law of copyright, the Statute of Anne: much of the old system was dismantled but legal deposit was retained, and augmented. Legal deposit has been adopted by many nations and has continued to be part of all copyright legislation in the United Kingdom.[11]

INTELLECTUAL PROPERTY RIGHTS IN DESIGNS

Modelled on the Statute of Anne, in important respects, the first act explicitly to protect intellectual property rights in design came in 1787, with the Calico Printers Act.[12] The shift from the protection of books to the protection of design was, notably, mediated through printing. Textile printing had been introduced to England in the late seventeenth century by French exiles in Richmond.[13] Initially, patterns printed on textiles were considered a threat to woven ones and were therefore given no protection. The 1787 Act bestowed on the printer of patterns this right:

> Every person who shall invent, design and print, or cause to be invented, designed and printed, and become the proprietor of any new and original pattern or patterns for printing linens, cottons, calicoes, or muslins shall have the sole right and liberty of printing and reprinting the same for the term of two months, to commence from the day of the first publishing thereof, which shall be truly printed with the name of the printer or proprietors at each end of every such piece of linen, cotton, callicoe, or muslin.[14]

When a print is first made available on the market (and thus vulnerable to imitation), it is deemed to be 'published': such is the metaphorical extension by which the law extends its range of protection. To ensure protection, designs had to be printed with the name of the printer, or the proprietor, at the end of each bolt of linen. This corresponds to the title page (or, now, the limitation page) of a published book. In the event of dispute, this section of the bolt would be produced as evidence against the infringing pattern.

Yet the Calico Printers Act was found inadequate as a means of protecting designers' rights, not least because of its limited scope. Those limits were, perhaps, determined by the constraints on the metaphors of 'printing' and 'publishing'. Various improvements and adjustments were made over the next fifty years, but only in 1839 would design be

protected in a more general way: that is to say, without reference to the process of printing. Two pieces of legislation in 1839 indicate this shift: the Copyright of Designs Act[15] and the Designs Registration Act.[16] The former extended the subject matter of the Calico Printers Act to include 'fabrics composed of wool, silk, or hair' and also 'mixed fabrics'.[17] (It is no longer specified, or even implied, that the process must involve printing.) The latter Act introduced a twelve-month protection of original designs for articles of manufacture (such as patterns and prints for textiles; the modelling, casting and ornamenting of manufactured articles, their shape, configuration and so forth).[18] Such protection, however, was conditional on the design being registered—before what was still termed 'publication'—in a newly established list of designs, or what might, today, be called a 'database'. Furthermore, it was stipulated that, for a design to qualify for protection, either three exemplars or three drawings of the design were to be deposited at a central Registry in London: 'Registrar shall not register any design unless he is furnished with three copies or drawings of such designs.'[19]

There is a terminological confusion between a registry and a depository. It was to prove a progressive and productive confusion. As Brad Sherman and Lionel Bently observe, this was the 'first occasion in which representative registration—the process whereby the creation was represented in pictorial or written terms rather than via a copy or model—was used with any degree of sophistication or thought in intellectual property law'.[20] Registration of deposits was already a familiar element of intellectual property rights protection; there had long been precedent for the deposit of the book itself: a book is both a representation (of itself) and an exemplar. Yet there is need also of a registry, in the form of a catalogue: a depository of things (including books) is of little use without a register listing, identifying and locating each item.

The cataloguing of printed material is straightforward: words are identified by words. In moving from printed books to printed patterns, and then to design in general, the law introduces what it terms 'representative registration'.[21] This, a new device in 1839, was clearly needed. The legal deposit of 'design objects' was modelled on that of books, and this created a number of problems. Unlike books, designed objects are not easily stacked or shelved. Secondly, design objects, unlike books, possess no inherent mode of classification (theme, genre) or principle of alphabetical ordering. Imagine compiling a catalogue itemizing and uniquely defining each of a thousand different screwdrivers, armchairs or toothbrushes. Apart from whatever words may be imprinted or otherwise indelibly marked on these objects, there are no words which inhere in each item. Yet, according to the Design Registration Act of 1839, it is the responsibility of the Registrar not only to register each new design-object as it is deposited but he is also enjoined thus: 'In order to give ready access to the copies of designs so registered, he shall keep a classified index of such copies of designs.'[22]

Those who drafted the law in 1839 had clearly not considered the difficulty of compiling a verbal register of things that lack words. This blindness is central to the emergence of the 'discursive episteme' that for Michel Foucault characterized modernity.[23] The ambition

of modernity is to describe all things in words, to insist on producing a verbal representation of everything, even what had traditionally been allowed to elude linguistic definition. The ambition to provide legal protection for 'the non-verbal' (or 'non-textual intellectual property') is central to the aims of the discursive episteme. The law itself is a predominantly verbal instrument and is most at ease in applying words to words, case by case. Discursive registration has administrative and pragmatic advantages, but it presents a challenge to the development of a legal discourse about evidence and rights: it opens up a conceptual space between the thing (the item deposited) and the 'intellectual property' inherent in it. This property transcends instantiation in any material object. The intellectual property remains (intangibly) with the designer, even when the tangible object has been legally transferred to the purchaser. Just as the 'work' of a book remains the author's property no matter how many copies are printed and sold, so the intellectual property in a designed thing remains the designer's, regardless of all commercial exploitation of that thing.

The problem with 'discursive representation' is that it does not acknowledge the difference between textual and non-textual forms of intellectual property; it proceeds as though intellectual property ought to be textual. The book provides an easily conceptualized distinction between the physical object, which anyone might own, and its intellectual content, which remains the author's. In copyright law, this is formulated as the distinction between the immaterial 'work' and the material 'copy'.[24] 'Discursive representation' extends this notion of intellectual property as 'immaterial' and as an 'intangible good': all design should thus aspire to the immateriality of a text. Today the system of discursive registration has become universal: actual samples of design objects are collected, if at all, as cultural artefacts for museums of design and industrial arts: they are not collected in depositories for legal purposes. OHIM deals only in documents, never with actual objects such as toothbrushes or bicycle wheels. Images are admitted as documents, though it is hard to conceive how, other than discursively (textually) these images might be ordered for storage and retrieval. To obtain design registration the applicant is required to submit both a discursive representation (in other words, a verbal or numerical description) and at least one visual representation of the object: either a photograph or a diagram. This 'discursive representation' must be adequate and appropriate, which is to say that it must conform to the EU definition of a design. When lawyers deal with design as intellectual property, they are dealing with a variety of representations, but never (or very rarely) with material objects, things in themselves.

THE NEGOTIATION OF DESIGN RIGHTS IN THE COURTROOM

The remaining part of this chapter will be devoted to the analysis of 'examples' or 'cases': the intangible discursive representation of two designs, the rights to which have been negotiated in, respectively, British and Danish courts. Both disputes concern copyright as extended to non-textual objects. A designer's rights of intellectual property to a designed object are defined and upheld by OHIM: in addition, in certain countries, including Britain and Denmark, the designer may claim copyright in certain types of non-textual ob-

ject. According to the British Copyright, Designs and Patents Act 1988, original 'artistic works' (such as paintings, drawings, photographs, sculptures, collages, architectural works) may be protected by copyright. Note that, apart from sculpture, all these modes of design exist on a two-dimensional surface and can thus be 'adequately represented' by print. This means that designs in the shape of 'surface decorations' fall under copyright, on the same terms as literary works. Works that fall within the category of 'industrial design' (objects that cannot be confined to a surface or adequately represented by print) are protected by a special design copyright that runs for twenty-five years, from the time when first marketed, or 'published'.[25] Danish Copyright Law differs from UK law in that it protects—insofar as they are 'original'—both industrial designs and applied arts under the same copyright, valid for the lifetime of the originator plus seventy years.[26]

Copyright is an attractive right not only because it lasts for a long time but also because it requires no formal application and no fees need to be paid. However, in the event of legal dispute over a designed object, the discursive representation of the design must be adequate to prove possession of the right; otherwise the design will not qualify for copyright protection. In particular, it must be established that one's design is 'original' and that its appearance is not merely a result of its function. Furthermore, if one claims that copyright in a design has been infringed, the infringing work must be shown to have substantial similarity—which is the test for copyright infringement—to the design that is protected.

DESIGNERS GUILD LTD VS. RUSSELL WILLIAMS (TEXTILES) LTD (2000)

Our first case, concerning the British company Designers Guild, was heard no fewer than three times: first in 1988 by the Chancery Division; then appealed in 1999; finally, by the House of Lords in 2000.[27] The plaintiff, Designers Guild, claimed that the design of a textile, Ixia, had been copied by defendant, Russell Williams, in his Marguerite (Fig. 15.1). In legal terms, copyright subsisted in the original 'artistic work', created by Helen Burke—employed by Designers Guild—on which Ixia was based. Williams was thus accused of unauthorized reproduction of Burke's original and 'immaterial' art work.

Fig. 15.1 Left: Ixia design. Right: Marguerite design. Photo courtesy of Designers Guild and Taylors Solicitors.

In each of the three courts, the verdict depends on the various discursive representations of the design on which the judges rely and on which one is favoured by each judge. The two designs under dispute were clearly not 'identical'. Being surface patterns, easily stored and transported, samples of each were presented in the court. The judge in Chancery described Ixia as 'a striped pattern with flowers scattered over it in a somewhat impressionistic style' (this is his 'discursive representation') while he described Marguerite as 'a striped design with scattered flowers . . . in a somewhat impressionistic style'. To assess infringement, the judge identified seven similarities between the Ixia and the Marguerite fabrics:

1. Each fabric consists of vertical stripes, with spaces between the stripes equal to the width of the stripe, and in each fabric flowers and leaves are scattered over and between the stripes, so as to give the same general effect.
2. Each is painted in a similar neo-Impressionistic style. Each uses a brushstroke technique, i.e. the use of one brush to create a stripe, showing the brush marks against the texture.
3. In each fabric the stripes are formed by vertical brush strokes, and have rough edges which merge into the background.
4. In each fabric the petals are formed with dryish brushstrokes and are executed in a similar way (somewhat in the form of a comma).
5. In each fabric parts of the colours of the stripes shows through some of the petals.
6. In each case the centres of the flower heads are represented by a strong blob, rather than by realistic representations.
7. In each fabric the leaves are painted in two distinct shades of green, with similar brush strokes, and are scattered over the design.[28]

One admires the judge's eye, and especially his attention to the nature and quality of the brushwork. One would appreciate some elucidation, however, of the phrases 'somewhat impressionistic' and 'neo-Impressionistic', and the distinction between them. There was no way of proving that the designer of Marguerite had in fact seen Ixia. The similarities between the two designs and the inability of the defendant to provide adequate and appropriate evidence of an independent origin for Marguerite were taken by the judge as evidence of infringement. Thus in the Chancery Court, the case brought by Designers Guild was upheld.

In the Court of Appeal the verdict was overturned. Here the judge focused not on whether there had been copying (which, to some extent, is inevitable and must be permitted) but on whether there was 'substantial similarity' between the two designs. Only 'substantial similarity' can be taken as evidence of infringement of copyright. The appellant judge considered the seven similarities analysed by the judge in Chancery and, for each similarity, drew attention to a difference. According to Judge Morritt's 'discursive representation', both Ixia and Marguerite show 'a combination of flowers and stripes but with different flowers differently disposed'.[29] Although both designs use a technique showing the brush marks against the textured ground, creating rough edges, the effects are dissimilar:

The effect is more pronounced in Marguerite than in Ixia, partly because the stripes are wider and partly because the effect appears to have been exaggerated beyond what would normally be produced by a single brush stroke. In Marguerite the flowers and leaves are much more prominent in relation to the background than is the case with Ixia.[30]

Judge Morritt then comments on the 'similarity analysis' of the judge in Chancery:

It is clear, as the judge recorded, that in both fabrics the colour of the stripes shows through some of the petals. But, so it appears to me, that verbal description conceals a significantly different visual effect. In Ixia the petals appear to be translucent. In Marguerite they appear to be multi-coloured or perforated.[31]

Crucially, Judge Morritt finds that the verbal description of the judge in Chancery obscures the visual dissimilarities between the two designs. Judge Morritt concludes that 'the stripes and the flowers were not copied from Ixia into Marguerite'.[32] The Court of Appeal ruled that there had been no infringement. The dichotomy between idea and expression, a fundamental doctrine in British copyright law, dictates that to copy the expression of a work is unlawful, but that there can be no offence in 'following' or 'taking up' an idea. And Russell Williams Textiles had taken not the 'visual' expression but only the idea: what the defendant had done was not to copy, but to draw inspiration.

The House of Lords unanimously overturned the ruling of the Court of Appeal. The Lords were particularly critical of Judge Morritt's analysis of the two designs where, instead of looking at the design as a visual whole, he focused on particular features of the two designs in order to highlight dissimilarities: this 'exercise in dissection' was erroneous inasmuch as 'it dealt with the copied features piecemeal instead of considering, as the [first] judge had done, their cumulative effect'.[33] To judge whether there is substantial similarity and, accordingly, copyright infringement, one should consider each work in general terms. Thus Lord Hoffmann brings us to the very heart of 'design': for design must involve a particular arrangement or disposition of elements that, in themselves, might have little or nothing whatever in common.

FRITZ HANSEN A/S VS. DAN-FORM APS (2002)

In Denmark, a Supreme Court decision from 2002 concerned the legacy of Arne Jacobsen: his classic Ant chair from 1952 was alleged to have been illegally copied by a chair labelled Jackpot[34] (Fig. 15.2). The producers of the Ant lost their case in the Supreme Court: though bearing obvious signs of similarity to the Ant, the Jackpot chair was not considered to be an infringing copy. This ruling was somewhat puzzling as it seemed to reverse a Supreme Court judgment of 2001: Peter Opsvik and Stokke Fabrikker vs. Tvilum Møbelfabrik.[35] Then, the Court had decided that the producers of a child's highchair named the 2-Step chair had infringed the copyright in Stokke and Peter Opsvik's Tripp-Trapp highchair. In the Tripp-Trapp verdict it had been stated—in accordance with Danish doctrine on copyright in industrial designs—that, as the dispute concerned a piece of functional design, only an extremely close imitation would amount to infringement. The 2-Step chair,

even though it was obviously not a slavish imitation, had then been found to be close, to the extent of infringement.[36]

The Ant case had first been heard by the Copenhagen Maritime and Commercial Court where the plaintiff (representing the estate of Jacobsen) had been successful. The defendant claimed not to have thought of the Ant when he designed the Jackpot. The court found this unlikely: the Ant is one of the most famous chairs in the world, and the designer of the Jackpot was himself Danish. While Jacobsen had spent two years designing the Ant chair, the defendant had taken just two months. Large amounts of quantitative data were presented to the court, describing and, both verbally and numerically, analysing the two chairs; their measurements were not identical. The chairs themselves were present in the court.[37] The judge found that such an analysis of the chairs was irrelevant. Rather, he emphasized, the judgment must rest on a comparison of the overall impression:

> It is of no consequence that the chairs differ in a number of ways—particularly as regards, in the Ant, the characteristic 'milling-out' of its back, which has been omitted in the Jackpot chair—in that the differences are insignificant in relation to the overall evaluation which reveals that the chairs share the same appearance and lines. No element has been added to the Jackpot chair to make its design go further than the design of the Ant and the Jackpot chair appears simply as a designerly reduction of the internationally renowned design of the Ant. By producing and selling the Jackpot chair, defendant has, therefore, infringed paragraph 2 of the Danish Law of Copyright.[38]

Viewed overall, the Ant and the Jackpot chairs are substantially similar, sharing the same lines and contours. Nothing new was added in the Jackpot chair: it was merely a reduced version of the Ant chair and, accordingly, an infringing copy.

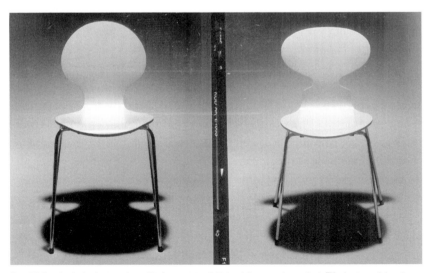

Fig. 15.2 Left: Jackpot chair. Right: original Fritz Hansen Ant chair™ designed by Arne Jacobsen. Photo courtesy Fritz Hansen® and Erling Borcher.

Yet, overturning this verdict, the Danish Supreme Court found no infringement. The similarities between the Ant and the Jackpot chairs were represented in a rather different way. The Ant was treated as an original work which—with its unique design—revolutionized furniture design in the 1950s. As such, the Supreme Court allowed that the Ant should be recognized as the origin of a type of chair, quite common today, which has slim steel legs, a moulded back, and can be easily stacked. Nevertheless, according to the Supreme Court judges, 'the Ant is most accurately defined by the distinct back . . .' and this feature is not shared by the Jackpot. Thus, the judges conclude, 'the Jackpot chair resembles other chairs of this type, based on the same technique, more than it resembles the Ant'.[39] In other words, the Supreme Court ignores the prevailing Danish tradition in both design and its legal protection, and discounts what is 'merely' 'determined by function'.

At the first hearing, the Copenhagen Maritime and Commercial Court had taken a formalist approach to the two chairs; the Ant chair was seen as the achieved instantiation of Jacobsen's idea, and the Jackpot chair as a reduction thereof. However, the Supreme Court took a contextual approach and represented the two chairs as variants of the same type of 'ideal chair', neither of which (in Plato's term) would have the priority that belongs only to the true and immaterial chair. Inverting the sequence and hierarchies of the Designers Guild case in Britain, it was the lower court which focussed on the general appearance, while the Supreme Court took just one element, the narrow waist, and declared that the Ant was uniquely distinguished by its back, 'whence its name derives'. Here the marketing label of 'the Ant chair' has served as its own discursive representation, and the label has had the most unfortunate effect in, of all places, the Supreme Court of Denmark. The label 'ant' has got in the way and blocked a general view of the design as a whole. The marketing title has been allowed, in the Supreme Court, to take the place and do the work of a legally valid 'discursive representation'. The label has, in effect, prevented the judge from taking a good look at the chair.

The law has established the convention that a designer's rights to intellectual property are conditional on an adequate discursive representation of the design and proof of its originality. An expert called as witness in the Ant case explained: 'It is among the duties of the designer to add distinctiveness or personal "artistic expression" to the product, which may serve, among others, the purpose of differentiating it from comparable products.'[40] However, it is among the duties of a judge, while relying on discursive representations, not to allow them to interfere with the visual evidence.

NOTES

1. See http://oami.europa.eu/ows/rw/pages/OHIM/statistics.en.do.
2. In 1469 the Cabinet of Venice started to grant temporary monopolies to print. See Horatio Forbes Brown, *The Venetian Printing Press: An Historical Study Based upon Documents for the most Part Hitherto Unpublished* (London: John C. Nimmo, 1891).

3. See Elizabeth Armstrong, *Before Copyright: The French Book-Privilege System 1498–1526*, Series: Cambridge Studies in Publishing and Printing History (Cambridge: Cambridge University Press, 1990); Joseph Loewenstein, *The Author's Due: Printing and the Prehistory of Copyright* (Chicago: University of Chicago Press, 2002); and Stina Teilmann-Lock, *British and French Copyright: A Historical Study of Aesthetic Implications* (Copenhagen: DJØF Publishing, 2009).

4. See A. A. Gomme in *Patents of Invention: Origin and Growth of the Patent System in Britain* (London: Longmans Green, 1946). A patent system came into existence in the nineteenth century. See Christine MacLeod, *Inventing the Industrial Revolution: The English Patent System, 1660–1800* (Cambridge: Cambridge University Press, 1988).

5. In 1534, Henry VIII had announced the crown's prerogative to rights in printing.

6. See MacLeod, *Inventing the Industrial Revolution*.

7. 'An Act for Preventing the frequent Abuses in printing seditious, treasonable and unlicensed Books and Pamphlets, and for regulating of Printing and Printing-Presses', 13 & 14 Car. II, c. 33.

8. 13 and 14 Car. II, c. 33, III.

9. See Robert C. Barrington Partridge, *The History of the Legal Deposit of Books throughout the British Empire* (Welwyn: Broadwater Press, 1938).

10. The legal deposit of books seems to have originated in France, in 1498; see Armstrong, *Before Copyright*.

11. Today, the *Legal Deposit Libraries Act 2003* makes it an obligation to deposit printed publications in six nominated 'legal deposit libraries'.

12. 'An Act for the Encouragement of the Arts of designing and printing Linens, Cottons, Calicoes and Muslins, by vesting the Properties thereof in the Designers, Printers and Proprietors, for a Limited Time.' 27 Geo. III c. 38, (1787 Calico Printers' Act); see *Primary Sources on Copyright (1450–1900)*, ed. Lionel Bently and Martin Kretschmer, www.copyrighthistory.org.

13. See Mildred Davison, 'Printed Cotton Textiles,' *The Art Institute of Chicago Quarterly* 52, no. 4 (1958): 83.

14. 27 Geo. III c. 38, I.

15. 'An Act for Extending the Copyright of Designs for Calico Printers to Designs.' 2 Vict. C. 13.

16. 'An Act to Secure to Proprietors of Designs for Articles of Manufacture the Copyright for such Designs for a limited time.' 2 Vict. C. 17.

17. 2 Vict. C. 13, III.

18. 2 Vict. C. 17, I.

19. 2 Vict. C. 17, VI.

20. Brad Sherman and Lionel Bently, *The Making of Modern Intellectual Property Law: The British Experience 1760–1911* (Cambridge: Cambridge University Press, 1999), 72.

21. Arguably, the patent specification is an antecedent of representative registration.

22. 2 Vict. C. 17, IV.

23. Michel Foucault, *Les mots et les choses: Une archéologie des sciences humaines* (Paris: Gallimard, 1966).

24. See Stina Teilmann, 'On Real Nightingales and Mechanical Reproductions', in *Copyright and Other Fairy Tales: Hans Christian Andersen and the Commercialisation of Creativity*, ed. Helle Porsdam (London: Edward Elgar Publishing, 2006), 23–39.

25. *Copyright, Designs and Patents Act 1988*, s. 52. The term 'design', as defined by the *Copyright, Designs and Patents Act 1988*, s. 51 denotes 'any aspect of the shape or configuration (whether internal or external) of the whole or part of an article, other than surface decoration.' '*Industrial design*' refers to designs which are either 'one of more than fifty articles' or which 'consists of goods manufactured in lengths or pieces, not being hand-made goods.' *The Copyright (Industrial Process and Excluded Articles)(No. 2) Order 1989*, s. 2.

26. *Consolidated Act on Copyright 2006*, s. 1.

27. *Designers Guild Ltd.* v. *Russell Williams (Textiles) Ltd* (1998) FSR 803 (Ch. D); (2000) FSR 121 (CA); (2001) 1 All ER, 700; (2000) 1 WLR 2416 (HL). For case commentary see e.g. Simon Stokes, *Art & Copyright* (Oxford: Hart Publishing, 2001); and Leslie Kim Trieger Bar-Am, 'Authors' Rights as a Limit to Copyright Control', in *New Directions in Copyright Law*, ed. Fiona Macmillan, vol. 6 (Cheltenham: Edward Elgar, 2007).

28. *Designers Guild Ltd.* v. *Russell Williams (Textiles) Ltd* (1998) FSR 803 (Ch. D), 813.

29. *Designers Guild Ltd.* v. *Russell Williams (Textiles) Ltd* (2000) FSR 121, paragraph 32.

30. Ibid., 33.

31. Ibid., 34.

32. Ibid., 35.

33. *Designers Guild Ltd.* v. *Russell Williams (Textiles) Ltd* (2001) 1 All ER, 5.

34. U.2002.1715/2H.

35. U.2001.747H.

36. See Stina Teilmann, ' "Much More than a highchair:™" A Cultural-Legal Case Study of the Tripp-Trapp Chair,' in *FLUX—Research at the Danish Design School*, ed. Anne Louise Sommer, Maria Mackinney-Valentin, Marie Brobeck, Nina Lynge and Thomas Binder (Copenhagen: Danish Design School Press, 2009), 142–9.

37. So I am kindly informed by the lawyer who was, on that occasion, acting on behalf of the authorised producer of the Ant chair, Erling Borcher of Kromann Reumert, e-mail of 4 Jan. 2010.

38. U.2002.1715/2H, 1726.

39. U.2002.1715/2H, 1728.

40. U.2002.1715/2H, 1719.

16 TEXT-LED AND OBJECT-LED RESEARCH PARADIGMS: DOING WITHOUT WORDS

MICHAEL BIGGS AND DANIELA BÜCHLER

This chapter is based on preliminary outcomes of a three-year project aimed at investigating non-traditional knowledge and communication (NtKC) at the University of Hertfordshire, 2008–2011.[1] The project considered research in the creative industries,[2] especially in the area known as practice-led or practice-based research. The research proposal followed from ongoing debates about the variable quality and consistency of research funding applications, outcomes and education in the United Kingdom. We believed that these debates indicated a lack of fundamental research in the area that the NtKC project addressed. At the time of writing this chapter, we had already completed the first year and were in the second year of the investigation.

As a result of Year 1, we began to describe the project as primarily diagnostic, in which we considered the 'dissatisfaction' that arises when practitioners from the creative industries join the academy and produce academic research.[3] We heard the academic community at large—understood as researchers in any academic area and discipline—express the dissatisfaction that what creative practitioners produce is not academic research. We also heard the dissatisfaction of the creative-practitioner community that their values are not embodied in the academic research models that are available to them and, as a result, when they use these models to produce academic research, the outcomes are not relevant to their practice or to their community. We therefore identified a disjunction between the requirements and standards of the academy and those of creative practice. This disjunction arises from each community's different understanding of the nature of knowledge and communication in research that contains elements of creative practice. It involves the epistemology of traditional academic research in general, the concerns of the creative practice community, specific aspects connected to the notions of knowledge of that community, and the potential for communication through nontraditional means. In the NtKC project, we worked from within a framework that analyses the worldviews of communities and embodiment of those worldviews in the research paradigms that these communities use.

In this chapter we claim that the worlds of object production and of textual commentary are distinct. We separate one world, in which persons are trained to produce objects for visual and aesthetic consumption, from the other. In the visual world, visual judgments are made about visual objects, and success involves these objects being recognized, and their images recorded, to form the canon of design. In the conceptual world, text-makers

are trained in the use of words and traditionally write post-production commentary and criticism about these objects. The value of these texts does not lie in their descriptive but rather in their analytical qualities. Objects *per se* may not have analytical qualities. We therefore identify two different worldviews: the practice-led, and the academic or text-led, each with equally valid but different values.

The long history of using, and justifiably valuing, textual criticism may lead us to overlook the fact that it cannot be substituted for its subject. In everyday use, it may be apparent that an architectural text cannot substitute for the building itself, but in our appreciation of the object these two may become confused. However, we have good reason to be sceptical of the closeness of the relationship between object and word. Modern linguistics differentiates both between the spoken and the written,[4] and between thought and language.[5] In this academically sceptical context, we should reconsider the impact of the word on our view of the world.

We describe the visual and the textual as having different roles in different worldviews—each worldview has its own value and belief sets. The relationship between a worldview and the role of the visual and the textual can be coherent or incoherent. Within the same paradigm there is coherence. However, across paradigms, the relationship is between different but, perhaps, equally rigorous, research models. Within a research model, the visual may hold a role that seeks equivalence to the textual, where visual material is viewed according to textual values. However, the visual may alternatively seek coherence with the values of the community within which it is meaningful and significant. The problem we identify here is the dissatisfaction that arises when one set of criteria is applied in another research paradigm. Concepts such as 'unambiguous', 'correct', 'appropriate', and so on, belong to distinct frames of reference and judgment that are specific to each worldview. Furthermore, we claim that in the distinct frameworks of text and image, certain concepts have been transferred uncritically from one to the other, without recognition that the change of context changes their meaning or renders them meaningless.

Within this theoretical construct, we can discuss the possibility of a distinct object-led research paradigm. In this chapter we discuss this in terms of the 'traditional—non-traditional divide', 'sites of resistance', the attempts at overcoming those obstacles through the use of 'strategies' and the notion of an 'alternative object-led research paradigm' that would do away with these problems.

By 'traditional' we mean research that conforms to the academic expectation of outcomes in the form of published papers and the like, and is therefore text-led. By 'nontraditional' we mean not only research with outcomes that are non-textual, for example designed objects, but more particularly research in which the non-textuality of the process impacts on the way the research is undertaken and the corresponding concepts of knowledge and knowledge production. By 'sites of resistance' we mean those locations in which the beliefs and actions of one community confront and potentially impact on the beliefs of another community. However, at these sites, there is also the opportunity for traditional research to be modified in the light of emerging non-traditional activity within these other areas of

research. Therefore, it is not only a matter of what text-led approaches can contribute in order to structure creative practice but also of how object-led production and processes can contribute to academic knowledge. By 'strategies', we refer to particular approaches that we have identified within non-traditional research communities for overcoming this resistance. We claim that the existence of strategies is a symptom of the dissatisfaction of one research community with the methods and outputs of the other. And by 'alternative object-led research paradigm', we refer to a rigorous and scholarly research model that embodies the values and interests of the practitioner-researcher community.

In Britain, the profile of those using design historical approaches is changing. It now includes not only researchers who have been trained as academics but also researchers who have been trained as creative practitioners. This latter group comprises the newly emergent practitioner-researchers who often employ so-called practice-based methods in research. Therefore, although both design historians and practitioner-researchers may use design historical research methods, the reasons for adopting them vary. Owing to the pressures of academicization, practitioners often adopt methods and approaches from traditional, that is text-led, academic disciplines such as design history. There is therefore a distinction between those who adopt design historical methods because they are coherent with their worldview (in other words, design historians), and those who adopt these methods as a strategy in order to produce research that appears to be, or is regarded as, academic (namely, practitioner-researchers). We see this as epitomized in the potentially incoherent use of text-led approaches for object-led studies by practitioner-researchers. However, we see an opportunity for such transdisciplinary approaches to be productive; that is, for object-led methods, once clarified, to be of use in text-led studies, and *vice versa*. In this chapter, we are therefore identifying a crossover between production and criticism that is potentially significant to both parties, and we make the significance explicit by describing these two communities within the same theoretical framework.

The theoretical framework that we use establishes a relationship between one's worldview and the research paradigm that one adopts. A worldview is basically a set of beliefs that one holds about the nature of the world and one's place in it, which determines the activities one would undertake as a researcher. If we think, for example, of the stereotypical model from classical physics, we find that the classical physicist believes in an external world, and that facts can be discovered about that external world. As a consequence of being external, it is independent of the emotional responses and interests of the researcher. It is an objective world and one can say objective things about it; one can find evidence for it, and anyone else can find this combination of evidence and objective statements. As a result, they will conclude broadly the same things about the nature of the world. In this worldview, the more repeatable the outcomes, the more the statements and claims are held to correspond to what is actually out there. Such a worldview invites a research paradigm in which certain activities are relevant, for example reaching for evidence and setting up repeatable experiments (Fig. 16.1).

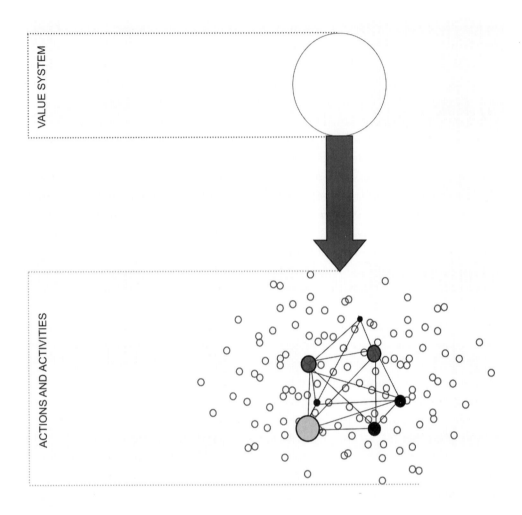

Fig. 16.1 Values and beliefs determine what is meaningful and significant. Image: Michael Biggs and Daniela Büchler.

Figure 16.1 shows a set of actions and activities that are performed in pursuit of research by a community, based on their value system and belief set. Out of the plethora of actions performed by a community, some are relevant towards the construction of a meaningful research activity, while others are not. The meaningful actions form a network and become conventionalized as defining the academic research activity in that discipline. Therefore, not every action that a physicist performs in a laboratory would constitute an element of the academic research activity in that discipline. This is because research actions have to be justified within a network of concepts towards argument-building, including the relationship between a question and an answer and the method that is adopted.[6] Consequently, out of all the actions that are relevant to a community, only a few select ones are net-

worked in a particular way that defines them as the valid academic research activity for that community.

But, of course, the classical physics worldview is not the only one. If we consider instead the worldview of literary theory, we find that literary theorists do not approach the world in this way. They do not believe that there are objective answers to questions such as, for example, the final interpretation of a text. Their worldview is much more engaged with the reading of the individual person and therefore with the subjective experience of the reader in constructing the text. The individual's interpretation is at least as meaningful as anything that one might claim the author put into the text. In the literary worldview there is no such thing as objective content, in the sense of reader-independent content, to be searched for. The option that the world may be regarded as a construction of the individual, contributes to Nelson Goodman's concept of 'world-making'.[7] Goodman regards worldviews as a representational problem whereas Egon Guba and Yvonna Lincoln refer to the relationship of the researcher to the world.[8] In the latter, each worldview is differentiated because the communities have different responses to the implied ontological, epistemological and methodological questions.

In our view, there are as many research paradigms as there are community-specific responses to these questions, although they can be clustered into '-isms' such as 'Constructivism' and 'Positivism'. These responses form networks within which one can evaluate whether research actions are appropriate. This is because research actions need to be coherent with the worldview in order to be perceived as appropriate and lead to meaningful outcomes. Our use of the term 'paradigm' differs from Thomas Kuhn's earlier use.[9] For Kuhn, a paradigm is a large-scale set of dependent concepts that determines a view of the world across a wide range of subjects. It forms a way of thinking that pervades enquiry in all fields until it is replaced by a new paradigm. For Kuhn, paradigm shifts occur when the existing way of thinking becomes stretched to breaking point whereas, for us, paradigms do not shift. We claim that a paradigm is a way of addressing the world according to a worldview. In this sense, it is possible to have a variety of research paradigms in place at the same time (as represented in Fig. 16.2).

The worldview-research model relationship enables us to differentiate communities, their values and consequent production. If we take the example of text-led and object-led as two different modes of knowledge production and communication, we see that each holds different meaning and significance for the practice and the academic communities. An example of community identity and the independence of the value systems of academia and design practice could be seen when the NtKC project hosted a postdoctoral researcher who came from a project that was concerned with digitizing a large archive of architectural drawings—mostly sketches rather than drawings for technical production. In our theoretical construct, we inferred that these objects were valued and that the postdoctoral researcher represented the community that valued them. Therefore, we heard in the researcher's interest to pursue this as a postdoctoral study, symptoms of a community who shared a common valorization of an object in a particular way and which bound them

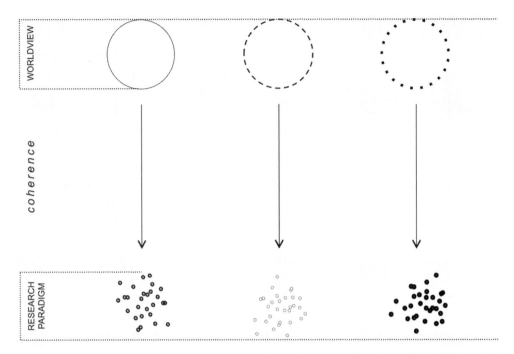

Fig. 16.2 Different research paradigms can exist alongside one another. Image: Michael Biggs and Daniela Büchler.

together as a community. This was further reinforced by the actions of the researcher's university to fund such a study.

We would describe the postdoctoral researcher's project as looking at architectural drawings as content objects, and we think her analysis of that content differed from the way our project saw it. The researcher analyzed the situation as one in which there was a division between traditional and non-traditional. Traditionally, she claimed, architectural sketches are regarded as organizational tools and also formal devices in the search for what are called 'best-fit solutions', thereby representing a means of testing out ideas and finding solutions. The non-traditional way of describing architectural sketches, in which the postdoctoral researcher was actually more interested, is that there is a particular role for sketches in developing the architect's skill and identity as an architect, and of gaining a certain kind of understanding through the act of drawing. In this description, the drawings are a trace, a record of an activity that is conceptual and physical. Architectural sketching is therefore a skill developed through time, and people can be experienced and inexperienced in this activity.

The outcomes of this activity assume meaning within a particular community which shares a set of values and describes its actions in particular ways. This overlaps with the interests of the project: we identify communities of people who share certain views, are satisfied by certain kinds of product and certain kinds of action, and who find that these are meaningful and produce significant results. Outside of that community, or across com-

munities, these products and actions are found to be less resonant, less meaningful, less significant, and less satisfying. Within the architectural community, certain highly schematized drawings, with very little claim to represent a three-dimensional object, can nonetheless be valued and esteemed. This raised the postdoctoral researcher's question about why they are valued, to which our response was that: one demonstrates one's membership of the community by valuing these drawings.

When academicization pushes practitioners into the academic arena, a 'practitioner-researcher' community emerges. The practitioner-researcher archetype describes the creative practitioner who seeks to produce research that is regarded as academic without, however, abandoning their practitioner community values. Typically, the practitioner-researcher community finds itself performing the activities that are significant to them, but in an academic context which holds different values. Although certain activities are similar and can be homogenized, others represent fundamental differences that emerge as sites of resistance. This creates a situation in which what is fundamental to one community can be perceived as an obstacle for another.[10] Each community perceives in the other's activity a site of resistance that they must somehow pass and, to that end, certain strategies are employed as mechanisms to get past those obstacles. In this context, practitioner-researchers adopt strategies in order to produce research that is regarded as being academic. In addition to adopting these strategies, we claim that there is also the possibility of the design practice worldview possessing its own unique and coherent research model, that is an alternative object-led research paradigm.

In Figure 16.3 we have represented groups of practitioner-researchers according to how they approach the production of academic research. The creative practice and academic research communities can be perceived as two distinct communities, and this distinction can be perceived as possible or impossible, desirable or undesirable, to bridge. Figure 16.3 shows two positions on what academic research in areas of creative practice would be, and also three strategies for producing this kind of research depending on how one understands the situation.

In Position 1, we find those practitioner-researchers who hold that, although there are two distinct communities, the practitioner only inhabits the creative practice community and produces both practice and research in terms of that set of community values. In this case, the bridging of one community to another is unnecessary for the production of academic research with practice, embodied in the concept of 'practice-as-research'.

When the communities are seen as distinct, and bridging them is seen as possible and desirable for some reason, it is necessary for the practitioner-researcher to adopt a strategy in order to include creative practice in academic research. These strategies are adopted/created as a response to the assumption that there are two distinct communities, and that therefore when conducting research in areas of creative practice, strategies are necessary to ensure that the values and requirements of both communities are accommodated. In Figure 16.3, the circles represent the fact that the values and consequent actions and activities that are developed by that community are seen as something that should be upheld and

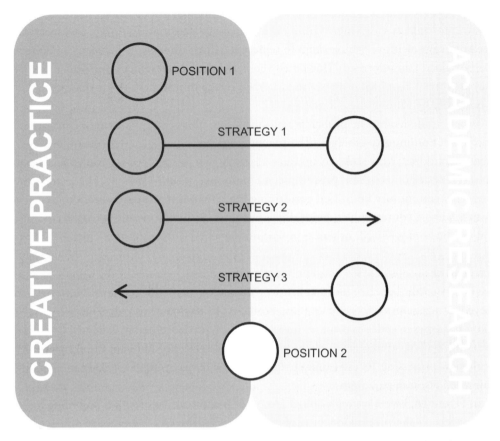

Fig. 16.3 Two positions and three strategies for the production of academic research with creative practice. Image: Michael Biggs and Daniela Büchler.

preserved. When the values and practices of a community are taken to another community, represented by the arrow, it is because the researcher wishes to transform the other community by changing in some way their values or actions. In the three strategies there is an attempt to bridge communities.

Strategy 1 describes practitioner-researchers who attempts to optimize their dual production, that is creative practice in the design studio and research in the academic context. When in the studio, these practitioner-researchers hold practitioner values and do not respond to any requirement to talk about their work or report on it in a structured academic way. Then when they are producing their PhDs or their academic research, they have their academic hats on and take on the academic values that are linked, for example, to the text as medium. Strategy 1, therefore, denotes the situation when practitioner-researchers take on the values of the community within which they are producing their work.

In Strategy 2, practitioner-researchers hold their own practitioner values and, when producing research, they attempt to transform certain models that are accepted in the

academic community. For the classical physicist, reporting on one's work in the laboratory is an accepted research method. These researchers conduct an experiment and then report on it, explaining their process point by point, and justifying it in terms of their theory and hypotheses. The studio practitioners who use a method such as reflective practice are essentially doing the same thing by reporting on their own process.[11] In this sense, the reflective practice method would represent a creative practice increment on a traditional research method. In Strategy 2, practitioner-researchers try to reflect on their own practice without, however, abandoning the value that their practice is that which is primarily significant, relevant and meaningful, and as such the models from academic research should be adapted in order to better serve and thereby reinforce those primary values.

In Strategy 3, practitioner-researchers try to academicize their own practice. Rather than transform the models that can be found in academic research, they adopt the whole research paradigm because they value the current critical framework that comes with the chosen academic area, in the hope that it transforms their practice. In Strategy 3, practitioner-researchers try to incorporate their own practice but never abandon the value that established academic models are primarily significant, relevant and meaningful, and as such the design practices should be transformed, benefiting from the contact with those primary values.

In Position 2, we find practitioner-researchers of a different genealogy; rather than being a native of the practice community that attempts to incorporate academic values, these practitioner-researchers are second-generation offspring of the two communities. Position 2 is an example of the view that there are not two distinct communities but a single set of values that encompasses both practice and research—that is, a single community of practitioner-researchers who, therefore, do not need to adopt strategies. For them, there is no discernable distinction between the production of practice and the production of academic research, not because these are one and the same, as Position 1 would hold, but because they inhabit an alternative paradigm which holds a single set of values. It is in Position 2 that we think there is scope for an alternative object-led research paradigm.

Position 2 reveals that academic research in areas of creative practice need not be problematic, as the existence of the strategies might indicate. Rather than seeing this as a problematic area that needs to be incorporated into established research paradigms through the use of strategies, we see it as a potential new worldview, albeit one which is yet to be formalized as a research paradigm. This alternative object-led research paradigm arises authentically from the values of the community by mobilizing meaningful activities from the outset. By 'authentic' we mean that the actions are recognized as meaningful by that community, that they address research questions that are topical and result in outcomes that have a significant impact on those problems for that community. This object-led research paradigm emerges from a coherent relationship with the worldview of the practice community and, as such, is authentic to the extent that it is faithful to the values of that community.

Given this landscape, we can conclude by identifying a fundamental dissatisfaction with the disjunction between worldview and research paradigm in the academicized areas of

creative practice. This dissatisfaction is not resolved by merely adopting compensatory bridging strategies. Instead, this dissatisfaction may indicate the existence of an alternative object-led research paradigm that is yet to be configured by the practice community and accepted by the wider traditional academic community. Indeed, there is still considerable debate about the potential for research in areas of creative practice, sometimes known as practice-based research. Our chapter does not resolve these debates but describes where the solution should be sought. It describes a framework in which the coherence between worldview and research action results in satisfaction, whereas the production arising within a cross-paradigmatic research model results in dissatisfaction. Satisfaction can only come from finding the common values of a newly emergent practitioner-researcher worldview, and we claim this has yet to happen because the parent communities still act independently. We have been critical of the compensatory bridging strategies that we observed being deployed in so-called practice-based research areas. These do not really address the fundamentally different worldviews occupied by traditional text-led worldviews and non-traditional object-led worldviews. Our recommendation is therefore that the value-actions that are authentically linked to these worldviews need to be identified in order to establish what they have in common and, therefore, what object-led research methods could contribute to traditional academic research, and *vice versa.*

ACKNOWLEDGEMENT

The authors gratefully acknowledge the support of the Arts and Humanities Research Council, United Kingdom.

NOTES

1. See http://r2p.herts.ac.uk/ntkc/.
2. John Hartley, ed., *Creative Industries* (Oxford: Blackwell Publishing, 2005).
3. Michael Biggs and Daniela Büchler, 'Communities, Values, Conventions and Actions,' in *The Routledge Companion to Research in the Arts*, ed. Michael Biggs and Henrik Karlsson (London: Routledge, 2011), 82–98.
4. Ferdinand de Saussure, *Course in General Linguistics* (La Salle, IL: Open Court, 1983 [1916]).
5. Benjamin Lee Whorf, *Language, Thought and Reality: Selected Writings of Benjamin Lee Whorf* (Chicago: MIT Press, 1956).
6. Michael Biggs and Daniela Büchler, 'Eight Criteria for Practice-based Research in the Creative and Cultural Industries,' *Art, Design and Communication in Higher Education* 7, no. 1 (2008): 5–18.
7. Nelson Goodman, *Ways of Worldmaking* (Indianapolis: Hackett Publishing, 1978).
8. Egon G. Guba and Yvonna S. Lincoln, 'Paradigmatic Controversies, Contradictions and Emerging Confluences,' in *Sage Handbook of Qualitative Research*, ed. Norman K. Denzin and Yvonna S. Lincoln (London: Sage, 2005), 191–215.

9. Thomas Kuhn, *The Structure of Scientific Revolutions* (Chicago: University of Chicago Press, 1970 [1962]).

10. Michael Biggs and Daniela Büchler, 'Transdisciplinarity and New Paradigm Research,' in *Transdisciplinary Knowledge Production in Architecture and Urbanism: Towards Hybrid Modes of Inquiry*, ed. Isabelle Doucet and Nel Janssens (Amsterdam: Springer Verlag, 2011), 63–78.

11. Donald A. Schön, *The Reflective Practitioner: How Professionals Think in Action* (London: Arena, 1991).

SELECT BIBLIOGRAPHY

Achilli, Franco. *Manifesto. Trentanove poster di A G Fronzoni*. Milan: Aiap, 1992.

Adamson, Glenn, ed. *The Craft Reader*. Oxford: Berg, 2010.

Aichner, Christian, and Kuchenbeiser, Bernd. *A G Fronzoni*. Baden: Lars Müller Verlag, 1997.

Allan, Kathryn. *Metaphor and Metonymy: A Diachronic Approach*. Chichester: Wiley-Blackwell, 2008.

Amphoux, Pascal. 'Pléonasme: l'architecture naturellement s'expose.' *Faces* 53 (2003–4): 18–22.

Andel, Jaroslav. *Avant-Garde Page Design 1900–1950*. New York: Delano Greenidge Editions, 2002.

André, Jacques, and Girou, Denis. 'Father Truchet, the typographic point, the Romain du roi, and tilings.' *TUGboat* 20, no. 1 (1999): 8–14. http://www.tug.org/TUGboat/Articles/tb20-1/tb62andr.pdf.

Antonelli, Paola, ed. *Design and the Elastic Mind*. New York: Museum of Modern Art, 2008.

Argan, Guilio Carlo. *Progetto e oggetto: scritti sul design*. Milan: Medusa, 2003.

Armstrong, Elizabeth. *Before Copyright: The French Book-Privilege System 1498–1526*. Cambridge: Cambridge University Press, 1990.

Arnold, Ken, and Olsen, Danielle. *Medicine Man: the Forgotten Museum of Henry Wellcome*. London: British Museum Press, 2003.

Aynsley, Jeremy, and Berry, Francesca. 'Introduction: Publishing the Modern Home—Magazines and the Domestic Interior 1870–1965.' *Journal of Design History* 18, no. 1 (2005): 1–5.

Bachfischer, Gerhard, and Robertson, Toni. 'From Movable Type to Moving Type—Evolution in Technological Mediated Typography.' AUC Academic and Developers Conference, Hobart, Tasmania, Australia, September 2005. Accessed 23 February 2011. http://auc.uow.edu.au/conf/conf05/pdf/AUC_Conf_2005_Proceedings.pdf.

Bacon, Francis. *The Advancement of Learning*, edited by G. W. Kitchin. London: Dent, 1973 (1605).

Baker, Nicholson. *The Mezzanine*. New York: Vintage, 1990 (1988).

Bal, Mieke, and Gonzales, Bryan, eds. *The Practice of Cultural Analysis: Exposing Interdisciplinary Interpretation*. Palo Alto, CA: Stanford University Press, 1999.

Banham, Reyner. *Theory and Design in the First Machine Age*. London: Architectural Press, 1960.

Barthes, Roland. *The Fashion System*, translated by Matthew Ward and Richard Howard. Berkeley and Los Angeles: University of California Press, 1983.

Barthes, Roland. *Image Music Text*, translated by Stephen Heath. London: Fontana, 1977.

Barthes, Roland. *Mythologies*, translated by Annette Lavers. London: Jonathan Cape, 1972.

Barthes, Roland. *The Pleasure of the Text*, translated by Richard Miller. London: Cape, 1976.

Barthes, Roland. *S/Z*, translated by Richard Miller. New York: Hill and Wang, 1974.

Bently, Lionel, and Kretschmer, Martin, eds. *Primary Sources on Copyright (1450–1900)* [website]. Accessed 23 February 2011. http://www.copyrighthistory.org.

Biggs, Michael, and Büchler, Daniela. 'Communities, Values, Conventions and Actions.' In *The Routledge Companion to Research in the Arts*, edited by Michael Biggs and Henrik Karlsson, 82–98. London: Routledge, 2010.

Biggs, Michael, and Büchler, Daniela. 'Eight Criteria for Practice-based Research in the Creative and Cultural Industries.' *Art, Design and Communication in Higher Education* 7, no. 1 (2008): 5–18.

Biggs, Michael, and Büchler, Daniela. 'Transdisciplinarity and New Paradigm Research.' In *Transdisciplinary Knowledge Production in Architecture and Urbanism: Towards Hybrid Modes of Inquiry*, edited by Isabelle Doucet and Nel Janssens, 63–78. Amsterdam: Springer Verlag, 2011.

Bird, Jon, Curtis, Barry, Mash, Melinda, Putnam, Tim, Robertson, George, Stafford, Sally, and Tickner, Lisa, eds. *The BLOCK Reader in Visual Culture*. London: Routledge, 1996.

Blauvelt, Andrew. *Strangely Familiar: Design and Everyday Life*. Minneapolis: Walker Art Center, 2003.

Bourke, Joanna. *Dismembering the Male: Men's Bodies, Britain and the Great War*. London: Reaktion, 1996.

Braeken, Jo, ed. *Renaat Braem 1919–2001 Architect 2*. Brussels: ASA Publishers/Vlaams Instituut voor het Onroerend Erfgoed, 2010.

Brown, Bill, ed. *Things*. London: University of Chicago Press, 2004.

Buchanan, Richard. 'Declaration by Design: Rhetoric, Argument, and Demonstration in Design Practice.' *Design Issues* 2, no. 1 (Spring 1985): 4–22.

Burman, Barbara. 'Better and Brighter Clothes: The Men's Dress Reform Party, 1929–1940.' *Journal of Design History* 8, no. 4 (1995): 275–90.

Caballero, Rodriguez, *Re-Viewing Space: Figurative Language in Architects' Assessment of Built Space*. Berlin: Mouton de Gruyter, 2006.

Candlin, Fiona, and Guins, Raiford, eds. *The Object Reader*. London: Routledge, 2009.

Carter, Simon. *Rise and Shine: Sunlight, Technology, and Health*. Oxford: Berg, 2007.

Caruso, Adam. *The Feeling of Things*. Barcelona: Ediciones Poligrafa, 2008.

Cellini, Francesco, and D'Amato, Claudio. 'The Construction of the Strada Novissima.' *Controspazio* 1–6 (1980): 10–11.

Chappell, Warren, and Bringhurst, Robert. *A Short History of the Printed Word*. 2nd ed. New York: Hartley and Marks, 1999.

Cheung, Victor. *(Art)ifact: re-recognizing the essential of products*. Hong Kong: Viction:ary, 2007.

Chickering, Roger, and Förster, Stig, eds. *Great War, Total War: Combat and Mobilization on the Western Front, 1914–1918*. Cambridge: Cambridge University Press, 2000.

Clark, Hazel, and Brody, David, eds. *Design Studies: A Reader*. Oxford: Berg, 2009.

Clifford, James, and Marcus, George, eds. *Writing Culture: the Poetics and Politics of Ethnography*. Berkeley: University of California Press, 1986.

Cogdell, Christina. 'Design and the Elastic Mind, Museum of Modern Art (Spring 2008).' *Design Issues* 25 (Summer 2009): 92–101.

Cohen, Jean-Louis. 'Exhibitionist Revisionism: Exposing Architectural History.' *Journal of the Society of Architectural Historians* 58 (1999): 316–25.

Coles, Alex. *Design and Art*. London: Whitechapel Gallery/MIT Press, 2007.

Colomina, Beatriz, and Buckley, Craig, eds. *Clip, Stamp, Fold: The Radical Architecture of Little Magazines, 196X to 197X*. Barcelona and New York: Actar, 2010.

Corey, Mary F. *The World through a Monacle: The* New Yorker *at Midcentury*. Cambridge, MA: Harvard University Press, 1999.

Côrte-Real, Eduardo. 'The Word "Design": Early Modern English Dictionaries and Literature on Design, 1604–1837.' In 'Writing Design: Words, Myths, Practices,' edited by Grace Lees-Maffei. *Working Papers on Design* 4 (Dec. 2010). http://sitem.herts.ac.uk/artdes_research/papers/wpde sign/wpdvol4/vol4.html.

De Kooning, Mil, Strauven, Iwan, and Floré, Fredie. 'Le design mobilier en Belgique: 1945–1958.' In *Art Nouveau & Design. Les arts décoratifs de 1830 à l'Expo 58*, edited by C. Leblanc, 174–91. Brussels: Editions Racine, 2005.

De Kruif, Paul. *Men Against Death*. New York: Harcourt, Brace and Company, 1933.

de Oliveira, Nicolas, and Oxley, Nicola. *Installation Art in the New Millennium: The Empire of the Senses*. London: Thames and Hudson, 2003.

de Saussure, Ferdinand. *Course in General Linguistics*, edited by Charles Bally and Albert Sechehaye. Translated by Roy Harris. La Salle, IL: Open Court, 1983.

Derrida, Jacques. *Of Grammatology*. Baltimore: Johns Hopkins University, 1974.

Dewalt, Kathleen M., and Dewalt, Billie R. *Participant Observation: A Guide for Fieldworkers*. Lanham, MD: AltaMira Press, 2002.

Drury, Maurice O'Connor. *The Danger of Words*. London: Routledge, 1973.

Dunaway, David K., and Baum, Willa K. *Oral History: An Interdisciplinary Anthology*. Lanham, MD: AltaMira Press, 1996.

Dunne, Anthony. *Hertzian Tales: Electronic Products, Aesthetic Experience and Critical Design*. London: RCA CRD Research Publications, 1999.

Dyer, Gillian. *Advertising as Communication*. London: Methuen, 1982.

Elno, K.-N., *De vorm der dingen. Beschouwingen over industriële en ambachtelijke vormgeving*. *Vlaamse pockets* 156. Hasselt: Uitgeverij Heideland, 1965.

Elno, K.-N., *Ruimte en beelding. Beschouwingen over architektuur, plastische kunsten, fotografie en typografie*. *Vlaamse pockets* 157. Hasselt: Uitgeverij Heideland, 1965.

Emmons, Paul. 'Diagrammatic Practices: The Office of Frederick L. Ackerman and *Architectural Graphic Standards*.' *Journal of the Society of Architectural Historians,* 64 (2005): 4–21.

'Employee Facilities.' *Progressive Architecture* 33 (October 1952): 123–9.

Evelyn, John. *The Diary of John Evelyn,* edited by Esmond S. de Beer. 6 vols. Oxford: Clarendon Press, 1955.

Fallan, Kjetil. 'Architecture in Action: Traveling with Actor-Network Theory in the Land of Architectural Research.' *Architectural Theory Review* 13, no. 1 (2008): 80–96.

Fallan, Kjetil. 'Heresy and Heroics: The Debate on the Alleged "Crisis" in Italian Design around 1960.' *Modern Italy* 14, no. 3 (2009), 257–74.

Fallan, Kjetil. *Design History: Understanding Theory and Method*. Oxford: Berg, 2010.

Ferguson, Eugene S. 'Technical Journals and the History of Technology.' In *In Context: History and the History of Technology,* edited by Stephen H. Cutcliffe and Robert C. Post, 53–70. Bethlehem, PA: Lehigh University Press, 1989.

Ferguson, Eugene S. *Engineering and the Mind's Eye*. Cambridge, MA: MIT Press, 1992.

Floré, Fredie. 'Sociaal Modernism: De Designkritiek van K.N. Elno (1920–1993).' *De Witte Raaf* 89 (January–February 2001): 6–8.

Floré, Fredie. 'Karel Elno.' Master's thesis, Ghent University, 1997.

Floré, Fredie. 'Architect-designed Interiors for a Culturally-Progressive Upper-Middle Class: The Implicit Political Presence of Knoll International in Belgium.' In *Atomic Dwelling*, edited by Robin Schuldenfrei. London: Routledge, 2012.

Forty, Adrian. 'Ways of Knowing, Ways of Showing: a Short History of Architectural Exhibitions.' In *Representing Architecture. New Discussions: Ideologies, Techniques, Curation*, edited by Penny Sparke and Deyan Sudjic, 42–61. London: Design Museum, 2008.

Forty, Adrian. *Objects of Desire: Design & Society from Wedgwood to IBM*. New York: Pantheon, 1986.

Forty, Adrian. *Words and Buildings: a Vocabulary of Modern Architecture*. London: Thames and Hudson, 2000.

Foucault, Michel. *Discipline and Punish: The Birth of the Prison*. London: Penguin, 1977.

Frank, Isabelle, ed. *The Theory of Decorative Art: an Anthology of European and American Writings, 1750–1940*. New York: Bard Graduate Center for Studies in the Decorative Arts and New Haven, CT: Yale University Press, 2000.

Fry, Tony. *Design History Australia*. Sydney: Hale and Iremonger and the Power Institute of Fine Arts, 1988.

Fujita, Haruhiko, ed. *Words for Design: Comparative Etymology and Terminology of Design and Its Equivalents*. 3 vols. Osaka: Japan Society for the Promotion of Science, 2007–09.

Giedion, Siegfried. *Mechanization Takes Command: A Contribution to Anonymous History*. Oxford: Oxford University Press, 1948.

Godfrey, Jason. *Bibliographic: 100 Classic Graphic Design Books*. London: Laurence King, 2009.

Goodman, Nelson. *Ways of Worldmaking*. Indianapolis, IN: Hackett Publishing, 1978.

Gramsci, Antonio. *Selections from Cultural Writings*, edited by David Forgacs and Geoffrey Nowell-Smith; translated by William Boelhower. Cambridge, MA: Harvard University, 1985.

Greenhalgh, Paul, ed. *Quotations and Sources on Design and the Decorative Arts*. Manchester: Manchester University Press, 1993.

Gropius, Walter, and Moholy-Nagy, László. *Staatliches Bauhaus Weimar 1919–1923*. Berlin: Kraus Reprint, 1980.

Guba, Egon G., and Lincoln, Yvonna S. 'Paradigmatic Controversies, Contradictions and Emerging Confluences.' In *Sage Handbook of Qualitative Research*, edited by Norman K. Denzin and Yvonna S. Lincoln, 191–215. London, Sage, 2005.

Hartley, John, ed. *Creative Industries*. Oxford: Wiley-Blackwell, 2005.

Highmore, Ben, ed. *The Design Culture Reader*. London: Routledge, 2009.

Hill, Leonard. *Sunshine and Open Air: Their Influence on Health, with Special Reference to the Alpine Climate*. London: E. Arnold, 1924.

Hillner, Matthias. 'Text in (e)motion.' *Visual Communication* 4, no. 2 (2005): 165–71.

Hostetler, Soo C. 'Integrating Typography and Motion in Visual Communication.' Paper presented at the 2006 iDMAa and IMS conference, Miami, 2006. Accessed 23 February 2011. http://www.units.muohio.edu/codeconference/papers/papers/Soo%20Hostetler-2006%20iDMAa%20Full%20Paper.pdf.

Howell, Martha C., and Prevenier, Walter. *From Reliable Sources: An Introduction to Historical Methods*. Ithaca, NY: Cornell University Press, 2001.

Hunt, Lynn, ed. *The New Cultural History*. Berkeley and Los Angeles: University of California Press, 1989.

Huygen, Frederike. *Visies op vormgeving. Het Nederlandse ontwerpen in teksten. Deel 2: 1944–2000.* Amsterdam: Architectura and Natura Pers/Premsela, Dutch Platform for Design and Fashion, 2008.

James, Emily Alana, Milenkiewicz, Margaret T., and Bucknam, Alan. *Participatory Action Research for Educational Leadership: Using Data-Driven Decision Making to Improve Schools.* Los Angeles: Sage, 2008.

Janser, Andres, and Rüegg, Arther. *Hans Richter: New Living: Architecture, Film, Space.* Baden, Switzerland: Lars Müller, 2001.

Jencks, Charles, ed. *The Presence of the Past: First International Exhibition of Architecture—Venice Biennale 1980.* London: Academy Editions, 1980.

Johnson, Philip. *Machine Art.* New York: Museum of Modern Art, 1934.

Jones, Owen. *The Grammar of Ornament.* London: Bernard Quaritch, 1910 (1856).

Kac, Eduardo. 'Key Concepts of Holopoetry.' In *Experimental-Visual-Concrete: Avant-Garde Poetry Since the 1960s*, edited by David Jacksin, Eric Vos, and Johanna Drucker, 247–57. Amsterdam: Rodopi, 1996.

Kaufman, Edward N. 'Architectural Representation in Victorian England.' *Journal of the Society of Architectural Historians* 46, no. 1 (1987): 30–8.

Kinross, Robin. *Modern Typography: An Essay in Critical History.* London: Hyphen Press, 2004.

Koureas, Gabriel. *Memory, Masculinity and National Identity in British Visual Culture, 1914–1930.* Aldershot: Ashgate, 2007.

Kuhn, Thomas. *The Structure of Scientific Revolutions.* Chicago: University of Chicago Press, 1970 (1962).

Kwint, Marius, Breward, Christopher, and Aynsley, Jeremy, eds. *Material Memories: Design and Evocation.* Oxford: Berg, 1999.

Lakoff, George, and Johnson, Mark. *Metaphors We Live By.* Chicago: University of Chicago Press, 1980.

Lassels, Richard. *The Voyage Of Italy, Or A Compleat Journey through Italy: In Two Parts. With the Characters of the People, and the Description of the Chief Towns, Churches, Monasteries Tombs, Libraries Pallaces, Villa's, Gardens, Pictures, Statues, and Antiquities. As Also of the Interest, Government, Riches, Force, &c. of all the Princes. With Instructions concerning Travel.* 2 vols. Paris: V. du Moutier, 1670.

Latour, Bruno. 'Why Has Critique Run out of Steam? From Matters of Fact to Matters of Concern.' *Critical Inquiry* 30, no. 2 (2004): 225–48.

Le Corbusier. *Towards a New Architecture.* New York: Payson and Clarke, 1927.

Leatherbarrow, David. *Uncommon Ground: Architecture, Technology, and Topography.* Cambridge, MA: MIT Press, 2000.

Lees-Maffei, Grace. 'From Service to Self-Service: Advice Literature as Design Discourse, 1920–1970.' *Journal of Design History* 14, no. 3 (2001): 187–206.

Lees-Maffei, Grace. 'Introduction, Studying Advice: Historiography, Methodology, Commentary, Bibliography.' *Journal of Design History* 16, no. 1 (2003): 1–14.

Lees-Maffei, Grace. 'The Production-Consumption-Mediation Paradigm.' *Journal of Design History* 22, no. 4 (2009): 351–76.

Lees-Maffei, Grace, and Houze, Rebecca, eds. *The Design History Reader.* Oxford: Berg, 2010.

Lloyd Thomas, Katie. 'Specifications: Writing Materials in Architecture and Philosophy.' *Arq: Architectural Research Quarterly* 8 (2004): 277–83.

MacLeod, Christine. *Inventing the Industrial Revolution: The English Patent System, 1660–1800*. Cambridge: Cambridge University Press, 1988

Macmillan, Fiona, ed. *New Directions in Copyright Law*. 6 vols. Cheltenham: Edward Elgar, 2005–09.

Maldonado, Tomás. 'Is Architecture a Text?' *Casabella* 560 (September 1989): 35–7, 60–1.

Maldonado, Tomás. *Es la arquitectura un texto?, y otros escritos*. Buenos Aires: Infinito, 2004.

Margolin, Victor. 'Narrative Problems of Graphic Design History.' In *The Politics of the Artificial: Essays in Design and Design Studies*, 188–201. Chicago: University of Chicago Press, 2002.

Margolin, Victor, ed. *Design Discourse: History, Theory, Criticism*. Chicago: University of Chicago Press, 1989.

Martinez, Javier Gimeno. 'The Introduction and Dissemination of the English Word "Design" in the Belgian Context.' In *Words for Design II*, edited by Haruhiko Fujita, 53–59. Osaka: Japan Society for the Promotion of Science, 2009.

Mead, Margaret. *The World Ahead: An Anthropologist Anticipates the Future*. New York and Oxford: Berghahn Books, 2005.

Medway, Peter. 'Constructing the Virtual Building: Language on a Building Site.' *Using English: From Conversation to Canon*, edited by Janet Maybin and Neil Mercer, 108–12. London: Routledge, 1996.

Meikle, Jeffrey L. 'Material Virtues: On the Ideal and the Real in Design History.' *Journal of Design History* 11, no. 3 (1998): 191–9.

Meikle, Jeffrey L. 'Preface to the Second Edition.' *Twentieth Century Limited: Industrial Design in America, 1925–1939*. 2nd ed. Philadelphia: Temple University Press, 2001.

Miller, J. Abbott. *Dimensional Typography*. New York: Princeton Architectural Press, 1996.

Miller, R. Craig, Sparke, Penny, and McDermott, Catherine. *European Design since 1985: Shaping the New Century*. London: Merrell, 2008.

Mitchell, W.J.T. *Iconology: Image, Text, Ideology*. Chicago: University of Chicago Press, 1986.

Moholy-Nagy, László. 'Contemporary Typography.' In *The Bauhaus*, edited by Hans M. Wingler, 79–81. Cambridge, MA: MIT Press, 1969.

Monroe, Jonathan, ed. *Writing and Revising the Disciplines*. Ithaca, NY, and London: Cornell University Press, 2002.

Mumford, Lewis. 'Architecture: Beautiful and Beloved.' *New York Times Magazine*, 1 February 1953: 23.

Mumford, Lewis. 'Follies of Modern Architecture: Lewis Mumford tells AA students of "backward step."' *Architects' Journal*, 9 July 1953: 56–9.

Mumford, Lewis. 'House of Glass.' The Sky Line. *New Yorker*. 9 August 1952: 48–54.

Mumford, Lewis. 'Magic with Mirrors—I.' The Sky Line. *New Yorker*. 15 September 1951: 84–93.

Mumford, Lewis. 'Magic with Mirrors—II.' The Sky Line. *New Yorker*. 22 September 1951: 99–106.

Oak, Arlene. 'Particularizing the Past: Persuasion and Value in Oral History Interviews and Design Critiques.' *Journal of Design History* 19, no. 4 (2006): 345–56.

'Office Buildings.' Building Types Study No. 187. *Architectural Record* 111 (June 1952): 121–51.

Oldenziel, Ruth, Albert de la Bruhèze, Adri, and de Wit, Onno. 'Europe's Mediation Junction: Technology and Consumer Society in the 20th Century.' *History and Technology* 21, no. 1 (2005): 107–39.

Palmer, Harry, and Dodson, Mo, eds. *Design and Aesthetics: A Reader*. London: Routledge, 1996.

Partridge, R. C. Barrington. *The History of the Legal Deposit of Books throughout the British Empire*. Welwyn, Hertfordshire: Broadwater Press, 1938.

Pavitt, Jane. 'Design and the Democratic Ideal.' In *Cold War Modern: Design 1945–1970*, edited by David Crowley and Jane Pavitt, 73–93. London: V&A Publishing, 2008.

Pevsner, Nikolaus. *Pioneers of the Modern Movement: From William Morris to Walter Gropius*. London: Faber and Faber, 1936.

Porsdam, Helle, ed. *Copyright and Other Fairy Tales: Hans Christian Andersen and the Commercialisation of Creativity*. London: Edward Elgar Publishing, 2006

Port, M. H. 'The Office of Works and Building Contracts in Early Nineteenth-Century England.' *Economic History Review* 20 (1967): 94–110.

Pye, David. *The Nature and Art of Workmanship*. Cambridge: Cambridge University Press, 1968.

Quek, Raymond. 'Excellence in Execution: Disegno and the Parallel of Eloquence.' In 'Writing Design: Words, Myths, Practices,' edited by Grace Lees-Maffei. *Working Papers on Design* 4 (December 2010). http://sitem.herts.ac.uk/artdes_research/papers/wpdesign/wpdvol4/vol4.html.

Rajchman, John. 'The Story of Foucault's History.' *Social Text* 8 (Winter 1983–84): 3–24.

Roddolo, Enrica. *La Biennale: arte, polemiche, scandali e storie in Laguna*. Venice: Marsilio, 2003.

Rouse, Joseph. 'Power/Knowledge.' In *Cambridge Companion to Foucault*, edited by Gary Cutting. Cambridge: Cambridge University Press, 1994.

Ruskin, John. *The Works of John Ruskin: Library Edition*, edited by E. T. Cook and Alexander Wedderburn. 39 vols. London: George Allen, 1903–12.

Sandino, Linda. 'Oral Histories and Design: Objects and Subjects.' *Journal of Design History* 19, no. 4 (2006): 275–82.

Schön, Donald A. *The Reflective Practitioner: How Professionals Think in Action*. London: Arena, 1991.

Sherman, Brad, and Bently, Lionel. *The Making of Modern Intellectual Property Law: The British Experience 1760–1911*. Cambridge: Cambridge University Press, 1999.

Shonfield, Katherine. 'Purity and Tolerance: How Building Construction Enacts Pollution Taboos.' *AA Files* 28 (Autumn 1994): 34–40.

Simkins, Peter. *Kitchener's Army: The Raising of the New Armies, 1914–16*. Manchester: Manchester University Press, 1988.

Sobchack, Vivian, ed. *Meta-Morphing: Visual Culture and the Culture of Quick Change*. Minneapolis: University of Minnesota Press, 2000.

SOM.COM Skidmore, Owings and Merrill. 'Lever House.' Accessed 23 February 2011. http://www.som.com/content.cfm/lever_house

SOM.COM Skidmore, Owings and Merrill. 'Lever House—Curtain Wall Replacement.' Accessed 23 February 2011. http://www.som.com/content.cfm/lever_house_curtain_wall_replacement

Sommer, Anne Louise, Mackinney-Valentin, Maria, Brobeck, Marie, Lynge, Nina, and Binder, Thomas, eds. *FLUX—Research at the Danish Design School*. Copenhagen: Danish Design School Press, 2009.

Specht, Heidi. 'Legibility: How Precedents Established in Print Impact On-Screen and Dynamic Typography.' Master's thesis, Morgantown, West Virginia University, 2000.

Spiers, Edward M. *The Army and Society 1815–1914*. London: Longman, 1980.

Spradley, James P. *Participant Observation*. New York: Holt, Rinehart and Winston, 1982.

Steiner, Albe. *Il manifesto politico*. Rome: Editori Riuniti, 1978.

Stokes, Simon. *Art & Copyright*. Oxford: Hart Publishing, 2001.

Street, George Edmund. *Notes of a Tour in Northern Italy*. London: Waterstone, 1986 (1855).

Sweetser, Eve. *From Etymology to Pragmatics: Metaphorical and Cultural Aspects of Semantic Structure*. Cambridge: Cambridge University Press, 1990.

Szambien, Werner, *Le musée d'architecture*. Paris: Picard, 1988.

Tafuri, Manfredo. *Architecture and Utopia: Design and Capitalist Development*. Translated by BarbaraLuigia LaPenta. Cambridge, MA: MIT Press, 1979.

Taylor, Mark, and Preston, Julieanna, eds. *Intimus: Interior Design Theory Reader*. Chichester: Wiley-Academy, 2006.

Teilmann-Lock, Stina. *British and French Copyright: A Historical Study of Aesthetic Implications*. Copenhagen: DJØF Publishing, 2009.

Toker, Franklin. 'Gothic Architecture by Remote Control: An Illustrated Building Contract of 1340.' *The Art Bulletin* 67, no. 1 (March 1985): 67–95.

Tomes, Nancy. *The Gospel of Germs: Men, Women, and the Microbe in American Life*. Cambridge, MA: Harvard University Press, 1998.

Triggs, Teal. *Fanzines*. London: Thames and Hudson, 2010.

Troika, Conny Freyer, Noel, Sebastian, and Rucki, Eva. *Digital by Design: Crafting Technology for Products and Environments*. London: Thames and Hudson, 2008.

Tschichold, Jan. *The New Typography*, translated by Ruari McLean. Berkeley: University of California Press, 1998.

Turner, E. S., *The Shocking History of Advertising*. Rev ed. Harmondsworth: Penguin, 1965.

Veseley, Dalibor. *Architecture in the Age of Divided Representation: The Question of Creativity in the Shadow of Production*. Cambridge, MA: MIT Press, 2004.

Webb, Beatrice P. *My Apprenticeship*. Cambridge: University of Cambridge Press, 1979.

Welters, Linda, and Lillethun, Abby, eds. *The Fashion Reader*. Oxford: Berg, 2007.

Whorf, B. *Language, Thought and Reality: Selected Writings of Benjamin Lee Whorf*, edited by John B. Carroll. Chicago: MIT Press, 1956.

Whyte, William Foote. *Participant Observer*. Ithaca, NY: ILR Press, 1994.

Whyte, William Foote. *Participatory Action Research*. London: Sage, 1991.

Williams, Gareth. *Telling Tales: Fantasy and Fear in Contemporary Design; Narrative in Design Art*. London: V&A Publications, 2009.

Williams, Raymond. 'Advertising: The Magic System.' In *Problems in Materialism and Culture*, 170–95. London: Verso, 1980.

Willis, Anne-Marie, ed. *Design Philosophy Papers Collection Two*. Ravensbourne, QLD: Team D/E/S Publications, 2005.

Winter, Jay M. 'Popular Culture in Wartime Britain.' In *European Culture in the Great War*, edited by Aviel Roshwald and Richard Stites, 330–48. Cambridge: Cambridge University Press, 1999.

Wittgenstein, Ludwig. *Tractatus Logico-Philosophicus*, translated by David Francis Pears and Brian F. McGuinness. London: Routledge, 1961.

Woolman, Matt, and Bellatoni, Jeffrey. *Type in Motion: Innovations in Digital Graphics*. London: Thames and Hudson, 1999.

Yagoda, Ben. *About Town: The* New Yorker *and the World It Made*. New York: Scribner, 2000.

Yow, Valerie Raleigh. *Recording Oral History: A Guide for the Humanities and Social Sciences*. 2nd ed. Lanham, MD: AltaMira Press, 2005.

Zweiniger-Bargielowska, Ina. ' "Raising a Nation of 'Good Animals' ": The New Health Society and Health Education Campaigns in Interwar Britain.' *Social History of Medicine* 20, no. 1 (2007): 73–89.

INDEX